Fourth Edition

A Short Course in PHOTOGRAPHY Digital

AN INTRODUCTION TO PHOTOGRAPHIC TECHNIQUE

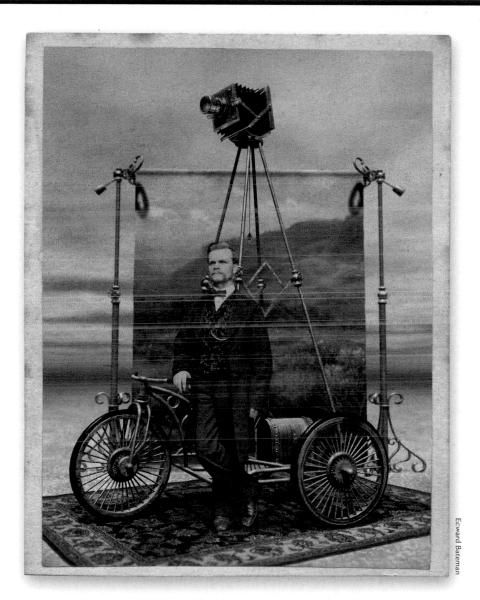

Barbara London Jim Stone

Publisher: Roth Wilkofsky Editorial Assistant: Kaylee Navarra Product Marketing Manager: Nicholas Bolt Executive Field Marketing Manager: Wendy Albert Managing Content Producer: Donna DeBenedictis Project Coordination, Text Design, and Electronic Page Makeup: SPi Global Cover Designer: Lumina Datamatics Cover Image: Adam Ekberg, *Vacuum on a Frozen Lake*, 2005. © Adam Ekberg Manufacturing Buyer: Mary Ann Gloriande Printer/Binder: LSC Communications Cover Printer: Phoenix Color

Acknowledgments of third-party content appear on the appropriate page in the text or on page 228, which constitutes an extension of this copyright page.

Frontispiece: Edward Bateman, Landscape Photographer, 2012 Opposite page: Teun Hocks, Untitled, 2000. Courtesy of the artist and Torch Gallery, Amsterdam

PEARSON and ALWAYS LEARNING are exclusive trademarks owned by Pearson Education, Inc. or its affiliates in the United States and/or other countries.

Unless otherwise indicated herein, any third-party trademarks that may appear in this work are the property of their respective owners and any references to third-party trademarks, logos, or other trade dress are for demonstrative or descriptive purposes only. Such references are not intended to imply any sponsorship, endorsement, authorization, or promotion of Pearson's products by the owners of such marks, or any relationship between the owner and Pearson Education, Inc., or its affiliates, authors, licensees, or distributors.

Library of Congress Cataloging-in-Publication Data

London, Barbara | Stone, Jim

A short course in photography. Digital : an introduction to photographic technique / Barbara London, Jim Stone. Fourth edition. | Upper Saddle River, New Jersey : Pearson Education, Inc., [2018] LCCN 2017047540| ISBN 9780134525815 | ISBN 0134525817 LCSH: Photography--Digital techniques--Textbooks. | Image processing--Digital techniques--Textbooks. LCC TR267 .L647 2018 | DDC 771--dc23

Copyright © 2019, 2015, 2012 by Pearson Education, Inc. All Rights Reserved. Printed in the United States of America. This publication is protected by copyright, and permission should be obtained from the publisher prior to any prohibited reproduction, storage in a retrieval system, or transmission in any form or by any means, electronic, mechanical, photocopying, recording, or otherwise. For information regarding permissions, request forms and the appropriate contacts within the Pearson Education Global Rights & Permissions Department, please visit www.pearsoned.com/permissions/.

4 18

Student Edition: ISBN 10: 0-13-452581-7 ISBN 13: 978-0-13-452581-5

A La Carte Edition: ISBN 10: 0-13-452603-1 ISBN 13: 978-0-13-452603-4

Instructor's Review Copy: ISBN 10: 0-13-452601-5 ISBN 13: 978-0-13-452601-0

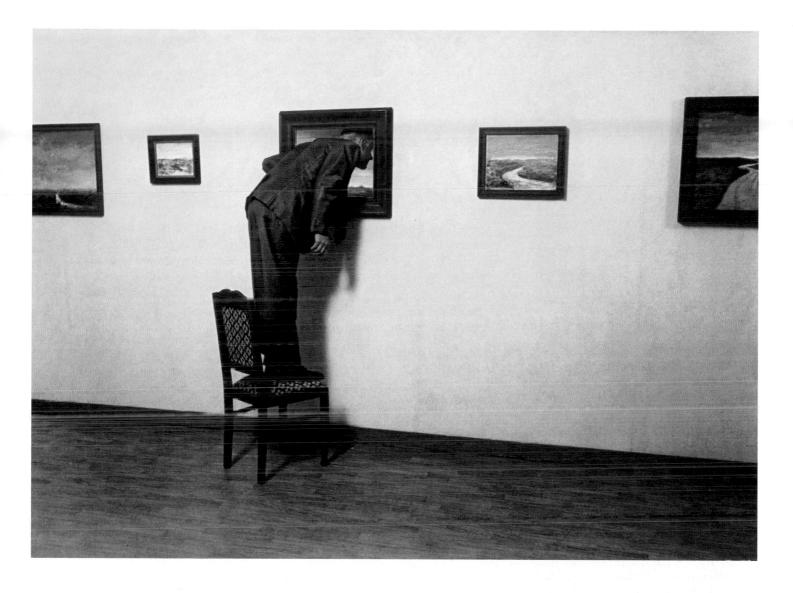

Contents

Preface vii

1 Camera 🌍 2

Getting Started Getting your camera ready 4
Focusing and setting the exposure 6
Exposure readout 7
Exposing images 8
What will you photograph? 9 Types of Cameras Film cameras 10
Digital cameras 12
Basic Camera Controls 14
More about Camera Controls 16
Inside a digital single-lens reflex camera 17
Shutter Speed Affects light and motion 18
Use it creatively 20
Aperture Affects light and depth of field 22
Use it creatively 24
Shutter Speed and Aperture Blur vs. depth of field 26
Getting the Most from Your Camera and Lens 28

2 Lens 🔘 30

Lens Focal Length The basic difference between lenses 32
Normal Focal Length The most like human vision 34
Long Focal Length Telephoto lenses 36
Short Focal Length Wide-angle lenses 38
Zoom, Macro, and Fisheye Lenses 40
Focus and Depth of Field 42
Automatic Focus 43
Depth of Field Controlling sharpness in a photograph 44
More about Depth of Field How to preview it 46
Perspective How a photograph shows depth 48
Lens Attachments Close-ups and filters 50

3 Light and Exposure 52

Sensors and Pixels 54 ■ Pixels and Resolution 55 ■ Color in Photography Color Systems 56 ■ Color Characteristics 57 ■ White Balance 58 ■ Using Histograms 60 ■ Exposure Meters What different types do 62 ■ How to calculate and adjust an exposure manually 64 ■ Overriding an Automatic Exposure Camera 66 ■ Making an Exposure of an Average Scene 68 ■ Exposing Scenes that are Lighter or Darker than Average 70 ■ Backlighting 72 ■ Exposing Scenes with High Contrast 73 ■ HDR High dynamic range 74

4 Digital Workplace Basics 🔏 76

Equipment and Materials You'll Need 78 = Pictures Are Files 80 = Digital Color Modes, gamuts, spaces, and profiles 82 = Channels 83 = Calibrating for accuracy 84 = Working with Camera Raw 85 = Stay organized Setting up a Workflow 86 = Photographer's Workflow Programs: 87 = Importing an Image 88 = Scanning 89

5 Image Editing 🕎 90

Getting Started Editing an Image 92
Adjusting an Image Levels 94
Curves 96
Adjusting Part of an Image Selections 98
More Techniques
Layers 100
Retouching 102
Sharpening 104
Compositing 106
Color into black and white 108
Filters 109
An Editing Workflow 110
Filters and Disite Imaging 112

Ethics and Digital Imaging 112

6 Printing and Display 🖶 114

Printers and Drivers 116 Papers and Inks 117 Soft Proofing 118 Panoramic Photographs 119 Presenting Your Work Framing 120 Matting a print 121 Mounting a Print Equipment and materials you'll need 122

Dry Mounting a Print Step by Step 124 Bleed Mounting/Overmatting 126

7 Organizing and Storing 📲 128

Image Storage 130 Using Metadata 131 Software for Organizing 132
Archiving Images and Prints 133

8 Using Light 🔓 134

Qualities of Light From direct to diffused 136 = Existing Light Use what's available 138 = The Main Light The strongest source of light 140 = Fill Light To lighten shadows 142 = Simple Portrait Lighting 144 = Using Artificial Light Photolamp or flash 146 = More about Flash How to position it 148 = Using Flash 150

9 Seeing Like a Camera 💽 152

What's in the Picture The edges or frame 154 = The background 156 = Focus Which parts are sharp 158 = Time and Motion in a Photograph 160 = Depth in a Picture Three dimensions become two 162 = Chaos into order 163 = Photographing for Meaning 164 = Portraits Informal: Finding them 166 = Formal: Setting them up 168 = Photographing the Landscape 170 = Photographing the Cityscape 172 = Photographing Inside 174 = Assembled to be Photographed 176 = Responding to Photographs 178

10 History of Photography 🤺 180

Daguerreotype "Designs on silver bright" 182 Calotype Pictures on paper 184 Collodion Wet-Plate Sharp and reproducible 185 Gelatin Emulsion/ Roll-Film Base Photography for everyone 186 Color Photography 187 Early Portraits 188 Early Travel Photography 190 Early Images of War 191 Time and Motion in Early Photographs 192 The Photograph as Document 193 Photography and Social Change 194 Photojournalism 196 Photography as Art in the 19th Century 200 Pictorial Photography and the Photo-Secession 201 The Direct Image in Art 202 The Quest for a New Vision 203 Photography as Art in the 1950s and 1960s 204 Photography as Art in the 1970s and 1980s 206 Color Photography Arrives—Again 208 Digital Photography Predecessors 210 Becomes mainstream 212

How to Learn More 214
Troubleshooting 215
Photographers' Web Sites 220
Glossary 222
Bibliography 226
Photo Credits 228
Index 230

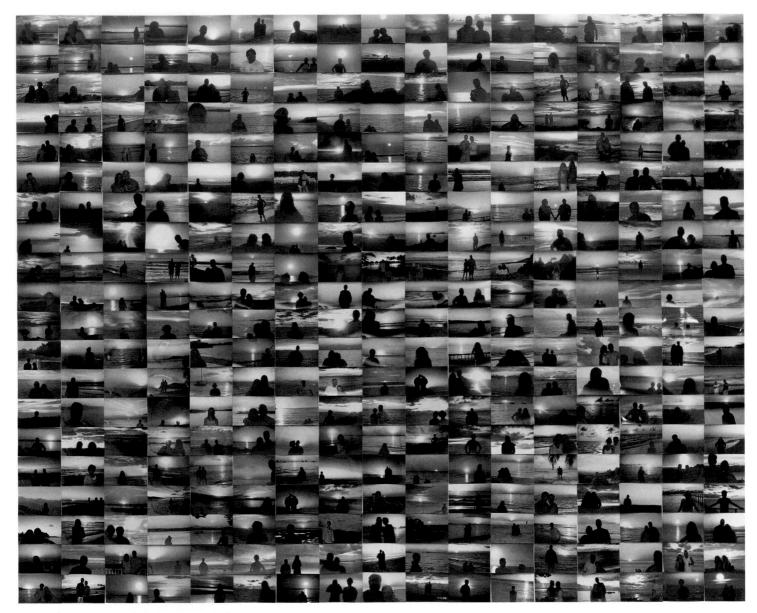

Penelope Umbrico. Sunset Portraits from 8,462,359 Flickr Sunsets on 12/21/10, 2010. **Photography can be your subject, as well as your medium.** Umbrico began searching the Web in 2006 for the most-often-photographed subject, finding it to be sunsets (541,795 pictures posted on the popular photo-sharing site Flickr at that time).

Umbrico had 4×6 -inch machine prints made from an "appropriated" selection (this 2010 piece includes only those sunsets with silhouetted figures), and exhibits them in grid form, about 8 feet tall. For a 2011 gallery show, she showed 1,058 4×6 -inch sunset portraits; by then the total number of sunsets on Flickr had grown to 9,623,557. As you make your own photographs, it is worth asking yourself questions. What are the ways you can improve the photographs you are now making? If others have already photographed your subject, how will your pictures be different? If you magnify the meaning your images have for you, will you also increase the impact they have on others? Read on.

Preface

f you don't know anything about photography and would like to learn, or if you want to make better pictures than the ones you are making now, *A Short Course in Photography: Digital* will help you. This book is modeled after the widely used film-and-darkroom edition of *A Short Course in Photography*, but presents the medium in its current, electronic form.

We present here, in depth, the basic techniques of photography:

- How to get a good exposure
- How to adjust the focus, shutter speed, and aperture (the size of the lens opening) to produce the results you want
- How to transfer your pictures to a computer and make sure they are organized and safe from loss
- How to use computer software to make your photographs look their best

Almost all of today's cameras incorporate automatic features, but that doesn't mean that they automatically produce the results you want. This edition of A Short Course in Photography devotes special attention to:

 Automatic focus and automatic exposure—what they do and, particularly, how to override them when it is better to adjust the camera manually

Some of the book's highlights include:

- Getting Started. If you are brand new to photography, this section will walk you through the first steps of selecting and installing a memory card, setting the camera's menu options, focusing sharply, adjusting the exposure, and making your first pictures. See pages 4–9.
- Projects. These projects are designed to help develop your technical and expressive skills. See page 136 or 155.
- Making Better Prints. This includes information about how to adjust your photographs with image-editing software (pages 92–111), select ink and paper for them (page 117), print them (page 118), and then display them in a mat and frame (pages 120–127).
- Types of lenses (pages 31–41), cameras (pages 10–13), lighting (pages 134–151), and software for organizing and archiving (pages 131–133).
- History of Photography. The medium has been used for documentation, persuasion, and personal expression since its 19th-century invention. See pages 180–213.

Photography is a subjective undertaking. A Short Course in *Photography* emphasizes your choices in picture making:

- How to look at a scene in the way a camera can record it
- How to select the shutter speed, point of view, and other

elements that can make the difference between an ordinary snapshot and an exciting photograph

- Chapter 9, Seeing Like a Camera, explores your choices in selecting and adjusting the image and presents ways to photograph subjects such as people and landscapes.
- An updated Chapter 10, The History of Photography, traces the technical, social, and artistic development of the medium since its inception.

New in this fourth edition are:

- The latest on camera technology and software, integration of workflow applications—including Capture One Pro—at every step, and expanded coverage of a Camera Raw workflow.
- New photographs by great contemporary artists, including Edward Bateman, Ian van Coller, Sam Comen, John Divola, Filip Dujardin, Adam Ekberg, Kate Joyce, David Leventi, Martina Lopez, Christoph Oberschneider, Todd Owyoung, Christian Richter, and Geoffrey Robinson.
- The 1970s explosion of color photography is explained in the History of Photography, Chapter 10.
- Current product and technical information throughout, with updated demonstration and example photographs.

This book is designed to make learning photography as casy as possible:

- Every two facing pages completes a single topic
- Detailed step-by-step instructions clarify each stage of extended procedures
- Boldfaced headings make subtopics easy to spot
- Numerous photographs and drawings illustrate each topic

Acknowledgments

Many people gave generously of their time and effort in the production of this book. Feedback from instructors helps confirm the direction of the book and determine the new elements in each edition. The authors are grateful to all those who reviewed previous editions and forwarded comments. At Pearson Education, Roth Wilkofsky provided editorial support. Annemarie Franklin, Steve Martel, and the team at SPi Global supervised the production of the book from manuscript to printer and caught our (extremely few, of course) errors. Amber, Jade, and Skye Stone gave their dad time to finish the book. If you have suggestions, please send them to Photography Editor, Pearson Education, 221 River Street, Hoboken, NJ 07030. They will be sincerely welcomed.

> Jim Stone Barbara London

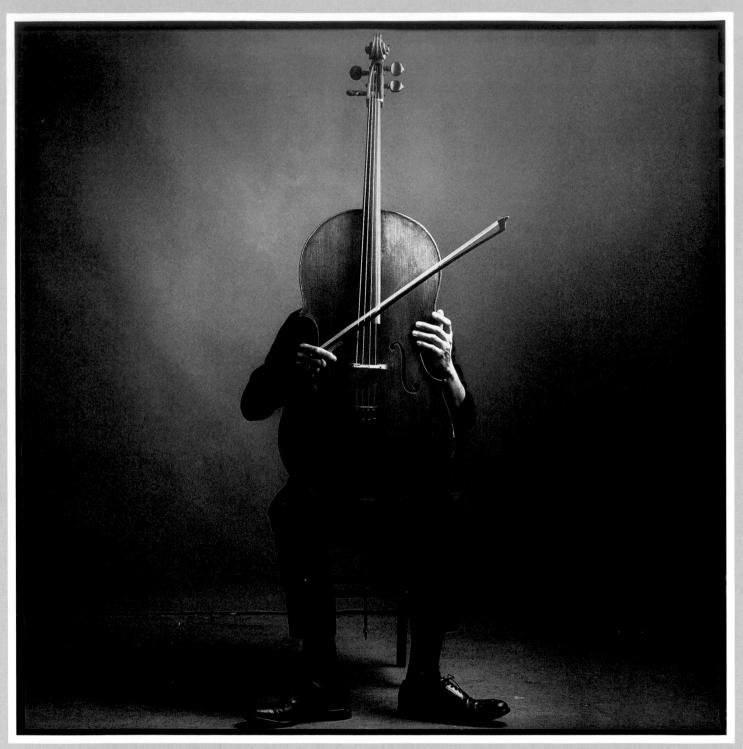

ANNIE LEIBOVITZ

Yo Yo Ma, 1998. Framing is a basic control you have in making a photograph. The two photographs on this page and opposite are about music. Would you center your subject or use a corner? Do you want action or repose? Black and white or color? Horizontal, vertical, or square? Candid or posed? Viewed from above, below, or straight on? More about framing on pages 154–155.

Getting Started 4 Getting your camera ready
Focusing and setting the exposure 6 Exposure readout
Exposing images
Types of Cameras10Film cameras10Digital cameras12
Basic Camera Controls 14
More about Camera Controls16 Inside a digital single-lens reflex camera17

Shutter Speed	•	•	•	•	•	•	•	•	•	18
Affects light and motion										
Use it creatively										

Aperture			•	•	•	•	22
Affects light and depth of field							22
Use it creatively	•	•			•	•	24

Shutter Speed

and Aperture	•	•	•	•	•	•	•	•	•	•	•	26
Blur vs. depth of field				•								26

Camera 🚳 1

In this chapter you'll learn...

- the basic controls of your camera and what they do.
- the categories of cameras, and their characteristics, so you can choose the right one for your purposes.
- the first steps of getting a camera ready, focusing an image, and adjusting the camera's settings.

Project: EXPOSE SOME PICTURES

YOU WILL NEED

Camera. We suggest one with adjustable controls. **Output.** To evaluate your work, it's good to see exactly what you did. Your digital pictures can be viewed on the camera's small monitor but they are easier to evaluate on a computer screen. Pages 8 and 88 tell you how to download photographs from your camera to a computer. Once they are on a computer, your unedited photographs can also be displayed large with a digital projector or on a wide-screen television so you can easily see small details and imagine what they might look like printed at a large size. If you shoot 35mm film you can take it to the photo lab in a drug store or supermarket chain for overnight processing and printing.

Pencil and notepad or smartphone to keep track of what you do. Optional, but highly recommended for all the projects.

PROCEDURE See pages 4-9 if you are just beginning to photograph. Those pages walk you through the first steps of setting up your camera, focusing an image sharply, adjusting the camera settings so your photographs won't be too light or too dark, and making your first pictures. See pages 10-13 for more about the kinds of cameras.

Have some variety in the scenes when you shoot. For example, photograph subjects near and far, indoors and outside, in the shade and in the sun. Photograph different types of subjects, such as a portrait, a landscape, and an action scene. Page 9 gives some suggestions.

HOW DID YOU DO? Which pictures did you like best? Why? Were some different from what you expected to get? Did some of your camera's operations cause confusion? It helps to read your instruction book all the way through or to ask for help from someone familiar with your camera.

Todd Owyoung. Drummer Questlove performing with the Roots, Fox Theater, St. Louis, Missouri, 2008.

Il cameras have four things in common: an image-forming lens; a light-sensitive surface (film or a digital sensor) to record the light that forms an image; a light-tight container (the camera's body) to keep other light out; and two important controls to adjust the amount of picture-making light (the exposure) that reaches the light-sensitive surface.

This chapter describes those light controls and how you can take charge of them, instead of letting them control you. Almost all current cameras are equipped with automatic exposure and automatic focus, and many have automatic flash. If you are interested in making better pictures, however, you should know how your camera makes its decisions, even if the automatic features can't be turned off. If they can, you will want to override your camera's automatic decisions from time to time and make your own choices.

- You may want to blur the motion of a moving subject or freeze its motion sharply. Pages 18–19 show how.
- You may want a scene sharp from foreground to background or the foreground charp but the background out of focus. See pages 44–45.
- You may want to override your camera's automatic focus mechanism so that only a certain part of a scene is sharp. Page 43 tells when and how to do so.
- You may decide to silhouette a subject against a bright background, or perhaps you want to make sure that you don't end up with a silhouette. See page 72.

Most professional photographers use cameras with automatic features, but they know how their cameras operate manually as well as automatically so they can choose which is best for a particular situation. You will want to do the same because the more you know about how your camera operates, the better you will be able to get the results you want.

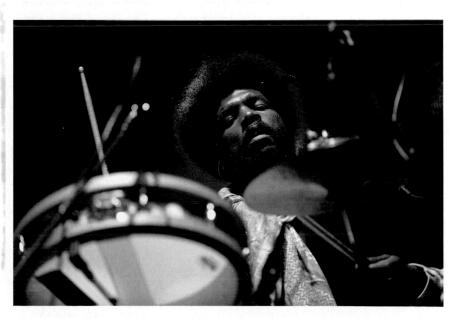

3

Getting Started **GETTING YOUR CAMERA READY**

A camera's main functions are to help you view the scene so you can select what you want to photograph, focus to get the scene sharp where you want it to be, and **expose** the picture so it is not too light or too dark.

This illustration divides a camera in half so it shows parts for both film and digital capture. For more about specific cameras, see pages 10-13.

> The lens moves forward and back to bring objects at different distances into sharp focus.

> > The **aperture** adjusts from larger (letting more light pass from the lens to the light-sensitive surface) to smaller (letting less light pass).

The shutter opens and closes to limit the length of time that light strikes the light-sensitive surface.

Film (in a film camera)

transmitted by the lens.

records the image

The sensor (in a digital camera) converts the light from the lens into electrical signals that are sent to the memory card.

The memory card (in a digital camera) stores images until they can be printed or transferred to a computer or other storage device.

The **viewfinder** shows

the picture that the lens will focus on the

sensor or film.

Choose a Memory Card

that vary in capacity and speed. Because there

are several types that are not interchangeable,

make sure you have one that fits your camera.

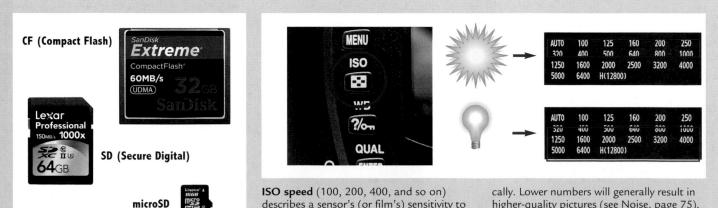

Select an ISO

describes a sensor's (or film's) sensitivity to light. The higher the number, the less light it needs for a correct exposure (for a picture that is not too light or too dark). With a digital camera, you may select an ISO set-Digital cameras store pictures on memory cards ting within that camera's range. You may choose a different ISO for each picture, or you may set your camera to do so automatihigher-quality pictures (see Noise, page 75).

More about camera controls on pages 14-27.

Set an ISO of 50 to 800 for shooting outdoors in sunny conditions. In dimmer light, such as indoors, use an ISO of 800 or higher. Film is made with a fixed ISO; an entire roll must be exposed at that speed. 400 speed film is a good all-purpose choice.

Check the Batteries

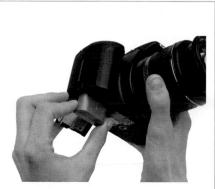

Make sure your camera's batteries have a fresh charge. No digital cameras and few film cameras will operate without power. A half-empty symbol will let you know when the battery is low.

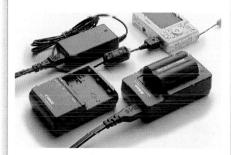

Many cameras use proprietary battery packs that must be recharged with the manufacturer's matching charger. Some compact cameras have built-in batteries that limit your shooting while they recharge.

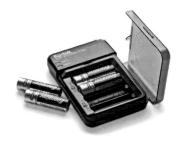

Some cameras use standard batteries that you can buy nearly anywhere. Most conventional sizes are available in moneysaving rechargeable versions.

Insert a Memory Card

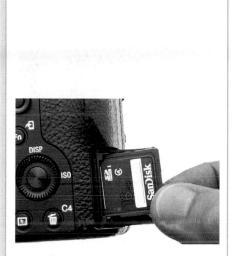

Insert the memory card only with the camera's power turned off. Then turn on the camera. Make sure you are using the right kind of card for your camera and one with enough capacity. Cards intended for another camera may not operate correctly in yours.

Keep cards protected when they are not in the camera. Memory cards are vulnerable to dust and moisture as well as magnetic fields, heat, and shock. Try not to touch the electrical contacts.

Display the Menu

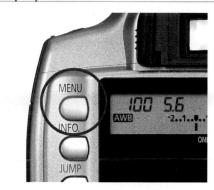

Open the options menu. Turn the camera on and press the button to display the menu on the camera's monitor.

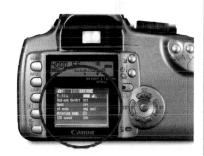

Review the defaults. In your camera's manual, read through the list of settings that can be changed by the operator. Decide which of them you would like to change from the camera's defaults, the way those options have been set by the factory.

	SHOOTING MENU		
0	Optimize image	ØN	•
Sandy No.	Image quality	RAW+F	
	Image size		
Y	White balance	Α	
1	ISO sensitivity	100	
	Long exp. NR	OFF	
?	High ISO NR	OFF	

Select a menu item with the control wheel on the camera's back, then use the jog dial (also on the back) to reveal a list of settings or choices for that item.

<u>Getting Started</u> focusing and setting the exposure

Set Basic Menu Options

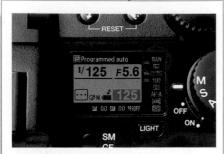

Select the file type and resolution. The menu item may be called "image quality," because visual fidelity is affected by your choice. A lower resolution or compressed file lets you store more pictures on your memory card, but at some loss of quality. Saving pictures in the camera's raw format, at its highest resolution, keeps the quality highest.

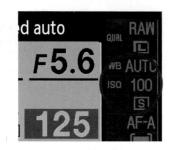

Choose an ISO speed. It can be different for each picture. Higher numbers let you shoot in lower light but produce an image with more noise (see page 75).

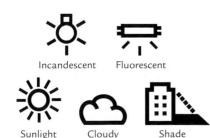

Select the white balance (color temperature) of the dominant light source in which you are shooting, such as incandescent (tungsten) bulbs, sunlight, or outdoor shade. A camera set on automatic makes these adjustments for you. If your camera has a raw format option, it leaves the white balance choice until you edit the file.

More about ISO speed on page 75.

Focus

Focus on the most important part of your scene to make sure it will be sharp in the photograph. Practice focusing on objects at different distances as you look through the viewfinder so that you become familiar with the way the camera focuses.

Ground glass

Focus Indicator

Manual focusing. As you look through the viewfinder, rotate the focusing ring at the front of the lens. The viewfinder of a single-lens reflex camera has a ground-glass screen that shows which parts of the scene are most sharply focused. Some cameras also have a microprism, a small ring at the center of the screen in which an object appears coarsely dotted until it is focused. An advanced or *system* DSLR may offer a choice of focusing screens.

Shutter release button Part way down autofocus activated All the way down: shutter released

Automatic focusing. Usually this is done by centering the focusing brackets (visible in the middle of the viewfinder) on your subject as you depress the shutter release part way. The camera adjusts the lens for you to bring the bracketed object into focus. Don't push the shutter release all the way down until you are ready to take a picture.

More about focus and when and how to override automatic focus on page 43.

Set the Exposure

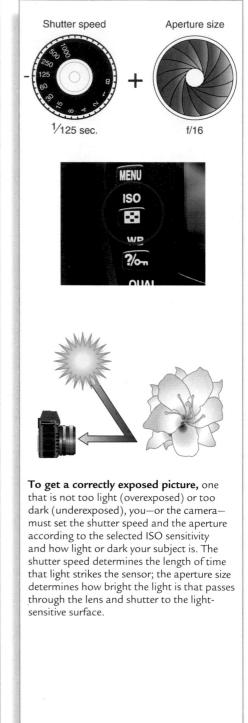

More about shutter speed and aperture on pages 18–27 and about exposure and metering on pages 62–73.

Exposure Readout

A data panel appears on the body of some cameras, displaying shutter speed and aperture settings (here, $\frac{1}{250}$ sec. shutter speed, f/16 aperture), as well as other information.

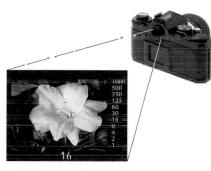

The shutter speed and aperture settings appear in the viewfinder of some cameras (here, $\frac{1}{250}$ sec. shutter speed, f/16 aperture).

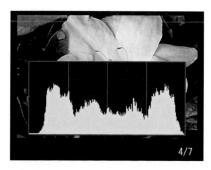

A histogram is an accurate representation of exposure that most cameras can display on the monitor after you take each photograph. If your subject is not moving or is otherwise cooperative, make a test exposure of the scene first. Over- or underexposed tests can be deleted. More about histograms on pages 60–61.

Manually Setting the Exposure

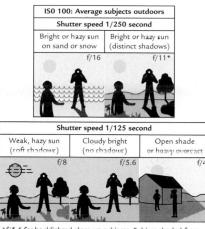

*f/5.6 for backlighted close-up subjects. Subject shaded from sun but lighted by a large area of sky.

With manual exposure, you set both the shutter speed and aperture yourself. How do you know which settings to use? At the simplest level you can use a chart like the one above. Decide what kind of light illuminates the scene, and set the aperture (the f-number shown on the chart) and the shutter speed accordingly.

Notice that the recommended shutter speed on the chart is $\frac{1}{230}$ sec. or $\frac{1}{123}$ sec. These relatively fast shutter speeds make it easier for you to get a sharp picture when hand holding the camera (when it is not on a tripod). At slow shutter speeds, such as $\frac{1}{30}$ sec. or slower, the shutter is open long enough for the picture to be blurred if you move the camera slightly during the exposure.

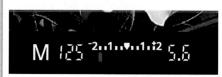

You can use a camera's built-in meter for manual exposure. Point the camera at the most important part of the scene and activate the meter. The viewfinder will show whether the exposure is correct. If it isn't, change the shutter speed and/or aperture until it is. Here, plus numbers signal overexposure, minus means underexposure. Lining up the red arrow with the dot in the center indicates the exposure is right.

To prevent blur caused by the camera moving during the exposure (if the camera is not on a tripod), select a shutter speed of at least $\frac{1}{100}$ sec. A shutter speed of $\frac{1}{120}$ sec. is safer.

EXPOSURE READOUT

Automatically Setting the Exposure

With automatic exposure, the camera sets the shutter speed or aperture, or both, for you.

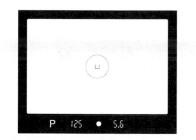

With programmed (fully automatic) exposure, each time you press the shutter release button, the camera automatically meters the light, then sets both shutter speed and aperture.

With shutter-priority automatic exposure, you set the shutter speed and the camera sets the aperture. To prevent blur from camera motion if you are hand holding the camera, select a shutter speed of 1/60 sec. or faster.

With aperture-priority automatic exposure, you set the aperture and the camera sets the shutter speed. To keep the picture sharp when you hand hold the camera, check that the shutter speed is $\frac{1}{60}$ sec. or faster. If it is not, set the aperture to a larger opening (a smaller f-number).

More about how to override automatic exposure on page 66.

Getting Started

Hold the Camera Steady

For horizontal photographs (sometimes called *"landscape"* mode), keep your arms against your body to steady the camera. Use your right hand to hold the camera and your right forefinger to press the shutter release. Use your left hand to help support the camera or to focus or make other camera adjustments.

For vertical photographs (*"portrait"* mode), support the camera from below in either your right or left hand. Keep that elbow against your body to steady the camera.

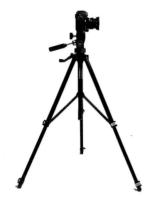

A tripod steadies the camera for you and lets you use slow shutter speeds for night scenes or other situations when the light is dim. Make sure to use a cable release, remote trigger, or self-timer with it.

Expose Some Images

Make an exposure. Recheck the focus and composition just before exposure. When you are ready to take a picture, stabilize your camera and yourself and gently press the shutter release all the way down. Most cameras prefocus automatically when you press the shutter button halfway down. If your subject cooperates, try several different exposures of the same scene, perhaps from different angles.

An LCD monitor shows exact framing and lets you check to see that the picture is not too light or too dark after you take it. Most digital cameras will also let you zoom in the monitor display on a small part of the saved picture to check precise focus.

You'll learn faster if you keep a record as you are shooting. Digital cameras automatically save camera and exposure information—like the aperture, shutter speed, and ISO—and store it with each picture. But it helps to note your reasons for those choices: the way a subject was moving, for example, or the direction and quality of light. This will let you identify the paths to your successful images and help you make great pictures more often. **Download the Pictures**

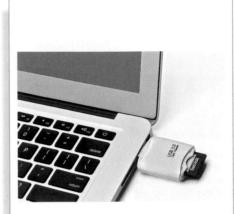

Transfer your pictures to another storage device, usually a computer's hard drive, at the end of a day's shooting or whenever you want to review them in detail. This transfer is called *downloading*. You can remove the memory card and plug it into a card reader, as shown above, or connect the camera and computer directly with a cable, below. Some cameras can transfer images wirelessly.

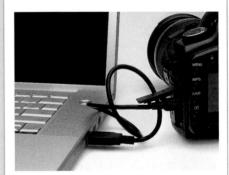

Download your pictures directly to a computer if it's convenient. If you are shooting on location you can transfer them to a portable hard drive or other device made for reading cards. Don't erase the memory card until you are sure all your images are secure and, if possible, duplicated in at least two places.

You can delete unwanted images from the card using the camera, but—unless you are running out of room on the card during a shoot—it is safer to save that editing step until after all your images have been downloaded.

WHAT WILL YOU PHOTOGRAPH?

Where do you start? One place to start is by looking around through the viewfinder. A subject often looks different isolated in a viewfinder than it does when you see it surrounded by other objects. What interests you about this scene? What is it that you want to make into a photograph?

Get closer (usually) Often people photograph from too far away. What part of the scene attracted you? Do you want to see the whole deck, the whole back yard, or are

you more interested in the person cooking? Do you want the whole wall of a building, or was it only the graffiti on it that caught your attention?

Try a different angle. Instead of always shooting from normal eye-level height, try getting up high and looking down on your subject or kneeling and looking up.

Look at the background (and the foreground). How does your subject relate to its surroundings? Do you want the subject centered or off to one side to show more of

the setting? Is there a distraction (like bright sunlight or a sign directly behind someone's head) that you could avoid by changing position? Take a look.

More about backgrounds and the image frame on pages 154–157.

Check the lighting. At first, you are more likely to get a good exposure if you photograph a more or less evenly lit scene, not one where the subject is against a very light background, such as a bright sky.

More about lighting on pages 134–151.

Don't be afraid to experiment, too. Include a bright light source or bright sky in the picture (just don't stare directly at the sun through the viewfinder). In the

resulting photograph, darker parts of the scene may appear completely black, or the subject itself may be silhouetted against a brighter background.

Types of Cameras

What kind of camera is best for you? For occasional snapshots of family and friends, an inexpensive, completely automatic, nonadjustable camera that you just point and shoot will probably be satisfactory. But if you have become interested enough in photography to take a class or buy a book, you will want an adjustable camera because it will give you greater creative control. If you buy a camera with automatic features, make sure it is one that allows you to manually override them when you want to make exposure and focus choices yourself.

Film camera designs

evolved as tools for specific tasks, and followed the slow evolution of film (see Chapter 10, pages 184–186). Here are the major styles, which are useful to know about because many elements of these designs have been incorporated into their digital counterparts.

Single-lens reflex cameras

(SLRs) show you a scene directly through the lens, so you can preview what will be recorded. You can see exactly what the lens is focused on; with some cameras, you can check the depth of field (how much of the scene from foreground to background will be sharp). Through-thelens viewing is a definite advantage with telephoto lenses, for close-ups, or for any work when you want a precise view of a scene.

Very early SLRs used large glass plates or film sheets but since the 1950s almost all were made to accept 35mm film. A few models aimed at (and priced for) professional pho-

Single-lens Reflex Camera

tographers used larger roll film. Recent SLRs incorporate automatic exposure, automatic focus, and automatic flash but allow manual control. Many different interchangeable lenses for SLRs are available.

Digital SLRs (DSLRs) resemble their 35mm film ancestors. Some SLR cameras made for 2¼-inch-wide roll film (called mediumformat) may be used with accessory digital capture backs. Digitalonly models, also called medium-format, are also available.

SLRs have long been very popular with professionals, such as photojournalists or fashion photographers, or with anyone who wants to move beyond making snapshots.

Rangefinder cameras are viewfinder film cameras.

This means they have a peephole, or window, separate from the lens, through which you view the scene. Inexpensive "point-and-shoot" viewfinder cameras simply show the approximate framing through the window. A rangefinder camera is more complex, with a visual focusing system that you use as you look through the viewfinder window. The window shows a split image when an object

is not in focus. As you rotate the focusing ring, the split image comes together when the object is focused

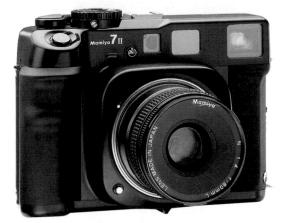

Rangefinder Film Camera

sharply. Rangefinder cameras let you focus precisely, even in dim light, but you cannot visually assess the depth of field because all parts of the scene, even the split image, look equally sharp in the viewfinder.

Because the viewfinder is in a different position from the lens that exposes the film, you do not see exactly what the lens sees. This difference between the viewfinder image and the lens image is called *parallax* error, and is greater for objects that are closer to the camera. Better rangefinder cameras correct for parallax error and have interchangeable lenses, although usually not in as many focal lengths as are available for SLRs. Most use 35mm film; ones called medium format are for wider roll film, few are digital. Rangefinder cameras are fast, reliable, quiet in operation, and relatively small. parallax error and a viewfinder image that is reversed left to right. Some now-discontinued TLRs had interchangeable lenses; adjustments on all models are completely manual.

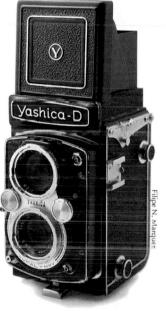

Twin-lens Reflex Camera

Twin-lens reflex cameras (TLRs), except for

a couple novelty "retro" digital versions, are all film cameras. New ones are made by a few companies, but secondhand models are widely available. They cannot easily be adapted to digital capture. Each camera has two lenses: one for viewing the scene and another just below it that exposes the film.

A large film format (2¼ inches square) is the TLR's advantage. Its disadvantages are

View cameras have a lens in the front, a groundglass viewing screen in the back, and a flexible, accordion-like bellows in between. The camera's most valuable feature is its adjustability: the camera's parts can be moved freely in relation to each other, which lets you alter perspective and sharpness to suit each scene. You can change lenses and even the camera's back; for example, you can attach a back to use selfdeveloping film or one to record a digital image.

Each film exposure is made on a separate sheet, so you can make one shot in color and the next in black and white, or develop each sheet differently. Film size is large—4 × 5 inches and larger—for crisp and sharp detail even in a big print.

Using a view camera can be a more considered process because they are slow to use compared to smaller hand-held cameras. They are large and heavy and must be mounted on a tripod. The image on the viewing screen is upside down, and it is usually so dim that you have to put a focusing cloth over your head and the screen to see the image clearly. When you want complete control of an image, such as for architectural or product photography or for personal work, the view camera's advantages outweigh what some might see as inconveniences.

Some cameras are made to fill a specialized need.

Panoramic cameras make a long, narrow photograph that can be effective, for example, with landscapes. Some of these cameras crop out part of the normal image rectangle to make a panoramic shape. Others use a wider-thannormal section of roll

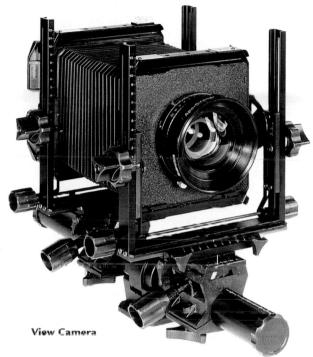

film; some may rotate the lens from side to side during the exposure.

Digital panoramas can be made during editing by stitching several individual frames together, either from digital capture or from scanned film, so specialpurpose panoramic cameras are no longer common. Some digital cameras can display a segment of the previous frame on the side of the monitor to help align the next shot for more seamless reassembly later. Other cameras (and smart phones) have a "sweep" mode that can capture a panoramic image with one press of

the button when moved across a scene.

Stereo or 3-D cameras take two pictures at the same time through two side-by-side lenses. The resulting pair of images, a *stereograph*, gives the illusion of three dimensions when seen in a stereo viewer.

Underwater cameras are not only for use underwater but for any situation in which a camera is likely to get wet. Some cameras are water resistant, rather than usable underwater. Speciallymade underwater housings are available for professional use or larger camera models.

Types of Cameras Digital cameras

Digital camera designs are continually evolving and the array of available models can be overwhelming. With so many options, you can usually choose a camera based on the combination of features you need, but you may have to compromise. To get the most out of this book (and your photography) choose a camera that offers you the option to control focus and exposure manually.

est SLR out for a walk requires a shoulder strap or camera bag. Using one in public suggests to others that you are not a casual snapshooter, that you are photographing seriously.

Compact cameras are mostly designed for amateur photographers but vary considerably in quality. The smaller the camera, the more likely its features will be limited. Some compacts are good enough to be used

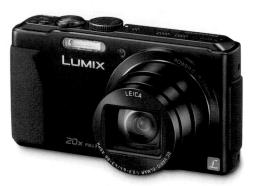

Compact Camera

Size is often the first consideration in choosing a camera. Your camera shouldn't be so large or so small that it gets in the way of your photography.

Digital single-lens reflex (DSLR) cameras are the most versatile choice but they are big enough that you'll probably carry one only when you are meaning to use it. Professional models can be relatively heavy, but taking even the smallest and lightby professionals when they don't want to carry a larger camera; some are made to be used a few times and then set aside. Most compact digital cameras are a bit too large and heavy for your pocket, but fit well in a small shoulder bag along with your phone and sunglasses.

Subcompact digital cameras can be carried in a pocket so you are ready to make pictures anywhere, any time.

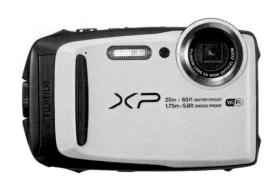

Compact Action Camera

With image quality and features that compare poorly to larger cameras, the market for subcompacts is giving way to smart phones.

Lens. Do you need interchangeable lenses? One common characteristic of a camera made for serious photographers is that a wide assortment of lenses can be attached. An arsenal of specialized lenses can be expensive to acquire and cumbersome to carry. A fixed lens may be all you need, especially if it is a zoom that covers the range you'd expect to use (see pages 32-33).

Viewing system. The purpose of a camera's viewing system is to let you frame and preview, as accurately as possible, the photograph you are about to capture.

A single-lens reflex camera projects the image-forming light directly from your lens

onto a mirror and then to your eye through a pentaprism (see page 17) so you see what the lens sees. Because the viewfinder is held to your eye, it is relatively easy to follow action. But the mirror must swing out of the way for the moment of exposure, so you don't actually see the exact image you have captured. And the mirror's motion can cause unwanted vibration that causes slight blurring.

Mirrorless cameras most often have a small monitor or LCD screen on the back of the camera that displays what the lens is seeing, transmitted directly from the image sensor. This image, called live view, is used for framing and focusing, and is replaced momentarily with a view of each captured image immediately after being taken.

Medium-format Digital SLR

The monitor on some cameras is articulated, or tiltable, for viewing from unusual angles, such as overhead or waist level.

Mirrorless cameras may have an *electronic* viewfinder, or EVF. This viewfinder is a smaller version of the LCD monitor that is located inside the camera. It can be seen when holding the camera to your eye rather than at arm's length. SLR-style mirrorless cameras have a characteristic pentaprism; other cameras resemble rangefinder film cameras with the EVF visible through a peephole located in a corner of the camera's back.

An EVF display can be made lighter and darker to compensate for the brightness of a scene or for setting different apertures (page 22). Some cameras can show in the viewfinder an outline of the areas of best focus, sometimes called *focus peaking*, or fill the frame with a very small section of the scene to allow more precise visual focusing.

Resolution. The maximum number of pixels a camera's sensor can capture is called its resolution. A camera, for example, may be 12, 16, or 24 megapixels (MP). An image file

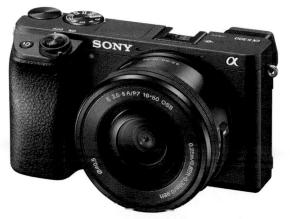

Mirrorless EVF Camera

captured by almost any current digital camera can make a satisfactory letter-size (8½ × 11) print. Generally, to keep the same image quality, the larger the print, the higher the resolution needed (see page 55). If you aren't planning to make large prints, you probably don't need the highest megapixel count.

Sensor size also affects image quality. A 12MP sensor can be physically large or small. If it is small, to have the same number of individual light-sensing elements as a large 12MP sensor, the elements must also be smaller and more tightly packed. The larger and less crowded these elements are on the sensor, the higher the quality of the image (see noise, page 75). Most subcompact cameras and all cell phones have very small sensors and, therefore, produce images of somewhat lower quality. A sensor the same

size as a 35mm film frame is called *full frame*. Larger sensors are made for medium-format digital cameras, priced for well-paid professional photographers. Some common sensor sizes smaller than full frame are (in descending order of size) APS-C, Four-Thirds, 2/3", 1/1.8" (see the chart on page 45).

Other features may be a factor in your choice. Most cameras have a built-in flash for use in dim light. A few have built-in Wi Fi that can transfer image files wirelessly to a computer as you shoot. Some cameras can be remotely controlled with built-in Wi-Fi, Bluetooth, infrared, or radio receivers. Many cameras will capture video at very high quality levels. They have built-in microphones to record sound and many allow external microphones to be connected. To record an active lifestyle, there are action sports cameras (opposite page, top) that are waterproof, shock resistant. and can be helmet or surfboard mounted.

Cell phone cameras now outnumber all other types by a wide margin, and they capture a majority of the photographs made daily, worldwide. Most take only low-resolution images and allow the user no control other than where it points and when it shoots, but the best camera is always the one you have with you.

Basic Camera Controls

Get the pictures you want. Cameras don't quite "see" the way the human eye does, so at first the pictures you get may not be the ones you expected. This book will help you gain control over the picture-making process by showing

you how to visualize the scene the camera will capture and how to use the camera's controls to make the picture you have in mind. Digital cameras are shown here. A film camera will have some or all of these same controls.

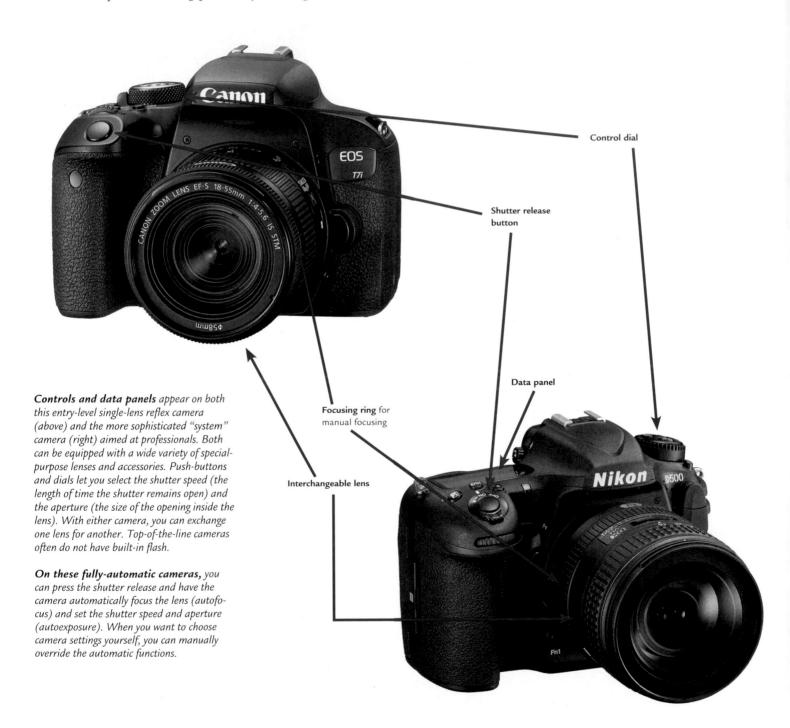

Focusing. Through the viewfinder window you see the scene that will be recorded, including the sharpest part of the scene, the part on which the camera is focused. A particular part of a scene can be focused sharply by manually turning the focusing ring on the lens, or you can let an autofocus camera adjust the lens automatically. More about focusing and sharpness appears on pages 42-45.

Shutter-speed control.

Moving objects can be shown crisply sharp, frozen in midmotion, or blurred either a little bit or a lot. The faster the shutter speed, the sharper the moving object will appear. Turn to pages 18–19 for information about shuller speeds, motion, and blur.

Aperture control. Do you want part of the picture sharp and part out of focus or do you want the whole picture sharp from foreground to back-ground? Changing the size of the aperture (the lens opening) is one way to control sharpness. The smaller the aperture, the more of the picture that will be sharp. See pages 22–25.

Lens focal length. Your lens's focal length controls the size of objects in a scene and how much of that scene is shown. The longer the focal length, the larger the objects will appear. See pages 32–39 for more about focal length.

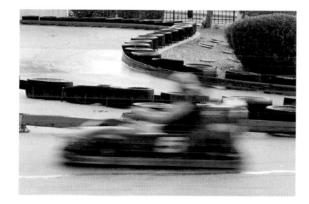

15

More about Camera Controls

Automatic exposure is a basic feature in almost all cameras. The purpose is to let in a controlled amount of light so that the resulting image is neither too light nor too dark. The camera's built-in meter measures the brightness of the scene and then sets shutter speed, aperture (lens opening), or both in order to let the right amount of light reach the camera's recording sensor (or the film in a film camera). As you become more experienced, you will want to set the exposure manually in certain cases, instead of always relying on the camera. Read more about exposure in Chapter 3, pages 60–73.

You have a choice of exposure modes with many cameras. Read your camera's instruction manual to find out which exposure features your model has and how they work. You may be able to download a replacement manual from the manufacturer's Web site, if you don't have one.

With programmed (fully automatic) exposure,

the camera selects both the shutter speed and the aperture based on a program built into the camera by the manufacturer. This automatic operation can be useful in rapidly changing situations because it allows you simply to respond to the subject, focus, and shoot.

In shutter-priority mode, you set the shutter speed and the camera automatically sets the correct aperture. This mode is useful when the motion of subjects is important, as at sporting events, because the shutter speed determines whether moving objects will be sharp or blurred.

In aperture-priority mode, you set the lens opening and the camera automatically sets the shutter speed. This mode is useful when you want to control the depth of field (the sharpness of the image from foreground to background) because the size of the lens opening is a major factor affecting sharpness.

Manual exposure is also a choice with many automatic cameras. You set both the lens opening and shutter speed yourself using, if you wish, the camera's built-in light meter to measure the brightness of the light.

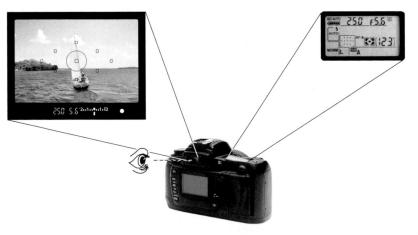

Exposure information appears in the viewfinder of many cameras. This viewfinder shows the shutter speed (here, $\frac{1}{250}$ sec.) and aperture (f/5.6). Displays also show you when the flash is ready to fire and give you warnings of under- or overexposure.

Some cameras also have a data panel on the body of the camera that shows the same information—shutter speed and aperture—as well as exposure, autofocus, and ISO modes and the number of exposures remaining on the memory card (here 123).

INSIDE A DIGITAL SINGLE-LENS REFLEX CAMERA

All cameras have the same basic features:

- A light-tight box to hold the camera parts and a recording sensor or film
- A viewing system that lets you aim the camera accurately
- A lens to form an image and a mechanism to focus it sharply
- A shutter and lens aperture to control the amount of light that reaches the recording surface
- A means to hold a memory card that saves its captured information or to hold and advance film
- A. Body. The light-tight box that contains the camera's mechanisms and protects the light-sensitive surface (sensor or film) from exposure to light until you are ready to make a photograph.
- B. Lone. Focuses an image in the viewfinder and on the light-sensitive recording surface.
- C. Lens elements. The optical glass lens components that produce the image.
- D. Focusing ring. Turning the ring focuses the image by adjusting the distance of the lens from the recording surface. Some cameras focus automatically.
- E. **Diaphragm.** A circle of overlapping leaves inside the lens that adjusts the size of the aperture (lens opening). It opens up to increase (or closes down to decrease) the amount of light reaching the recording surface.
- F. Aperture ring or button. Setting the ring or turning a command dial (O) determines the size of the diaphragm during exposure.
- G. **Mirror.** During viewing, the mirror reflects light from the lens upward onto the viewing screen. During an exposure, the mirror swings out of the way so light can pass straight to the recording surface.
- H. **Viewing screen.** A ground-glass (or similar) surface on which the focused image appears.
- 1. **Pentaprism.** A five-sided optical device that reflects the image from the viewing screen into the viewfinder.
- J. Metering cell. Measures the brightness of the scene being photographed.
- K. Viewfinder eyepiece. A window through which the image from the pentaprism is visible.
- L. **Shutter.** Keeps light from the recording surface until you are ready to take a picture. Pressing the shutter release opens and closes the shutter to let a measured amount of light reach the sensor.
- M. **Sensor.** A grid (usually called a CCD or CMOS array or chip) comprising millions of tiny light-sen-

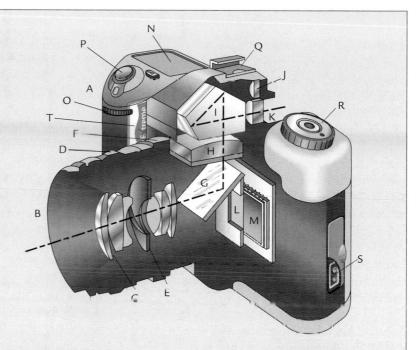

sitive electronic devices (photosites) that record the image. The ISO (or light sensitivity) of the sensor is adjustable, and is set into the camera by a dial or menu setting.

- N. **Data panel.** A display (most often an LCD screen) for such information as shutter speed, aperture, ISO, exposure and metering modes, and the number of exposures remaining on the memory card.
- O. **Command dial.** Selects the shutter speed, the length of time the shutter remains open. On some models, it also sets the mode of automatic exposure operation. In some locations, it is called a thumbwheel or jog dial.
- P. **Shutter release.** A button that activates the exposure sequence in which the aperture adjusts, the mirror rises, the shutter opens, light strikes the recording surface, and the shutter closes.
- Q. Hot shoe. A bracket that attaches a flash unit to the camera and provides an electrical linking that synchronizes camera and flash.
- R. Mode dial. Sets a manual or one of several automatic exposure modes. On film cameras, a crank to rewind an exposed roll of film may be located here. Most new film cameras rewind automatically.
- 5. **Cable connections.** Plug in cables that, for example, connect external power or a computer, or control the camera remotely.
- T. **Memory card.** Stores image files. May be erased and reused; capacity varies. Can be removed to facilitate transferring files to a computer or other storage device.

A simplified look inside a digital single-lens reflex camera or DSLR (designs vary in different models). The camera takes its name from its single lens (another kind of reflex film camera has two lenses) and from its reflection of light upward for viewing the image.

Shutter Speed AFFECTS LIGHT AND MOTION

Light and the shutter speed. To make a correct exposure, so that your picture is neither too light nor too dark, you need to control the amount of light that reaches the digital image sensor (or film). The shutter speed (the amount of time the shutter remains open) is one of two controls your camera has over the amount of light. The aperture size (page 22) is the other. In automatic operation, the camera sets the shutter speed, aperture, or both. In manual operation, you choose both settings. The shutter-speed dial (a push button on some cameras) sets the shutter so that it opens for a given fraction of a second after the shutter release has been pressed. The B (or bulb) setting keeps the shutter open as long as the shutter release is held down.

Motion and the shutter speed. In addition to controlling the amount of light that enters the camera, the shutter speed also affects the way that moving objects are shown. A fast shutter speed can freeze motion-1/250 sec. is more than fast enough for most scenes. A very slow shutter speed will record even a slow-moving object with some blur. The important factor is how much the image

actually moves across the recording surface. The more of that surface it crosses while the shutter is open, the more the image will be blurred, so the shutter speed needed to freeze motion depends in part on the direction in which the subject is moving in relation to the camera (see opposite page).

The lens focal length and the distance of the subject from the camera also affect the size of the image on the sensor (or film) and thus how much it will blur. A subject will be enlarged if it is photographed with a long-focal-length lens or if it is close to the camera; it has to move only a little before its image crosses enough of the recording surface to be blurred.

Obviously, the speed of the motion is also important: all other things being equal, a darting swallow needs a faster shutter speed than does a hovering hawk. Even a fast-moving subject, however, may have a peak in its movement, when the motion slows just before it reverses. A gymnast at the height of a jump, for instance, or a motorcycle negotiating a sharp curve is moving slower than at other times and so can be sharply photographed at a relatively slow shutter speed.

See the project on motion, page 161.

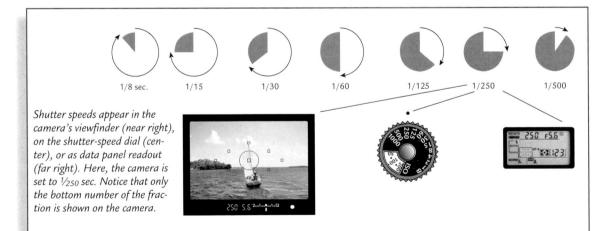

Shutter-speed settings are in seconds or fractions of a second: 1 sec., 1/2 sec., 1/4, 1/8, 1/15, 1/30, 1/60, 1/125, 1/250, 1/500, 1/1000, and sometimes 1/2000, 1/4000, and 1/8000. Each setting lets in twice as much light as the next faster setting, half as much as the next slower setting: 1/250 sec. lets in twice as much light as 1/500 sec., half as much as 1/125 sec. With many cameras, especially in automatic operation, shutter speeds are "stepless;" the camera can set the shutter to 1/225 sec., 1/200 sec., or whatever speed it calculates will produce a correct exposure.

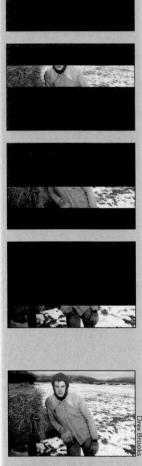

A focal-plane shutter consists of a pair of curtains usually located in the camera body just in front of the sensor. During exposure, the curtains open to form a slit that moves across the lightsensitive surface.

The size of the slit is adjustable: the wider the slit, the longer the exposure time and the more light that reaches the sensor or film. Focal-plane shutters are found in most single-lens reflex cameras and some rangefinder cameras.

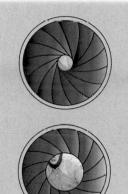

1/30 sec.

Slow shutter speed, subject blurred. The direction a subject is moving in relation to the camera can affect the sharpness of the picture. At a slow shutter speed, a driver moving from right to left is not sharp.

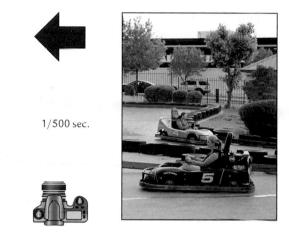

Fast shutter speed, subject sharp. Photographed at a faster shutter speed, the same driver moving in the same direction Is sharp. During the shorter exposure, her image did not cross enough of the recording surface to blur.

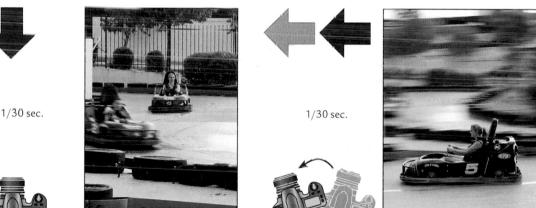

Slow shutter speed, subject sharp. Here the driver is sharp even though photographed at the slow shutter speed that recorded blur in the first picture (top left). She was moving directly toward the camera, so her image did not cross enough of the recording surface to blur. The other go-kart, turning to move across the frame, becomes blurred.

Blurring to show motion. Freezing motion is one way of representing it, but it is not the only way. In fact, freezing motion sometimes eliminates the feeling of movement altogether so that the subject seems to be at rest. Allowing the subject to blur can be a graphic means of showing that it is moving.

Panning with the vehicle is another way to keep it and the driver relatively sharp. During the exposure, the photographer moved the camera in the same direction that the go-kart was moving (a horizontal sweep from right to left). Notice the streaky look of the background, characteristic of a panned shot.

Panning to show motion. Panning the cameramoving it in the same direction as the subject's movement during the exposure-is another way of showing motion (bottom right). The background will be blurred, but the subject will be sharper than it would be if the camera were held steady.

A leaf shutter is usually built into the lens instead of the camera body. The shutter consists of overlapping leaves that open during the exposure, then close again.

The longer the shutter stays open, the more light that reaches the light-sensitive surface. Leaf shutters are found on most compact, point-and-shoot, rangefinder, and twin-lens reflex cameras, view-camera lenses, and some medium-format single-lens reflex cameras.

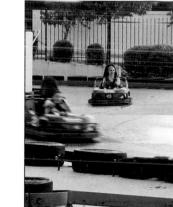

19

Shutter Speed USE IT CREATIVELY

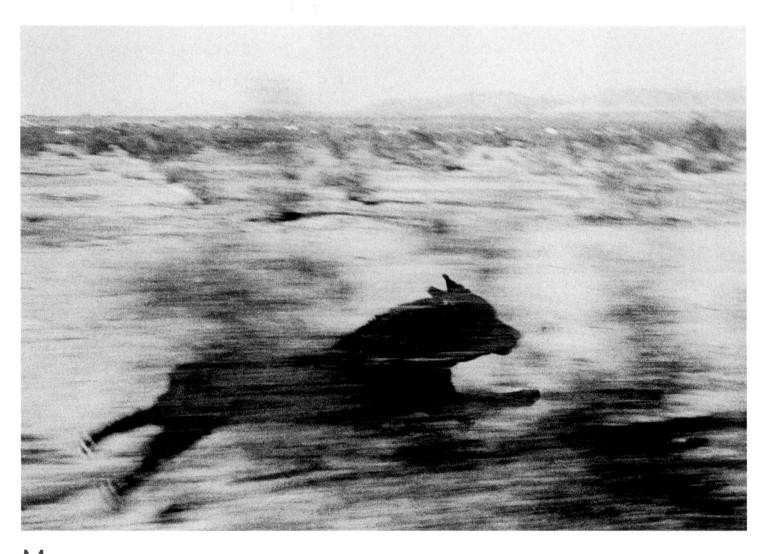

Make a decision about shutter speed for every shot; don't simply inherit one from your previous exposure or let the camera choose for you. Experiment with arresting motion, like the photographs on the opposite page, and with the possibilities of blur. Try making a long exposure of a moving subject with a motionless camera, as shown on page 160, and by panning, as above. Every photograph you decide to make can capture multiple variations of movement, and each can still be a correct exposure. John Divola. D07F12, from the series Dogs Chasing My Car in the Desert, Morongo Valley, California, 1997. Creating blur can effectively suggest motion and can often be a better choice than freezing a moving subject. Panning (page 19) is most often accomplished by sweeping the camera across the field of view from a fixed vantage point. Divola held his camera out the window of his moving car; the dog cooperated by matching the speed of the vehicle.

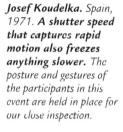

Naoya Hatakeyama. Blast #5416, 1998. The shutter arrests action but it doesn't protect the photographer. For his own safety, making this series of pictures of explosions at a quarry, Hatakeyama used a remote control to trigger the 1/1000-sec. exposures. He relied on advice from the blasting engineer, who understood the "nature" of the rock, to locate his camera to capture the "nature" of violence without damage.

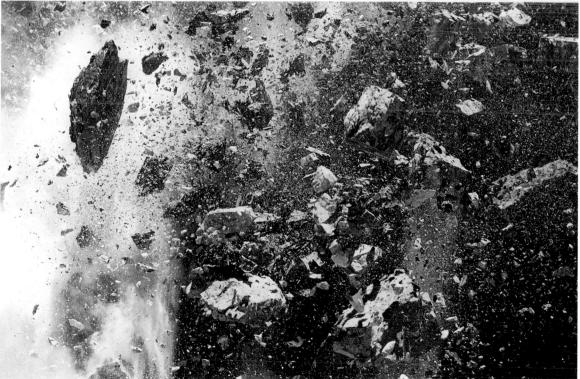

21

Aperture AFFECTS LIGHT AND DEPTH OF FIELD

Light and the aperture. The aperture, or lens opening, is the other control that you can use in addition to shutter speed to adjust the amount of light that reaches the digital image sensor or film. Turning a ring on the outside of the lens (pushing a button on some cameras) changes the size of the *diaphragm*, a ring of overlapping metal leaves inside the lens. (In automatic operation, the camera can do this for you.) Like the iris of your eye, the diaphragm can get larger (open up) to let more light in; it can get smaller (stop down) to decrease the amount of light.

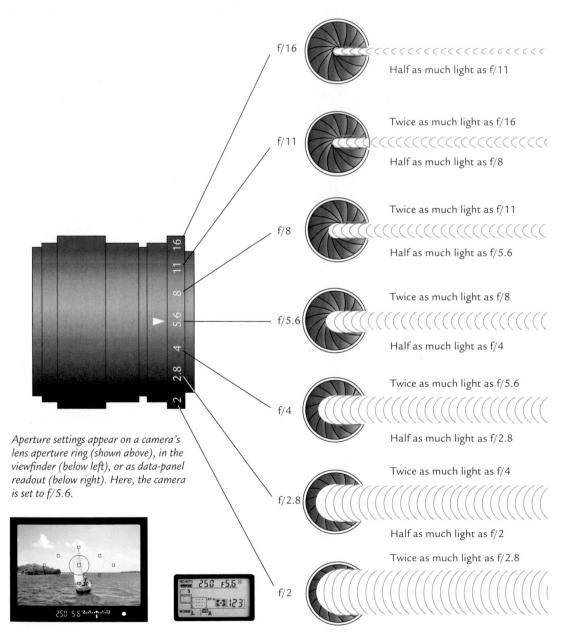

Light and the aperture.

The size of the lens opening-the aperture, or f-stop—controls the amount of light that passes through the lens. Each aperture is one "stop" from the next; that is, each lets in twice as much light as the next smaller opening, half as much light as the next larger opening. Notice that the lower the f-stop number, the wider the lens opening and the more light that is let in. For example, f/8 is a wider opening and lets in more light than f/11, which lets in more light than does f/16, and so on.

Aperture settings (f-stops). Aperture settings, from larger lens openings to smaller ones, are f/1, f/1.4, f/2, f/2.8, f/4, f/5.6, f/8, f/11, f/16, f/22, and f/32. Settings beyond f/32 are usually found only on some view-camera lenses.

The lower the f-stop number, the wider the lens opening; each setting lets in twice as much light as the next f-stop number up the scale, half as much light as the next number down the scale. For example, f/11 lets in double the light of f/16, half as much as f/8. Larger openings have smaller numbers because the f/ number is a ratio: the lens focal length divided by the diameter of the lens opening.

Referring to a stop (without the "f") is a shorthand way of stating this half-or-double relationship. You can give one stop more (twice as much) exposure by setting the aperture to its next wider opening, one stop less (half as much) exposure by *stopping* (closing) down the aperture to its next smaller opening.

No lens has the entire range of f-stops; most have about seven. A 50mm lens may range from f/2 at its widest opening to f/16 at its smallest, a 200mm lens may range from f/4 to f/22. Most lenses can set intermediate f-stops partway between the whole stops, often in one-third-stop increments. The widest lens setting may be an intermediate stop, for example, f/1.8.

Depth of field and the aperture. The size of the aperture setting also affects how much of the image will be sharp. This is known as the depth of field. As the aperture opening gets smaller, the depth of field increases and more of the scene from near to far appears sharp in the photograph (see photos below and pages 42 and 45). See the depth of field project on page 159.

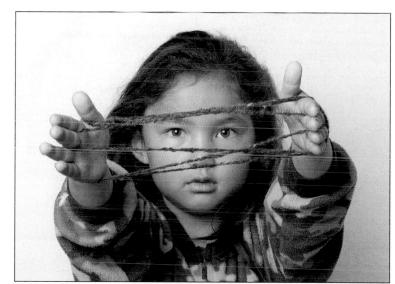

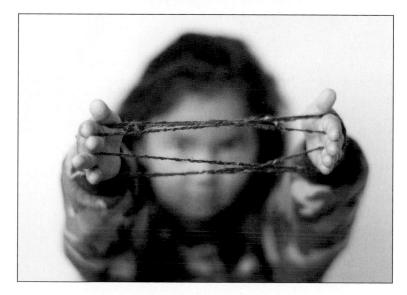

Small Aperture More Depth of Field

Depth of field and the aperture. The smaller the aperture opening, the greater the depth of field At f/16 (left, top), with the hands and string in the foreground crisply in focus, the face in the background is also sharp. At a much larger aperture, f/1.4 (left, bottom), there is very little depth of field. The face in the background is completely out of focus.

Large Aperture Less Depth of Field

Aperture USE IT CREATIVELY

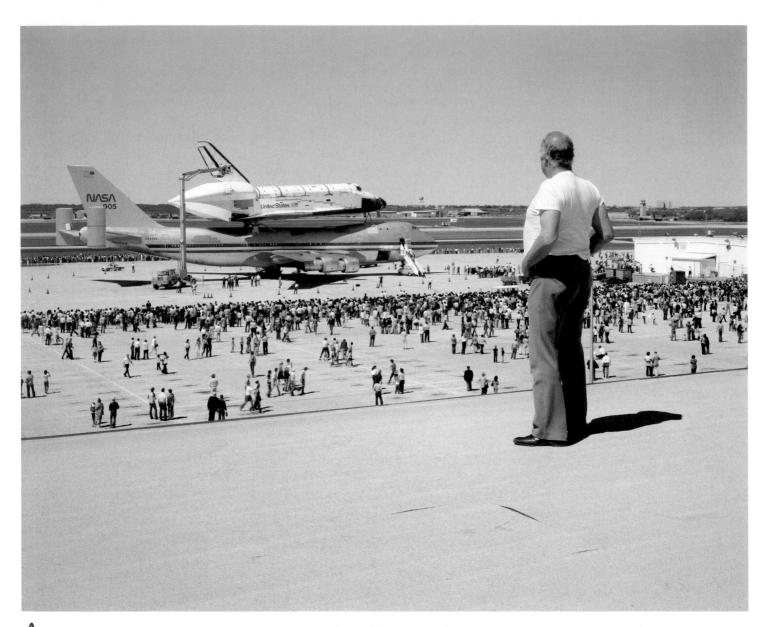

A choice about aperture is a choice about focus, one of the most important decisions you can make about a picture. For all the similarities, a camera doesn't really see the way your eye does. A picture freezes focus; sharp parts stay sharp, blur and softness remain no matter how much we stare at a photograph. Our vision, though, is fluid. Our eyes dart around a scene so we can perceive it as a whole, and they are constantly—and involuntarily—refocusing. Knowing the difference between human vision and photographic vision can be a powerful tool, as these examples show. Joel Sternfeld. The Space Shuttle Columbia Lands at Kelly Air Force Base, San Antonio, Texas, March 1979. A small aperture gives great depth of field that can make all parts of an image equally sharp. This can seem, as here, to flatten three dimensions into two. Sternfeld uses that flatness for a playful ambiguity. The foreground spectator appears to be inspecting a wall-sized photograph or watching a giant television.

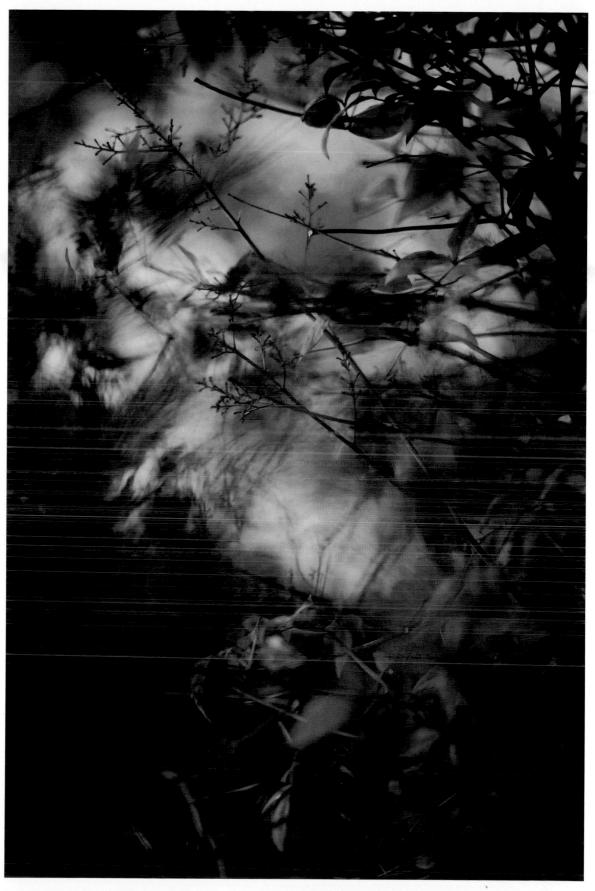

Terri Weifenbach. Untitled, 2014. A large aperture creates a narrow band of focus that can slice through the middle of a scene, leaving objects blurry both in front and behind. This

image—of an evergreen that produces red winter berries—was the "sign-off" at the end of a long visual conversation carried out via email between Weifenbach in the US and another artist in Japan.

Shutter Speed and Aperture BLUR VS. DEPTH OF FIELD

Controlling the exposure. Both shutter speed and aperture affect the amount of light reaching the camera's light-sensitive recording surface. To get a correctly exposed picture, one that is neither too light nor too dark, you need to find a combination of shutter speed and aperture that will let in the right amount of light for a particular scene and ISO setting. (Pages 60–73 explain how to do this.)

Equivalent exposures. Once you know a correct combination of shutter speed and aperture, you can change one setting and still keep the exposure the same as long as you change the other setting the same amount in the opposite direction. If you want to use a smaller aperture (which lets in less light), you can keep the exposure the same by using a slower shutter speed (which lets in more light), and vice versa.

A stop of exposure change. Each full f-stop setting of the aperture lets in half (or double) the amount of light as the next full setting, a one-stop difference. Each shutter-speed setting does the same. The term stop is used whether the aperture or shutter speed is changed. The exposure stays constant if, for example, a move to the

next faster shutter speed (one stop less exposure) is matched by a move to the next larger aperture (one stop more exposure).

Which combination do you choose? Any of several combinations of shutter speed and aperture could make a good exposure, but the effect on the appearance of the image will be different. Shutter speed affects the sharpness of moving objects; aperture size affects depth of field (the sharpness of a scene from near to far). Shutter speed also helps prevent blur caused by camera motion during the exposure. If you are holding the camera in your hands, you need a faster shutter speed than if you have the camera on a tripod (see page 28 for details).

You can decide for each picture whether stopped motion or depth of field is more important. More depth of field and near-to-far sharpness with a smaller aperture means you would be using a slower shutter speed and so risking that motion would blur. Using a faster shutter speed to freeze motion means you would be using a larger aperture, with less of the scene sharp near to far. Depending on the situation, you may have to compromise on a moderate amount of depth of field with some possibility of blur. Cameras set shutter speeds between whole stops. Older shutters only had full stops, each double the amount of time of the shutter speed before it or half that of the one after it. Today's shutters set shutter speeds in increments of one-half or onethird stops. This chart shows, in gray, those fractional stops.

Some cameras allow you to choose among different ways to set shutter speeds (and apertures), use full stops while learning.

these are	mera displays; e fractions, lay is 1/8 sec.
1/3 STOP	1/2 STOP
1	1
1.3	1.5
1.6	
2	2 3
2.5	3
3	
4	4
5	6
6	
8	8
10	11
13	
15	15
20	20
25	
30	30
40	45
50	
60	60
80	90
100	
125	125
160	180
200	
250	250
320	350
400	
500	500

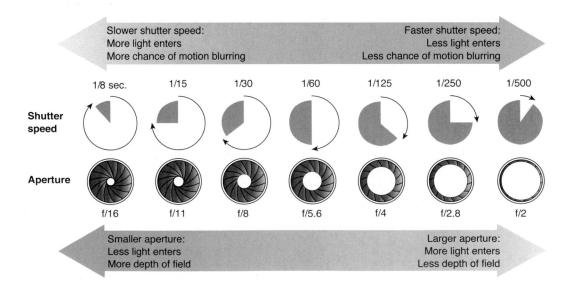

Shutter speed and aperture combina-

tions. Both the shutter speed and the aperture size control the amount of light. Each setting lets in half (or double) the amount of light as the adjacent setting—a one-stop difference.

If you decrease the amount of light one stop by moving to the next smaller aperture setting, you can keep the exposure constant by also moving to the next slower shutter speed. In automatic operation, the camera makes these changes for you.

Each combination of aperture and shutter speed shown at left lets in the same amount of light, but see the photographs on the opposite page: the combinations change the sharpness of the picture in different ways. **Fast shutter speed** ($1/_{500}$ sec.): the moving swing is sharp. **Wide aperture** (f/2): the trees, picnic table, and person in the background are out of focus. Only objects the same distance as the foreground posts, on which the lens was focused, are sharp.

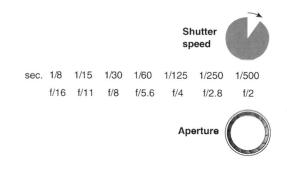

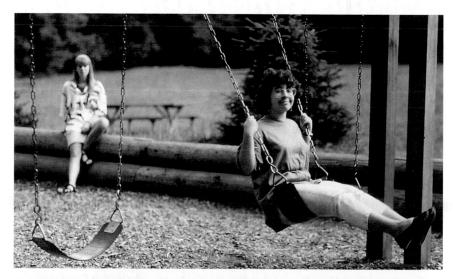

Medium-fast shutter speed ($\frac{1}{60}$ sec.): the moving swing shows some blur. **Medium-wide aperture** ($\frac{f}{5.6}$): the background is still a little fuzzy but the middle ground appears in focus.

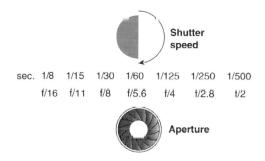

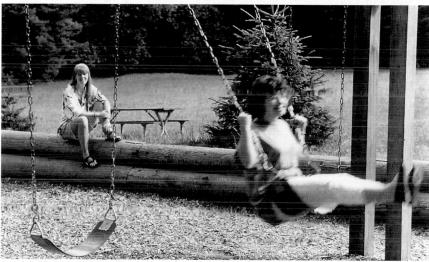

Slow shutter speed (V_8 sec.): the moving swing is completely blurred. **Small aperture** (f/16): the middle- and background are completely sharp.

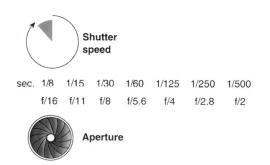

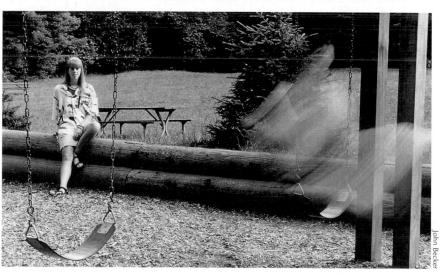

Shutter speed and aperture combinations. Each of the exposure combinations for this scene lets in the same total amount of light, so the overall exposure stays the same. But the motion of the swing is blurred with a slow shutter speed, sharp with a fast shutter speed. The depth of field (overall sharpness of near-to-far objects) is shallow with a larger aperture, extends farther with a small aperture.

27

Getting the Most from Your Camera and Lens

Camera motion causes blur. Though some photographers claim to be able to hand hold a camera steady at slow shutter speeds—1/15 sec. or even slower—it takes only a slight amount of camera motion during exposure to cause a noticeable blur in an image. If a sharp picture is your aim, using a fast shutter speed or supporting the camera on a tripod is a much surer way to produce a sharp image.

When hand holding the camera (see right, top and center), use the focal length of your lens as a guide to how fast your shutter speed should be. The longer the focal length, the faster the shutter speed must be, because a long lens magnifies any motion of the lens during the exposure just as it magnifies the size of the objects photographed.

As a general rule, the slowest shutter speed that is safe to hand hold is matched to the focal length of the lens. That is, a 50mm lens should be hand held at a shutter speed of $\frac{1}{50}$ sec. or faster, a 100mm lens at $\frac{1}{100}$ sec. or faster, and so on. This doesn't mean that the camera can be freely moved during the exposure. At these speeds, the camera can be hand held, but with care. At the moment of exposure, hold your breath and squeeze the shutter release smoothly.

The camera itself can affect your ability to hand hold it; some cameras vibrate more than others during exposure. A single-lens reflex camera, with its moving mirror, for example, vibrates more than a rangefinder or compact camera. Some lenses and camera bodies have electronic stabilization systems that help you take sharp photographs at longer exposures.

A tripod and cable release (shown right, bottom) will keep the camera absolutely still during an exposure. The tripod supports the camera steadily; the cable release lets you trigger the shutter without having to touch the camera directly. A tripod and cable release are useful when you need a slower shutter speed than is feasible for hand holding; for example, at dusk when the light is dim. They also help when you want to compose a picture carefully or do close-up work. They are always used for copy work, such as photographing a painting, another photograph, or something from a book, because hand holding at even a fast shutter speed will not produce critical sharpness for fine details. A view camera is always used on a tripod.

The job of a cable release, to trigger the shutter without transmitting movement, may also be accomplished at a distance with a variety of remote wireless triggers that use radio or infrared signals.

To protect a camera in use, use a neck strap, either worn around your neck or wound around your wrist. It keeps the camera handy and makes you less likely to drop it. Lenses can be kept in lens cases or plastic bags to protect them from dust, with lens caps both back and front for additional protection of lens surfaces.

A padded bag, case, or backpack will protect your equipment from bumps and jolts when it is carried or moved, a camera bag makes your accessories and extra film readily available. Aluminum or molded plastic cases with fitted foam compartments provide the best protection; some are even waterproof. Their disadvantage is that they are bulky, not conveniently carried on a shoulder strap, and the camera may not be rapidly accessible.

Battery power is essential to the functioning of most cameras. If your viewfinder display or other data display begins to act erratically, the batteries may be getting weak. Many cameras have a battery check that will let you test battery strength or an indicator that warns of low power. It's a good idea to check batteries before beginning a day's shooting or a vacation outing and to carry spares in your camera bag. If you don't have spares and the batteries fail, try cleaning the ends of the batteries and the battery contacts in the camera with a pencil eraser or cloth; the problem may just be poor electrical contact. Warming the batteries in the palm of your hand might also bring them back to life temporarily.

To hand hold a camera, keep feet apart, rest the camera lightly against your face. Hold your breath as you squeeze the shutter release slowly.

With the camera in a vertical position, the left hand holds and focuses the lens; the right hand releases the shutter.

A tripod and cable release are essential if you want a sharp image at slow shutter speeds. Keep some slack in the cable release so it doesn't tug the camera.

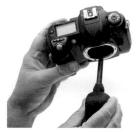

Clean the sensor and inside the camera very carefully. When you blow air inside the camera, tip the camera so the dust falls out and isn't pushed into the mechanism. Don't touch anything, even with a brush, unless ubsolutely necessary.

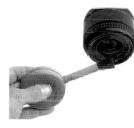

Clean the lens. First, blow then brush any visible dust off the lens surface. Hold the lens upside down to let the dust fall off the surface instead of just circulating on it.

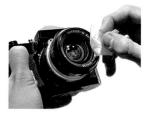

Use lens cleaning fluid. Dampen a wadded piece of lens-cleaning tissue with the fluid and gently wipe the lens with a circular motion. Don't put lens fluid directly on the lens because it can run to the edge and soak into the barrel. Finish with a gentle, circular wipe using a dry lens tissue.

Cameras and memory cards in transit should be protected from strong magnetic fields, shock, excessive heat, and sudden temperature changes. Avoid leaving equipment in a car on a sunny day. Excessive heat can soften the oil lubricant in the camera, causing the oil to run out and create problems, such as jamming lens diaphragm blades. At very low temperatures, moving mechanisms, both oil-lubricated and dry, as well as camera, flash, and meter batteries may be sluggish, so on a cold day it is a good idea to keep the camera warm by carrying it under your coat until you're ready to take a picture. When you bring a camera in from the cold, let it warm up before removing the lens cap to keep condensation off the lens. On the beach, protection from salt spray and sand is vital.

If a camera will not be used for a while, turn off any on/off switches, and store the camera away from excessive heat, humidity, and dust For long-term storage, remove batteries because they can corrode and leak. Return the batteries temporarily and operate the shutter occasionally because it can become balky if not used.

Protect your camera from dust and dirt. Replace memory cards and change lenses in a dustfree place if you possibly can. You should blow occasional dust off the focusing mirror or screen, but it's wise to let a competent camera technician do any work beyond this.

Dust and specks that appear in your viewfinder are usually outside the optical path and will likely not appear in your photographs. However, any dust or dirt on a digital sensor (actually, on the built-in glass filter that covers it) will appear on each picture. Some cameras have a built-in mechanism to shake the sensor clean but when you see unwanted marks in the same location on all your pictures, consider cleaning the sensor.

Digital SLRs have a menu command for sensor cleaning, which locks the mirror up so you can access the sensor by removing the lens. It also cuts the sensor power to reduce static charge. **Touching the sensor can be risky;** scratches are permanent. Start by trying to blow off unwanted dust gently. A rubber squeeze bulb is safer than a can of compressed gas that may produce enough force to damage components. A squeeze bulb that blows ionized air will do a better job of removing dust held by an electrostatic charge.

If your camera's sensor needs a more thorough cleaning, special brushes, pads, or swabs are available. But touching the sensor may make permanent marks, and voids a camera's warranty; you may want to have your sensor cleaned professionally.

Any lens surface must be clean for best performance, but keeping dirt off in the first place is much better than frequent cleaning, which can damage the delicate lens coating. Avoid touching the lens surface with your fingers because they leave oily prints that etch into the coating. Keep a lens cap on the front of the lens when it is not in use and one on the back of the lens when it is removed from the camera. Clean back caps thoroughly before using them; dust on the cap will often find its way to your sensor.

During use, a lens hood helps protect the lens surface in addition to shielding the lens from stray light that may degrade the image. A UV (ultraviolet) or 1A filter will have very little effect on the image; some photographers leave one on the lens all the time for protection against dirt and accidental damage.

To clean the lens you will need a rubber squeeze bulb or a can of compressed gas, a soft brush, lens tissue, and lens cleaning fluid. Use a squeeze bulb or compressed gas to remove dust, lens cleaning fluid and tissue if you have fingerprints or smears. Cans of compressed gas may spray propellant if tilted; keep them vertical for use. Avoid using cleaning products made for eyeglasses, particularly any treated cloths; they are too harsh for lens surfaces. A clean cotton cloth or paper tissue is usable in an emergency, but lens tissue or an untreated microfiber cloth will be much better.

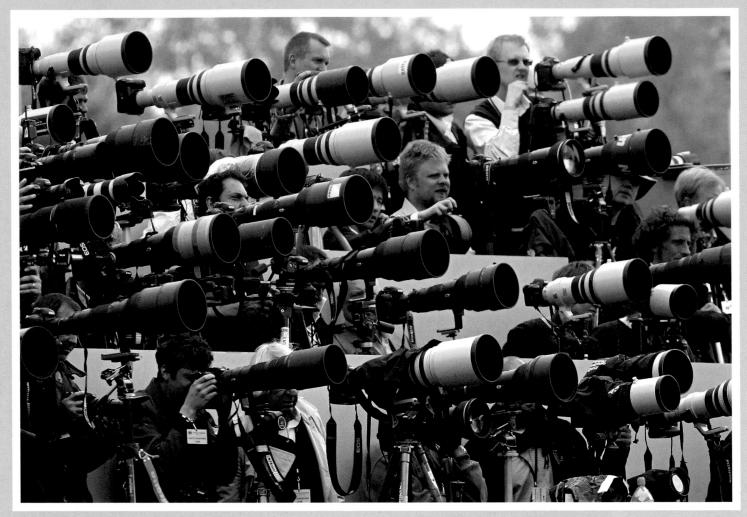

GEOFFREY ROBINSON Press photographers outside Buckingham Palace on the royal wedding day of Prince William and Kate Middleton, London, 2011. Working photographers are often constrained to a prearranged location at major events. Robinson shows us why it can be difficult to report the news from an unusual vantage point.

Lens Focal Length The basic difference between lenses	
Normal Focal Length The most like human vision	
Long Focal Length	
Short Focal Length Wide-angle lenses	
Zoom, Macro, and Fisheye Lenses	40
Focus and Depth of Field	42

Automatic Focus43
Depth of Field
Controlling sharpness in a photograph44
More about Depth of Field 46
<i>How to preview it</i>
Perspective
shows depth
Lens Attachments50
Close-ups and filters 50

Lens 🔘 2

In this chapter you'll learn...

- the focal length of a lens is the most important difference between lenses, the longer the focal length, the larger a subject appears.
- that a viewer almost always looks at the sharpest part of a photograph first, and you can control your photograph's sharpness in several ways.
- perspective is the impression of depth in a twodimensional image; we gauge it by the relative sizes of objects, determined by your lens and its distance from your subject.

On the lens barrel (as shown below) are controls such as a ring that focuses the lens. Cameras and lenses vary in design, so check the features of your own camera. For example, many cameras have push-button or dial controls on the camera body instead of an aperture control ring on the lens. Markings on the lens (shown below, right) always include its focal length and maximum aperture (or a range for each if it is a zoom), usually along with a serial number and the maker's name.

Focusing ring

different parts of the

scene into focus.

Depth-of-field scale

shows how much of the scene will be sharp at a given aperture (explained on page 46).

Aperture-control ring selects the f-stop or size of the lens opening. Distance marker indicates on the distance scale the distance in feet and meters on which the lens is focused. orming an image. Although a good lens is essential for making crisp, sharp photographs, you don't actually need one to take pictures. A primitive camera can be constructed from little more than a shoe box with a tiny pinhole at one end and a digital sensor, a piece of film, or a sheet of light-sensitive photographic paper at the other. A pinhole won't make as clear a picture as a glass lens, but it does form an image of objects in front of it.

A simple lens, such as a magnifying glass, will form an image that is brighter and sharper than an image formed by a pinhole. But a simple lens has many optical defects (called *aberrations*) that prevent it from forming an image that is sharp and accurate. A modern compound lens subdues these aberrations by combining several simple lens elements made of different kinds of glass and ground to different thicknesses and curvatures so that they cancel out each other's aberrations.

The main function of a lens is to project a sharp, undistorted image onto the light-sensitive surface. Lenses vary in design, and different types perform some jobs better than others. Two major differences in lens characteristics are focal length and speed.

Lens focal length is, for a photographer, the most important characteristic of a lens. One of the primary advantages of a single-lens reflex camera or a view camera is the interchangeability of its lenses; many photographers own more than one lens so they can change lens focal length. More about focal length appears on the following pages.

Lens speed is not the same as shutter speed. More correctly called *maximum aperture*, it is the widest aperture to which the lens diaphragm can be opened. A lens that is "faster" than another opens to a wider aperture and admits more light; it can be used in dimmer light or with a faster shutter speed.

Focal length. The shorter the focal length, the wider the view of a scene. The longer the focal length, the narrower the view and the more the subject is magnified.

Manufacturer

Maximum aperture. The lens's widest opening or speed. Appears as a ratio, here 1:2. The maximum aperture is the last part of the ratio, f/2.

Filter size. The diameter in mm of the lens, and so the size of filter needed when one is added onto the lens.

Lens Focal Length The basic difference between lenses

Photographers describe lenses in terms of their focal length; generally they refer to a normal, long, or short lens, a 50mm lens, a 24–105mm zoom lens, and so on. Focal length affects the image formed on the sensor or film in two important and related ways: the amount of the scene shown (the *angle of view*) and thus the size of objects (their magnification). A lens with a single, or fixed, focal length is called a *prime* lens; a variable or adjustable focal-length lens is called a *zoom* lens.

How focal length affects an image. The shorter the focal length of a lens, the more of a scene the lens takes in and the smaller it makes each object in the scene appear in the image. You can demonstrate this by looking through a circle formed by your thumb and forefinger. The shorter the distance between your hand (the lens) and your eye (the digital sensor or film), the more of the scene you will see (the wider the angle of view). The more objects that are shown on the same size sensor (or negative), the smaller all of them will have to be (the less magnification). Similarly, you could fill a sensor either with an image of one person's head or with a group of twenty people. In the group portrait, each person's head must be smaller.

The size of the recording surface affects the angle of view. With the same lens, a smaller sensor will capture less of a scene. Some digital

sensors are the same size as a frame of 35mm film (24×36 mm); these are called *full-frame* sensors and are usually found on relatively expensive cameras marketed to professionals. With cameras that use other, usually smaller, size sensors, lens focal lengths are often given in terms of a 35mm equivalent. A camera with an APS-C sensor (about 15×22 mm) using a 31mm lens has the same angle of view as a full-frame camera with a 50mm lens (see the opposite page). Focal lengths in this book are given as 35mm equivalents. A camera with an APS-C sensor is also said to have a *crop factor* of 1.6. Multiplying its lens focal length by 1.6 will give the 35mm equivalent.

Interchangeable lenses are convenient. The amount of a scene shown and the size of objects can be changed by moving the camera closer to or farther from the subject, but the option of changing lens focal length gives you more flexibility and control. Sometimes you can't easily get closer to your subject—for example, standing on shore photographing a boat on a lake. Sometimes you can't get far enough away, as when you are photographing a large group of people in a small room.

With a camera that accepts different lenses, such as a single-lens reflex camera, you can remove one lens and put on another when you want to change focal length. Interchangeable lenses range from super-wide-angle fisheye lenses to extra-long telephotos.

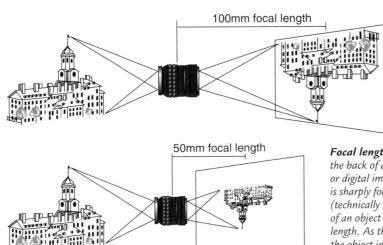

Focal length is measured from an optical point near the back of a lens to the image it forms on the film or digital image sensor. It is measured when the lens is sharply focused on an object in the far distance (technically known as infinity). Magnification, the size of an object in an image, is directly related to focal length. As the focal length increases, the image size of the object increases. A 100mm lens produces an image twice as large as one produced by a 50mm lens.

Project: LENS FOCAL LENGTH

YOU WILL NEED

A camera either with a zoom lens or with lenses of two different focal lengths. The greater the difference in focal lengths, the easier it will be to see the difference between them. If you can, use a short-focallength lens (35mm or shorter) and a long lens (85mm or longer).

PROCEDURE

Put the shorter lens on the camera or adjust the zoom lens to its shortest focal length (its widest view). Make a head-to-toe photograph of a friend. Note the distance you have to stand from your subject to have his or her feet just touch the bottom edge of the viewfinder frame while the top of the head grazes its upper edge.

Do the same with the longer lens or with the zoom lens adjusted to its longest focal length (its narrowest view). Make a similar pair of views of a house or a chair, fitting your subject exactly into the image frame.

HOW DID YOU DO?

Compare the pairs of views. How did the distances you had to be from your subject with the short lens compare to those needed with the long lens? How do the backgrounds in the pairs of views differ? Did the impression of depth in the photographs change when you switched from the short to the long lens? What else changed?

24mm focal length (APS-C: 15mm) 84° angle of view

50mm \ focal length (APS-C: 31mm) 47° angle of view

100mm focal length (APS+C: 62mm) 24° angle of view

200mm focal length (APS-C: 125mm)

12° angle of view

500mm focal length (APS-C: 310mm) 5° angle of view

1000mm focal length (APS-C: 625mm)

2.5° angle of view

What happens when you change lens focal length? If everything else stays the same, changing the focal length of the lens changes both the amount of a scene included in the image (angle of view) and the size of objects (magnification). To make this sequence, the photographer changed only the focal length of the lenses; the distance from lens to subject remained the same. As the focal length increases (for example, from 24mm to 50mm), the angle of view narrows and the size of objects increases.

These illustrations are accurate for comparing angles of view on a full-frame digital or 35mm film camera or when using "35mm equivalent" focal lengths. Focal lengths that match the angle of view on an APS-C camera are shown in parentheses.

Normal Focal Length The most like human vision

A lens of normal focal length, as you might expect from the name, produces an image that seems normal when compared with human vision. The image includes about the same angle of view as the human eye sees clearly when looking straight ahead, and the relative size and spacing of near and far objects appear normal. For full-frame cameras (or a 35mm film camera), this effect is produced by a lens of about 50mm focal length. Manufacturers that supply their cameras with a prime lens usually fit a lens of that length.

The size of the light-sensitive surface used in a particular camera determines what focal length is normal for it; a normal lens has a focal length approximately equal to the diagonal of the sensor or film frame. The normal focal length for a view camera with 4×5 -inch film, for example, is 150mm. Most digital sensors are smaller than full frame so their normal lens is shorter than one for a full-frame or 35mm camera. See the size chart at the bottom of page 45.

Normal lenses have many advantages. Compared with lenses of much shorter or much longer focal length, normal lenses are generally faster; they can be designed with wider maximum apertures to admit the maximum amount of light. Therefore, they are convenient for use in dim light,

Alison Carey. Graze, 2009. A normal-focal-length lens is a useful all-purpose lens in the studio. Carey fabricates her imagined landscapes indoors on a small scale with clay and paint. Carefully controlled artificial light and a painted backdrop help mimic reality. Her normalfocal-length lens provides a comfortable working distance and opens to a wide aperture when she wants shallow depth of field. especially where action is involved, as in theater or indoor sports scenes or in low light levels outdoors. They are a good choice if the camera is to be hand held because a wide maximum aperture permits a shutter speed fast enough to prevent blur caused by camera movement during exposure. Generally, the normal lens is more compact and lighter, as well as somewhat less expensive, than lenses of much longer or much shorter focal length.

Choice of focal length is a matter of personal preference. Many photographers with full-frame cameras regularly use a lens with a focal length of 35mm rather than 50mm because they like the wider view and greater depth of field that a 35mm lens has compared to a 50mm lens. Some photographers use an 85mm lens because they prefer its narrower view, which can concentrate the image on the central objects of interest in the scene.

Henri Cartier-Bresson. Greece, 1961. A lens of normal focal length produces an image that appears similar to that of normal human vision. Cartier-Bresson made many of his best-known photographs with a 50mm lens on his 35mm Leica camera. The amount of the scene included in the image and the relative size and placement of near and far objects are what you would expect to see if you were standing next to the camera. The scene does not appear exaggerated in depth, as it might with a short-focal-length lens, nor do the objects seem compressed and too close together, as sometimes happens with a long-focal-length lens.

Long Focal Length

A prime lens of long focal length seems to bring things closer, just as a telescope does. As the focal length gets longer, less of the scene is shown (the angle of view narrows), and what is shown is enlarged (the magnification increases). This is useful when you are so far from the subject that a lens of normal focal length produces an image that is too small. Sometimes you can't get really close—at a sports event, for example. Sometimes it is better to stay at a distance, as in nature photography. An Olympic finish line, the president descending from Air Force One, and an erupting volcano are all possible subjects for which you might want a long lens.

How long is a long lens? A popular mediumlong lens for a full-frame camera is 105mm; this focal length magnifies your view significantly but not so much that the lens's usefulness is limited to special situations. A lens of 65mm has a comparably long focal length for an APS-C camera with a 1.6x crop (or *lens conversion*) factor (see page 32), so does a 300mm lens on a 4×5 view camera. The difference between a medium-long lens and an extremely long one (for example, a 500mm lens with a full-frame camera) is rather like that between a pair of binoculars and a high-power telescope. You may want a telescope occasionally, but usually binoculars will do.

A long lens provides relatively little depth of field. When you use long lenses, you'll notice that as the focal length increases, depth of field decreases so that less of the scene is in focus at any given f-stop. For example, when focused at the same distance, a 200mm lens at f/8 has less Ed Jones. Fisherman's Dragon Boat Race, Hong Kong, 2010. A long lens can seem to compress space. Forced to shoot from shore, Jones chose a 500mm lens to fill his frame with the action. The boats and oarsmen seem to be stacked on top of one another in a jumble of action and color. When do you get this effect and why? See pages 48–49 to find out.

Andreas Feininger. The Ocean Liner Queen Mary, New York City, 1946. A long lens magnifies a distant subject, letting you shoot from a distance. Feininger used a 1000mm lens to shoot across the Hudson River from the New Jersey shore, two miles away. Built as a luxury liner, the Queen Mary served through the war as a troop transport beginning in 1940, and was decommissioned shortly after this photograph was taken.

> depth of field than a 100mm lens at f/8. This can be inconvenient—for example, if you want objects to be sharp both in the foreground of a scene and in the background. But it can also work to your advantage by permitting you to minimize unimportant details or a busy background by having them out of focus.

> A medium-long lens is useful for portraits because the photographer can be relatively far from the subject and still fill the image frame. Many people feel more at ease when photographed if the camera is not too close. Also, a moderate distance between camera and subject prevents the exaggerated size of facial features closest to the camera that occurs when a lens is very close. A good working distance for a head-and-shoulders portrait is 6–8 ft. (2–2.5 m), easy to do with a medium-long lens—from 85mm to 135mm focal length.

> A long prime lens, compared with one of normal focal length, is larger, heavier, and somewhat more expensive. Its largest aperture is

relatively small; f/4 or f/5.6 is common. It must be focused carefully because with its shallow depth of field there will be a distinct difference between objects that are sharply focused and those that are not. A faster shutter speed is needed to keep the image sharp while hand holding the camera (or a tripod should be used for support) because the enlarged image magnifies the effect of even a slight movement of the lens during exposure. These disadvantages increase as the focal length increases, but so do the long lens's unique imageforming characteristics.

Photographers often call any long lens a telephoto lens, or tele, although not all long-focallength lenses are actually of telephoto design. The optics of a true telephoto make it smaller than a conventional long lens of the same focal length. A tele-extender, or teleconverter, contains an optical element that increases the effective focal length of a lens. It attaches between the lens and the camera. The optical performance, however, will not be as good as the equivalent long lens.

CHAPTER 2

Short Focal Length

WIDE-ANGLE LENSES

Lenses of short focal length are also called wide-angle or sometimes wide-field lenses, which describes their most important feature—they view a wider angle of a scene than normal. A lens of normal focal length records what you see when you look at a scene with eyes fixed in one position. A 35mm wide-angle lens records the 63° angle of view that you see if you move your eyes slightly from side to side. A 7.5mm fisheye lens records the 180° angle you see if you turn your whole head to look over your left shoulder and then over your right shoulder.

A popular short lens for a full-frame camera is 28mm. Comparable focal lengths are 55mm for a medium-format film camera with 6×7 cm format, and 90mm for a 4×5 -inch view camera. David Leventi. Opéra de Monte-Carlo, Monaco, 2009. A shorterfocal-length lens lets you show a more complete view of the scene from any viewpoint. For his book Opera, Leventi photographed the world's great opera houses—this one opened in 1879—all from the central vantage point of a solo performer. Using a wide lens he could gather, from his fixed location, nearly the entire ornate interior.

Wide-angle lenses are also popular with photojournalists, feature pho-

tographers, and others who shoot in fast-moving and sometimes crowded situations. For example, many photojournalists regularly use 35mm or 28mm as their "normal" lens instead of a 50mm lens. These medium-short lenses give a wider angle of view than does a 50mm lens, which makes it easier to include the setting in close quarters. Shorter lenses also give you more depth of field, which can let a photographer focus the lens approximately instead of having to fine-focus every shot.

Short lenses show a wide view. Short-focal-length lenses are uscful for including a wide view of an area. They are capable of great depth of field so that objects both close to the lens and far from it will be in focus, even at a relatively large aperture.

Objects up close appear larger. A short lens can produce strange perspective effects. Because it can be focused at very close range, it can make objects in the foreground large in relation to those in the background. With the lens close to the resting man's feet, they look monumental, making a photograph with an entirely different meaning than the one above.

A short lens can give great depth of field. The shorter the focal length of a lens, the more of a scene will be sharp (if the f-stop and distance from the subject remain unchanged). A 28mm lens, for example, when stopped down to f/8 can produce an image that is sharp from less than 6.5 ft. (2 m) to infinity (as far as the eye or lens can see), which often will eliminate the need for further focusing as long as the subject is within the range of distances that will be sharp.

The focal length of what's called a wide (or normal or long) lens depends on the size or format of the film or digital sensor you are using. The light-sensitive recording chip in many digital cameras is smaller than full frame and, if it is, it will capture any given angle of view with a shorterfocal-length lens.

Depth of field, on the other hand, depends on the actual focal length of the lens; if everything else stays the same, a shorter lens will always give you greater depth of field. The compact camera on page 12, left, has a fixed zoom lens (see page 40) with a focal length of 4.3–86mm. Because of the small sensor size, its 35mm equivalent is a 24 480mm zoom. Using that camera, you would get much greater depth of field for any photograph than you would using its 35mm-equivalent lens with a full-frame camera.

Wide-angle "distortion." A wide-angle lens can seem to distort an image and produce strange perspective effects. Sometimes these effects are actually caused by the lens, as with a fisheye lens (page 41 bottom). But, more often, what seems to be distortion in an image made with a wide-angle lens is caused by the photographer shooting very close to the subject.

A 28mm lens, for example, will focus as close as 1 ft. (0.3 m), and shorter lenses even closer. Any object seen from close up appears larger than an object of the same size that is at a distance. While you are at a scene, your brain knows whether you are very close to an object, and ordinarily you would not notice any visual exaggeration. In a photograph, however, you notice size comparisons immediately. Our impression of perspective is based on size relationships that depend on lensto-subject distance. See the photographs at left.

39

Zoom, Macro, and Fisheye Lenses

Other lenses can view a scene in a new way or solve certain problems with ease.

Zoom lenses are popular because they combine a range of focal lengths into one lens (see below). The glass elements of the lens can be moved in relation to each other; thus infinitely variable focal lengths are available within the limits of the zooming range. Using a 50-135mm zoom, for example, is like having a 50mm, 85mm, 105mm, and 135mm lens instantly available, plus any focal length in between. Compared to prime, or fixedfocal-length, lenses, zooms are somewhat more expensive, bulkier, and heavier, but one of them will replace two or more fixed-focal-length lenses. Zoom lenses are best used where light is ample because they have a relatively small maximum aperture. Older zoom lenses were significantly less sharp than fixed-focal-length lenses but new designs nearly match them. The "kit" lenses sold as a package with DSLRs are usually zooms. Most current zoom lenses are also autofocus.

"Digital" zoom, a feature found on some digital cameras marketed to amateurs, only crops the image, enlarging the pixels in the part of the image that's left. Quality is less than you'd get by using a longer lens or moving closer for the shot. **Macro lenses** are used for close-up photography (opposite, top). Their optical design corrects for the lens aberrations that cause problems at very short focusing distances, but they can also be used at normal distances. Their disadvantages are a slightly smaller maximum aperture, often f/2.8 for a 50mm lens, and slightly higher cost. (More about making close-up photographs on page 50.) Longer-focal-length macro lenses let you magnify an image, like the one opposite, top, without disturbing the subject.

Macro-zoom lenses combine both macro and zoom features. They focus relatively close, although usually not as close as a fixed-focallength macro lens, and give a range of focal length choices in one lens.

Fisheye lenses have a very wide angle of view—up to 180°—and they exaggerate to an extreme degree differences in size between objects that are close to the camera and those that are farther away. They actually distort the image by bending straight lines at the edges of the picture (opposite, bottom). Fisheye lenses, because of their very short focal length, also produce a great deal of depth of field: objects within inches of the lens and those in the far distance will be sharp.

A zoom lens gives you a choice of different focal lengths within the same lens. The rectangles overlaid on the picture show you some of the very different ways you could have made this photograph by zooming in to shoot at a long focal length or zooming back to shoot at a shorter one. Stanley Rowin. Acupuncture, 1995. The therapist's hands were shot with a macro lens. The background was purposefully rendered dark and featureless to avoid distracting from the subject.

Donald Miralle. Woodlake Rodeo, California, 2005. **A fisheye lens** and unusual vantage point help capture the fury of a bull breaking from the gate at the start of a bull-riding competition. The fence is bent into a curve by the lens. Objects at the edge of the fisheye's image circle are distorted more than those at the center.

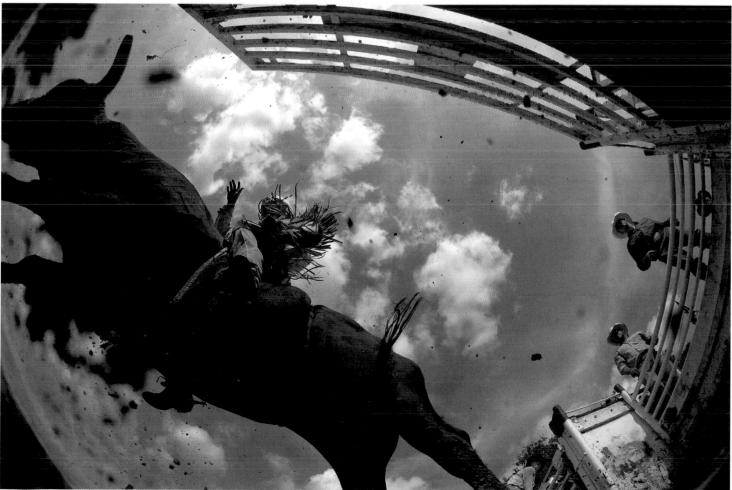

41

Focus and Depth of Field

Sharp focus attracts the eye. Sharp focus acts as a signal to pay attention to a particular part of a photograph, especially if other parts of the image are not as sharp. If part of a picture is sharp and part is out of focus, it is natural to look first at the sharply focused area (see photographs, pages 158–159). When you are photographing, it is also natural to focus the camera sharply on the most important area. You can select and, to a certain extent, control which parts of a scene will be sharp.

When you focus a camera on an object, the distance between lens and film (or digital image sensor) is adjusted, automatically with an internal motor or manually by your rotating a ring on the lens barrel, until the object appears sharp on the viewing screen. You focus manually by turning that focusing ring until the object appears sharp in your viewfinder or a mark on the lens barrel corresponding to its distance aligns with a focusing mark. If you are using an automaticfocus camera, you focus by aiming the focus indicator in your viewfinder (usually a spot in the center) at the object and partially depressing the shutter-release button. The motor in the lens moves the lens elements away from or closer to the film or sensor until that spot is in focus.

Depth of field. In theory, a lens can only focus on a flat plane at one single distance at a time and objects at all other distances will be less sharp. The distance from your lens to that plane, the *plane of critical focus*, is called the *object distance* and is usually indicated by a distance scale on the lens. In most cases, however, part of the scene will be acceptably sharp both in front of and behind the most sharply focused plane. Objects will gradually become more and more out of focus the farther they are from the most sharply focused area. This region within which objects appear acceptably sharp in the image—the depth of field—can be increased or decreased (see pages 44–45).

Depth of field is the part of a scene that appears acceptably sharp in a photograph. Depth of field can be deep, with everything sharp from near to far. In the photograph above, left, it extends from the dog's paws in the foreground to the fluted column behind him. The

photographer actually focused on the dog's eye. For another picture, above right, the photographer wanted shallow depth of field, with only some of the scene sharp. Here the only sharp part of the picture is the eye on which the lens was focused.

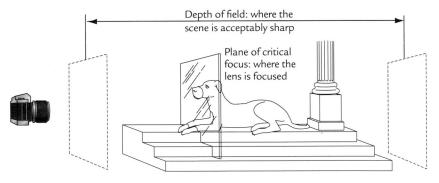

Imagine the plane of critical focus (the distance on which you focus the lens) to be something like a pane of glass stretched from one side of the scene to the other. Objects that lie along that plane will be sharp. In front of and behind the plane of critical focus lies the depth of field, the area that will appear acceptably sharp. The farther objects are from the plane of critical focus in a particular photograph, either toward the camera or away from it, the less sharp they will be. If objects are far enough from the plane of critical focus to be outside the depth of field, they will appear noticeably out of focus.

Notice that the depth of field extends about one-third in front of the plane of critical focus, two-thirds behind it. This is true at normal focusing distances, but when focusing very close to a subject, the depth of field is more evenly divided, about half in front and half behind the plane of critical focus.

Automatic Focus

Auto focus can mean out of focus when a scene has a main subject (or subjects) off to one side and at a different distance from whatever object is at the center. Most autofocus cameras will focus on the object at the center of the frame, here within the small bracketed area, over the shoulder of the subject.

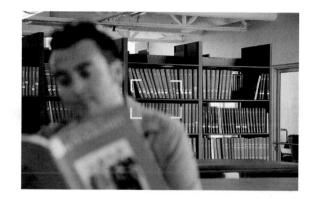

To correct this, first choose the focusing distance by placing the nutofocus brackets on the main subject and partially pressing down the shutterrelease button. Lock the focus by keeping partial pressure on the shutter release.

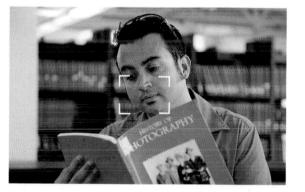

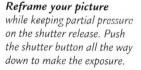

Automatic focus used to be found only on point-and-shoot snapshot cameras. But now it is standard equipment on almost all cameras. When you push down the shutter-release button part way, the camera adjusts the lens to focus sharply on what it thinks is your subject—usually whatever object is at the center of the viewing screen.

Sometimes you will want to focus the camera manually. Just as with automatic exposure, there will be times when you will want to override the automatic mechanism and focus the camera yourself. Most single-lens reflex and full-featured compact cameras with automatic focus will also let you focus manually.

The most common problem occurs when your subject is at the side of the frame, not at the center (see photos, left). A camera may also have problems focusing through glass, or if a subject has very low contrast, is in very dim light, or consists of a repetitive pattern.

Moving subjects can also cause problems. The adjustment of the autofocus mechanism can sometimes take long enough for a fast-moving subject, such as a race car, to move out of range. The lens may "hunt" back and forth, unable to focus at all or may make an exposure with the subject out of focus.

Some cameras have more sophisticated electronics to deal with these problems better. Automatic focus is more rapid, for example, when the focusing motor is located in the lens instead of the camera body. Some cameras can be set so the lens, once it is focused on a moving object, will keep it in focus for a series of exposures. Read the instructions for your camera and lens so you know how the autofocus mechanism operates.

Take a moment to evaluate each situation. Override the automatic system when it is better to do so, rather than assume that the right part of the picture will be sharp simply because you are set for automatic focus.

43

<u>Depth of Field</u> controlling sharpness in a photograph

Depth of field. Completely sharp from foreground to background, totally out of focus except for a shallow zone, or sharp to any extent in between—you get to choose how much of your image will be sharp. When you make a picture, you can manipulate three factors that affect the depth of field (the distance in a scene between the nearest and farthest points that appear sharp in a photograph). Notice in the illustrations opposite that doing so may change the image in other ways.

Aperture size. Stopping down the lens to a smaller aperture, for example, from f/2 to f/16,

increases the depth of field. As the aperture gets smaller, more of the scene will be sharp in the photograph.

Focal length. Using a shorter-focal-length lens also increases the depth of field at any given aperture. For example, more of a scene will be sharp when photographed with a 50mm lens at f/8 than with a 200mm lens at f/8.

Lens-to-subject distance. Moving farther away from the subject increases the depth of field most of all, particularly if you started out very close to the subject.

Marc PoKempner. Rev. Ike, Chicago, 1975. Shallow depth of field lets you draw immediate attention to one area; we tend to look first at the sharpest objects in a photograph. The message of preacher Reverend Ike is that God is generous and will give you exactly what you ask for, including, for example, a diamond-studded watch, ring, and cuff links, on which the photographer focused.

The smaller the aperture (with a given lens), the greater the depth of field. Using a smaller aperture for the picture on the far right increased the depth of field and made the image much sharper overall. With the smaller aperture, the amount of light entering the camera decreased, so a slower shutter speed had to be used to keep the total exposure the same.

The shorter the focal length of the lens, the greater the depth of field. Both of these photographs were taken from the same position and at the same aperture. Notice that changing to a shorter focal length for the picture on the far right not only increased the depth of field but also changed the angle of view (the amount of the scene shown) and the magnification of objects in the scene.

The farther you are from a subject, the greater the depth of field, at any given focal length and aperture. The photographer stepped back to take the picture on the far right. If you focus on an object far enough away, the lens will form a sharp image of all objects from that point out to infinity.

Small Sensor = Great Depth of Field

Digital cameras with small sensors can give you unexpected depth of field. The shorter a lens's focal length (at the same aperture and distance from the subject), the greater the depth of field. The size of a camera's sensor affects what is considered a normal-, short-, or long-focal-length lens for that camera.

A "normal" lens for a camera (see page 34) is one with a focal length about the same as the length of a diagonal line across the light-sensitive surface in the camera. A full-frame digital or 35mm film camera has a 24×36 mm light-sensitive surface: a normal lens for that camera is 50mm.

Large Aperture

Small Aperture

Short Lens

Up Close

Farther Back

The sensor in most digital cameras is smaller. A normal lens for that type of camera will be shorter than the 50mm lens that is normal for a full-frame camera, and so will have more depth of field. The compact digital camera pictured on page 12, top, for example, has a sensor of 6.2 × 4.55mm. The normal focal length is 8mm. If everything else is equal, the 8mm lens will give you much greater depth of field than the 50mm lens.

> Small sensors use an obscure naming system devised for TV camera tubes in the 1950s. Here are sensor diagonals—hence normal lens lengths—for some common sizes.

Sensor Name	Diagonal		
1/2″	8.0mm		
1/1.8″	8.9mm		
2/3″	11.0mm		
Four Thirds″	22.5mm		
1.8″ (APS-C)	28.4mm		

More about Depth of Field HOW TO PREVIEW IT

Know the extent of the depth of field when photographing a scene—how much of the scene from near to far will be sharp—to make better pictures. You may want to be sure that certain objects are sharp. Or you may want something deliberately out of focus, such as a distracting background. To control what is sharp, it is useful to have some way of gauging the depth of field.

Checking the depth of field. With a singlelens reflex camera, you view the scene through the lens. No matter what aperture setting you have selected, the lens is ordinarily wide open for viewing to make the viewfinder image as bright and easy to see as possible. However, the large aperture size means that you see the scene with depth of field at its shallowest. When you press the shutter release, the lens automatically closes down to the taking aperture. Unless you are taking a picture using the widest aperture, the viewfinder image will not have the same depth of field as the final photograph. Some single-lens reflex cameras have a previewing mechanism that lets you, if you wish, stop down the lens to view the scene at the taking aperture and see how much will be sharp.

Unfortunately, if the lens is set to a very small aperture, the stopped-down image on the viewing screen may be too dark to be seen clearly. If so, or if your camera doesn't have a preview feature, you may be able to read the near and far limits of good focus on a depth-of-field scale on the lens barrel (this page, bottom). Many newer autofocus lenses don't have them, but you can use tables showing the depth of field for different lenses at various focusing distances and f-stops. Such tables were originally printed in books, now online and portable calculators and smartphones provide the same information (see opposite page).

A rangefinder or viewfinder camera shows you the scene through a small window in the camera body through which all objects look equally sharp. Some digital cameras without a viewfinder window let you zoom in to a test shot on the monitor to judge depth of field very accurately. You can also use a depth-of-field scale on the lens

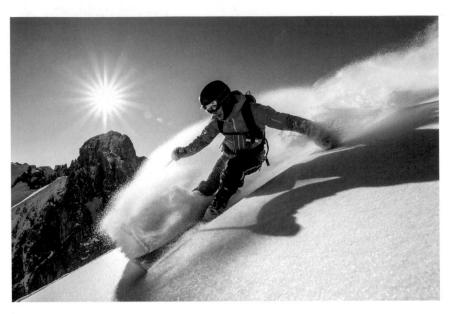

barrel, a printed table, or a calculator to estimate depth of field with these cameras as well. An electronic viewfinder can preview depth of field.

Zone focusing for action. Know the depth of field in advance when you want to preset the lens to be ready for an action shot without lastminute focusing. Zone focusing uses a table or the depth-of-field scale on the lens to preset manual focus and aperture so that the action will be photographed well within the depth of field (see below and right).

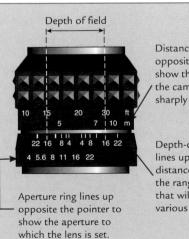

Distance scale lines up opposite the pointer to show the distance from the camera to the most sharply focused object.

Depth-of-field scale lines up opposite the distance scale to show the range of distances that will be sharp at various apertures.

Christoph Oberschneider.

Dolomites, Italy, 2015. With zone focusing you can be ready for an action shot by manually focusing in advance, if you know approximately where the action will take place. Suppose you are on a ski slope and you want to photograph a skier coming down the hill. The nearest point at which you might want to take the picture is 15 ft. (4.5 m) from the action; the farthest is 30 ft. (9 m).

Line up the distance scale so that these two distances are opposite a pair of f-stop indicators on the depth-of-field scale (with the lens shown at left, the two distances fall opposite the f/16 indicators). Now, if vour aberture is set to f/16. everything from 15ft. to 30 ft. (4.5-9 m) will be within the depth of field and in focus. It doesn't matter exactly where the subject is when you shoot, as long as it is somewhere within these distances. Prefocus an autofocus lens by aiming at a spot the same distance the action will be and holding the shutter button down halfway until you frame and press it the rest of the way.

Ansel Adams. Tetons and the Snake River, Wyoming, 1942. The smaller the aperture the greater the depth of field. Everything in the picture at right is sharp. Adams usually used a view camera (page 11), which offers additional control over focus, and he preferred its large-format film for making prints of greater clarity.

View cameras are always used on a tripod. Even if you are using a small camera, a tripod is a good idea to avoid motion hlur when the aperture is small and the shutter speed is correspondingly slow.

> **Focusing for the greatest depth of field.** When you are shooting a scene that includes important objects at a distance as well as close up, you will want maximum depth of field. Shown in the box at right is a way of setting the lens to permit as much as possible of the scene to be sharp. It is easy if you have a lens that has a depth-of-field scale. If not, you can look up the depth of field in a printed table or by using a depth of field application (see below).

Depth-of-field tables list, for each lens focal length, focusing distance, and aperture, the near and far limits of good focus and the hyperfocal distance (see the box at right). At one time only available as a lengthy book, a full set of depthof-field tables can now be downloaded as an app (a software program) for your smartphone. You can have complete focus information handy wherever you are. At left is Simple D-o-F Calculator on an iPhone.

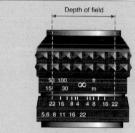

When the lens is focused at infinity (∞ on the lens distance scale), everything at some distance away and farther will be sharp: with this lens at f/22 everything will be sharp from 50 ft. (16 m) to infinity (as far as the eye can see).

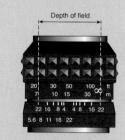

You can increase the depth of field even more if, instead of focusing on infinity, you set the infinity mark (∞) opposite the point on the depth-of-field scale (22) that shows the f-stop you are using (f/22). You are now focused on a distance (50 ft., 16 m) slightly closer than infinity (technically called the hyperfocal distance). Now everything from 23 ft. (7 m) to the far background is within the depth of field and will be sharp in the image.

Perspective how a photograph shows depth

Perspective: the impression of depth. Few lenses (except the fisheye) noticeably distort the scene they show. The perspective in a photograph-the apparent size and shape of objects and the impression of depth-is what you would see if you were standing at the camera position. Why then do some photographs seem to have an exaggerated depth, with the subject appearing stretched and expanded (this page, top), whereas other photographs seem to show a compressed space, with objects crowded very close together (this page, bottom)? The brain judges depth in a photograph mostly by comparing objects in the foreground with those in the background; the greater the size differences perceived, the greater the impression of depth. When viewing an actual scene, the brain has other clues to the distances. But, when looking at a photograph, the brain relies primarily on relative sizes.

Perspective can be controlled in a photograph. Any lens very close to the foreground of a scene increases the impression of depth by increasing the size of foreground objects relative to objects in the background. As shown on the opposite page, perspective is not affected by changing the focal length of the lens if the camera remains in the same position. However, the relative sizes of objects do change if the distance from lens to subject is changed.

Perspective can be exaggerated if you change both focal length and lens-to-subject distance. A short-focal-length lens used close to the subject increases differences in size because it is much closer to foreground objects than to those in the background. This increases the impression of depth. Distances appear expanded and sizes and shapes may appear distorted.

The opposite effect occurs with a longfocal-length lens used far from the subject. Differences in sizes are decreased because the lens is relatively far from all objects. This decreases the apparent depth and sometimes seems to squeeze objects into a smaller space than they could occupy in reality.

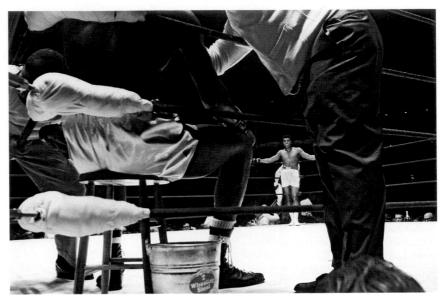

Walter looss. Ali vs. Terrell, Houston, 1967. **Expanded perspective** seems to result from the very wide lens. But using any lens this close to a subject stretches distances because it magnifies objects near the lens in relation to those that are far from the lens.

Walter looss. 100 m start, Los Angeles, 1983. **Compressed perspective** is usually associated with a long-focal-length lens. It is because the lens is relatively far from both foreground and background that size differences between near and far parts of the scene are minimized, as is the impression of depth.

Changing focal length alone does not change perspective—the apparent size or shape of objects or their apparent position in depth. In the photographs above, the camera was not moved, but the lens focal length was increased. As a result, the size of all the objects increased at a comparable rate. Notice that the size of the fountain and the size of the windows in the background both change the same amount. The impression of depth remains the same.

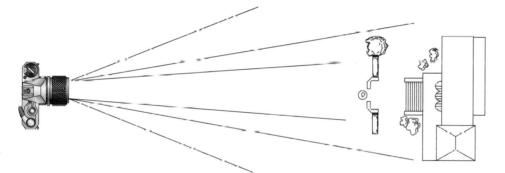

Lens-to-subject distance controls perspective. Perspective is changed when the distance from the lens to objects in the scene is changed. Notice how the size of the fountain gets much bigger while the size of the windows remains about the same. The depth seems to increase because the camera was brought closer to the nearest part of the subject.

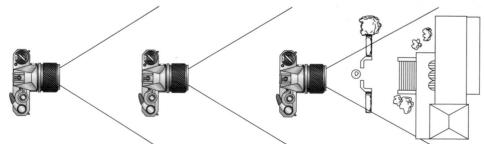

49

Lens Attachments CLOSE-UPS AND FILTERS

Close-up equipment, some of which is shown on the right, will let you move in very close to a subject. The closer your camera is to a subject, the larger the image on the sensor or film. A *close-up* is an image on the light-sensitive surface from about V_{10} life size (1:10) to life size (1:1). *Macrophotography* refers to an image that is anywhere from life size (1:1) to as big as ten times life size (10:1). *Photo-micrography* uses a microscope to get an image larger than 10:1.

Depth of field is shallow in close-ups. The closer the lens comes to the subject, the narrower the depth of field (the more the background and foreground go out of focus). Focusing manually and moving the camera slightly forward or back may help to get precise focusing. Smaller apertures for increased depth of field will increase the exposure time; a tripod (used with a cable release, remote trigger, or self-timer) will prevent camera motion during exposure.

Increased exposures are always needed for close-ups. Regardless of the method—a macro lens, extension tubes, or a bellows—the lens must move farther from the sensor or film to focus closer to a subject. But the more the lens is extended, the dimmer the light that reaches the light-sensitive surface, and the more exposure you need so the result will not be underexposed.

A camera that meters through the lens will increase the exposure automatically. But if the close-up attachment breaks the automatic coupling between lens and camera, you must increase the exposure manually; follow the recommendations given by the manufacturer of the tubes or bellows.

Lighting close-ups. Direct light on a subject can let you use smaller apertures for greater depth of field. To bring out texture, angle light across the subject from the side to pick out every ridge and crease. Direct light can be very contrasty, though, with bright highlights and too-dark shadows. If this is the case, fill light can help lighten the shadows (pages 142–143). Close-up subjects are small, so using even a letter-sized piece of white paper as a reflector can lighten shadows significantly.

To copy a flat subject, such as a page from a book, lighting should be even. Two lights of equal intensity, one on each side of the subject and at the same distance and angle, will illuminate it uniformly.

A macro lens is your best choice for sharp close-ups. If you don't have one, there are other ways to get close.

A close-up lens attaches to the front of a camera lens. They come in strengths measured in diopters; the higher the diopter number, the closer you can focus. Close-up lenses are relatively inexpensive and small, but image quality will not be as good as with other methods.

Bellows (and similar extension tubes) fit between the lens and the camera to increase the distance from the lens to the sensor or film; the greater this distance, the closer you can bring the lens to the subject. Extension tubes come in fixed sizes; a bellows is more adaptable because it can be expanded to any length. Using either will require increasing the exposure; see the text above left.

Laurisa Galvan. Gold teeth, Dallas, Texas, 2011. Getting close can often make the strongest photograph, as in this image of a man showing off his "grill" in South Central Dallas. Although not then a resident, Galvan began to document the notorious neighborhood for an assignment in her college photography class. Now a daily fixture on the street corners and accepted as a local, she has continued the project for several years. A filter can be a useful camera accessory. Glass filters attach to the front of the lens and are made in sizes to fit various lens diameters. To find the diameter of your lens, look on the ring engraved around the front of the lens. The diameter (in mm) usually follows the symbol Ø. Lessexpensive, but fragile, gelatin filters are available that can be cut to size with scissors and taped in place over the lens or held with an adapter.

Exposure must increase when filters are used. Filters work by removing some of the light that passes through them; you must increase the exposure to prevent underexposure. A rhrough-the-lens meter should compensate accurately, but check your camera's response with a test shot. Look at the histogram (pages 60–61) and adjust the settings manually, if needed. Using a hand-

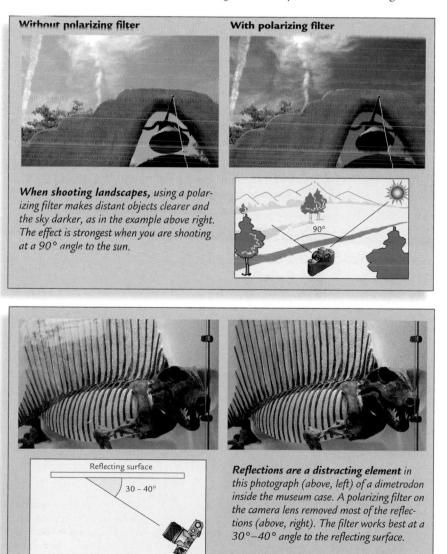

held meter, read filter instructions for a recommended exposure increase in stops or a filter factor that tells how many times the exposure should be increased.

A polarizing filter can remove reflections. If you have ever photographed through a store window and got more of the reflections from the street than whatever you wanted to photograph inside the store, you know how distracting unwanted reflections can be. Using a polarizing filter is a way to eliminate some of these reflections (see photographs at left, bottom). The filter eliminates or decreases reflections from glass, water, or any smooth nonmetallic surface.

Landscapes can be sharper and clearer with a polarizing filter. Light reflected from particles of water vapor or dust in the atmosphere can make a landscape look hazy. A polarizing filter will decrease these minute reflections and allow you to see more distant details. It may also help to make colors purer and more vivid by diminishing unwanted coloring such as reflections of blue light from the sky. And using a polarizer will darken the sky (see the photographs above left).

A polarizing filter works best at certain angles; it attaches to the front of the lens and can rotate to increase or decrease the effect. Changing the angle to the subject also affects the polarization (see diagrams at left). A camera that views through the lens lets you see in the viewfinder the effect of the filter; a test exposure will show it in a monitor. Adjust your position or the filter until you get the results you want.

Neutral-density (ND) filters remove a fixed quantity of light from all wavelengths, consequently reducing the overall amount of light that reaches the lens. These filters make it possible to use a slower shutter speed or larger aperture than you otherwise could. For example, if you want to blur action but can't use a slower shutter speed because you are already set to the lens' smallest aperture and your camera's lowest ISO, an ND filter over the lens has the effect of dimming the light, letting you then set a slower shutter speed. Similarly, if you want to decrease depth of field but are already set to your fastest shutter speed and lowest ISO, an ND filter would let you open the aperture wider.

JAVIER MANZANO Two rebel soldiers in Syria guarding their sniper's nest in the Karmel Jabl neighborhood, Aleppo, Syria, 2012.

Overriding an Automatic Exposure Camera66
Making an Exposure of an Average Scene 68
Exposing Scenes that are Lighter or Darker than Average70
Backlighting72
Exposing Scenes with High Contrast73
HDR 74 High dynamic range 74

Light and Exposure

In this chapter you'll learn...

- the difference between additive and subtractive color systems, the primary colors of each, and their practical applications.
- how to use a light meter or a histogram to get a picture that is not too dark or too light.
- the ways light sources and the time of day can affect the colors in your image.

Light is energy. When certain wavelengths of energy strike the human eye, they are perceived as light. Digital sensors (and film) change when struck by this part of the electromagnetic energy spectrum. Some can respond to additional wavelengths that the eye cannot see, such as ultraviolet and infrared light.

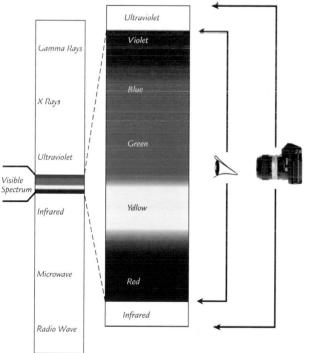

Minor White. Vicinity of Alfred, New York, from Sequence 10: Rural Cathedrals, 1955. *Infrared radiation is electromagnetic energy in wavelengths that are invisible to the naked eye,* but digital sensors as well as special film can record them. In an infrared photograph like this one, leaves and grass appear very light because they reflect more infrared radiation than non-living things. The result can be a strangely dreamlike landscape. White said he used infrared-sensitive film because he "wanted to give contrast to the landscape," but he also appreciated its surreal qualities. See page 108 for more. **our digital camera's sensor is light sensitive.** Like film, when a sensor is exposed to light, a change occurs that can be recorded and saved. Light is the visible part of the electromagnetic energy that exists in a continuum from radio waves through visible light to cosmic rays. These energy forms differ only in their wavelength, the distance from the crest of one wave to the crest of the next. The visible part of this spectrum, the light that we see, ranges between 400 and 700 nanometers (billionths of a meter) in wavelength.

Exposing your pictures correctly (that is, setting the shutter speed and aperture so they let in the correct amount of light for a given ISO and scene) makes a big difference if you want a rich image with realistic tones, dark but detailed shadows, and bright, delicate highlights, instead of a too dark, murky picture or a picture that is barely visible because it is too light.

At the simplest level, you can let your automatic camera set the shutter speed and aperture for you. If your camera has manual settings, you can calculate them by using a hand-held or built-in exposure meter to make an overall reading of the scene. You can even use a simple that of general exposure recommendations like the one on page 7. In many cases, these standardized procedures will give you a satisfactory exposure. But standard procedures don't work in all situations. If the light source is behind the subject, for example, an overall reading will silhouette the subject against the brighter background. This may not be what you want.

You will have more control over your pictures—and be happier with the results—if you know how to interpret the information your camera or meter provides and can adjust the recommended exposure to get any variation you choose. You will then be able to select what you want to do in a specific situation rather than exposing at random and hoping for the best.

Sensors and Pixels

Your digital camera's lens projects an image onto a digital sensor that is a grid (or array) of cells called *photodiodes* or *photosites*. Each photosite is a single electronic device called a *CMOS* or a *CCD* that can collect light. Each photosite collects and measures the amount of light that falls on it during an exposure. After the exposure, the measurements from all the photosites on the sensor are converted to digital numbers and stored on the camera's memory card. Then the sensor is cleared for the next exposure. Each photosite's digital number is a measure of the lightness or darkness (sometimes called the *value*) of a single square called a *pixel* (from *pic*ture *element*). Sometimes photosites themselves are called pixels.

A digital picture is made up of a large

number of pixels, each one a square with a single value and color, in a grid like a checkerboard or a piece of graph paper. If there are enough pixels and they are small enough, your eye blends them together and the picture looks like a *continuous-tone* photograph. If the pixels are large enough, they are visible as squares and the image looks coarse—see the photographs on the opposite page.

You must control the amount of light that falls on the sensor during each picture so that you get a correct exposure. Too much light can overwhelm a photosite, making its measurement inaccurate, and too little will cause it to record as a randomly—and undesirably—colored pixel called *noise* (see page 75). You need to determine, before you shoot, an exposure that is correct for each scene. The following pages show you how to use the light meter that is built into your camera, or a similar but separate *hand-held* light meter, to set your aperture and shutter speed for a correct exposure every time. **Exposure determines the lightness or darkness of the image.** The exposure you select (the combination of f-stop and shutter speed) determines how much light from a scene will reach the sensor and how light or dark the recorded image will be. The "correct" exposure for a given situation depends on how you want the photograph to look, and you may have some exposure *latitude*—a range of exposures within which your results will be equally satisfactory. But with too much variation from the correct exposure, results begin to look disappointing (see page 61, bottom). The following pages tell how to adjust the exposure to get the effect you want.

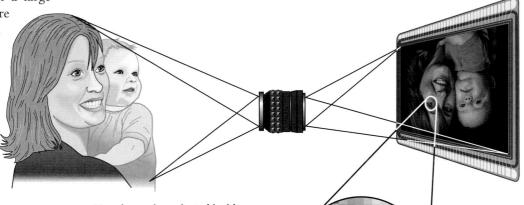

Your image is projected inside the camera onto a sensor (sometimes called the camera's chip) which breaks it up into individual image squares, or pixels, each in a single uniform color. The more (and smaller) the pixels in the grid that forms your image, the finer the detail. This picture grid is recorded as numbers on your camera's memory card, which can be transferred to a computer where it is reassembled on the monitor, ready to be edited and printed.

Pixels and Resolution

For the same image size, the higher the resolution (the more pixels per inch), the finer the detail of the image, but the more pixels required. The photographs at right show increased detail with smaller—therefore more—pixels. This image has 18 pixels per inch; at this size it is a 40×50 pixel grid, or 2000 pixels.

Double the resolution makes four times as many pixels. This image is an 80 × 100 pixel grid, or 8000 pixels. Many of the pixels are identical, pure white, so they are not visible as squares, but each must still be saved as part of the file.

36 pixels per inch

This resolution is the maximum that can be reproduced in this book. This image is a 800×1000 pixel grid, 800,000 pixels, nearly one million.

360 pixels per inch

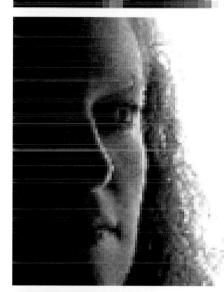

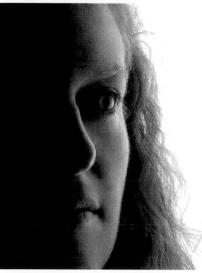

More pixels are needed for a finer picture.

Each pixel is a square of a uniform color or, in a black-and-white photograph, a shade of gray. In any individual photograph, the pixels are all the same size, and they can only be captured or displayed in a specific number of colors or shades. As you can see from the photographs on this page, an image looks coarse (*pixelated*) when the pixels are large enough to be visible. This usually results when there are too few pixels.

Resolution measures the fineness of an image but resolution goes down when size goes up. A large number of very small squares can make a picture with more detail and smoother tones than one from a smaller number of larger squares. More detail makes possible (but doesn't guarantoo) a higher quality photograph.

We measure resolution in pixels per inch (ppi) or pixels per cm; if you have a fixed number of pixels and make them bigger to cover a larger area, the pixels appear more coarse and image quality seems lower. If your digital camera captures a photograph that is 2000 pixels across, you can make a print with a resolution of 200 ppi if you choose to make it 10 inches wide, but only 100 ppi if you enlarge it to 20 inches wide.

You can create more pixels in an image during editing. Image-editing software can turn your picture that is 2000 pixels across into one . that is 4000 pixels across by a process called resampling. This example creates more pixels and is called upsampling; making fewer pixels is downsampling. By upsampling you can end up with higher apparent resolution. But to do that, the software must interpolate between your original pixels, making an educated guess at what the in-between pixels should look like. An upsampled file won't display coarse, larger pixels like the photo at top left, it will show smoother tones and blended colors. You may find upsampling useful when you want to make a large print. But the software can't invent fine detail, like the weave of a jacket or small text on a sign; for that, you need to capture higher resolution.

CHAPTER 3

Color in Photography

COLOR SYSTEMS

All colors can be created by mixing three primary colors—either the additive primaries (red, green, and blue) or the subtractive primaries (cyan, magenta, and yellow). Most colors we see in nature consist of a blend, or spectrum, of all possible colors, but any visual sensation or perception of color can be matched with the right quantities of three specifically chosen primaries.

The additive process (below, center) mixes red, green, and blue light in varying proportions to match any color. Television sets and computer monitors use additive color. Equal quantities of the three colors appear neutral gray or, if they are bright enough, white.

The subtractive process (below, right) uses cyan (a bluish green), magenta (a purplish pink), and yellow to match any color. Each color absorbs (or subtracts) one of the additive primaries. If you put cyan paint or pigment on paper, for example, it removes red from white light that shines on it, and allows green and blue to be reflected. Your eye perceives that mix of green and blue light to be cyan.

Digital color systems separate full color into primary colors, each saved as a *channel* of information. Every pixel has a separate numerical value for the amount, or value, of each primary. In a similar way, color films have three emulsion layers, each one sensitive to only one color, to separate a full-color spectrum into primaries. When working in color digitally, you have your choice of two color modes, RGB or CMYK (a third common mode is grayscale, or black and white). RGB (for Red, Green, Blue) is additive, and it is preferable for most photographic work. CMYK is a standard used in commercial publishing and printing. This mode adds black (abbreviated K instead of B to avoid confusion with Blue) to the three subtractive primaries to suit the needs of the printing industry. The three primaries together can make black, but black ink is added to the darkest shadow areas in pictures and is used to print text because it is less expensive and easier to keep neutral than a mix of the other three colors.

All printers use the subtractive primaries. Devices that mix ink or paint, pigment or dye, to create photographic color on a reflective surface such as paper must use the subtractive primaries: cyan, magenta, and yellow. But even though all desktop photo printers actually use CMYK inks, they are designed to receive files in the RGB mode for best results; editing files in CMYK mode is rarely needed outside the offsetprinting industry.

A color wheel shows the relationship of the subtractive and additive primary colors.

The additive primaries produce white light when all three are mixed. Combining two at a time can make each of the subtractive primaries.

The subtractive primaries each remove one of the additive primaries. All three together make black.

COLOR CHARACTERISTICS

Color systems divide all colors into three measurements-hue, value, and saturation. Hue is the most intuitive of these; it is what we normally name the color of an object—a blue car, a green hat. Value (sometimes called lightness or luminance) is a measure of the brightness or darkness of the color, or of the gray that would be left if a color's hue were removed, as in a black-and-white photograph. You can imagine a blue car and a green hat that might have the same luminance. Saturation (or chroma) is a description of a color's purity. You could have a tomato and a brick that are the same red hue (neither one more blue or yellow than the other). The difference is that a tomato is a more pure-or saturated-red than a brick. Various factors can affect saturation (see box below).

Maria Robledo. Cheese Still Life. This photograph is enhanced by its low saturation, controlled by the photographer's sensitive choices of subject, film, and lighting.

White balance. To our eyes, a white shirt looks white both outdoors in daylight and indoors in artificial light. But the two light sources do not have the same mix of colors; our brains compensate in a way that lets us also see blue pants as the same blue in both places. Unless there are two light sources to compare, we ignore the differences—but photographs record them. Regardless of whether you shoot digitally or with film, white balance has an important influence over the impact and effectiveness of your photographs. Even subtle shifts in color balance can create dramatic changes in emotional content. **Saturation.** The purity—or vividness, or intensity—of a color is its saturation. The color saturation that exists in front of the camera depends on the physical characteristics of objects in the scene and on the kind of illumination. Saturation in the way colors are reproduced is also affected by the specific kind of sensor or film used to capture the image, and the manner of post-processing—film development, image editing, and printing. Some films are made in different versions, producing more saturation (advertised as "vivid" color) or less. Digital image editing gives direct control over saturation (see page 98).

Photographic color can't duplicate colors in a scene, it can only fool the eye. Light reflected from an object usually contains all the wavelengths of the visible spectrum in varying quantities. The daylight that illuminates a green apple contains all wavelengths in more-or-less equal quantities. The apple reflects a high percentage of the green wavelengths and very little (absorbing the remainder) of the red and blue ones, so we see green.

To reproduce that sensation of seeing the green of an apple, photographs are limited to using three very specific primary colors that do not necessarily contain all the wavelengths of the spectrum. Photographic color can look accurate because of the way our eyes identify color. But the colors in a photograph are not actually the same as those of its subject, in the same way that the photograph itself is not actually the same as its subject.

The way photographs are made gives you control over some important characteristics of their color. Remember that the colors in a photograph only reference, they don't duplicate, those of a subject; it is up to you, the photographer, to control that difference for your own ends. You may want your viewer to believe strongly in the accuracy of your photographs, or it may be more important that your viewer have a specific emotional response to them. The way you treat color has a strong effect on the interpretation of your pictures; experiment to find out how to make the best use of these important controls.

Characteristics of a Color Photograph

Contrast. Two kinds of contrast are important in a photograph; both are established by the kind of illumination on the scene and can be altered by your technique. Overall (or global) contrast, or dynamic range, is the difference between the lightest and darkest parts of a scene or image. The range you can capture varies; all films and digital sensors have different limits on the range that can be captured (see page 73).

Local contrast is what makes photographs look crisp or soft, and has to do with the edges and transitions of color and tone. It is affected by the quality of the lens (and how clean that lens is), the kind of film or sensor used, and by digital editing.

Your light source makes a difference when you are photographing in color. We identify a wide variety of light as "white," or having no color of its own. Despite our perception that daylight is "white" or "neutral" light, its color is constantly changing throughout the day. Midday light is more blue (cooler); early morning and late afternoon light is more red (warmer). Other light sources, such as light bulbs, also emit white light of a specific color balance or white balance-the mixture of wavelengths of different colors that it contains. This quality of white light sources is also called its color temperature, and it is measured in degrees Kelvin (K), an international-standard temperature scale like Celsius (C) that starts with its zero at absolute zero rather than at the freezing point of water.

Light from an ordinary incandescent lightbulb, with a color temperature of about 2800K, has proportionately less blue and more yellow and red than does daylight at 5500K. You can see this difference if you turn on an indoor lamp in a daylit room: the light from the lamp looks quite yellow. At night, with no daylight for comparison, you see the same lamplight not as yellow but as white. Our brains ignore color balance when we look at a scene, perceiving either daylight or lamplight as "white" if there is only one kind of light present. Unless there are two differently balanced light sources in a scene (see the photograph on the opposite page) color photographic images can be adjusted, if desired, to match the color temperature of each picture's light source.

Digital cameras can adjust themselves for color temperature (in digital photography it is usually called white balance). Built into each digital camera is the ability to measure the color temperature of whatever light is illuminating the scene, and to adjust its white balance for each photograph. You can choose one of the camera's presets for several kinds of light, measure and set the white balance manually before each shot, or set the camera to adjust itself automatically. Use a *color conversion* filter (page 218) to shoot color film under any source other than 5500K.

Include a standard color for more accuracy. Shoot a color-neutral gray card or a standardized color chart on an adjacent frame in the same light. You'll be able to match it later when you edit the file to correct all the colors at once. A chart (or *target*), coupled with software, can create a camera profile (opposite page, top right) you can use to auto-correct the color in a group of photographs.

For the best results, capture your pictures in Camera Raw format (page 85) which lets you control the interpretation of sensor data during editing. The white balance adjustment is part of the processing that is applied to raw sensor data after capture, so you can compensate at that time for the effects of different light sources without degrading the quality of your image. If your camera captures in JPEG or TIFF format, white balance is applied by the camera.

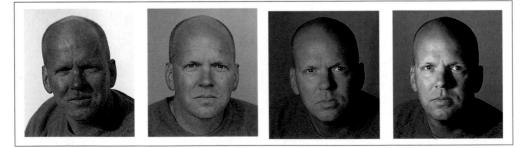

Setting a digital camera's white balance to daylight (or using color film) is correct for the relatively bluish color balance of midday light (5500K color temperature), as in the left photo. In open shade (second photo) the results are more blue,

because the light from a blue sky has a higher color temperature than direct sunlight. If you use a daylight white balance (or color film) in the warmer light of an incandescent bulb (third photo, about 2800K), your picture may look more reddish than you expect. The fourth photo was taken under fluorescent light, which tends to have proportionately more green than daylight. In each, a piece of white cardboard was held behind the man, and he is wearing the same gray shirt.

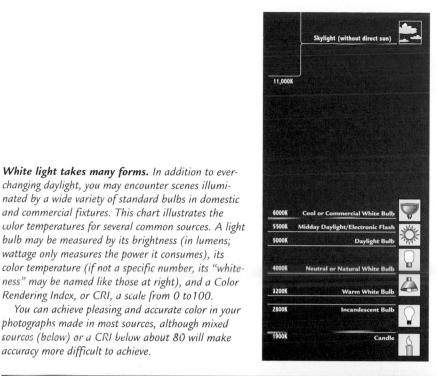

White light takes many forms. In addition to everchanging daylight, you may encounter scenes illuminated by a wide variety of standard bulbs in domestic and commercial fixtures. This chart illustrates the

bulb may be measured by its brightness (in lumens;

ness" may be named like those at right), and a Color

photographs made in most sources, although mixed

sourcos (below) or a CRI below about 80 will make

wattage only measures the power it consumes), its

Rendering Index, or CRI, a scale from 0 to 100.

accuracy more difficult to achieve.

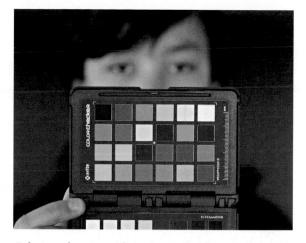

Colors can be accurately interpreted with a camera profile (see page 84). Photograph a color chart like the ColorChecker Passport shown and open it with the software supplied with the chart. Follow the simple on-screen steps to generate a profile that can be used to correct color-in one step, for any image made in the same lighting conditions. Most profiling software is made for interpreted, not raw, files but Adobe Camera Raw, Lightroom, and Photoshop can apply a profile to DNG files using the chart above and its software.

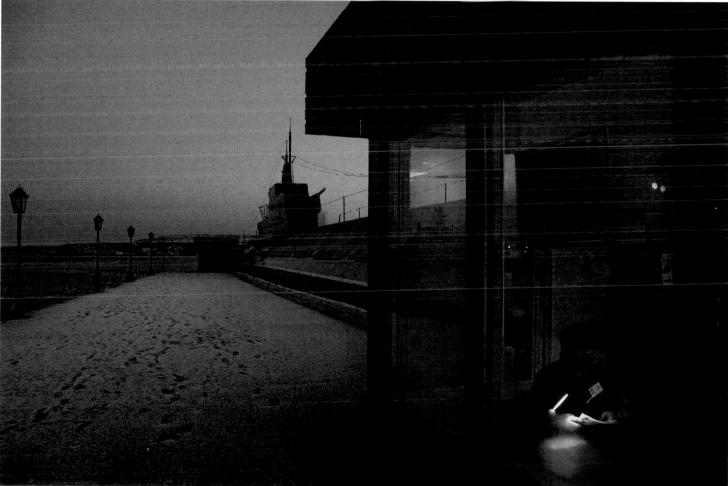

Gueorgui Pinkhassov. Murmansk, Russia, 2006. Mixed light can suggest mixed environments. Warm (lower color temperature, or more red) light from the interior incandescent lamp presents a sharp contrast with the cool (higher color temperature, more blue) dusk daylight illuminating this winter scene. Because the port of Murmansk on the Kola Bay remains ice-free year round, it provides a safe harbor for Russian (and, previously, Soviet) ballistic missile submarines like this one.

Using Histograms

A histogram is a graph that shows the brightness values (tones) of all the pixels in an image. The brightness levels in an image between black and white are divided into a discrete number, often 256, of different tones; the height of each bar in the chart represents the number of pixels of a particular brightness level that occur anywhere in the image. Usually colors are merged into a single display, black is displayed as 0, middle gray 128, and white 255.

For most scenes, a rich image uses all of the 256 tones, from the subtle highlight values of a white cloud to the deep shadows on the side of an old barn. Empty space on one end of a histogram means a digital image has no bright highlights or no dark shadows; it can be a sign of a careless scan or a poorly exposed image from a digital camera. Empty space on both sides of a histogram indicates a subject with a narrow dynamic range.

In this chapter, some histograms are displayed along with their corresponding pictures to help you understand how the information contained in them can be interpreted and used.

Histograms can guide your adjustments during image editing, in scanning software programs, and in setting your camera exposure. A histogram of any recorded image can be displayed to direct your lightness, contrast, and color adjustments. The software displays a histogram (for example, see Curves, pages 96–97), and you redistribute the tones in the image according to the information it presents.

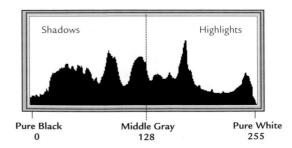

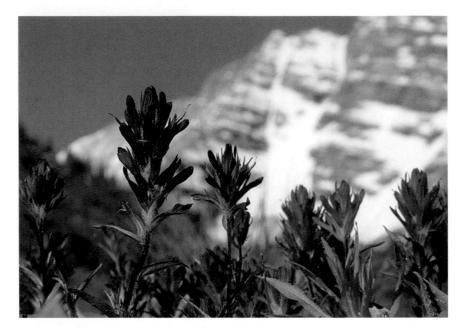

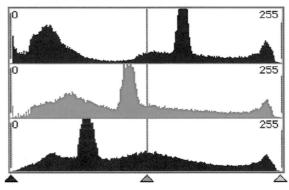

Christine Chin. Indian Paintbrushes, Colorado, 2004. **A color photograph can have one histogram for each channel**, plus a combined one that merges them. In the R, G, and B histograms for this photograph, shown above, you can see tall bumps from a cluster of light blue values in the sky, medium-toned green values from the foliage, and darker reds from the flowers. At the right end of the histogram, the nearly identical bumps in the very bright highlights for all three channels are from the neutral-colored snow.

The three channels are shown below displayed simultaneously. Where two additive primaries overlap it shows the resulting subtractive primary (page 56). A digital camera generally displays a single merged histogram (left).

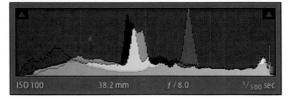

Bohnchang Koo. Chae Shirah, 2004. A histogram can be the best light meter. Koo shot the Korean movie star for a magazine using his DSLR in the indirect light of an outdoor garden. With consistent lighting and the time to take a test shot, the camera's histogram is your most accurate exposure guide. Digital cameras can be set to display a histogram of an image you have just taken immediately after exposure. It will tell you if your picture was over- or underexposed so you can adjust your shooting strategy. If the situation allows, you can take a test exposure, review the histogram, correct your exposure settings, and even delete the test image from the memory card before making your intended photograph.

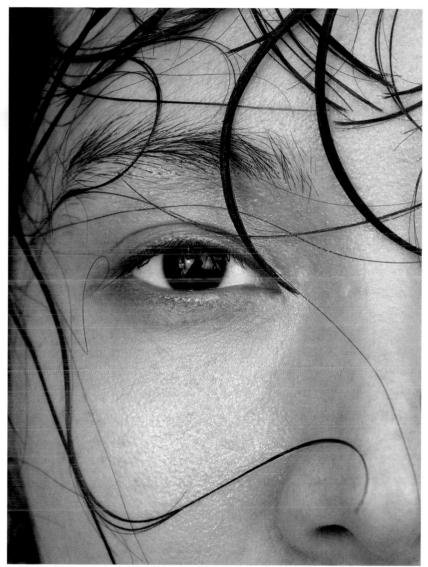

The histogram that appears on your camera's monitor can be used instead of a light meter reading. Like a light meter (also called an *exposure* meter, see page 62) it can provide very accurate information about exposure, including separate graphs showing the values of each primary color, but it is only available after the picture has been made. The examples below show you how to use the histogram to adjust your next exposure.

Expose to the right. Generally, a digitally captured photograph should be given as much exposure as possible without pushing important highlights past the right end of the histogram (called *clipping*, see below). If there is empty space in the histogram, it should be at the left. Because digital sensors are *linear* and our eyes are not, lighter tones are captured with more detail, leaving more room for later adjustment during editing, than darker ones.

A camera's histogram is made from a JPEG preview, so it is not completely accurate. Even if you shoot only raw files, the camera's built-in conversion software makes a small jpeg for the preview image it displays on the monitor. The histogram is made from this preview, but the conversion process clips a little highlight detail. You can extract that detail later in a more careful conversion of your camera raw file (see page 85) but it won't be enough to save an overexposed image.

Don't forget how to use your light meter. As useful as the histogram is, there are many situations—especially the fast-moving ones—in which you must be ready to shoot first, using your light meter as a guide. The remainder of this chapter tells you how. But if you have the luxuries of predictable lighting and enough time to make a test exposure or two, you can learn even more with a histogram than you can with a light meter and make each image perfectly exposed.

Underexposure shows tones grouped at the left end of the histogram with little or nothing on the right. When tonal values pass one end of the histogram and are discarded it is called clipping.

Overexposure clusters all the information at the right of the histogram, indicating that more subject tones exist to the right of the cutoff line but were not recorded.

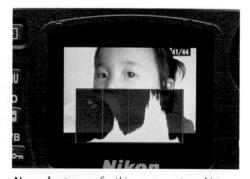

Normal exposure for this scene creates a histogram with tones distributed like this; it shows that all tones in dark areas (at left) and in light areas (right) have been recorded.

Exposure Meters what different types do

Exposure meters vary in design, but they all perform the same basic function. They measure the amount of light; then, for a given sensor or film sensitivity (ISO), they calculate f-stop and shutter-speed combinations that will produce a correct exposure for a scene that has an average distribution of light and dark.

Meters built into cameras measure reflected light (see opposite page, top center). The lightsensitive part of the meter is a photoelectric cell. When the metering system is turned on and the lens of the camera is pointed at a subject, the cell measures the light reflected from that subject. With automatic exposure operation, you set either the aperture or the shutter speed and the camera adjusts the other to let in a given amount of light. Some cameras set both the aperture and the shutter speed for you. In manual exposure operation, you adjust the aperture and the shutter speed based on the meter's viewfinder or data-panel readout. **Hand-held meters** measure reflected light or incident light (see opposite page, top left and right). When the cell of a hand-held meter (one that is not built into a camera) is exposed to light, it moves a needle across a scale of numbers or activates a digital display. The brighter the light, the higher the reading. The meter (set for your ISO) then calculates and displays recommended f-stop and shutter-speed combinations.

Meters are designed to measure middle gray. A reflected-light meter measures only one thing—the amount of light—and it calculates for only one result—an exposure that will reproduce that overall level of light as a medium-gray tone in the final photograph. The assumption is that most scenes, which consist of a variety of tones including very dark, medium, and very light, average out to a middle tone, one with equal color values. Most, in fact, do. Pages 68–73 tell how to use a meter to measure an average scene and what to do for scenes that are not average.

A hand-held meter is separate from the camera. After measuring the amount of light, the meter's calculator dial or display panel shows the recommended f-stop for your selected shutter-speed and ISO. This type of meter can read either incident or reflected light depending on the position of the small dome on the meter.

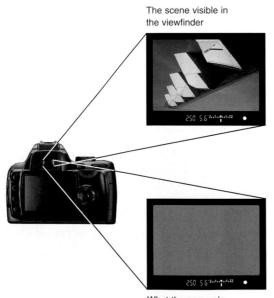

What the camera's metering system "sees"

A through-the-lens (TTL) meter, built into a camera, shows in the camera's viewfinder the area that the meter is reading. You can see the details of the scene, but the camera's metering system does not. Many "see" simply the overall light level. Whether the scene is very light or very dark, the meter always calculates a shutter speed and aperture combination to render that light level as middle gray in the picture. Some meters (as shown opposite, bottom) are more sophisticated and favor the exposure of certain parts of the image.

A TTL meter is usually coupled to the camera to set the exposure automatically. This viewfinder displays, below the image, the shutter speed and aperture to which the camera is set. It also signals under- or overexposure when you choose an aperture or shutter speed for which there is no corresponding setting within the range of those available on your camera.

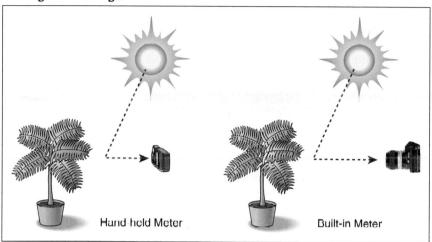

An incident-light meter measures the amount of light falling on it—and so, the amount of light falling on a

A reflected-light meter measures the amount of light reflected from an object. It can be hand held (left) or built into a camera (right). To make a reading, point the meter at the entire scene or at a specific part of it.

falling on it—and so, the amount of light falling on a subject in similar light. To make a reading, point the meter away from the subject, toward the camera.

Meter Weighting. What part of a scene does a reflected-light meter measure?

An averaging or overall meter reads most of the image area and computes an exposure that is the average of all the tones in the scene. A hand-held meter, like the one shown opposite, typically makes an overall reading.

A spot meter reads only a small part of the image. Very accurate exposures can be calculated with a spot meter, but it is important to select with care the areas to be read. Hand-held spot meters are popular with photographers who want exact measurement and control of individual areas. Some cameras with built-in meters have a spot metering option.

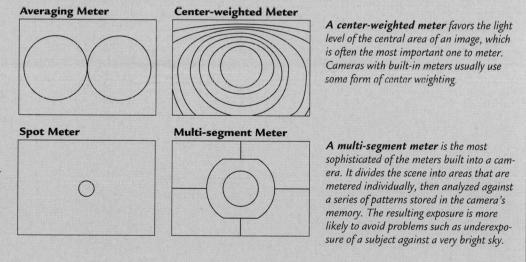

Reading Incident Light

63

Exposure Meters

HOW TO CALCULATE AND ADJUST AN EXPOSURE MANUALLY

How do you calculate and adjust an expo-

sure manually? Even if you have an automatic exposure camera, it will help you to know how to do so. Many automatic cameras do not expose correctly for backlit scenes or other situations where the overall illumination is not "average," and you will need to know how much and in what direction to change the camera's settings to get the results you want.

This page shows the way a hand-held meter works. It is likely you will never use one or even hold one in your hand. But once you grasp its operation, you will know how any meter functions, whether built into a camera or separate and hand-held. It's also useful to understand that the functions of your camera and those of a light meter, even the one inside your camera, are independent from one another. Pages 68-73 tell how to use any meter for different types of scenes.

Exposure = Intensity × **Time.** Exposure is a combination of the intensity of light that reaches the light-sensitive surface (controlled by the size of the aperture) and the length of time the light strikes it (controlled by the shutter). You can adjust the exposure by changing the shutter speed, aperture, or both.

Exposure changes are measured in stops, a doubling (or halving) of the exposure. A change from one aperture (f-stop) to the next larger aperture opening, such as from f/5.6 to f/4, doubles the light reaching the sensor (or film) and results in one stop more exposure. A change from one shutter speed to the next slower speed, such as from $\frac{1}{250}$ sec. to $\frac{1}{125}$ sec., also results in one stop more exposure. A change to the next smaller aperture or the next faster shutter speed halves the light and produces one stop less exposure. Doubling the illumination in a room would also be referred to as a one-stop change.

It is worth your effort to memorize the f-stop and shutter-speed sequences, at least the wholestop ones (see the box on page 26), so you know Power Switch

Mode Switch Changes from continuous light (like daylight) to electronic flash.

The f-stop settings are one stop apart. f/8 lets in half as much light as f/5.6. Remember that the lower the f-number, the larger the lens aperture, and so the more light let into the camera.

ISO button; speed ratings double each time the sensitivity of the sensor (or of film) doubles. A setting of ISO 400 is one stop faster than a setting of ISO 200. It needs only half as much light as does ISO 200.

which way to move the controls when you are faced with an exposure you want to bracket or otherwise adjust.

Bracketing helps if you are not sure about the exposure. To bracket, you make several photographs of the same scene, increasing and decreasing the exposure by adjusting the aperture or shutter speed. Among several different exposures, there is likely to be at least one that is correct. It's not just beginners who bracket exposures. Professional photographers often do it as protection against having to repeat a whole shooting session because none of their exposures was quite right.

To bracket, first make an exposure with the aperture and shutter speed set by the automatic system or manually set by you at the combination you think is the right one. Then make a second shot with one stop more exposure and a third shot with one stop less exposure. This is easy to do if you set the exposure manually: for one stop more exposure, either set the shutter to the next

125

Reads fractions in between the whole f-stop settings.

A hand-held exposure

meter. Light striking this meter's light-sensitive photoelectric cell results in the display of an f-stop and a shutter speed on its electronic display window. You set the ISO and shutter speed, and it calculates the correct aperture for a normal exposure in light of that intensity. An automatic exposure camera performs the same calculation for you, using a light meter built into the camera.

Most current hand-held meters will also calculate exposures when you are using electronic flash (see pages 146–149) or mixing flash with daylight.

Bracketing Exposures

Bracketing produces lighter and darker versions of the same scene. Suppose an exposure for a scene is 1/60 sec. shutter speed at f/5.6 aperture.

Original exposure

1/8	1/15	1/30	1/60	1/125	1/250	1/500 sec.
f/16	f/11	f/8	f/5.6	f/4	f/2.8	f/2

To bracket for one stop less exposure, which would darken the scene, keep the shutter speed at 1/60 sec. while changing to the next smaller aperture, f/8. (Or keep the original f/5.6 aperture while changing to the next faster shutter speed, 1/125 sec.)

Bracketed for one stop less exposure

1/8	1/15	1/30	1/60	1/125	1/250	1/500 sec.
f/16	f/11	f/8	f/5.6	f/4	f/2.8	f/2

To bracket for one stop more exposure, which would lighten the scene, keep the shutter speed at $\frac{1}{60}$ sec. while changing to the next larger aperture, f/4. (Or keep the original f/5.6 aperture while changing to the next slower shutter speed, $\frac{1}{30}$ sec.)

Bracketed for one stop more exposure

1/8	1/15	1/30	1/60	1/125	1/250	1/500 sec.
f/16	f/11	f/8	f/5.6	f/4	ſ/2.8	f/2

slower speed or the aperture to the next larger opening (the next smaller f-number); for one stop less exposure, either set the shutter to the next faster speed or the aperture to the next smaller opening (the next larger f-number).

How do you bracket with an automatic exposure camera? In automatic operation, if you change to the next larger aperture, the camera may simply shift to the next faster shutter speed, resulting in the same overall exposure. Instead, you have to override the camera's automatic system. See page 66 for how to do so. Some cameras can be set to make three bracketed exposures in succession when you press the shutter once.

> lack Delano, Union Station. Chicago, 1943. Bracketing your exposures is useful when you are not sure if an exposure is correct or if you want to see the results from different exposures of the same scene. Judging the exposure for this kind of extremely contrasty scene can he very difficult; brackotod exposures give you a choice. With more exposure in the photograph at left, detail in the interior would have been more visible but the beams of sunlight would lose their drama. Less exposure would darken everything so people on the benches would disappear entirely.

CHAPTER 3

Overriding an Automatic Exposure Camera

Many cameras with automatic exposure have a means of overriding the automatic system when you want to increase the exposure to lighten a picture or decrease the exposure to darken it. The change in exposure is measured in stops. A one-stop change in exposure will double (or halve) the amount of light reaching the sensor or film. Each aperture or shutter-speed setting is one stop from the next setting.

Exposure lock. An exposure lock or memory switch temporarily locks in an exposure, so you can move up close or point the camera in a different direction to take a reading of a particular area, lock in the desired setting, step back, and then photograph the entire scene.

Exposure compensation. Moving this dial or indicator to +1 or +2 increases the exposure by one or two stops and lightens the picture. Moving it to -1 or -2 decreases the exposure and darkens the picture. (Your camera may have a button you must hold down while making this change.)

Backlight button. If a camera does not have an exposure compensation dial, it may have a backlight button. Depressing the button adds a fixed amount of exposure, 1 to $1\frac{1}{2}$ stops, and lightens the picture. It cannot be used to decrease exposure.

ISO setting. Changing the ISO setting on a digital camera will change either aperture or shutter speed but will not make the picture lighter or darker. Instead you will need to use the button, dial, or menu item that controls exposure compensation. You can set the camera to expose all your photographs at a fixed amount more or less than the meter indicates, or you can make an exposure change for one picture at a time.

Setting the ISO on a film camera doesn't change the light sensitivity of the film, so you can change the exposure (if the camera allows you to set an ISO manually) by changing the film speed setting. The camera responds as if the film were slower or faster than it really is. Doubling the film speed (for example, from ISO 100 to ISO 200) darkens the picture by decreasing the exposure one stop. Halving the film speed (say from ISO 400 to ISO 200) lightens the picture by increasing the exposure one stop.

Manual mode. With an automatic camera that has a manual mode, you adjust the shutter speed and aperture yourself. You can increase or decrease the exposure as you wish.

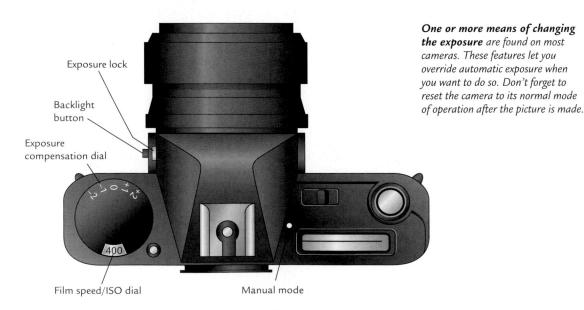

Adam Ekberg. Vacuum on a Frozen Lake, Maine, 2005. Low light exposures can be difficult to get right. You can use manual mode to set the shutter speed and aperture, but be sure to bracket if you can. Ekberg used a meter, and then made exposures from ½ to 30 seconds to be certain he captured the balance of warm incandescent light from the vacuum with the cool light of dusk. He tossed his family's Eureka onto the surface of a frozen lake from outside the frame so there would be no footprints to disturb this absurdist image.

67

Making an Exposure of an Average Scene

Deborah Willis. Trail of Tears, 2001. Scenes in diffused light can be exposed well with an overall reading, for example, an overcast day, outdoors in the shade like this, or indoors when the light is coming from several light sources. Diffused light is indirect and soft. Shadows are not as dark as they would be in direct light.

Willis, a long-time resident of New York City, responded to the spontaneous memorials around her city with her series 911 The Day After, 9/12/2001, that includes this photograph.

What exactly do you need to do to produce a good exposure? How do you choose one that lets just enough light into the camera so that the image is neither underexposed, making the picture too dark, nor overexposed, making the picture too light? All meters built into cameras, and most hand-held meters, measure reflected light: the lightness or darkness of objects (but not their color). In many cases, you can simply point the camera at a scene, activate the meter, and set the exposure (or let the camera set it) accordingly.

A reflected-light meter averages the light entering its angle of view. The meter is calibrated on the assumption that in an average scene all the tones or values—dark, medium, and light—will average out to the value of a medium gray. So the meter and its circuitry set, or recommend, an exposure that will record all of the light reflectances that it is reading by centering them around a middle gray.

This works well if you are photographing an "average" scene, one that has an average distri-

bution of light and dark areas, and if the scene is evenly illuminated as viewed from camera position, that is, when the light is coming more or less from behind you or when the light is evenly diffused over the entire scene (like the photograph above). See opposite for how to meter this type of average or low-contrast scene.

A meter can be fooled, however, if your subject is illuminated from behind (backlit), surrounded by a much lighter area, such as a bright sky, or by a much darker area, such as a large dark shadow. Even a flatly lit scene can present an exposure challenge if it is not a good balance between light and dark areas. See pages 70–73 for what to do in such cases.

A digital camera's preview or an editing histogram of the scene on this page would look like the one at left. A

histogram is a visual display of the way tones are distributed in an image. Flat, even illumination usually makes a histogram that fits all tones comfortably within the available latitude. This one shows a decline to the baseline at both ends indicating that all the tones have been captured. The rise at the left indicates slightly more dark tones than middle or light ones. Overall it is relatively flat, characteristic of an average subject in soft light, the result of an almost equal distribution of tones from dark to light.

Using a meter built into a camera for exposure of an average scene

- Select an ISO and set it in the camera. Some film cameras do this automatically when you load the film.
- 2 Select the exposure mode: automatic (aperture priority, shutter priority, or programmed) or manual. Activate the meter as you look at the subject in the viewfinder.
- 3 In aperture-priority mode, you select an aperture. The camera will select a shutter speed; make sure that it is fast enough to prevent blurring of the image caused by camera or subject motion. In shutter priority mode, you select a shutter speed. The camera will select an aperture; make sure it gives the desired depth of field. In programmed (fully automatic) mode, the camera selects both aperture and shutter speed. In manual mode, you set both aperture and shutter speed based on the readout in the viewfinder.

Calculating exposure of an average scene with a hand-held reflected-light meter

- Set the ISO or film speed into the meter.
- 2 Point the meter's photoelectric cell at the subject at the same angle seen by the camera. Activate the meter to measure the amount of light reflected by the subject.
- 3 Line up the number registered by the indicator needle with the arrow on the meter's calculator dial. (Some meters do this automatically.)
- 4 Set the camera to one of the combinations of f-stops and shutter speeds shown on the meter. Any combination shown lets the same quantity of light into the camera and produces the same exposure.

Calculating exposure of an average scene with a hand-held incidentlight meter

Set the ISO or film speed into the meter.

Position the meter so that the same light is falling on the meter's photoelectric cell as is falling on the part of the subject seen by the camera. To do this, point the meter's photoelectric cell away from the subject, in the opposite direction from the camera lens. Activate the meter to measure the amount of light falling on the subject. Make sure the same light that is falling on the subject is falling on the meter. For example, take care not to shade the meter if the subject is brightly lit. Proceed as in steps 3 and 4 for reflected-light meter.

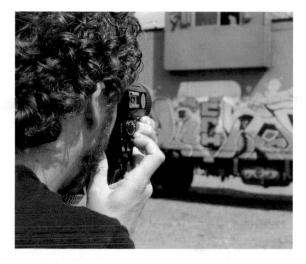

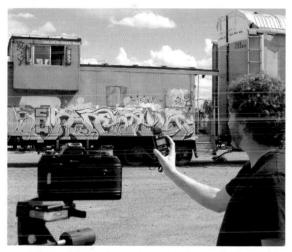

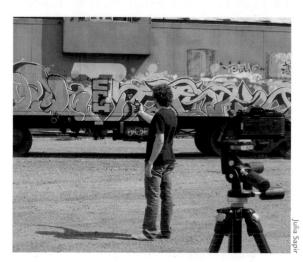

Exposing Scenes that are Lighter or Darker than Average

"It came out too dark." Sometimes even experienced photographers complain that they metered a scene carefully, but the picture still wasn't properly exposed. All a meter does is measure light. It doesn't know what part of a scene you are interested in or whether a particular object should be light or dark. You have to think ahead of the meter and sometimes change the exposure it recommends.

Scenes that are light overall, such as a snow scene, can look too dark in the final photograph if you make just an overall reading or let an automatic camera make one for you. The reason is that the meter will make its usual assumption that it is pointed at a scene consisting of light, medium, and dark tones (one that averages out to middle gray), and it will set the exposure accordingly. But this will underexpose a scene that consists mostly of light tones, called *high-key*, resulting in a too-dark photograph. Try giving one or two stops extra exposure to such scenes. **Scenes that are dark overall** are less common, but do occur. When the meter sees an entire scene that is very dark, called *low-key*, it assumes it is a dimly lit average scene and lets in more light. If your main subject is not as dark as the background, it will be rendered too light. Try reducing the exposure one or two stops.

You can make some adjustments in tone later, when you edit your pictures. But good results and the effect you want are easier to get if you first use the camera to capture the correct exposure. Bracket your exposures (page 64) if you are not sure, especially if you notice that the scene is not average—equally light and dark. If your camera is capturing TIFF or JPEG files, you have little leeway. Shooting Camera Raw files gives you a better chance at retrieving an image that was slightly over- or underexposed. But an image that was captured with the correct exposure will always be your best bet for making a print of the highest possible quality.

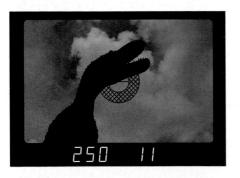

An underexposed (too dark) photograph can result when the light is coming from behind the subject or when the subject is against a much brighter background, such as the sky. The problem is that a meter averages all the tonal values that strike its light-sensitive cell. Here the photographer pointed the meter so that it included the much lighter tone of the sky and clouds as well as the sculpture. The resulting exposure of 1/250 sec. shutter speed at f/11 aperture produced a correct exposure for an average scene but not a correct exposure for this scene.

A better exposure for contrasty scenes results from moving up close to meter only the main subject, as shown above. This way you take your meter reading from the most important part of the scene—here, the dinosaur's head. The resulting exposure of V_{60} sec. at f/11 let in two more stops of exposure and made the final picture (right) lighter. The sky is more realistic and the important part of it, the figure, is not too dark.

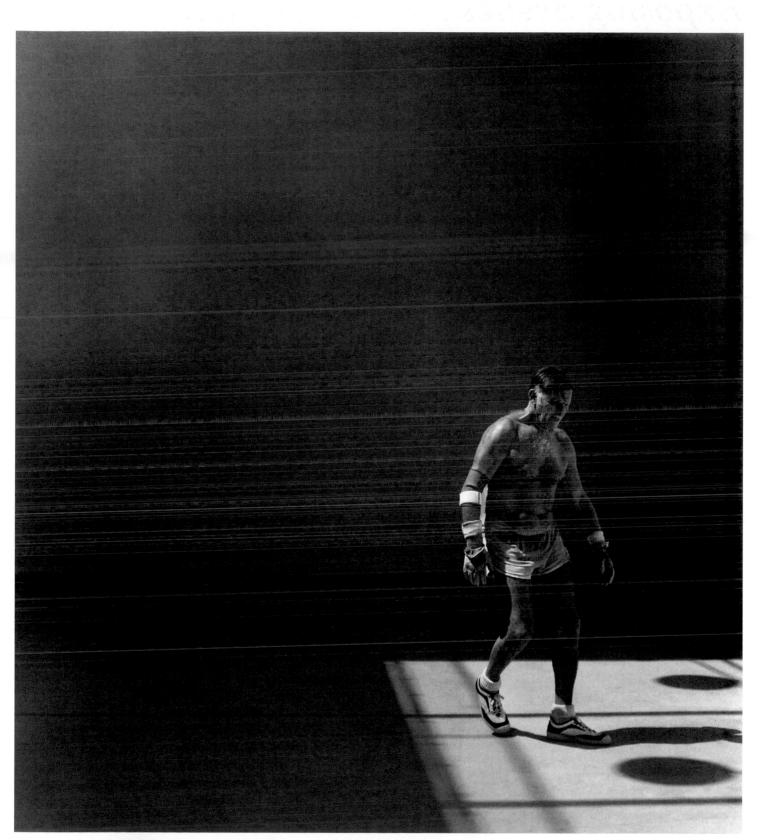

Jerome Liebling. Miami Beach, Florida, 1977. Some scenes need more care in metering, like this handball player in a shaft of sunlight. An average meter reading would see mostly the dark court and suggest an exposure that would make the sunstruck areas too light. Its histogram (left) shows mostly dark tones clustered at the left end of the graph. An averaging meter would try to move the large mass of tones toward the center, overexposing and clipping the highlights.

Backlighting

he most common exposure problem is a backlit subject, one that is against a much lighter background, such as a sunny sky. Because the meter averages all the tonal values it sees—light, medium, and dark—in the scene, it assumes the entire scene is very bright. Consequently, it sets an exposure that lets in less light, which makes the entire picture darker and your main subject too dark.

Backlight can make an effective silhouette,

but you shouldn't render your subject in blackness unless that's the effect you want. To show your main subject with detail in the shadowed side, like the photograph at right, make sure to meter the part of your subject facing the camera without letting the backlight shine into the meter, as shown below. When you want a silhouette against a bright background, try giving a stop or two less exposure than the meter recommends for the main subject.

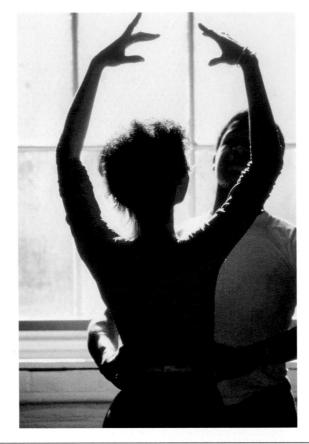

Lou Jones. Dancers Rehearsing, Boston, 1985. **Careful exposure is required** in backlit scenes like this one if you want to retain detai in the shadowed side of the subject

Using a Meter

Move in close to meter a high-contrast scene. With a built-in meter, move in (without blocking the light) until the important area just fills the viewfinder. Set the shutter speed and aperture and move back to your original position to take the picture.

With a hand-held, reflected-light meter, move in close enough to read the subject but not so close as to block the light. A spot meter, which reads light from a very narrow angle of view, is particularly useful for metering high-contrast scenes.

A substitution reading, such as one taken from the palm of your hand or a gray card, will give you an accurate reading if you can't get close enough to a subject or—as in this scene you can't easily find an area of average reflectance. Make sure you are metering just the palm (or the card) and not the sky or other background of a different tone. A hand-held reflected-light meter is shown, but you can also use a meter built into a camera.

If you meter from the palm of your hand, try the exposure recommended by the meter if you have very dark skin, but give one stop more exposure if you have light skin, as here. If you make a substitution reading from a photographic gray card, use the exposure recommended by the meter.

Exposing Scenes with High Contrast

Ray K. Metzker. Frankfurt, 1961. A high-contrast scene must be exposed carefully, as you can see from the histogram of this image shown below. It would take only a little overexposure to push the highlight tones (at the right) beyond the end of the graph, making them all a uniform white. Similarly, a little under exposure would clip the dark tones, making them all black.

> **High-contrast scenes are difficult to expose correctly** because the range of tones in a contrasty scene (also called a scene of wide or high *dynamic range*) can meet or even exceed the latitude (the range of tones that can be captured simultaneously) of the sensor or film. Even a small exposure error will leave you with detail missing (clipping) in your highlights or shadows. As always, it is safest to bracket.

> **Try not to underexpose** with film; the shadow areas suffer most from exposure error. Films have more latitude in the highlights. Don't overexpose with digital cameras, they typically capture a tonal range greater than negative films, but with less latitude in the highlights. Precise metering is more important in contrasty light.

To expose the main subject correctly in a contrasty scene, measure the light level for that part of the scene only. If you are photographing a person or other subject against a much darker or lighter background, move in close enough to exclude the background from the reading but not so close that you meter your own shadow. If your main subject is a landscape or other scene that includes a very bright sky, tilt the meter or camera down slightly so you exclude most of the sky from

the reading. But suppose a bright sky with interesting clouds is the area in which you want to see detail and there are much darker land elements silhouetted against it (see page 9, bottom center). If so, the sky is your main subject, the one you should meter to determine your camera settings.

A substitution reading is possible if you can't move in close enough to the important part of a contrasty scene. Find an object of about the same tone in a similar light and read it instead. For exact exposures, you can meter the light reflected from a *gray card*, a card that is a standard 18% reflectance middle gray (meters are designed to calculate exposures for subjects of this tone). You can also meter the light reflected by the palm of your hand (see box, opposite). Hold the card or your hand in the same light that is falling on the subject.

How do you set your camera after you have metered a high-contrast scene? If your camera has a manual exposure mode, set the shutter speed and aperture to expose the main subject correctly, using the settings from a reading made up close or from a substitution reading. In automatic operation, you must override the automatic circuitry (see page 66). Don't be afraid to do this; only you know the picture you want.

CHAPTER 3

HDR HIGH DYNAMIC RANGE

How do you capture a scene when the contrast is too great for your camera? What do you do when the highlights are too bright and the shadows too dark to be captured at the same time? The range of tones a sensor or film can capture (or a monitor can display or a printer can print) is called its dynamic range. When exposing a scene with too much contrast-too great a dynamic range-you can only make sure the most important tones are recorded, you can't capture all of them in one picture.

Photographers have always had to work around the limitations of the medium. In the 19th century, some photographers used a separate negative to add clouds to a print because the materials of the period couldn't record detail in a landscape and sky at the same time. Studio photographers must learn to arrange lights so the brightness range of their subject doesn't exceed the range their equipment can capture.

Software gives us a chance to overcome the limited range a sensor can capture. HDR (high dynamic range) images can be assembled from a bracketed sequence of exposures. Photoshop's Merge to HDR Pro feature and Lightroom's Photo Merge, as well as several separately available applications and plug-ins, automate the process by blending the light areas in the less-exposed frames with the shadow areas in the greater exposures.

Five to seven frames of a still subject bracketed one stop apart (see page 64) will give the best results. Although the programs will try to line up exposures that don't overlap perfectly, it is always more effective to use a tripod. Bracket the exposures using shutter speed rather than aperture to avoid depth-of-field variation between frames.

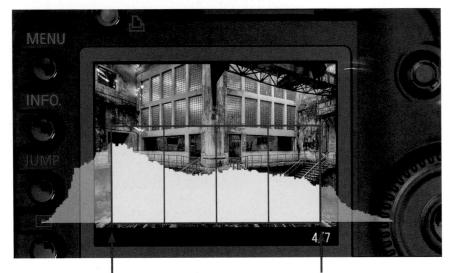

Sensor limit for low light.

A digital sensor can only capture the fixed range of brightnesses shown within the histogram displayed on your camera's monitor. With a very contrasty scene like the one below and opposite page, top, some tones will fall outside that range. These out-of-gamut (page 82) tones are not actually displayed by

Sensor limit for bright light.

a camera the way they are illustrated above, but are clipped—all tones to the right of the sensor's range are captured as pure white and everything to the left as pure black. Without the ability to merge bracketed HDR frames, your only option is to choose (by selecting an exposure) which partial range of tones you record.

Richter made five exposures to capture full detail in all important areas of this building interior, from 1/4 sec. to 4 sec. The

aperture was kept the same (f/11) for all so they could be merged (see the opposite page) with no depth-of-field variations.

Christian Richter. Power Line, Italy, 2008. With no electricity for interior lights, vacated buildings provide extremes of contrast. Merging five bracketed exposures was the only way Richter could reveal detail in all areas of this ruined powerplant.

Living in East Germany when the Berlin Wall fell, he began visiting, then photographing, abandoned spaces. As people moved from East to West, and from villages to cities, they left behind deteriorating factories, hospitals, inns, and public baths.

Digital Noise

in a digital photograph, the lower the light, the more the noise. A sensor's photosites are less accurate when they measure a very small amount of light, and in every photograph some will randomly generate pixels whose color and brightness are unrelated to the subject. Because noise increases as the light level decreases, there will always be more in dark areas of an image. And, because noise in shadows appears as bright sparkles of color in a dark field, it is most noticeable there, too.

Higher ISO settings increase noise. A photosite does not change its sensitivity—the way it responds to photons falling on it by collecting and counting electrons—when you adjust the ISO number to a higher setting. The camera's circuitry simply amplifies the data collected. With a higher ISO, you shoot with a smaller aperture or higher shutter speed, so the sensor receives less illumination overall. The kinds of noise that are always present at a low level are then amplified more than they would be at a lower ISO, and form a more noticeable part of the image. Longer exposures increase noise. You use a long exposure when very little illumination reaches the sensor-perhaps because of a very small aperture or a dimly lit subject. HDR photographs, for example, because of the great range of brightnesses, are often very dimly lit in the darker areas and require longer exposures. One kind of noise, heat-generated electrons called dark noise, accumulates over time, and so forms a more noticeable part of an image made with a long exposure.

Some noise can be removed. Some digital SLR cameras have a setting for Long Exposure Noise Reduction that works on the principle that some kinds of noise, notably dark noise, are predictable. A long exposure is followed automatically by an equally long exposure with the shutter closed. Noise generated during the second exposure is then subtracted from the first. In addition, several software programs, separate applications as well as Photoshop plug-ins, are available to help reduce noise, both in digitally captured and in scanned images.

Digital images can be degraded by noise, usually appearing as random light pixels that appear in dark areas. Noise increases with longer exposures.

MARTHA ROSLER Invasion, from the series House Beautiful: Bringing the War Home, New Series, 2008. Rosler collages the ads in mainstream magazines to critique the culture that reads them. Made as traditional cut-and-paste collages, early pieces in this series from the 1960s juxtapose smug suburban consumerism with the horrors of the Vietnam War. More recent images are digitally composited from scanned magazine pages. Rosler says she wanted "to go back to something that I had done many years before in exactly the same way...because we have sunk back to that same level, of a kind of indifferent relationship to what our country is doing."

Equipment and Materials	
You'll Need	78
Pictures are Files	80
Digital Color	82
Modes, gamuts, spaces,	
and profiles	82
Channels	
Calibrating for accuracy	84

Working with Camera
Raw85Stay Organized86Setting up a workflow86Photographer's workflow
programs87Importing an Image88Scanning89

Digital Workplace Basics

In this chapter you'll learn...

- to identify the components of a workspace for digital photography: a computer, its programs, and its peripheral devices.
- how to determine the best file format and resolution for each use you may have for a photograph.
- to plan an efficient series of steps to lead you from deciding to make a photograph to making sure you don't ever lose it.

fter capturing an image and before printing it, your photograph exists as a computer file, and lives its life in a computer. Computers alter photographs by manipulating the binary world of ones and zeroes; there is no darkroom, rectangle of film, or liter of developer. Software programs for editing photographs contain commands that are inherited from—and tools that are modeled after—the traditional processes of photography. You apply "filters" or use "burning and dodging" tools. It's useful—but not necessary—to know where those terms came from.

What you will need, however, to control all the stages between capture and output, is a reasonable comfort level with using a computer. Digital cameras can record hundreds of photographs on one reusable memory card; the computer facilitates saving and tracking them. Computer software lets you separately and precisely control tones and colors for individual areas of an image (or a group of them), and save each successive stage of the process. You can then send your choices to a desktop printer—connected to your computer—to make exactly repeatable prints. By the time you are a proficient digital photographer, you and your monitor and keyboard will be well acquainted.

Meggan Gould. From the series Screenshots, 2007–09. Your workspace reflects your individuality. Mass-produced objects like your computer and its monitor begin life with little character. As a digital photographer, you'll spend enough time with yours that your personality will gradually transfer to them and to the surrounding workspace. Gould asks, "What do our home screens reveal about us?"

Equipment and Materials You'll Need

CAPTURE

Digital camera does not use film. It electronically records an image in a numerical form that can be sent to the computer directly as digital information. Scanner reads a conventional negative, slide, or print and converts it into digital form. See

EDITING

page 89.

Computer is the heart of a digital-imaging system. It processes the image and drives the monitor, printer, and other devices to which it is attached. You'll need a recent Apple or Windows-compatible computer. The more powerful and faster models are preferable; editing photographs is among the more demanding uses for a computer. Adding more memory (RAM) will make any computer perform image editing faster.

Computer monitor

displays the image you are working on and shows various software tools and options. It should be calibrated (see page 84). Many all-in-one computers integrate monitor and computer into one unit. Image-editing software lets you select editing commands that change the image. Adobe Photoshop is the dominant product. The less expensive Photoshop Elements has a limited

number of the features

on the pages of this book were made with Photoshop CC on a Mac computer; the Standard and Windows editions look nearly identical.

This book is about photography. It can't replace the owner's

STORAGE AND TRANSMISSION

Hard disk (HDD or hard drive) stores image files within the computer. Solid state drives (SSD), essentially the same as camera memory cards,

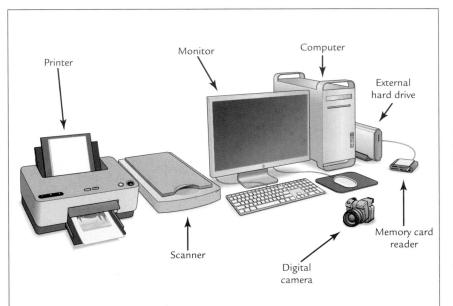

presented in this book. You may also choose a photographer's workflow application like Adobe *Photoshop Lightroom* or Phase One *Capture One Pro.* See page 87.

Editing software uses on-screen *menus* to list commands and to call for *dialog boxes* that open on the monitor. Most dialog boxes and other illustrations manual for your camera or an in-depth reference for imageediting software. You will need a book (or the screen-display or online equivalent) for your chosen software, either the one that comes with the program or one of the many good publications or webbased tutorials that cover in detail all its tools and controls. perform the same functions faster but are more expensive. You can add internal drives to tower-style computers. External drives may be added simply by connecting with a cable. *Cloud* storage lets you use remote storage via the Internet. Only a limited number of pictures can be stored internally on a single drive. See box page 80.

Optical storage medium

- such as a DVD or Bluray disk lets you expand your storage or take files to another location. Newer computers do not have built-in optical drives.
- Wi-Fi, cable, modem, or ethernet connection to another computer or a network of them lets you send and receive digital image files. Connecting to the Internet lets you transmit images worldwide.

OUTPUT

- Printer transfers the image to paper. Print quality, cost, and permanence vary widely. Printers may be the inkjet, laser, or dyesublimation type.
- Web site lets others see your photographs displayed on their monitors, phones, or tablets.

You don't need to own these items yourself.

If you are in a class, a lab will be provided. Otherwise, many schools and libraries provide access to computers, scanners, and printers. Service bureaus (often in shops that do copying) rent time on computers, scan and print images, and help you use their services.

Currle inae vveems. A Broad and Expansive Sky—Ancient Rome, from Roaming, 2006.

When and Where I Enter—Ancient Rome, from Roaming, 2006. This series, like much of Weems' work, is part photography and part performance. It began in Rome when she found horself before monuments and palazzos "thinking about questions of power." Her figure appears in each, taking up little of the frame, to lead the viewer into the spaces she investigates.

Resisting the commonplace urge to acquire an array of equipment, she says "I move around with an old beat-up camera...and as much film as I can carry. Then I just trust that I know what I'm doing with this little black box and that it's going to be okay." Her negatives are scanned (page 89) to generate image files for printing.

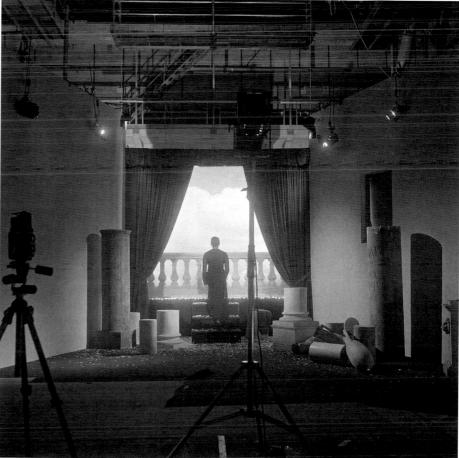

Pictures are Files

Your computer stores each picture as a file comprising a string of binary numbers (ones and zeroes) for each pixel. More pixels and greater bit depth (the amount of information per pixel) mean more potential sharpness, color quality, and tonal range in the image—and the bigger the size of the image file in the computer. Generally, better cameras capture a higher pixel count and greater bit depth, hence larger files. Increased file size causes your computer to take more time executing each command you give it. Larger files require more computer memory, and take more room to store. You may have to balance the quality and size of the picture you want against the practicality of the file size for your particular computer. You can find out more from your instructor at school or an image-editing software manual.

David Taylor. Pedestrian Fencing, Desierto de Altar/ Yuma Desert, 2009. This view of the Mexico–US barrier fence is made from a very large file (2GB), stitched from ten separate exposures that each recorded a section of this wide view. Taylor's 4 × 5-foot print yields information from very close inspection as well as from afar.

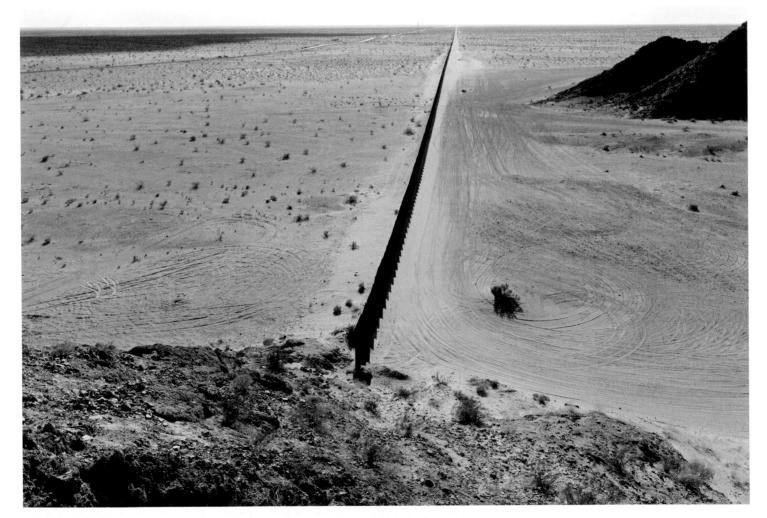

About File Sizes

File sizes are measured in *bytes* (8 bits). A 24-megapixel camera's recording chip might have a 4000 × 6000 grid of pixels—that's 24 million pixels. If each pixel uses 8 bits (one byte or 256 possible values) for each color (red, green, and blue), each image will produce a 72-megabyte file. BitSmallest unit of digital information,
can only be two values: 1 or 0Byte8 bits, can be 256 different valuesKilobyte(1K or KB) 1,000 bytesMegabyte(1M or MB) 1,000,000 bytesGigabyte(1G or GB) 1,000 MegabytesTerabyte(1T or TB) 1,000 Gigabytes

(The numbers are rounded off. A kilobyte actually contains 1,024 bytes, a megabyte 1,048,576.)

A file for a photograph on the Internet might be 90K, one for an 8 × 10-inch print 18MB, one for a poster 200MB or more.

Bit depth controls how smooth the tones will be. Computers operate on bits, numbers that can only be a one or a zero. An image with a bit depth of one can only have two different colored pixels, usually black and white. A bit depth of two

File Formats

You have a choice of file formats when you create or save a digital image. Some computers need a three-letter suffix (file extension) at the end of the file's name to identify the type. Here are the important ones.

.psd is Adobe's proprietary format for documents that can only be opened and edited in Photoshop. If you are using Photoshop to edit a file, there are few reasons to use any other format until your editing is complete and you save the file for a specific purpose.

.jpg (written JPEG) compresses photos into a smaller file. You can choose one of several quality levels for progressively smaller files; a low quality may allow an image saved as a JPEG to be reduced to as little as one-twentieth its original size. This kind of compression, which discards information, is called lossy. Every time you open and resave a JPEG its quality deteriorates; choose another format for editing. JPEGs, with smaller file sizes making faster transmission times, are common for displaying photographs on the Web or sending snapshots over the Internet. Digital cameras offer this format as a file option to fit more photographs on a memory card. A JPEG can only hold an 8-bit pixel depth.

.tif (written TIFF) is a nearly universal format that allows a photograph to be opened on any computer by nearly every program that works with photographs. Saving a file as a TIFF makes no changes to it (it is called *lossless*), nor does its optional compression mode (LZW). A TIFF can be 8- or 16-bit.

Camera Raw (.CR2, .NEF, .PEF, etc.) files do not conform to a single set of standards like JPEGs or TIFFs. Raw is a generic term for the individual and proprietary way that a digital camera produces unprocessed data, before settings like white balance are applied. Starting with a raw file allows more precise editing control and lets you keep your pictures in the high-bit (12 or 16 bits per pixel) format that better digital cameras eapture. You can open raw files with software from the camera manufacturer, but try your editing software first

.dng (Digital Negative) is an opensource (no owner, publicly available) format developed by Adobe in the hope that camera makers would standardize their now-proprietary formats. Adobe's software, or their free utility, will let you convert any Camera Raw file into a .dng, which may eventually become the standard Camera Raw format. means you can have four colors—adding a dark and a light gray, for example. The pixels in an 8-bit picture or file can have 256 different values: black, white, and 254 shades of gray in between.

The human eye can distinguish only about two hundred different shades between black and white, so a photograph with 8-bit pixels (each having 256 possible tones of gray, including black and white) is enough for a black-and-white picture (see the photograph bottom right). But for a full-color image, three times that much is needed—256 different values for each of three component colors, red, green, and blue (see page 56). Each pixel in a full-color photograph is usually stored as a 24-bit number.

High-bit files let you make more adjustments.

Some cameras and scanners can capture up to 16 hits per color. You can't non or print such fine dis tinctions (16 bits can hold 65,536 values between black and white) but having more data lets you make extreme adjustments without losing quality.

Camera Raw files preserve all the capture data with no loss. If you are using TIFF or JPEG files from your camera, you are accepting the camera's interpretation of what its sensor captured, along with some loss of original data. If your camera lets you download raw files in the camera's own format (see box at left), you can then control the interpretation of sensor data (color balance, tonal relationships, etc.), tailoring it to make an image file that is exactly what you want. More on page 85.

Increasing Bit Depth

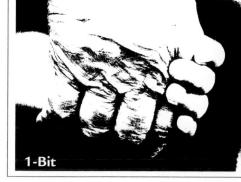

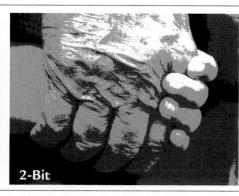

For the same image size, higher bit depth reproduces more tones but requires more pixels. A bit depth of one (left) can reproduce only black or white. A bit depth of two (center) adds two gray shades. An 8-bit image (right) can reproduce all the grays we can perceive between black and white. A 16-bit image divides the tones between black and white even more finely than our eyes can distinguish, allowing more adjustment. For a full-color image, each pixel has at least three 8- or 16-bit segments, one for each primary color.

Digital Color modes, gamuts, spaces, and profiles

Color in digital imaging shows its working parts to the user; the controls and procedures used to adjust color are visible and systematic. Understanding how digital imaging deals with color will give you better control of tools that can help you get the final image you want.

Every digital image has a color mode, a means of defining the colors in an image. Black-and-white photographs are usually stored in a mode called *grayscale*, which saves only light or dark tones, not color. The *luminance* or value (light-ness or darkness) of a grayscale pixel is usually described by one number, between 0 and 255.

When an image has color information that needs to be stored for each pixel along with its value (or lightness), several options are available. The most common in digital photography is the *RGB* mode in which all colors are made by combining the primary colors red, green, and blue (more about primary colors on page 56). *CMYK* mode (cyan, magenta, yellow, and K for black), used by graphic artists, combines the ink colors used in commercial printing.

Three numbers are enough to describe the color of any pixel in an RGB color image. In that mode, one number (between 0 and 255) is a measure of the amount of red in a given pixel, one is the amount of green, and one is the amount of blue. A pixel that is part of the image of a slightly warm-toned concrete building in afternoon sunlight might be described as 202, 186, 144. That pixel contains some red, somewhat less green, and even less blue. (If all three numbers were the same, the color would be a neutral gray.)

You can't print all the colors you can see. All digital capture or display devices—cameras, scanners, monitors, and printers—are slightly limited when compared to human vision. The color *gamut* (a *color space*) of a device is the total of all the colors it can accept or produce. Knowing the extent of this gamut is useful because it is always smaller than the gamut of human vision; it tells us what colors we can see but can't reproduce. More importantly, the gamuts of various devices and materials are different from each other. For example, you can capture some colors with your camera that a monitor can't display. And your screen can show you some colors you can't reproduce with a printing press (or your inkjet printer).

Each image carries with it a working space, a gamut that should be slightly larger than all the other gamuts (monitor, printer, etc.) to allow for translations from one to another without loss. Software (in its *Color Settings* or *Preferences* dialog box) assigns or lets you assign each document a color space—use *Adobe RGB* (1998) or *ProPhoto RGB* if you expect to print the image, *sRGB* for the Web or hand-held devices.

Profiles translate one gamut into another. No two printers, for example, have the same gamut—they can't reproduce exactly the same range of colors. In order to be able to print the same photograph on two different printers and make the two prints look as much alike as possible, you need a profile that describes each gamut. An output profile accompanies each file you send to a printer and adjusts that photograph to the individual color characteristics of that printer. A monitor profile standardizes what you see on your screen so your picture looks the same (or very close to the same) on any profiled monitor.

A gamut is all the colors a device can render. This three-dimensional graph represents the gamut of a monitor, white at the top and black at the bottom. Colors farthest out from the vertical axis are the most saturated. Its outer edges, projected below it, are the limits of what it can accurately reproduce.

Three channels contain the visual

information in a color photograph. The record of brightness (or luminance) in each primary color channel (here red, green, and blue) lets you see the image in full color (below), each color separately, or each individual color image converted to black and white (below right).

Three channels produce three different black-and-white photographs and give you more

choices when you want to convert a color image to black and white. The red channel (right) is the smoothest and most flattering rendering of the man's face. Green and blue have more contrast and give the face more texture.

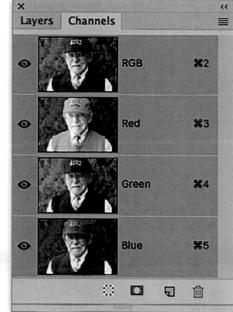

Green

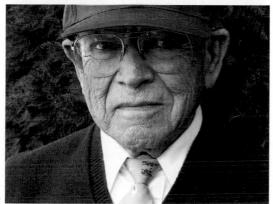

CHANNELS

A digital color image is made up of several black-and-white ones. A photograph on traditional color film or a color print in a darkroom is recorded on three superimposed layers; each is actually a black-and-white photograph rendered in one primary color by a dye. A digital image file in color is the same; every pixel has a separate luminance (lightness) for each of three primary colors. The luminance values of a single primary color in a photograph can be viewed as a monochromatic image (left). Image-editing software lets you see and edit each primary separately.

Digital cameras and scanners capture in the red, blue, and green additive primaries. Unless specified otherwise, this book only discusses images in the RGB mode. Software can convert those to CMYK (the cyan, magenta, and yellow subtractive primaries with black) in preparation for commercial printing in ink.

Your RGB photograph has three *channels*; each comprised of the values of a single primary color. A single channel can be displayed as a mono chromatic photograph, usually in black and white (called grayscale). Photoshop uses a *channels palette* (see left, top), which gives you the option of seeing the red channel, for example, in shades of red instead of grayscale as shown. In addition to seeing each channel separately, you can perform most of Photoshop's image adjustments on any one channel independently. Workflow programs divide an image into channels only in a histogram and allow only limited single-channel adjustments.

More channels can add masks. When you want to apply an adjustment to one part of an image and not another (for example, making someone's face lighter but not the background), Image-editing software needs a map that tells it which areas you want adjusted. A new channel called a mask is created and saved as part of the image file. Masks are ordinarily not visible but you can choose to display them for editing. Photoshop shows a mask as white where you want the image adjusted, black where you don't, and gray where you want only a partial adjustment.

Blue

Digital Color CALIBRATING FOR ACCURACY

Your monitor should be *calibrated,* or made to display colors in a standardized way. After capturing a photograph, you will make most of your color and luminance decisions when looking at it on your monitor. But monitors vary considerably in the way they reproduce any specific set of color numbers. Monitors from different manufacturers will display colors differently; there are differences even between models and sizes from the same maker. In addition, the color response of an individual monitor changes over time, the colors *drift.* You need to know that the colors you see are the right ones.

A *profile* aligns a device to a known standard.

In the case of a monitor, calibration generates a profile; the device is first *characterized*, meaning its color display behavior is measured. This measured behavior is converted into a monitor profile, a data file that—once it is installed in the operating system—corrects your monitor's unique characteristics so it matches a standard. For example, if your monitor displays 202R, 186G, 144B darker and more blue than it should, the computer will use the profile to make pixels with those numbers appear the right amount lighter and more yellow.

Choose one standard for white point and gamma and calibrate your monitor to that. There are two common choices for each, used for different tasks and in different industries. Unless you have specific workgroup requirements, set a gamma of 2.2 and a D65 white point; they are best for photographic printing.

Color management is the practice that assures you of consistent and predictable colors throughout your work, from capture to output. Calibrating your monitor is an important starting point; do so at least once a month, more often for critical work. If you can, set up your workspace so the environment and the lighting are consistent. Changes in ambient light while you are working and even the reflections from colored walls and clothing can affect your perceptions of the colors on a screen.

Monitors, like televisions, should display the right colors. The wide-screen TV sets on display above are all being fed the same signal and should, in an ideal world, show the same colors (they should also be, of course, the right colors). Your monitor can show the right colors, accurate colors, only if it has been calibrated—adjusted with a profile to display colors and tones in a standardized way. For casual picture-making, it is enough to use the calibration utility that is part of your computer's operating system.

For more accurate results, use a third-party calibrating program with a hardware "puck" (a spectrophotometer or colorimeter) that rests on your screen and reads directly from it. Its supplied software generates a measured set of colors, compares the sensor's reading of what is displayed, and generates a monitor profile to be stored in the computer's operating system. Make sure your monitor is thoroughly warmed up (at least 30 minutes) before calibrating.

Some spectrophotometers, like the one shown below, can also be used to generate an output profile for a specific combination of printer, ink, and paper (see page 117).

Working with Camera Raw

Understanding and using Camera Raw files can make your photographs better. A digitally captured picture is only abstract data (see box below) until it is interpreted to look like the scene you photographed. If you set your camera to save pictures as TIFF or JPEG files, this interpreting, or processing, is done by the camera. Most digital cameras can only save in one or both of those formats. But if yours can save Camera Raw files, you can interpret the data yourself later. It is easy to do, gives you more control, and can produce a higher-quality final image.

Software does the job. Most cameras marketed to professionals and serious amateurs can record and save raw files, and are sold with software to process and interpret them. After processing, the software will let you save the interpreted files in another format (usually TIFF) that can be read by other programs.

For most scenes, there is no absolutely "correct" interpretation. The first image you see of any picture is a preview that is only a pre programmed guess at an accurate interpretation. It is up to you to guide it from this starting point. White balance (pages 57 and 58), for example, is not part of the sensor data, but of the interpretation. The raw file saves the setting you (or the camera in auto mode) chose for each shot. That choice affects the preview, but you may process it to be different.

A workflow application (page 87) saves your interpretation along with (or in) the file as a set of adjustment decisions, and leaves the raw data unaltered. Photoshop uses a separate application called Adobe Camera Raw (ACR) to interpret and convert the file into Photoshop's native PSD format. Once a raw file is converted and saved in another format it cannot be returned to its raw state.

Consider converting your raw files to DNG, especially if you plan to use a workflow program. Adobe's Lightroom and Bridge will do the converting, as will their free DNG Converter program, if you choose to manage and edit your files with other software. DNG preserves original sensor data in a form more likely to be readable in the future than your camera's proprietary raw format.

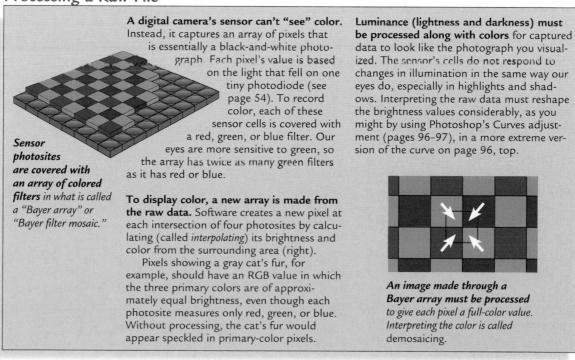

Processing a Raw File

CHAPTER 4

Stay Organized Setting up a workflow

A workflow is an organized series of steps

leading to a desired result. The image-editing workflow on page 110 is an example of the adjustment steps using Photoshop that lead from a raw scan or camera file to an image with the desired colors and tones. Follow the more comprehensive series of steps below to ensure that you get through the entire process of digital photography with the results you want.

Capture your photographs: expose the image sensor or film. Capture is what most people think photography is all about—shooting and camera work—but there's more to it than that.

Download (also called *import* or *ingest*) your images from the memory card of your camera (or from a scanner) into a computer so you can complete the rest of the steps. The computer is the command center for all the operations of your workflow. Downloading the images to your computer's hard drive also frees the camera's memory card to be reused. Scanned images are sent directly from the scanner to the computer.

Convert your Camera Raw files to DNG (optional). As part of a Camera Raw Workflow, you may wish to convert your digital camera's proprietary raw files into the more generic DNG format (pages 81 and 85).

Organize your images, keeping in mind that you may soon have thousands. Pages 131 and 132 discuss ways to make sure you can find the needles in your haystack. Information can slip from your memory if there are long delays between shooting and organizing; try to make time to put your image files in order at the end of every shooting day.

Edit. Editing has two different meanings in a photographer's workflow. The traditional meaning of editing, letting the "good" pictures rise to the top, is actually part of organizing. Workflow applications (opposite) let you code the keepers by assigning a flag, a color, a number of stars, or by sorting similar photos into a stack with the "select," or best one, on top.

Digital image editing, sometimes called *post-processing*, encompasses a wide range of adjustments and alterations to a photograph that can go well beyond the choices that might have been be made when printing an image from film in a darkroom. Workflow software (see opposite page) can perform all the standard image adjustments cropping and rotating, changing size, or modifying hue, value, and saturation—and can drive a printer. Some workflow programs, and Adobe Photoshop, can do much more.

Image editing is used to prepare an image for the next step, output. Because you may have several different uses for the same image, you may edit one photograph into several different versions. Editing has its own workflow, see An Editing Workflow on pages 110 and 111.

Output is not limited to printing, although that may now be your primary focus. Later you may want to show a prospective client your work on a tablet or laptop, or email images to a gallery. Your output may be destined for a billboard or a Web site, as well as a wall. To create the best file for each use will require different editing strategies.

Archive your work in an organized way. In other words, make sure all your original and *deriva-tive* files (the altered or edited versions) not only are safe—preserved against change, damage, and loss—but that individual items may be found and retrieved quickly and easily when necessary.

Digital files present unique challenges for long-term storage (see page 133) but have a big advantage over most materials you'd like to preserve; they can be identically duplicated. A copy of a file (or of an entire drive) is called a backup. All the media on which files can be kept are vulnerable to common threats like theft, fire, and flood, and each has its own set of weaknesses to things like dust, magnetism, heat, and shock. Your best defense is to make multiple copies of everything you do, as early in the process as possible, and to create two or more identical archives that are stored in different locations. A digital file can vanish in an instant; once it is gone_if you don't have a copy_it is gone forever.

Capture

Download

Organize

Edit

Archive

PHOTOGRAPHER'S WORKFLOW PROGRAMS

Photographer's workflow software integrates most of the tools a digital photographer needs. Several similar applications are available—Adobe Photoshop Lightroom, Phase One Capture One Pro, and Corel AfterShot Pro are the best known. They allow you to perform *nondestructive* editing by saving your files in their original camera raw format along with a record of your decisions about tone, color balance, crop-

Lightroom and Capture One Pro let you customize your workspace by showing, moving, or hiding, tools, commands, and previews.

ping, and other characteristics for each picture. The saved adjustments are not applied (no pixels are changed) until you print or otherwise export the file—uploading it to your Web page, for example, or opening it in Photoshop. You can change and alter your editing decisions at any time or save multiple versions of the same image, and never make any permanent changes to the underlying, original file. Because the programs only save your editing commands, rather than an altered version of the entire file, your archive doesn't take up much more disk space than the raw files alone.

These programs include a complete workflow.

Each will download files from your memory card after a shoot, automatically organizing them into folders. You can set the program to rename your files in a group as they download and later use it to tag each file with its own star rating, color label, keywords, and other metadata (see page 131). You can search by keyword and/or rating through all the pictures you have downloaded into the program. You can edit each image for color and tone, retouch, apply sharpening, and then print, upload your photos to a Web site, or make a slide show.

With a workflow application you may not need Photoshop, unless you want to add text or graphic elements, make a composite photograph (pages 106–107), or need to work in the CMYK mode.

Capture One Pro and

Lightroom will, if you have two monitors, display a full-screen preview of the file you are editing on one, along with editing tools and other previews on the other.

Importing an Image

Your photographs are saved on a memory card when you use a digital camera. Most cameras will accept only one kind of card (see some of the styles below) but you will still have choices to make when you want to buy one.

Bigger isn't necessarily better. Cards are flash memory devices made in a variety of capacities. To choose one, know your needs as well as the size file your camera makes. A 16-megapixel camera produces a camera raw file of about 16 megabytes. If you have the camera set to save JPEGs, they will be less than half that size. An 8GB card will let you take over 300 photographs as 16MB raw files.

If you are shooting underwater or photographing a wedding or sporting event, for example, you might want to avoid interruptions by using the largest capacity card you can find. If you work at a slower pace, having several smaller cards might be a better idea.

Cards are rated by their speed too; the ratings refer to how fast the card can read or write data. The write speed usually matters most, because it affects your ability to shoot several photographs in rapid succession. A card's speed might be rated at 133x, which is a transfer rate of about 20MB per second. The speed of some cards is stated directly in MB/s (megabytes/second).

Don't leave your pictures on a card any longer than you have to. Cards and cameras are vulnerable to shock, heat, and magnetic fields; they are susceptible to damage and theft. Once your photographs are transferred to a computer you can make backups to protect against loss. After your files are duplicated and stored in at least two places, you can reformat the card for further use.

CF card (Compact Flash)

Connect your camera and computer with a cable, a wireless link, or remove the memory card and insert it into an appropriate card reader (see below). Some universal readers can accept as many as 12 different card styles, others are barely bigger than the card itself. Like the card speed, a reader's speed affects download time. Because your computer can write any kind of file directly on a card, you can use a spare card like a portable hard drive to transfer files to a service bureau or between home and school.

Transferring from a card to a computer is called downloading, or importing, and it is the best time to rename your files rather than leaving them the way the camera named them (like IMG_0237.CR2). At the same time you can add standard metadata (page 131) like your copyright and contact information, and convert proprietary Camera Raw files into the more universal DNG format (page 81). Lightroom and Bridge (a utility program that comes with Photoshop) will rename, write metadata, and convert each file to DNG as it is downloaded. If you aren't using one of those, get Adobe's free DNG converter from their Web site for the last step.

A card reader lets you transfer pictures into your computer. Most cameras can be wired directly to the computer but the reader won't drain the camera's battery. Make sure you get a reader that is compatible with your camera's memory card. Some different kinds of cards are shown below and left.

microSD

SCANNING

Scanners are the link between film or print and your computer. When you use a digital camera, it captures what you see directly as pixels that can be edited on the computer. But photographs that were made on film need to be digitized first. Scanning is the process that reads color and luminance values from a negative, print, or object and converts it into a pixel grid just as though the picture had been taken with a digital camera.

Scanning software controls the process, and offers you choices about how your image will be scanned, in the same way that software interprets a Camera Raw file (page 85). Your image-editing software gives you many more tools for editing than does scanning software and allows more precise adjustments, but you should make as many color and tone corrections as possible in the scan as well as choosing a resolution based on your final use for the image. Just as making the right choices when exposing an image is better than trying to fix everything in editing, making good exposure, contrast, and color balance decisions when you scan can improve your results considerably. Most photographers make basic corrections when scanning and refine them later.

Scanner Features That Affect Quality

Optical resolution or hardware resolution refers to the number of pixels per inch (or centimeter) the scanner is capable of capturing and is often described by two numbers, such as 3200×9600 ppi (pixels per inch), for flatbed scanners. The first number is the resolution across the width of the scanning area; the second is along its length. The smaller number represents the scanner's maximum optical resolution. Scanning film at a higher resolution than 4000 ppi may have llule benefit.

Dynamic range is the brightness range of an image, the difference between the darkest shadows and lightest highlights. A scanner should capture a dynamic range of at least 3.5. Slides usually have a wider dynamic range than negatives. A scanner with a dynamic range of 4.2 will gather virtually anything on film and will get the most out of difficult originals.

Bit depth measures how many different tones can be distinguished between black and white (see page 81). At least 24 bits per pixel (8 bits each of red, green, and blue) are needed for a continuous-tone print. To maintain quality during later adjustments, 36 (12 bits per pixel) or 48 (16 per pixel) bits are better.

Interpolated resolution uses software to guess what the pixels might look like in between the ones the scanner can actually measure. No real information beyond the scanner's hardware resolution is captured, so it is best to scan no higher than the optical resolution. **Focusing** may be automatic or manual and can be used, for example, to adjust for warped or buckled film frames.

Sharpening is usually an option in scanning software. Sharpening tools in image-editing software are almost always better, so turn off sharpening during scanning and leave it for later editing.

Multiscanning allows scanning one frame multiple times (typically 4 or 16 times) as a noise-reduction technique. Useful with slides, multiscan is not an advantage for scanning negatives because their dark tones become highlights in which noise is hard to see.

Dust removal is provided in some scanners by an extra infrared channel that can be used to detect and remove dust, fingerprints, scratches, and other surface damage from the scanned image. This does not work with conventional black-and-white film or Kodachrome, but it does with most dye-based slides, color negatives, and chromogenic black-and-white films.

Scanning software is an independent program that operates the scanner and produces a TIFF file to be opened in an image-editing program. Some exist also as a Photoshop plug-in that permits scanning directly into Photoshop for further manipulation. Most scanners come with dedicated software. Third-party vendors like SilverFast and VueScan sell scanning software that may be more sophisticated and provide more control.

Flatbed scanners are primarily intended for opaque, reflective originals, like photographic prints. The scanner's hed is a rectangular sheet of glass—inexpensive scanners are letter ($8\frac{1}{2} \times$ 11 inches) or legal ($8\frac{1}{2} \times$ 14 inches) size; professional models may be tabloid (11×17 inches) size or larger. A flatbed scanner will digitize anything placed on the glass: a photograph, drawing, magazine page, or even your hand or face. Some flatbed scanners can accept film using an illuminated cover or a separate drawer.

Film scanners are made specifically for transparencies or negatives and cannot scan anything opaque. The one shown above, left, will scan mounted slides or strips of 35mm or 120 film. Others have a batch feeder that holds a stack of slides. Film scanners that accept medium- and large-format film are generally more expensive than those made only for 35mm.

Professional-level film scanners (above, right) offer higher resolution, greater bit depth, and more dynamic range, and produce less image noise. They are very expensive, but you may find access to one at a very well-equipped school or service bureau.

89

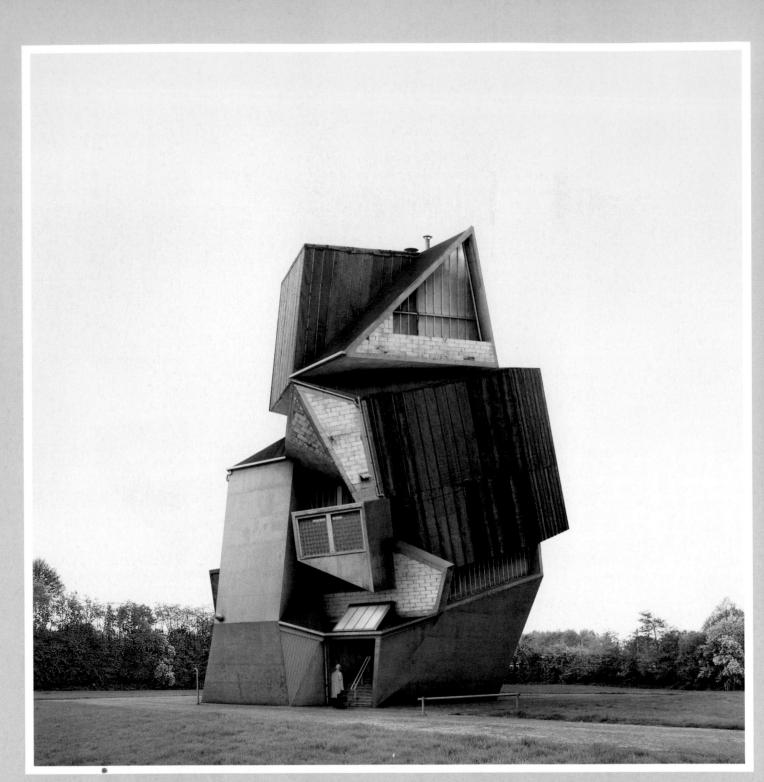

FILIP DUJARDIN

Untitled, 2009. Invention can create an entirely believable environment. Dujardin references the deconstructivist architecture of Frank Gehry in this almost unstable, low-tech structure. It is assembled, fragment by fragment, from his photographs of real buildings. He added a person to "give a certain ambiguity" to its function.

Sophisticated image-editing software has given us the tools to explore the edge of the plausible, as well as making it easy to reach well into the realm of completely invented imagery.

an Image	92
Adjusting an Image	94
Levels	
Curves	96
Adjusting Part	
of an Image	98
Selections	98

More Techniques 100
Layers
Retouching 102
Sharpening 104
Compositing 106
Color into black and white 108
<i>Filters</i> 109
An Editing Workflow 110
Ethics and Digital Imaging 112

Image Editing **5**

In this chapter you'll learn...

- to have a workflow—an orderly series of steps—to take you from a raw image or scan to a finished photograph.
- to adjust the colors, tonal values, and other characteristics of a photographic image using the tools and procedures of Photoshop.
- the challenges of keeping yourself and your images on the legal and ethical side of copyright protection.

ith editing you can simply enhance an image or radically change it. Saving a digitally edited photo preserves all your decisions exactly and produces results of identical quality from one generation of an image to another. Regardless of how much you have manipulated a digital image, once it is finished you can print it now or in six months, a year, or more and still get the same results from the original file. In addition to performing standard picture-adjustment procedures such as changing contrast or lightening and darkening an image, you can combine images, add color, posterize, incorporate drawing or text, and otherwise manipulate a photograph. In effect, you can create a new image with exactly the qualities you want but, if you ever change your mind about what you want, you can always go back and change them.

Editing is deciding. Even before you begin to decide about the tones, contrast, and colors of an individual image, you will probably need to decide among several similar captures to narrow down your pick (your select), for further editing. Workflow applications such as Lightroom (above) give you extensive tools for the job. Two similar photographs taken a few seconds apart are shown here side by side. You can enlarge both at the same magnification to compare critical sharpness and other small details, and replace either side with another from the group. Once you have chosen the pick of the litter you can mark the best with a flag or star and hide the rest "underneath" in a stack so you see only the selects in your filmstrip (at bottom, above) or lightbox (page 87 bottom) view. Review all your photographs before deleting any.

Getting Started Editing an Image

Open your image-editing software so it is running, or active, on your computer. With Adobe Photoshop use File>Open to call up your photograph; you will see a screen that looks like the one on the page opposite. You can also start by opening an image file directly (an image is a data file; your software is an application file). The computer will usually recognize the file type (see page 81) and open the appropriate application automatically. With workflow software, open the application, then navigate to the photograph you want in its catalog or library. The following pages refer more specifically to Photoshop, but most of the adjustments and controls they describe are available in any image editor or photographer's workflow program.

Tools and commands are used to manipulate your photograph in image-editing software. Tools appear as small symbols called *icons*, displayed in a toolbox (the series of small boxes shown at the left side of the screen, opposite) or in an onscreen panel. Word commands, such as Transform, Sharpen, and Print, can be reached from pull-down menus across the top of the screen or as modules within a panel. Palettes, like the Layers palette or Info palette that appear on the screen in Photoshop, provide information in addition to more tools and word commands.

Photoshop's menu commands often require navigating through several nested levels. Click on a menu heading, then on each level in turn; or hold the mouse down as you drag the screen cursor to the command you want. The common notation for such a sequence is, for example, Image>Adjustments>Curves.

Back up your file before you make any changes to it, see page 133. In Photoshop, use File>Save As and give the working file a slightly different name. Then you can experiment and still have the original to go back to.

Learn to navigate around the image. You can see the entire picture at once or zoom in to any magnification. The window in which the picture is displayed can fill the monitor's screen or be any size smaller, and you can display or hide palettes, panels, and tools. It helps to have a large monitor (or two, as shown below) so you can make your image large enough to make accurate adjustments and not have part of it covered with palettes and tools.

Workflow programs make excellent use of a dual-monitor setup. You can display all the images from a recent shoot or project on one screen (small previews called thumbnails in a *filmstrip* or *grid* view) and a full-screen version of a selected image on the other. You can also display larger versions of two or more images on the second screen in order to compare similar shots, for example, of the same portrait subject to select the best expression.

Start by making the image the right shape.

Rotate the photograph and crop it if needed. You can usually undo a command, or several, if you change your mind. Raw-format workflow programs let you go back one step at a time, all the way to the unadjusted original file; Photoshop limits how many editing steps you can undo, but you can always start over from your backup file. Don't hesitate to do so; you can learn by simply opening an image file and experimenting with various tools and commands.

More is better, when it comes to monitors. You don't have to be working with panoramic images, as shown here, to make good use of more "screen real-estate," as it is called. Larger screens, or multiple displays, let you isolate an image and keep it separate from menus, palettes, and other software displays.

Menu headings open to reveal commands. Here, the Window menu is open; it lets you display different palettes on the screen. Click on a checked (open) item to close it if your screen seems cluttered. **Palettes** provide information as well as various ways to modify images. Click on the menu icon at the top right to reveal other commands and options.

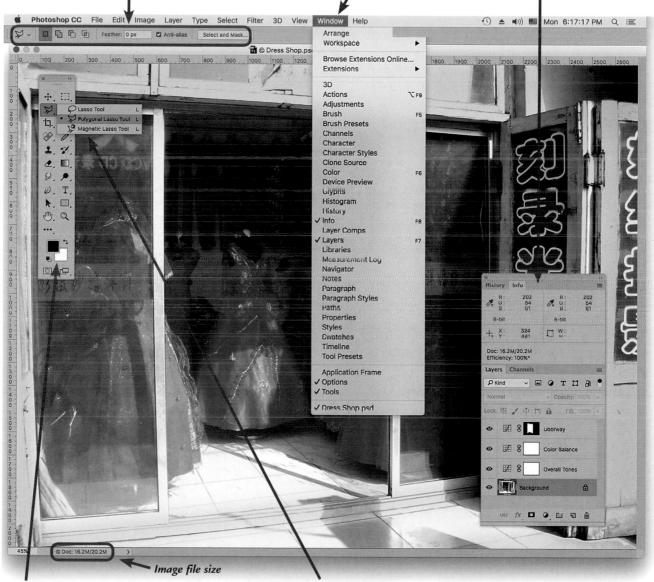

Toolbox, where commonly used editing tools reside on screen. Select a tool by clicking on it. You can then define its characteristics in the Tool Options Bar at the top of the screen. **Tools with arrows to the right** provide access to related tools. Click on the tool shown and hold the mouse button down to see and select other versions. **Plug-ins offer more options.** Plug-ins are add-on software modules that expand editing capabilities—they create borders, add special effects, operate scanners and cameras, and more. Plug-ins are available from several software companies; you can download free, time-limited trial versions of most.

Adjusting an Image

Levels is a simple and rapid way to adjust the tones in an image using a histogram. The same control is also incorporated into the more complex and powerful Curves adjustment (pages 96-97). Sliders let you adjust the brightness separately for dark, middle-value, or light pixels (shadows, midtones, or highlights). After setting the exact tones that will become black and white (while preserving shadow and highlight detail), you can lighten or darken the middle tones without changing the extreme highlights or deepest shadows. This page shows images in black and white, but you can set Levels separately for each channel to make rapid color balance adjustments in color photographs. Moving the red channel's midtone slider to the left, for example, will make the image more red.

Choose Layer>New Adjustment Layer> Levels to generate a histogram that guides your Levels adjustments; they can later be altered or discarded (see Adjustment Layers, page 100).

The photographer wanted more contrast in this scanned image of a road through a forest. He used Levels to adjust the dynamic range exactly by setting white and black points (see opposite page) that were just right for the printer he used.

Setting and Using the Eyedroppers

Photoshop lets you define specific white and black points so you can keep detail easily in highlights and shadows. The settings remain in place as the default setting for any file you open until you change them; these values should apply to most inkjet printers, but test first and set your own values.

Open the Levels dialog box (shown opposite, top) for any image. Double-

0 # #

click on the blackpoint eyedropper at the bottom right of

the dialog box. This will open the Color Picker box (right). Set the Red, Green, and Blue values at 10 to define the darkest black with some detail. (Zero in each color would produce a black with no detail.) Click OK.

Double-click on the white-point eyedropper to reopen the Color Picker box. Set the Red, Green, and Blue values at 244 to define the brightest white with detail. Click OK. Once these values are set, you can quickly adjust highlight and shadow values (and simultaneously neutralize their color) in any image. Open Levels, select the shadow eyedropper, and click it on the spot in your image you want to be the darkest black with detail (see box, right). Repeat for the highlights using the highlight eyedropper. This three-eyedropper icon is repeated for setting values in several other Photoshop dialog boxes.

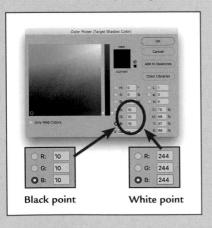

Seeing the White and Black Points

Photoshop lets you see your white and black points so you can choose where to

use the eyedroppers. Open the image and then the Levels dialog box. Hold the Option key and move the highlight slider (opposite, top). The lightest pixels are the first to appear. At any position, the pixels to the right of the slider will be displayed as white, the others black (left, center). Holding the Option key and moving the shadow slider reveals the black point (left, bottom).

At each slider position, you can see exactly which pixels will be set to white or black if you leave the slider in that position. See opposite, top center.

The histogram from this photograph's scanned negative shows that the tones of the image are not distributed throughout the available tonal range, represented by the numbers from 0 to 255. Empty space at the ends of the histogram suggests that, if left uncorrected, the shadow areas will be too light and the highlights too dark, making the flat image on the opposite page.

The Levels dialog box shows the histogram but also gives you tools to adjust the image. The left-hand slider (black triangle) sets the black point, the right-hand slider the white point. Moving them to the ends of the captured information sets the shadow and highlight areas of the image closer to white and black. The middle slider changes the gamma making the middle tones darker or lighter.

A histogram of the final image (below), after pressing OK to apply the change, shows a broader distribution of pixels between the pure white and pure black endpoints. With a color image you can separately set the black, white, and middle points for each component channel. Separate adjustment of the middle sliders alters overall color balance.

Tom Tarnowski. Cumberland Island, Georgia, 2001.

Adjusting an Image CURVES

Curves is a graphic way to view and make tone and color changes, a kind of multi-tool for making a photograph look exactly the way you want. In image editing, a curve is a standard graphic representation for adjusting the values, or lightness and darkness, in an image. Photoshop's control of the same name allows you to adjust independently and with great precision—the image tones and contrast of each primary color as well as its black and white points.

Layer>New Adjustment Layer>Curves opens a dialog box like the one shown opposite, right; its main features are a square graph with a corner-tocorner diagonal line and a histogram overlay of the image. The graph plots *input* (existing brightness values) on the horizontal axis, against *output* (those same values in your picture after the adjustment) on the vertical axis. Shadows are at the bottom and left, highlights at the top and right. The exact center of the graph is 128/128: middle gray input, middle gray output. A 45° diagonal line means that the output values will be the same as the input values, no tones change.

You can put an adjustment point anywhere on the line and move it. The line becomes a smooth curve that passes through that point. If you click on the middle (128/128) and move that point straight up to 128/140, the "after" (output) value of anything that was a middle value increases (gets lighter) and so do all the other tones along the curve. See the top photograph on this page. The middle values have moved the farthest from the original diagonal; darker and lighter tones will change proportionately less.

The shape of the curve (or of any section) indicates contrast. A steeper slope is higher contrast; more horizontal means lower contrast. Increasing contrast in one part of the curve means losing it somewhere else. Up to sixteen points can determine how the tones are altered. If you want to remove a point, just pull it off the side of the graph.

Like Levels, Curves can be applied directly rather than as an Adjustment Layer (see page 100) but the changes are permanent. A similar adjustment can be found in any workflow program.

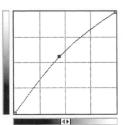

Move the curve up to lighten all the tones in the image. Middle tones are displaced the most.

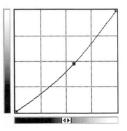

Move the curve down to darken all the tones in the image. Very dark areas don't change much.

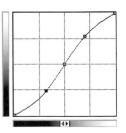

This S-curve makes light tones lighter and dark tones darker, raising the contrast.

This S-curve makes light tones darker and dark tones lighter, lowering the contrast.

Several points can be added to the curve to adjust the tones very precisely.

The curves for each channel can be adjusted independently. Here the blue channel is lightened in the highlights—visible in the road—and darkened in the shadows; the red and green channels remain unchanged.

Reducing blue (darkening) is the same as adding its complement, yellow. In the shadow areas this is most noticeable in the green of the trees.

In practice, very small adjustments of this sort are the most useful.

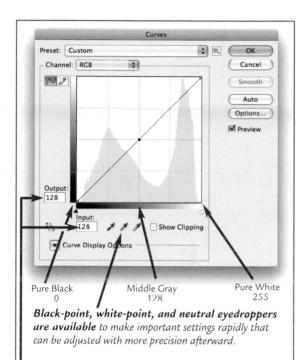

Exact Input and Output numbers are shown as you add or move points on the curve.

Lawrence McFarland. Farm entrance near Assisi, Italy, 2002.

Adjusting Part of an Image

SELECTIONS

Selecting an area lets you edit or adjust part of an image instead of all of it. All the pixels in a subject may be selected or just one. You may choose to select pixels in a geometric shape like a square or to follow an outline to select all the pixels that form a particular image, for example, of a bird. Your selection may encircle one shape or be formed of several separate pieces. And importantly, pixels can be partially selected, in addition to entirely or not at all selected. Workflow programs allow basic adjustments of a selected area (calling the selection a *masked* area that is chosen by brushing or painting) and can automatically identify edges to help you create a precise mask.

A selected area is like a separate picture. It can be made darker or lighter—called burning or dodging, as in a conventional darkroom. In addition, its color, contrast, or saturation can be changed. With Photoshop, a selected area can be made larger or smaller, it can be rotated or distorted, or it can be moved to another part of the picture or to another picture entirely. Selecting is the first step toward compositing—assembling an image from separate pieces (see pages 106–107).

The selection itself can be edited. You can add to and subtract from a selection, expand or shrink it, or feather its edges. *Inverting* a selection changes the selected pixels to unselected and vice versa. Selections can be saved with the document, to be brought back, or *loaded*, later. Photoshop provides many different tools for making and altering selections (opposite) because it is such an important part of the digital editing process.

Adjustments will be made only to the selected area. For example, if you select an area, then apply a Levels adjustment, it will only affect the selected pixels. Partially selected pixels (such as those made by feathering an edge) will be partially adjusted. Making an adjustment layer (see page 100) when pixels are selected makes changes only to those selected pixels and lets you later adjust those changes. The selection, saved as a mask (opposite, bottom), may also be later adjusted.

Selecting the object makes it possible to adjust its tones separately from the background. Once the overall colors and values look good in the photograph at left, the glass butter dish in the middle of the scene is too dark and has a color cast.

Following its outline with the Lasso tool (see opposite page) turns the object into a selection and lets a separate Curves adjustment make it an eyecatching centerpiece.

The selection of an object can be inverted to select the background. Once the background is selected, any of its characteristics, including its color, can be changed, below. It is also possible—and very frequently useful—to eliminate the background entirely, right.

The toolbar displays selection tools and their variations.

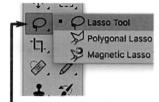

Tool variations show in a submenu accessed by clicking on the tool's icon.

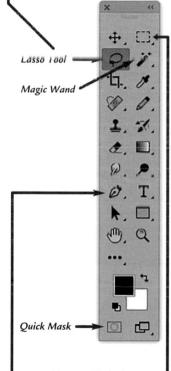

Marquee Tool selects geometric shapes. Its options include square and rectangle, circle and oval.

Pen Tool makes smooth and precise outlines called Bézier curves that are the mainstay of drawing and illustration software. Its use is less intuitive than other selection tools and takes a bit longer to learn.

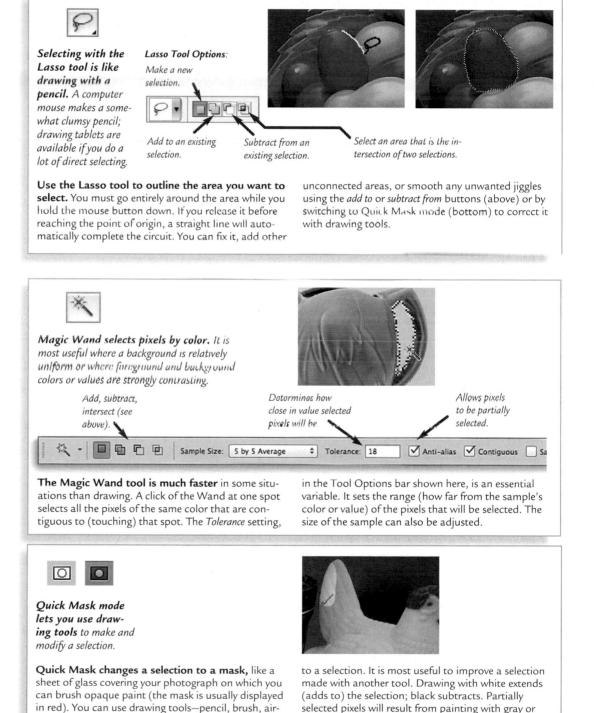

brush-to reshape the mask and then change it back

99

using a feather-edge tool.

More Techniques

_ayers may be Photoshop's greatest feature

and one that most clearly sets its abilities apart from photographer's workflow programs. Adding a layer to your image is like putting a sheet of clear glass over a print. You can draw on the layer or make alterations that change the image below the layer, but you can still take it away to reveal the unchanged picture. And you can add another layer and another (Photoshop lets you add thousands) that are individually editable, removable, and—except for what you put on them—completely transparent.

Layers make it easier to composite a picture, assembling elements from more than one image. Each part of your picture can sit on an individual layer, which you can then move and change and move and change again, until your final image looks the way you want (see pages 106–107).

Adjustment layers let you make tonal chang-

es, using Curves, Levels, or other tools, without permanently altering the original, underlying image. Use Layers>New Adjustment Layer; then you can revisit your changes and modify them at any time, the way you can in a workflow application. When you need to finalize your decisions, to print, for example, you can *flatten* the file to make the adjustments permanent, but you can—and should—keep a copy of the unflattened file.

The direct use of Levels, Curves, or almost anything else that alters a picture, causes the software to discard some information when it applies the change. If you darken a picture, for example, and later you decide it should be even darker, more information is discarded. Each time, the image is further degraded.

Using an adjustment layer for such changes avoids this problem; the settings you choose affect the image that is displayed or printed but they don't change the pixel values in the original file until you choose to flatten it. All settings can be changed—or discarded—without loss. Photoshop's "smart" filters are also on the list of non-destructive adjustments. The most important of these filters is sharpening; you can change the amount you apply to an image for each different output.

The second layer, a Curves adjustment layer shown at right, adds contrast. Each additional layer affects only those that appear below it in the Layers Palette, far right.

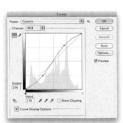

Two layers make all the adjustments this photograph needs. The first layer (shown below left) makes some areas lighter and others darker, the same way you might apply burning and dodging if you were printing in a darkroom.

To make it, Layer>New> Layer was opened. In the dialog box Mode: Overlay was selected, then Fill with Overlay-neutral color was checked. The Overlay layer fills with middle gray but nothing but its effect is visible unless you turn off the background layer's display by clicking its eye icon. Making the Overlay layer's neutral gray lighter or darker with any tool—even if you don't see it—lightens or darkens the underlying image. The foreground roof is lightened. A gradient darkens the sky gradually toward the upper left corner.

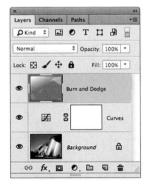

Peter Vanderwarker. Peter B. Lewis Building, Case Weatherhead School of Management, Cleveland, Ohio, 2003.

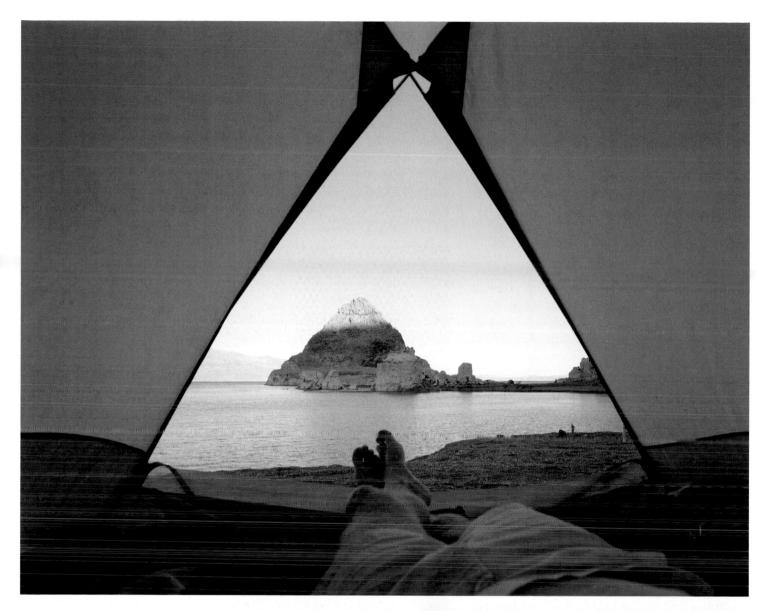

Mark Klett. View from the tent at Pyramid Lake, 7:45 AM, Nevada, 9/16/00. Adjustment layers control individual areas when they are applied through a mask. A selection (made with the tools on pages 98–99) creates a layer mask so an adjustment can affect only the area you choose. Layer masks are shown as a small image in the layers palette, left, with an icon for the type of layer. Naming the layers helps keep track of what they are for. By creating several different masks, each filtering a separate adjustment layer, Klett lightened parts of the tent floor (the selected layer at right), made the sides of the tent appear to be the same brightness, and deepened blues in the sky and water to accentuate the early morning sunlight.

Each layer—and its mask—can be changed or deleted at any time without affecting settings of any other layers. After building a final image like this, one layer at a time, Klett makes a small proof print to see if any of the layers need to be further modified before making a final print at full size.

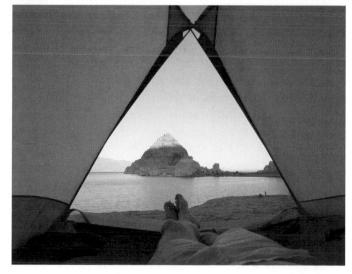

The original scan from Mark Klett's large-format color negative looks passable but it needs some work to bring out its full potential, shown above. Klett began with a curves layer to set black and white points and the overall color balance. A luminosity layer makes small adjustments to the tones and contrast without affecting the color. Other layers are added for further, more subtle, adjustments.

CHAPTER 5

101

More Techniques

RETOUCHING

Digital capture avoids almost all unwanted specks generated by the process. Only if you get dust or a scratch on the sensor should you need to cover up such flaws through retouching, essentially painting over part of an image. Scans require this kind of attention; it is nearly impossible to keep a negative or print (and the scanner itself) perfectly clean during scanning.

"Improving" someone's complexion in a portrait is also called retouching. Regardless of the reason for retouching, you make changes once and save them. For minor (but careful) retouching of small areas in Photoshop, you can alter your background layer directly-assuming you have saved a copy. For major alterations, such as those on the photograph below, make a new duplicate layer to retouch. Go to Layers>Duplicate Layer, and then perform your corrections on the new layer.

To repair damaged photographs or to remove unwanted specks and scratches, various tools are available in Photoshop, such as the clone stamp, healing brush, smudge, focus, toning, and sponge tools, along with the patch tool shown at right. Before you begin, adjust the image for contrast, brightness, and, if working in color, color balance.

Workflow programs include retouching tools that are especially useful when dust on your camera's sensor marks each image in the same location. Within any catalog of images you can instantly apply one picture's retouching to a selected group of others.

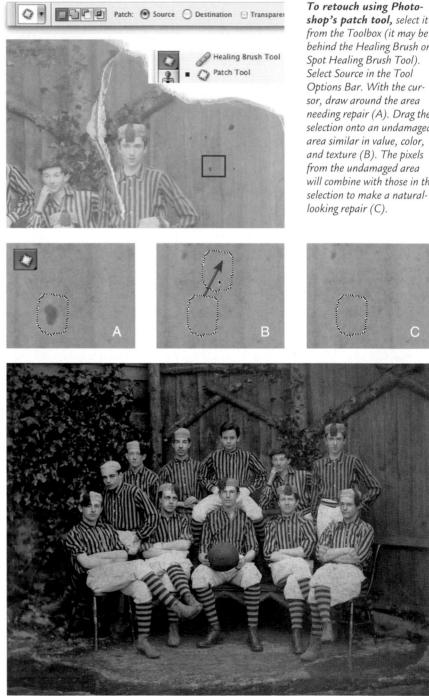

For best results, build up a repair slowly. Work in layers to protect the original image. Found at a flea market, this torn and faded old photograph was scanned, then retouched just enough to restore the original appearance of

the image. Adjustment with Curves brought the tones back to an approximation of its unfaded state. Some drawing skill can help in replacing a large damaged area; the key is to borrow bits from other, similar areas in the picture.

102

from the Toolbox (it may be behind the Healing Brush or Spot Healing Brush Tool). Select Source in the Tool Options Bar. With the cursor, draw around the area needing repair (A). Drag the selection onto an undamaged area similar in value, color, and texture (B). The pixels from the undamaged area will combine with those in the

Michael Schäfer. Aufzug (HGB), 2002. **Retouching can work miracles.** Here, the photographer removed every trace of himself and his camera from the mirror inside an elevator, with its door closed, to achieve a hauntingly surreal image that suggests a journey—up or down—into the existential.

More Techniques

SHARPENING

Sharpening improves most digital images

but won't save a photograph that was made out of focus. It is an important adjustment that should be applied to all scans and digitally captured photographs, usually just before printing or other export. Generally, more sharpening is needed for digital capture than for scans from film. JPEG files are sharpened by the camera but you should sharpen all captured TIFF and Camera Raw files.

The amount of sharpening for best results depends on a number of factors, one of which is the resolution used for a particular output. Because you may want to put your file on a Web site as well as making a print (or make differentsized prints from the same image), sharpening should probably not be applied as a permanent alteration. If you are using a workflow application or Photoshop CS3 (or later), sharpening can be changed each time you send an image to a different output. With earlier versions of Photoshop, save an unsharpened version of your file.

Unsharp masking (USM) means sharpening.

The seemingly contradictory name is a legacy from darkroom photography, a way of improving sharpness by placing a slightly out-of-focus negative in contact with a film positive, or slide, during enlarging. The result of this film sandwich is increased contrast at the edges of objects, the same effect you introduce to an image using digital sharpening.

The sharpening tool or filter identifies areas of transition, for example, from dark to light or from red to yellow, which our eyes tell us are edges. Then it exaggerates the transition. Making dark pixels darker only when they are near light pixels, and vice versa, creates a subtle halo around edges that we perceive as enhanced sharpness.

Sharpen for the output. Higher output resolution, usually for a larger print, requires more sharpening. A file printed on an inkjet printer needs different sharpening than you would apply to the same file sent to an offset press. Even the paper matters; uncoated papers and matte surfaces need a little less sharpening than glossy paper. Always judge the sharpening by displaying your

All scans and digital captures need sharpening. The Unsharp Mask filter increases tone differences between adjacent pixels to make the image appear sharper.

Too much sharpening is as bad as not enough. When you see obvious halos around fine details in your image, you have gone too far. Use the preview option on screen to compare before and after, viewing at 100%.

onscreen image at 100% (also called 1:1); even better, make a proof on the printer and paper you will be using for your final print.

Some photographers prefer to use a two-step sharpening process for digitally captured files: input sharpening based on the specific camera and output sharpening based on the subject and the file's destination.

Sharpen for image content. A landscape may require different treatment than a cityscape. Sharpening for a portrait will need a different approach than for a forest scene. Facial skin is a special concern because sharpening enhances texture and blemishes, usually undesirably. For portraits, you may have success using an increased radius and lower amount, or by sharpening only the red channel in RGB or the black channel in CMYK. Photoshop's High-Pass filter is useful for confining sharpening to prominent edges. You may want to apply sharpening through a mask, as was done in the photograph opposite. And there are several ways to apply sharpening by hand, brushing it in around eyes and hair, for example, while leaving the rest of a face unsharpened.

The right amount of sharpening makes details and edges crisp without sacrificing smooth tones. Different pictures and different uses need different amounts.

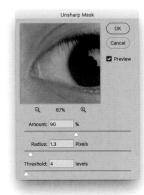

Select Filter>Sharpen> Unsharp Mask... in Photoshop. Its dialog box lets you set the filter's three variables, Amount, Radius, and Threshold, and to view a preview to see how your choice of values affects the image.

Radius controls how close to an edge the sharpening occurs; use values from 0.5 to 3, higher numbers for higher resolution files. Amount affects the contrast of sharpened pixels, values between 50 and 200 are common for photographs. Threshold determines how different a pixel must be from its neighbors to comprise an edge pixel. Low values sharpen more of an image. Start with 3–5.

Similar controls are given in workflow programs; Aperture has Intensity and Radius, with a separate control for edge sharpening. Lightroom uses sliders for Amount, Radius, and Detail, with a fourth slider for Masking—the equivalent of edge sharpening. Jim Scherer. Fork with Peppers, 2006. Sharpening must be applied carefully when out-of-focus areas are particularly important. Scherer wanted just the in-focus areas to stand out crisply, so he used a softedged selection as a mask to sharpen only the two pepper slices in the center. Sharpening out-of-focus areas in digitally captured photographs like this one risks enhancing granularity and noise.

More Techniques

COMPOSITING

Digital editing was invented for composit-

ing, or so it might seem. The kinds of images that have become most closely associated with digital photography are the invented spaces and impossible situations that we see everywhere in advertising. It is not that such *composited* (combined from several sources) images weren't possible with conventional photographic techniques (see photos below and on page 112), but it was always very difficult and often prohibitively time consuming to do so. Assembling an image from parts requires complex and extensive editing tools; workflow programs do not provide features for compositing.

Mastering the composite takes some effort even with a computer to help. Learning the tools takes some time, but is not the real challenge. Learning to think ahead and to create and assemble parts that fit together visually—that requires practice, clear thinking, and attention to detail. **Consistent illumination is most important** to make everything in your image believable. If you take people from a photograph made on a sunny day and drop them into an overcast landscape, it won't look right no matter what you do. Few viewers will be able to tell exactly what the problem is, but everyone will find viewing the image a little uncomfortable.

Display several images at once when you combine elements from multiple pictures. A large (or second) monitor helps when you want to have several files open and still see your tools and palettes. The Info palette provides useful measurements to maintain consistency among different elements, as do the rulers that appear on two borders of each window. Keep each element on a separate layer. You can make an adjustment layer (see page 100) that is *linked* (attached) to each and won't affect any other layers.

Francis Frith. Hascombe, Surrey, c. 1880. **The composite photograph is not new.** To "improve" this 19th-century English landscape, Frith cut a horse and cart—along with their convincing shadow—from another photograph and pasted it onto the original photograph.

Julieanne Kost. Isostacy, 2007. *To create this surreal montage,* Kost combined a scanned painting with digitally captured photographs of unrelated landscapes and textures.

Isostacy (or Isostatic equilibrium) describes an object in balance between two media, the way scientists would describe an iceberg with its portion in the air betraying a hidden mass in the water below.

Kost bogan by scanning an encaustic (wax) painting she had made (above), and darkening its edges with a mask (below). She keeps each element and its adjustments in separate layers as the piece is being assembled; it allows each to be further altered as the work bocomos more complex.

The clouds come from this photograph, with the barn and its foreground and background masked out. The trees (right) were also masked to fit.

The landscape is a separate layer, as is the mask that blends its edges into the background. The mask can be displayed in red or in black and white.

The final touches are textures added from pictures of rust (above right) and bubbles of sea foam (right). Both were incorporated as layers with reduced opacity so they don't overwhelm the image of clouds on a layer beneath. The finished composite image has twelve layers.

107

More Techniques color into black and white

Color channels can be blended together in image-editing software. With Capture One Pro's *Black & White tool* and Lightroom's *Grayscale Mix* you get sliders similar to those you can call up in Photoshop by choosing *Black & White*, an adjustment under the Image menu. In each of the programs you can control the proportion of each primary color channel that will be incorporated into the resulting black-and-white image while you watch the on-screen preview change.

You can set many digital cameras to capture in black and white. The camera will produce a grayscale JPEG or TIFF image, and the camera's monitor will show a black-and-white preview. If your camera is set to capture a Camera Raw file, however, a black-and-white image will show on the camera's monitor but all the color information will still be present in the saved file. You can then control the conversion to grayscale, as described above, with image-editing software.

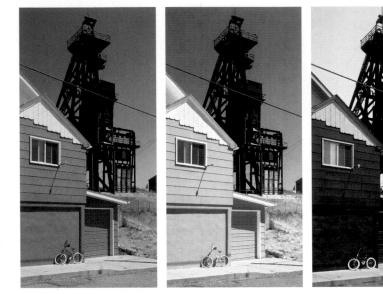

Very different black-and-white renderings can be made from the same color photograph leading to different interpretations of their content. Image-editing software gives you the opportunity to make a controlled blend

from the three channels. The center image above, for example, incorporates a high proportion of red and green but little blue from the left-hand image, and leads to a brighter image than the one on the far right.

Infrared Black and White

Digital camera sensors are covered with a filter that blocks infrared radiation but it is still possible to make black-and-white photographs using that invisible energy just beyond the spectrum of visible light.

The effectiveness of infrared blocking filters varies from one camera model to another, but fortunately none blocks infrared completely. Cover your lens with a filter that blocks visible light and passes infrared, like a Wratten No. 87, Hoya R72, or Heliopan RG715. With visible light removed, whatever the sensor receives will be infrared. But it will be very little radiation, and you will need a long exposure—usually more than a second in daylight even at your widest aperture. Trial and error should lead to satisfactory results.

If you are very serious about shooting infrared black and white with a digital camera, you can dedicate a camera to that purpose by removing the IR-blocking filter from its sensor. A little online searching will turn up (somewhat complex) instructions for those who are technically inclined. Some camera-repair shops will be able to modify your camera.

Jingbo Wu. Indian Ruin, 2007. **Foliage looks white in infrared** and skies go nearly black, making possible very dramatic landscapes. Wu bought an inexpensive DSLR on eBay and followed instructions he found on the Web to remove its IR-blocking filter. A Hoya R72 filter covers his lens.

FILTERS

Filters are playful and can lead to the strange and unexpected. The photograph at right was subjected to a sampling of filters, as shown below.

Chrome filter

Craquelure filter

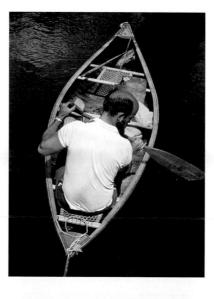

Glass filter

Stamp filter

Filters are automatic—and often exotic image manipulations. In Photoshop they go by self-descriptive names like Colored Pencil, Twirl, and Glowing Edges. If the ones that come with your image-editing program aren't enough for you, independent developers offer hundreds more for sale as plug-ins (see page 93). You can add plug-in filters to workflow software, too. But Filter is also the name such programs usually give to search criteria when you want to find, for example, all your one- and two-star pictures of trees.

Look under Photoshop's Filter menu for many different options, or choose Filter>Filter Gallery to browse through them at random. Each gives control over several variables. For example, the Stained Glass filter lets you set different values for cell size, border thickness, and light intensity. The variations are endless and, if you select "Convert for Smart Filters," re-editable.

Be careful, filters are like candy; restraint is advised. They are appealing confections but it is easy to overindulge. Remember also that exactly the same zoomy special effects are available to the millions of other users of Photoshop, and their arbitrary use can easily appear to be a cliché. Many filters belong in your toolbox, especially if your task is illustration, but don't assume that because you've never seen the results of the Craquelure filter, no one else has either.

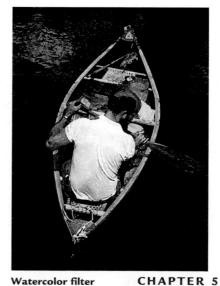

Watercolor filter

An Editing Workflow

Here is an outline of the basic steps to a finished, printed digital photograph using Photoshop.

- **Open the file and save a duplicate.** Use File>Save As and give a new name to the version with which you'll be working. Make sure your original, raw file is archived properly (see page 133.)
- 2 Rotate and crop the image so the edges of the frame are exactly where you want them. By cropping you can choose an aspect ratio more suited to your vision than the one dictated by your camera's sensor or the film's frame.
- 3 Retouch (page 102) to remove dust, scratches, or spots. Scans generally require retouching; photographs captured with a digital camera may not.
- 4 Add a Levels or Curves adjustment layer. Use it to set the black and white points and the overall color balance (pages 94–97). Remember that with adjustment layers you can make more changes later. Make general adjustments first, then fine-tune them after your other adjustments have been made.
- **5** Make other overall adjustments. A Curves adjustment layer in the Luminosity mode lets you adjust tones and contrast without affecting color. A Hue/Saturation adjustment layer is often useful to reduce the color bias of some scanners and digital cameras or to increase the vibrancy of selected colors.
- 6 Make local adjustments. When the overall image has been improved, if certain areas need individual attention, make a selection and add an adjustment layer with the selec-

tion in place (page 98). Both the selection (automatically saved as a layer mask) and the adjustment can be later edited. Add as many individual adjustments as you need, but keep in mind each one adds to the file size, makes each successive step take a little longer, and fills your storage space faster. Save the full-size, layered file before continuing on to resize, the next step.

- **Resize if necessary.** It helps to know how you'll be using a picture—on a magazine page, in a Web display, or making it into a poster—to know how big a file and how much resolution you need. Some printers make the best print if the file matches their *native* resolution, often 300 or 360ppi.
- 8 Sharpen the background layer. If you need to use the photograph for a different application or print it at a different size, go back to the unsharpened full-size file with all its layers, resize and sharpen a copy for each use. See pages 104–105.
- **9** Soft proof and print your photograph (see page 118). Flatten the layers before printing, emailing, or exporting to the Web. Think of your first print as a test. Are there changes to make? If so, use the History palette to go back to the sharpened, layered version.
- **1 O** Make any necessary final adjustments. Make a final print. Once you are satisfied with the print, go back to the full-sized version of the file if you resized it for printing, make the same final changes, and save it.

Dionisio González. Paulistana Ajuntada, 2006. Digital tools let González suggest the future of a city. He photographed the irregular neighborhoods and chaotic shantytowns of São Paulo, Brazil that are giving way to demolition and rebuilding by the government. Through digital manipulation, he proposes a recycling "intervention" that inserts segments that appear to be modernist structures into the threatened spaces.

A workflow for this kind of imagemaking may start with workflow software for importing and organizing the elements, but the final assembly depends on the layers and compositing tools available in Photoshop. Your editing workflow may be more efficient if you use a workflow application. Adobe Photoshop is used by professionals in many areas besides photography; it serves the graphic arts, the printing industry, and video, as well as fields such as medicine and science. As a result, it has numerous features that you probably won't need. It was constructed to let images become whatever anyone can imagine, one at a time.

Workflow software has been tailored to the basic tasks of photographers, so one of these programs may do everything your work requires. Using either program, all editing decisions listed on the opposite page can be applied in any order and re-adjusted at any time before you print or export a file. Changes in such qualities as color, lightness, and saturation may be brushed on or applied through a mask. Sharpening may be applied in stages, some during import, some to the image you see and manipulate on the monitor, and more later for output. Size, shape, and resolution decisions are applied only to the finished product, not to the original file.

Adjustments and settings may be saved as a preset and applied simultaneously to a group of images. These presets may be applied when you download your images or later, to a selected group. With only a couple commands, a wedding photographer may turn hundreds of pictures from one memory card into sepia-toned black and white as they are imported, and print them as a sequence of two-by-three-inch proofs, twelve to a sheet of letter-size paper, with a number under each small image and the photographer's copyright and contact information at the bottom of each sheet. Your own workflow can be customized and saved.

CHAPTER 5 2 111

Ethics and Digital Imaging

Just because you can alter an image, should you? Digital methods haven't substantially changed the laws or ethics of photography, it has simply become much easier to violate them. Now that almost anyone can make extensive changes in a photograph that are sometimes impossible to detect, the limits of acceptability are constantly tested and debated.

Has photography lost any claim on accurate representation of reality? For a 1982 *National Geographic* cover, digital image editing was used to move one of the Pyramids of Giza a little for the cover photograph so it would better fit the magazine's vertical format. When some readers objected, the change was defended as being merely "retroactive repositioning," the same as if the photographer had simply changed position before taking the shot. Was it different? The magazine eliminated this practice.

Photojournalists usually follow fairly strict rules concerning photographic alterations. Generally, they agree that it's acceptable to lighten or darken parts of an image. However, many newspapers don't allow the use of digital editing to, say, remove a distracting telephone pole or, worse, to insert something new.

Advertisers often take considerable leeway with illustrations. We have come to expect exaggeration in advertising, as long as the products are not misrepresented. Few people would object to the altered photograph, above right, even when the advertiser doesn't mention a change. But would the same image be acceptable without explanation if it ran with a news story?

Photographs in fashion advertising are often digitally retouched to make the models appear thinner. Is it possible that exposure to these idealized images contributes to eating disorders?

Working photographers are concerned about financial matters, and reasonably so. When your efforts result in something you can sell, you probably think it is stealing if someone uses what you have made without asking. How can you protect your rights when images are easily accessible electronically? How can you collect fees for use of your work when images, after they leave your hands, can be downloaded or scanned, altered, and then incorporated in a publication? When, if ever, is it acceptable for someone to take your image and use it without permission or payment? The law is continually redefined by court cases. Each new copyright infringement lawsuit makes the line a little clearer but there are still more questions than answers. One of these photojournalists is not really there. This photograph of all the members of the photo agency VII was originally commissioned for a magazine. By the time it was selected for the camera company's ad, one of the members had been replaced. The new member, at the far right, was shot in the same New York café in the same position as the man he replaced, then added to the picture digitally.

Matthew Brady. Sherman and his staff, 1865. **Altering the guest list is not new.** This widely distributed photograph of William Tecumseh Sherman and all his generals (above left), taken just after the Civil War ended, includes General Francis P. Blair at the far right. Blair, however, missed the sitting, so Brady photographed him separately later, pasted a cutout into a print of the group (above right), and rephotographed the composite to make a new negative.

Joan Fontcuberta. From Sputnik, 1997. Many of Fontcuberta's works tamper with reality. In Sputnik, he fabricated a gallery installation and invented a book-length story in which the existence of a Soviet cosmonaut lost in space during a shuttle mission is covered up by embarrassed officials.

Above, using a real Soviet government

photograph (bottom), the artist added the astronaut (actually Fontcuberta himself) into the image (top). In his story, he redefines the top photo as the original one and the bottom photo as the one altered by the government. The "evidence" appeared so real that the exhibit drew protests from a Russian ambassador. Reality is whatever you can Photoshop it to be. **Digital editing raises ethical questions in the fine arts as well.** It is easy to scan a photograph from a magazine or download one from the Internet and to incorporate all or part of it in your own work. Perhaps you intend to criticize or comment on consumerism by "quoting" recognizable pieces of advertising in a montage. Artists' *appropriation* of copyrighted material—incorporating an image as a form of critique—has been a widely debated topic and continues to be the subject of legal battles.

Copyright laws have certain built-in excep-tions called *fair use*; among them is educational work. What you make for a class project by "bortowing" someone cloc's work may be protected, but if you try to sell it in a gallery or distribute it on your Web site you may be infringing on someone's copyright.

Remember that any photographs you post on social media arc available to be copied by anyone. Copyright protection is broad and not terribly complex, but what is and what is not protected may not be obvious. In the United States, your photographs are protected by copyright as soon as you've made them, but the protection is stronger if you register your copyright with the government. To use your photograph legally, someone must have your permission, and generally you can expect to negotiate and be paid a *royalty* for any commercial use. Be careful what you agree to when you upload your pictures on a photo-sharing site like Facebook or Instagram.

Many images posted online are defined as "royalty-free," which does not necessarily mean that they can be used without permission, but that one agreement or fee will cover all current and future uses. The alternate is "rights managed," which means the copyright holder only releases a very specific use of an image, for example, on the cover of one paperback edition of a novel in English sold only in North America.

Photographs made for the U.S. government are said to be in the *public domain*, along with, in general, anything made before 1923, and may be used for any purpose without permission.

CHAPTER 5

113

Untitled, 2000. Dutch artist Hoc	ks makes
sketches first, then creates t	heatrical
sets in which he plays the cen	tral role.
After the moment is captured, he m	akes very
large black-and-white prints and th	en paints
them with transpo	rent oils.

Printers and Drivers 1	16
Papers and Inks1	17
Soft Proofing1	18
Panoramic Photographs 1	19
Presenting Your Work 1	20
Framing 1	20
Matting a print1	21

Equipment and materials	
you'll need	
Dry Mounting a Print Step by Step124	
Bleed Mounting/ Overmatting126	

Printing and Display

In this chapter you'll learn...

- the choices you need to make about hardware and materials—printer, paper, and ink—before you make prints from your digital files.
- how to use output profiles and soft proofing to make sure your prints have the colors and tones you expect after seeing the image on a monitor.
- some of the methods and styles for matting and framing your photographs for presentation.

uch pleasure lies in taking pictures and skimming through them onscreen but the big reward lies in printing and viewing the results. Yet some photographers never seem to finish their images; they shoot a lot but have few pictures that they carry to completion. Printing translates your vision into an object that can be displayed on a wall, in a gallery, or in other locations, in addition to being an image you can email or share on Instagram. Finishing and mounting a photograph is important because it tells viewers your vision is worth their attention. You will see new aspects in your photographs if you take the time to complete them.

Your work's impact is influenced by its display

The impression a viewer gets from a photograph comes from a combination of the image content and the context in which it is experienced. Do you see the photograph on the front page of a daily newspaper, mounted in a family album, or ('like those below) on public display as fine art in a gallery or museum? The understanding we come away with after viewing a photograph is affected by what else we see with it; an ornate frame carries a different message than a pushpin, a sequence can be more complex and nuanced than a single image. A photograph can be accompanied by words: a news article below it, an artist's statement next to it on the gallery wall, or the story you tell friends when you pass around your recent prints

Rolf Peterson. Installation view of the Family of Man exhibition, Museum of Modern Art, New York, 1955. **Curator Edward Steichen distilled this show from over two million submitted photographs** "covering the gamut of human relations." Photographers that were represented in the enormously popular exhibition, once selected, relinquished control. They loaned their negatives; prints were made to Steichen's specifications, in sizes from snapshot to mural, then displayed according to architect Paul Rudolph's design.

Ron Jude. Installation view of the solo exhibition Backstory. Museum of Contemporary Photography, Chicago, 2013. **The artist planned and laid out this exhibition with the curator.** In the same way he sequences his photographs for publication, Jude made a computer model of each wall and placed each framed piece in exact scale. Months before the show was hung, he could view the space as it would appear on its opening day. The calm and ordered presentation gives the viewer in this space a completely different feeling than the one shown above, left.

Printers and Drivers

Holding a newly printed photograph is a rewarding moment. Even though you view your images through every step of preparing them, seeing the image on paper remains a high point. The quality of your results depends not only on your abilities but also on your choice of printers, papers, and inks.

Printers affect the way your prints look and how large you can make them. A printer limits the size of a print by the maximum width of the paper it will accept. Photo-quality desktop printers typically print a maximum width of 8¹/₂ or 13 inches.

Desktop Inkjet Printer

Inkjet printers are universal and inexpensive; they can print on a wide variety of surfaces. Models intended for photographs make sharp, colorful, long-lasting prints at a reasonable price.

Wide-format inkjet printers that print on two-, four-, or six-foot-wide paper are available but are fairly expensive. You may be able to use one in your school or have large prints made for you at a service bureau.

Dye-sublimation printers produce smooth tones and subtle colors but the prints do not resist fading, and your choices of printers, paper, and ink are limited.

Photographic laser printers make digital prints on traditional photographic paper. Laser or LED light exposes photo paper (often 50-inch-wide color paper) that is then fed directly into a rollertransport chemical color processor. The result is

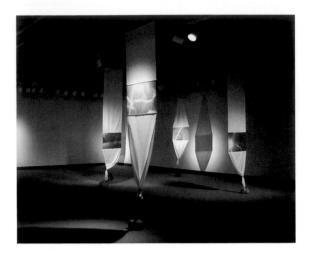

an extremely high-quality digital print with the smooth tones and predictable archival qualities of a traditional color photograph. Large and very expensive, these machines (LightJet and Lambda are the best known) generally can be found only in professional color labs and service bureaus.

Printers need a driver (the software that reads pixels in your image and tells the printer how to spray ink, vaporize dye, or emit light to make a picture from those pixels). A driver is supplied with the printer and must be installed on the computer that is connected to it. Drivers are occasionally updated; check the printer manufacturer's Web site to be sure that your driver is current.

Some labs use a *RIP* (raster image processor) instead of a driver. A RIP is software or a computer/ software combination that must be purchased separately. RIPs add control over individual ink colors and have the ability to group smaller images together onto a larger sheet or roll of paper.

Pixels per inch (ppi) vs. Dots per inch (dpi)

Pixels per inch (ppi), measure the resolution of an image that has a physical

Dots per inch (dpi), measure a printer's resolution. It is used for machines that convert pixels into tiny dots of ink, a desktop inkjet printer or an offset press, for example.

Theoretically, the greater the dpi, the better the quality of your image. But more isn't always better: the greater the dpi, the more time a printer will take to make a print and the more ink your printer will use. **Peggy Ann Jones.** The Veil Project, 2005. **Jones used a** wide-format inkjet printer to print directly on cloth for this gallery installation. Each image was sewn to a fabric panel that was hung from the ceiling and tied at the bottom to a rock. Panels—and the shadows they cast—move with the air motion created as viewers walk past, seeming almost alive.

size, like a print or a monitor display. See page 55.

You may not need to print at the highest possible dpi. The quality we can see in a print is limited by our eyesight, the viewing distance, and paper texture, as well as by the output method—the size of the dots produced by the printer. As a practical matter, try printing an image at different resolutions (dpi) to find out what gives the best visible quality with your printer. Then you can start with that dpi setting for future prints.

Papers and Inks

Paper makers offer choices. Manufacturers of inkjet printers, the kind you are most likely to use at home or school, supply their own *OEM* (Original Equipment Manufacturer) brand of papers that are convenient and work well with their printers. You can also experiment with a wide variety of papers that may better suit your vision or budget. Most non-OEM papermakers provide profiles you can download from their Web sites for using each of their papers with most popular printers.

Papers vary in brightness or whiteness, usually measured on a scale of reflectance from one to one hundred. Whiteness can be enhanced with optical brightening agents (OBAs), chemicals that are very effective in making your prints sparkle. But optical brighteners can affect image colors, and will fade with time; if you want archival prints, look for a paper without them.

Photo papers for inkjet printing resemble traditional darkroom papers. They can be *fiber-based* or *resin-coated*. The best fiber papers are made from cotton rag and are more likely to be chemically neutral (and therefore longer lasting) than those made from wood pulp. A coating that is receptive to ink is applied directly to the paper fibers. Resin-coated papers have a layer of plastic bonded to paper. Some inkjet "papers" may be all plastic. Most specialty paper retailers offer sample packs containing an assortment of letter-size sheets. It is worth making some tests before committing to a quantity of one kind.

Ink cartridges for inkjet printers can contain pigments or dye; usually a printer is made to use one or the other, rarely both. Dye-based inks have a wide color gamut and can produce vivid colors but are very prone to fading. For that reason, most serious photographers choose printers that use pigment (sometimes called pigmented) inks.

Pigment inks can make a print that resists noticeable fading for many times longer than the best dye-ink prints. The permanence of any print depends on the specific ink-paper combination as well as the storage or display conditions. (See wilhelm-research.com for the results of lab tests.) Pigment inks display more *metamerism*—when colors appear to shift under different lighting conditions although recent advances in printer design have nearly eliminated the problem.

OEM inks are the most trouble-free option but can be a major expense. For some printers, off-brand cartridges are available, or you can purchase ink in larger quantities and refill depleted cartridges, although the practice can be tedious and messy. Using alternate ink sets will definitely require you to make your own output profiles (pages 82, 84, and 118).

If you are interested in printing only black and white, you can replace the color inks in some printers with a special set that includes a black and several grays. These may result in smoother, more neutral, and more permanent images than you would get by printing black-and-white photographs with color inks.

Printers that use inks packaged in individual colors are usually more economical than those that combine, for example, cyan, magenta, and yellow in one cartridge. When one color in a multi color cartridge runs out, you have to replace the whole cartridge.

Paper is available in an incredibly wide variety of sizes, surfaces, colors, textures, and weights.

Papers made for inkjet printing will take and hold the ink without smearing or blotting. Many other papers can be used, but test your choices for suitability. You can also print on a variety of other surfaces—cloth, self-stick labels, iron-on transfers, metallic paper, and even refrigerator magnets.

Soft Proofing

deally your print will look like what you see on the computer's monitor, but often it won't unless you *soft proof* while you are editing. Monitors have a wider gamut (range of colors) than a printer, so what you see on the monitor isn't necessarily what you'll get in a print. With soft proofing, you display on screen what the print will look like. This is useful because every combination of printer, paper, and ink will make a somewhat different version of the same file.

Soft proofing and printing use profiles (page 82) that take into account the characteristics of printer, ink, and paper. Standard profiles are supplied with desktop printers or can be downloaded from the paper manufacturers' Web site. Special hardware and software (page 84 bottom) makes custom profiles or you can have them made through an online service. A calibrated monitor and consistent ambient light at your workstation are also helpful for predictable and accurate results.

Following are some basic steps to proof and print in Photoshop. Lightroom has a simple checkbox for soft proofing in its Develop module. In Capture One Pro, enter your output profile (View>Proof Profile>Selected Recipe), then you can do all your editing while in the soft proof mode. Both let you make most of these same output choices for printing.

In Photoshop, open the file you want to work on.

2 Choose View>Proof Setup>Custom and select a profile for your printer and paper from the displayed list. Set Intent: Perceptual and check "Use Black Point Compensation."

	Customize Proof Condition		NAMES OF TAXABLE
Custom Proof Condition:	Custom		ОК
- Proof Conditions	and the second second second		Cancel
Device to Simulate:	Pro 7890 EMP_MK		
	Preserve Numbers	N. C. P. S.	Load
Rendering Intent:	Perceptual	:	Save
	Black Point Compensation		Preview
- Display Options (On-	-Screen)		
Simulate Paper Col	or		
Simulate Black Ink			

B Edit your image as needed. Turn on the printer and load the paper selected in step 2.

Choose File>Print, then select your output settings. The *Document* (or *Source*) Profile, such as Adobe RGB (1998), is your working space (page 82). In *Printer Profile* and *Intent* make the same selections you used for your Proof Setup (step 2).

Printer: (StylusPro 7890		
Presets: (Presentation Matte Sheet	•	
Copies:	1 Scollated		
Paper Size: (US Letter (Sheet) \$ 8.50 by	11.00 inches	
(Printer Settings	0	
	Basic Advanced Color Settin	igs	110
Page Setup:	Sheet		
	Presentation Paper Matte		•
Print Mode:	Color	1	
Color Mode:	Off (No Color Management)	j	
Output Resolution:	SuperPhoto - 1440 dpi	j	
	Super MicroWeave		
	High Speed		
	🗌 Flip Horizontal		
	Finest Detail		

Choose Print Settings to select the printer, paper size, and orientation. Photoshop uses icons to help you choose an orientation; sometimes words describe the orientation— *Landscape* for horizontal, *Portrait* for vertical.

6 Choose Print. Set No Color Adjustment under Color Management, and Photoshop Manages Colors under Color Handling. These tell the printer to accept your profile and output settings without alteration. Otherwise, your printer will make color and contrast changes based on an average. Choose a printer resolution; higher resolutions yield finer-looking prints but longer printing times. When everything is set, select Print again, and enjoy.

Panoramic Photographs

xRez Studios, Inc. Night View of Chicago from the Penthouse of Hotel 71, 2007. Panoramic photographs can be assembled from smaller elements. This one—to greatly increase resolution—was made from

several hundred separate exposures made around n 360° field Recause it is pieced together from images made in a circle, the endpoints are arbitrary and parts of the scene may appear more than once.

The original file can make a highly detailed print more than five meters wide. It is displayed with other extreme resolution photographs on a Weh site that allows zooming in to see a close-up of any part of the frame: xRez.com. Digital photography has made panoramic photography more popular. In the recent past, if you wanted to make photographs in panoramic shapes you had only a few options. You could crop away part of a picture and then enlarge the rest, reducing its quality. You could invest in a specialized, and usually expensive, camera. Or you could take several pictures and display them side-by-side—either trying to hide the edges or making the joining appear intentional. Now there is another option.

Software makes it easy to piece together individual exposures to make a single larger image Called stitching, the procedure can be left to Photoshop (File>Automate>Photomerge) or to one of several aftermarket programs or plug-ins (see the photo on page 80). This way of combining pictures is so effective, you need only provide a set of adjoining frames and then decide how to crop the usually irregular edges of the result.

Some digital cameras have a panorama mode to help you make the needed overlapping images. After the first exposure, the camera's monitor displays a thin slice from the right edge of that picture on its left edge (or vice versa), making it easy to align objects and to create overlap for stitching software to work effectively. Some cameras and cell phones use a "sweep" mode to capture a panoramic photo from the arc of a moving camera.

The way inkjet printers work has also contributed to the popularity of wide pictures. Paper is transported along a straight path through the printer and receives a line at a time of ink dots deposited by a print head moving back and forth across the path. The width of that line of dots limits one dimension of the image, and it is fixed by the design of the printer. To make a wider print means using a different (and usually more expensive) printer.

But the length of your image can be as long as the paper and the printer driver will allow. Some desktop printers will print continuously on roll paper (sometimes called *banner* mode). The one shown on page 116 will print 13 inches wide and as much as 44 inches long. Many photographers, with only one available printer and looking for the visual impact that comes from larger prints, choose to make panoramas.

Presenting Your Work

FRAMING

Framing a print for the wall sets it apart as a special object. Whether you've made it for a family member's birthday or a gallery exhibit, matting (sometimes called mounting) and framing asserts that this photograph is to be viewed as a piece of art. Although your uses may not require it, once you have made a print you are proud of, you may want to consider processes and materials for presentation that are attractive and also *archival*, a term for anything used or done for the sake of long-term preservation.

Matting and framing have several goals—to call attention to your photographs, to create an elegant environment, to isolate them from distracting elements, and to protect them. There are almost as many display options as there are photographs, but a few generalities do apply. Keep in mind that framing is a specialty and many photographers leave it to a professional, but—on a modest scale—you can do it all yourself.

Mat your photograph before it is framed. A mat is a sheet or sheets of specially made stiff paper board. A thin sheet might be the thickness of three or four playing cards, heavy mat board (called 8-ply) is ¼-inch thick. Most matted prints are a sandwich with the print held in place between a backing sheet and an *overmat* (see page 126). Matting separates the print from the glazing.

Framed photographs are usually glazed, covered with a sheet of clear glass or plastic. Small works can be glazed with plain glass, but clear plastic is lighter and less likely to break and damage the work if mishandled. A framed photograph can be displayed unglazed, but glazing protects it from physical damage and also from harmful ultraviolet (UV) rays that accelerate fading.

Daylight and fluorescent light contain a high percentage of damaging UV. Plain glass absorbs about half of it, while plain acrylic absorbs about two-thirds. Coatings can extend that; conservation glass absorbs 97% of UV, whereas UV-filtering acrylic absorbs 99%. Also available are reflection-control glass and acrylic, both with and without UV-absorbing coatings. Standard non-glare glass should not be used for fine-art glazing because it can produce optical distortion.

Frames are commonly wood or metal. If you use wood frames, make sure there is a vapor barrier (usually aluminum or plastic tape) between the mat package and the wood. Wood is acidic; direct contact will shorten the life of anything made of paper. Avoid pressure-sensitive tapes unless you know them to be acid-free.

Frame moldings come in a wide variety of cross-sections, finishes, and colors. Aluminum section frames come in standard length pairs; for a 16×20 -inch frame you need a pair of 16-inch pieces, a pair of 20-inch pieces, and a 16×20 -inch sheet of glass or acrylic. Hardware to connect the pieces comes with the frame pairs; you can easily assemble it all with a screwdriver.

New presentation methods appear as technology changes. Lightweight rigid plastic and honeycombed aluminum sheets have been developed to hold large prints extremely flat. Special optically clear laminations can adhere a print to the back of an acrylic sheet with no bubbles or flaws, bonding the two so the face of the acrylic sheet becomes the surface of the photograph. There are no rules; just make sure, whatever presentation you choose, that you think it's the best choice.

Frames are available in precut kits if you want to do your own framing. Professional preparation may make a more polished presentation but will certainly cost more.

Modular, or section, frames are available in a wide variety of cross-sections, finishes, and colors. Each comes with two height and two width segments and four corner connecters. They can be disassembled, stored, and reused, and those in solid colors may be refinished easily with a can of spray paint.

The back of a connected corner is shown above.You'll need a screwdriver, the glass or acrylic, and a backing board. The curved pieces shown below are spring clips that press the backing and mat against the glazing from the back.

MATTING A PRINT

There are several ways to mat a print. Overmatting (pages 126–127) provides a raised border that helps protect the surface of the print. If you frame a print, the overmat will keep the print surface from touching and possibly sticking to the glazing. Direct contact with glass can eventually damage a print's surface.

John Gossage. Stallschreiberstrasse, West Berlin, 1989. The Berlin Wall was a glaring symbol of post-World War II political tension. It divided Germany's major city with a concrete-and-razor-wire barrier between the "free world" west and the communist east. Gossage's photographs, made between 1982

and the Wall's demolition in 1989, are purposefully dark and foreboding. His large prints are so dark that covering them with ordinary glass all but turns them into mirrors. For a New York gallery exhibition, Gossage framed them using nonreflective museum glass—the only way the images could readily be seen. An overmatted print held in place with corners is most often your best presentation choice because the print can be safely removed at any time. If a mat becomes soiled or damaged, it can be replaced. Museums often overmat and frame a print one way for one exhibition then, later, mat and frame it a different way for another show. An overmat allows for the normal expansion and contraction of paper with changing temperature and humidity.

Dry mounting is a common way to mount traditional photographic materials because it holds a print very flat and prevents curling from changes in humidity. A sheet of dry-mount tissue bonds the print finally to a piece of mount board when the sandwich of board, tissue, and print is heated in a mounting press.

Dry mounted prints look very presentable when framed but, if there is no overmat to provide an airspace, the print surface can be pressed against the glazing and eventually stick to it. If you don't overmat, consider using a shadow-box style frame.

Prints from digital output are often overmatted. Heat mounting will damage dye-sublimation or thermal-wax prints. High temperatures will not physically damage an inkjet print, but the heat may shorten the display life of its colors.

You have quality choices in the materials you use. Archival mounting stock (also called museum board) is the most expensive. It is made of rag (cotton) fiber, instead of wood pulp. Free of the acids that in time can cause paper to deteriorate; it is preferred by museums, collectors, and others concerned with long-term preservation. Most prints, however, can be mounted on less expensive but good-quality conservation board available in most art supply stores. If you want a print to last for even a few years, avoid long-term contact with materials such as brown paper, ordinary cardboard, most cheap papers, and glassine. Don't use brown paper tape, rubber cement, animal glues, spray adhesives, or (unless marked as archival) any kind of pressure-sensitive tape, such as masking tape or cellophane tape.

CHAPTER 6 🚔 121

<u>Mounting a Print</u> equipment and materials you'll need

MOUNTING EQUIPMENT

Utility knife with sharp blade trims the mounting stock and other materials to size. A paper cutter can be used for lightweight materials, but make sure the blade is aligned squarely and cuts smoothly.

Mat cutter holds a knife blade that can be rotated to cut either a perpendicular edge or a beveled (angled) one. It can be easier to use than an ordinary knife, especially for cutting windows in overmats.

If you expect to do a lot of matting, consider a larger mat cutting system that incorporates a straightedge and cutter, like the one above. The mat cutters used in frame shops can be quite expensive, but there are smaller, less expensive versions for the home studio.

Metal ruler measures the print and board and acts as a guide for the knife or mat cutter. A wooden or plastic ruler is not as good because the knife can cut into it.

Miscellaneous: pencil, soft eraser. *Optional:* fine sandpaper or an emery board for smoothing inside edges of overmat window, T-square to make it easier to get square corners. For archival or other purposes where extra care is required, cotton gloves protect mat or print during handling.

Mounting press heats and applies pressure to the print, dry-mount tissue, and mounting board to bond the print to the board. You can use an ordinary household iron to mount prints if no press is available, but the press does a much better job.

Tacking iron bonds a small area of the drymount tissue to theback of the print and the front of the mounting board to keep the print in a fixed position until it is put in the press. Again, you can use a household iron, but the tacking iron works better.

MOUNTING MATERIALS

Mount board (also called *mat board*) is available in numerous colors, thicknesses, and surface finishes.

Color. The most frequent choice is a neutral white because it does not distract attention away from the print. However, some photographers prefer an off-white, gray, or black mount.

Thickness. The thickness or weight of the board is stated as its ply: 2-ply (single weight) board is lightweight and good for smaller prints; more expensive, 4-ply (double weight) board is better for larger prints.

Surface finish. Finishes range from glossy to highly textured. A matte, not overly textured surface is neutral and unobtrusive.

Size. Full sheets of mat board are usually 32 × 40 inches. Boards are also available precut in standard sizes in art supply stores or online. A store can cut them for you, but it is often less expensive to buy a full sheet of board and cut it down yourself.

Quality. See information on page 121 about quality choices in mounting materials. Archival quality is best but not a necessity for most prints.

Dry-mount tissue is a thin sheet of paper coated on both sides with a waxy adhesive that becomes sticky when heated. Placed between the print and the mount board, the tissue bonds the print firmly to the board.

Some are removable, which lets you readjust the position of a print; others make a permanent bond.

Cold-mount tissues do not require a heated mounting press. Some adhere on contact; others do not adhere until pressure is applied, so that, if necessary, they can be repositioned. Mounting this way is usually used for prints that don't lie flat. A cover sheet protects the print or mount from surface damage. Use a lightweight piece of paper as a cover sheet between each print in a stack of mounted prints to prevent surface abrasion if one print slides across another during storage. Use a heavy piece of paper or piece of mount board as a cover sheet over the surface of the print when in the mounting press.

Release paper can be useful, for example, between the cover sheet and a print in a dry-mounting press. It will not bond to hot dry-mount tissue in case a bit of tissue protrudes beyond the edge of the print.

Tape hinges a print or an overmat to a backing board. Gummed linen tape and other archival tapes are available from specialty shops and online retailers. Archival tape should always be used for hinge mounting a print. Ideally, use linen tape to hinge an overmat to a backing board, but less expensive tape is also usable.

Jo Whaley. Cerambycidae, Selected Writings, 2003. **What should you photograph?** The answer is—anything you like. Photographs can be made rather than found, so don't limit your pictures to landscapes, portraits, or other existing subject matter. Here, a dried bug is combined with a book by Helen Keller found at the local shooting range.

CHAPTER 6 📥 123

Dry Mounting a Print Step by Step

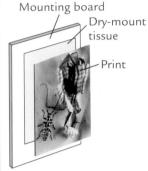

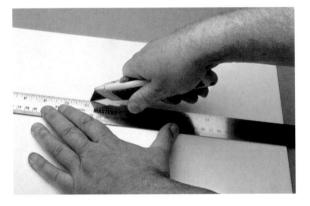

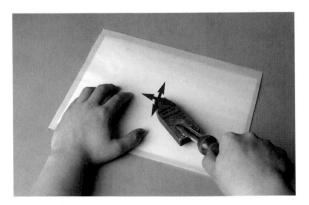

Dry mounting provides a good-looking, stable support for a print. Shown here is a mount with a wide border around the print. Bleed mounting, a borderless mounting, is shown on page 126. The mounting materials, the print, and the inner surfaces of the press should be clean; even a small particle of dirt can create a bump or dent when the print is put under pressure in the press.

Wearing cotton gloves when handling the print will keep smudges and fingerprints off the surface. When cutting, use a piece of cardboard underneath to protect the work surface. Several light cuts often work better than just one cut, especially with thick mounting board. The blade must be sharp, so be careful of your fingers.

Cut the mounting board to size using the knife or mat cutter and the metal ruler as a guide. Press firmly on the ruler to keep it from slipping. A T-square can help you get corners square.

Standardizing the size of your mount boards makes a stack of mounted prints somewhat neater to handle, and makes it easier to switch prints in a frame. Often $8\frac{1}{2} \times 11$ -inch prints are mounted on 11×14 -inch or 14×17 -inch boards. Generally, the board is positioned vertically for a vertical print, horizontally for a horizontal print. Some photographers like the same size border all around; others prefer the same size border on sides and top, with a slightly larger border on the bottom.

2 Heat the press and dry the materials. If you are mounting a darkroommade fiber-base print, heat the dry-mount press to 180°-210°F (82°-99°C) or to the temperature recommended by the dry-mount tissue manufacturer. Put the board, with a protective cover sheet on top, in the heated press for a minute to drive out any moisture. Repeat with the print. The heating will also take any curl out of the print, making it easier to handle.

For a resin-coated (RC) darkroom paper or inkjet prints on any material, use low-temperature dry-mount tissue. The press must be no hotter than 210°F (99°C) or an RC print may melt. Temperature control is inaccurate on many presses, so a setting of 200°F (93°C) is safer. There is no need to preheat an RC print, just the board and cover sheet.

Tack the dry-mounting tissue to the print. Heat the tacking iron (be sure to use a low setting for low-temperature tissue). Put the print face down on a clean smooth surface, such as another piece of mounting board. Cover the back of the print with a piece of dry-mount tissue. Tack the tissue to the print by pressing down the hot iron and sliding it smoothly from the center of the tissue about an inch toward one side. Do not tack at the corners. Do not wrinkle the tissue or it will show as a crease on the front of the mounted print.

Trim the print and dry-mount tissue. Turn the print and dry-mount tissue face up. Use the knife or mat cutter to trim off the white print borders, along with the tissue underneath them. Cut straight down on top of a piece of scrap cardboard so that the edges of the print and tissue are even. Press firmly on the ruler when making the cut, and watch your fingers.

5 Position the print on the mount board. First, position the print so that the side margins of the board are equal. Then adjust the print top to bottom. Finally, remeasure the side margins to make sure they are even. Measure each side two times, from each corner of the print to the edge of the board. If the print is slightly tilted, it will be noticeable at the corners even though the print measures evenly at the middle.

To keep the print from slipping out of place, hold the print down gently with one hand or put a piece of paper on the print and a weight on top of that.

Tack the dry-mount tissue and print to the board. Slightly raise one corner of the print and tack that corner of the tissue to the board by making a short stroke toward the corner with the hot tacking iron. Keep the tissue flat against the board to prevent wrinkles, and be careful not to move the print out of place on the board. Repeat at the diagonally opposite corner.

Mount the print. Put the sandwich of board, tissue, and print in the heated press with the protective cover sheet on top. If you have release paper, put it between the print and the cover sheet. Clamp the press shut for about 30 sec. or until the print is bonded firmly to the board. You can test the bond by flexing the board slightly after it has cooled.

Both time and temperature in the press affect the bonding. If the print does not bond, first try more time in the press. If the print still does not bond, increase the press temperature slightly.

Bleed Mounting/Overmatting

Mounting board Dry-mount tissue Print A bleed-mounted print is even with the edges of the mount.

Prepare the print and mount board. Cut the mount board, dry the materials, and tack the mounting tissue to the print (steps 1, 2, and 3 on page 124). In step 1, the board can be the same size or slightly larger than the print.

Trim off any excess dry-mount tissue so that the edges of the tissue are even with the edges of the print. Then tack the dry-mount tissue and print to the board, and heat in the press (steps 6 and 7, page 125).

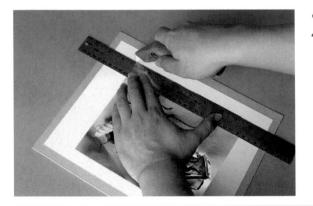

2 Trim the mounted print. Place the mounted print face up and trim off the white print borders, along with the mount board underneath, using the ruler as a guide. A T-square can help you get the corners square. Hold the knife blade vertically so that it makes an edge perpendicular to the surface of the print. Press firmly on the ruler, and watch your fingers.

Because the edges of a bleed-mounted print come right up to the edges of the mount board, be careful when handling the mounted print so you don't accidentally chip or otherwise damage the edges.

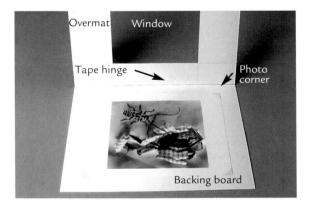

An overmatted print has a raised border around the print. It consists of an overmat (a piece of mount board with a hole cut in it) placed over a print that is attached to another piece of mount board (the backing board). The overmat helps protect the print and can be easily replaced if it becomes soiled or damaged. After overmatting, the print can be framed or displayed as is.

Overmatting is the preferred means of mounting a print if you are interested in archival preservation or if a print will be framed behind glass. A photograph pressed directly against glass can in time stick permanently to the glass.

Mark the window on the mount board. Cut two pieces of mount board. For easier shopping, framing, and storage, stick to standard graphic arts sizes: 11×14 , 14×17 , 16×20 . Subtract the width of your print from the width of the board. For a 7 × 9-inch vertical window in an 11×14 -inch board, the board is 4 inches wider than the print. Divide that by two to find the width of the border on each side: two inches. Do the same for the height to find the top and bottom border. Most artists prefer a print mounted slightly higher than center, so subtract $\frac{1}{4}$ inch from the top border and add it to the bottom one.

Mark the back of the board lightly in pencil for the window cut. Be sure the window aligns squarely to the edges of the board. A T-square, if you have one, will help. Cut the window. Don't even attempt to cut a window freehand with a mat knife. A mat cutter such as the one shown here and on page 122 is an inexpensive way to make your matting job look professional. Make sure to adjust the blade angle and depth so it penetrates the mat only enough to go through the board. Use a sharp blade. Push the blade tip through the mat at one corner and slide a metal ruler against the cutter's edge. Hold the ruler firmly, parallel to your edge mark, and push the cutter against it and away from you until it reaches the next corner.

Cut each side just to the corner, not past it. If the cut edges are a bit rough, you can smooth them with very fine sandpaper or an emery board. A beveled edge usually looks more elegant than a vertical cut.

Hinge the two boards together by running a strip of tape along a back edge of the overmat and a front edge of the backing board (see illustration on opposite page, second from bottom). You may not need to hinge the boards together if you intend to frame the print.

Position and attach the print Slip the print between the backing board and the overmat. Align the print with the window. The print can be drymounted to the backing board or attached with photo corners or hinges (see below).

Photo corners, like the ones used to mount pictures in photo albums, are an easy way to attach a print to a backing board. The print can be taken out of the corners and off the mount at any time. The corners are hidden by the overmat. You can buy corners or make your own from archival or acid-free paper (right) and attach them to the board with a piece of tape.

or...

Hinges hold the print in place with strips of tape attached to the upper back edge of the print and to the backing board.

A folded hinge (at right, left side) is hidden when the print is in place. Use a piece of tape to reinforce the part of the hinge that attaches to the mounting board.

A pendant hinge (at right, right side) is hidden by the overmat.

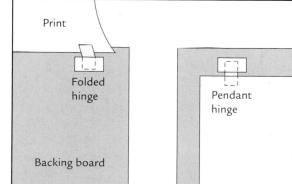

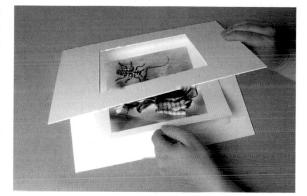

Fold

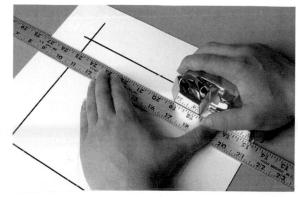

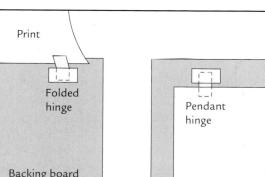

STAN STREMBICKI Untitled, from the series Memory Loss, a 9th Ward Photo Album, 2005.

 Software for Organizing 132 Archiving Images and Prints... 133

Organizing and Storing

In this chapter you'll learn...

- to have a strategy for naming and labeling your images that will help you find the ones you need now, among your most recent captures, and years from now when you have thousands.
- to make a plan for duplicating and backing up your files so you never risk losing any, and to familiarize yourself with hardware and software to help you execute that plan.
- to choose the materials and conditions that are best for keeping your prints to avoid fading and damage.

Stan Strembicki. Untitled, 2006. Our

wwn saved memories are fugitive, as we are reminded by these flood-damaged photos (at right and opposite) left in the wake of a natural disaster. A nonresident, Strembicki had been photographing New Orleans several times a year for over twenty years before Hurricane Katrina landed, decimating the city. In the aftermath, he made monthly trips to record the damage and efforts to rebuild. "As an artist, I felt compelled to do something, anything," he says. Trying to avoid an excess of pathos, he "looked for symbols of loss, and gravitated toward found photo albums." Family photo albums were often among the dehris hulldozed into piles in front of houses after they had been under water for weeks. Strembicki was careful not to enter houses, and took nothing away but the images captured by his DSLR. There is a caution for all of us in this work; our own photographs, digital or analog, are vulnerable, too. After each day of location shooting, Strembicki takes care not to put his at avoidable risk; he downloads all the files onto a laptop, duplicates them onto a portable hard drive, and then writes them to an optical disk.

etting your photos organized is easier than you think. Pictures can accumulate quickly and you can have thousands of them before you know it. But the computer is a great organizing tool and it is easy—when you shoot digital pictures—to let it help. One of the best things about a digital picture is that each one has a hidden compartment to hold all the extra information you might want to save about the image. And this saved information travels with the file; it can help you find that particular picture quickly—even if it is stored with tens of thousands of others.

Traditional photographic materials needed to be stored carefully in order to last. Photographic prints, no matter what the materials or process, can be damaged by time and careless storage. Far in the future, whether you are giving a picture album to your great-grandchildren or selling a portfolio to a museum, it is good to know that your prints will be as perfect as the day you made them.

Image Storage

As soon as you create a digital image, you have to think about storing it. The amount of storage space that image files occupy is a consideration whenever you are using a digital camera, scanning prints or negatives, editing files, or archiving them.

Save your files in their original form. The file as it is captured by your camera or scanner is often referred to as a *raw* file, as opposed to a *derivative* file—one that has been processed, altered, edited, or changed in some way. A Camera Raw file (see page 85) is a specific kind of raw file that holds all the information captured by a digital camera's sensor, in a completely unprocessed form. If you have instead set your camera to capture images and save them as TIFF files or JPEGs, those original files can be considered raw files as well.

Post-processing, or image editing, produces

more files. Saving them becomes another step in your workflow and, unless you use a photographer's workflow program with Camera Raw files, they take up more storage space. Derivative files are changed somehow from their original raw state. They may consist simply of your raw files with a few color and tone adjustments, resized to print, or may be complex, layered composite images. You may also save intermediate editing steps as additional derivative files, in case you want to return an image easily to a previous state.

Photo files can be stored on different devices. The easiest, fastest, and most accessible form of storage is to keep image files on your computer's internal hard drive. If you scan an image, the scanner sends the image directly to the drive. After you use a digital camera, you must transfer your photos from the memory card to the hard drive before editing them. Memory cards are not intended for long-term storage. You will probably want to erase (or reformat) a card for reuse anyway, so it is best to download your files onto a hard drive (and back them up) promptly.

Your computer's internal hard drive may run out of room, especially if you keep making and storing photographs. A 1TB drive can hold about 50,000 raw files from an 18MP camera, but that number is considerably reduced if the drive is also used to hold the computer's operating system, applications, and all your other data. External hard drives are available that can be plugged in to any computer to add to its storage capacity. You can add one just for picture files. Some drives, called *portable*, are smaller and better protected against being bumped and jostled than a fullsized external drive. Pocket drives are even smaller, very light, and-like most portable drives-draw their power directly from the computer rather than needing a separate voltage adapter (called a *power brick*). Even though they are well protected against the stresses of being carried, no hard drive should be dropped.

Digital files can be lost instantly. Hard drives are susceptible to stray dust, spikes of electricity, and magnetic fields, in addition to theft or physical damage. External media, including optical disks and magnetic tapes, are sensitive to storage conditions and can become *corrupted* (unreadable) over time, as can individual files. Losing files can also be your own doing; you can accidentally delete a file or write over one unintentionally by saving something else with the same name.

Fortunately, with digital photographs you can have several originals. Keeping a set of identical copies of each picture file is essential to protect you against loss. You will want to have a *backup* strategy that you can both follow and afford (see more on page 133).

In addition to having copies of everything, you will also want to make sure that you can find something among all the copies. The following page describes ways to name and label your work so you can quickly search for and find anything.

External hard drives are easy to add whenever you need more storage.

Portable hard drives (above) and pocket drives (above top) let you move your files easily to another computer or download from your camera on location.

Optical disk storage is less likely to be damaged by magnetism, electrical storms, or water, but their popularity is diminishing. Gold DVDs (shown here) are said to have a longer storage life than other kinds. Larger capacity Blu-ray (BD) disks can hold up to 3000 15MB files.

Using Metadata

Computers are good at keeping track of things, but you have to help. Before digital photography, there was only one original—a negative or slide. Most photographers had to devise a system, not only to store and find a piece of film, but also to keep track of any information relating to it. A digital image consists of data; information about it—data about data—is called *metadata*.

Metadata comes in several forms. You are probably already using simple metadata that includes the name of a file, its size, and its format: a 22MB JPEG file called RailStation.jpg, for example. This information is part of the file itself, so it is not lost if the file is moved or copied, and it is displayed by the computer in any list or directory of files. A date is also part of that kind of file metadata, although it is usually the date the file was added to the computer.

Digital cameras save capture information. Each file format that your camera can use has an internal data block, separate from the image pixels, for the camera to store the capture details for each frame. Cameras can save the aperture and shutter speed, time and date, ISO setting, lens focal length, metering mode, camera brand,

Alex Webb. Port-au-Prince, Haiti, 1979. Photographs have many uses. Webb is a member of the photo agency Magnum; prospective clients can search magnumphotos.com by entering keywords to find his photographs

that meet their needs. Keywords for this photograph include Afro-Caribbean, Bunch of flowers, Column, Door, Haitian, Hat, Man, Port-au-Prince, Red, Shadow, Streak of light, and Sunshine. model, and serial number, and even a GPS location for each exposure. This camera-related metadata is kept in a standard form called *Exif* (Exchangeable image file format), and each different category (like shutter speed) is called a *tag* or *field*.

Metadata can be added later. A file's IPTC (International Press Telecommunications Council) fields are intended to hold metadata about the photographer and the picture's subject, ownership, and use. Image editors, browsers, and cataloging applications (page 132) let you view the information in these fields, add to it, or change it. If you keep your files in their original Camera Raw format, these applications will save IPTC data in a separate *sidecar* file that has the same name and a .xmp file extension. TIFF, JPEG, and DNG files can hold IPTC data within the file itself. IPTC data is saved in several *panels*. The Contact panel, for example, has fields for the name and contact information of the file's creator: you, the photographer.

Metadata in any field can be added to a group of images at once. You may want, as you download your shoot from a memory card, to tag each pho tograph with your email address and copyright, or the name of a location, client, or assignment.

Metadata stays with the image. Except for Camera Raw files that need a sidecar file, if you make a copy or a derivative version of your file, all metadata is automatically transferred to the new file. This can be useful. For example, if you post one of your photographs on a Web site or send it to a stock agency, your copyright and contact information stays with it; anyone who downloads it also receives fair warning that the image can't be reused without permission and has a way to reach you to negotiate for permission to use it.

Keywords and ratings are metadata. Files can be tagged with descriptive words that make finding them easier. In a similar way, a rating (stars) or a label (colors) can be applied to a photograph to distinguish it from others that are similar. Once you have a few thousand photographs, you will be glad you spent the time to add this kind of metadata. Page 132 discusses programs that let you search by keyword and rating.

Software for Organizing

Photographer's applications—computer software programs—can help with many of your tasks. Image editing is the centerpiece of postprocessing, getting the photograph you took to look exactly the way you want. Along with editing, Photoshop also lets you read existing metadata and embed your own into a file (File>File Info... opens Exif and IPTC metadata panels). But Photoshop can't help you get organized or find anything.

File browsers like Bridge, a freestanding application supplied with Photoshop (File>Browse in Bridge...), help you organize and locate images. Bridge can download photos from a memory card, rename them, display *thumbnails* (small versions of the files) of an entire folder or a full-screen preview of a selected image, and apply metadata, keywords, and ratings to all or a selected group of files.

Photographer's workflow applications like Lightroom and Capture One Pro (page 87) do everything most photographers need. Like Bridge, they will download raw files from a memory card to a location you specify, and let you rename, rate, and tag them with keywords. You can make image adjustments, resize, and print the images, or upload them to a Web site. In addition, they include most of the functions of a cataloging application, one that can help you find specific files across all your storage folders with a search for specific metadata.

Cataloging applications are specially designed to help you find needles in your haystack. Sometimes called an image database or digital asset management program, a cataloging program or image database like the one shown at right can keep track of hundreds of thousands of images. Like a browser or workflow application, it can embed a selected group of images with keywords and other metadata. It can search for and display images based on multiple criteria (photographs of mountains taken in 2012 anywhere except in Montana). It can quickly assemble groups of selected pictures to present to a client on screen, to print, or to post on a Web site. But an image database program does not usually provide any editing tools. A cataloging application keeps information about a file and its location in its own separate database file, so you can use it to find files that have been stored *offline*, which means that the storage medium or volume is not connected to the computer. This helps you find backup copies saved on, for example, the backup Blu-ray disks you keep in your safe-deposit box. Because its database is separate from the image files, you can add some metadata to an entry that is not embedded in the file; if you distribute the file, some keywords can remain private.

These applications let you display your work as a "slide show." You can select a group of photographs to be seen on the monitor or a digital projector one at a time, filling the screen. You can automate a presentation and choose the timing and the transitions (like a fade or dissolve) between images. With some workflow programs you can also superimpose selected text and play your choice of music along with the show.

An image database,

or asset manager (the one shown is Photo Supreme), can display a selected group of stored photographs and help you find exactly the photograph or photographs you are looking for among thousands.

Archiving Images and Prints

AN ARCHIVING WORKFLOW FOR RAW FILES 1. DOWNLOAD FILES directly from the camera or through a card reader.

2. RENAME FILES. Use a logical system that will still be useful after you have 50,000 photographs.

3. ADD BULK META-DATA. Bulk metadata (for example, your name, contact information, and copyright) is what goes on all your photographs.

4. CONVERT CAMERA RAW FILES TO DNG if you choose (page 85). Some applications let you do it all—convert, rename, and append metadata—as

you download. 5. ADD INDIVIDUAL KEYWORDS. With most applications you can display a large number of image thumbnails and apply a key-

word to a selected group.

6. APPLY RATINGS. Decide which image, of several similar ones, is the one worth returning to. Give a higher rating to the best of the shoot.

7. SAVE TO A SECOND HARD DRIVE. If you have a mirror RAID (text, right), this happens automatically. After saving a second copy of everything, you can reformat your camera's memory card to use again.

8. BACK UP ON TWO OPTICAL DISKS or a third hard drive. Store disks in a cool, dry, dark place for maximum life. Don't store your backups in the same place as your computer. Give each disk a unique name so you can file and find it easily, for example, *Photos 2014-045*.

9. ADD TO YOUR IMAGE CATALOGING DATABASE as soon as you write the files to optical disks, so it can keep track of the copies in your offline storage system.

With digital photographs you can have more than one original. And, because they take up little actual space, it makes sense to have several copies of everything. Prints, slides, and negatives have always been vulnerable to catastrophic loss or damage, as well as to degradation over time. Image files that are digital can be stored unchanged for the foreseeable future and—importantly—they can be duplicated exactly. You can dramatically reduce your chances of loss by keeping copies of all your image files.

Have a backup strategy that you can stay with. Don't wait until you have lost some important images before you make and stick to a plan for archiving your work.

It is most convenient to have all your files online, which means they are saved on one or more hard drives that are powered up and connected to the computer whenever you work. But hard drives can fail; to be safe you should also have at least two additional copies of everything, and preferably three or more.

The best system, at a minimum, is to make a second copy of all your raw files on another hard drive as soon as they are renamed and tagged (and

Prints should be kept in archival boxes. Elegant archival portfolio boxes like the clamshell design on the left make a beautiful presentation but may be too expensive for regular storage. Simple, acid-free, cardboard storage boxes, shown on the right, are as safe. Larger sizes are made from acid-free corrugated cardboard to be more rigid. before you have erased them from the memory card) and, shortly thereafter, make two more copics on external hard drives or on removable media such as optical-CD, DVD, or BD (Blu-ray)-disks. A second copy of everything on a local hard drive (one that's in the same location as your main computer) lets you restore files quickly in case of a primary drive failure or other data loss; the copies on removable or portable disks can be kept in two different locations to protect you in case of a disaster such as fire or theft. Cloud-based storage, remote storage that is accessed through the Internet, is also useful for keeping off-site backups. You will also want to have a naming, organizing, and backup strategy for finished derivative files and for those in progress.

A RAID array can help make local storage safer. RAID is an acronym for redundant array of inexpensive (or independent) disks. You can use your computer's operating system to format, or initialize, two disk drives for RAID level 1, called *mirror ing*. Once formatted this way, the two drives act like one—you see only one icon for the drive, and you write to and read from it normally. But, invisibly, all data is written simultaneously to both. This kind of system is called *fault-tolerant* because it creates redundant data; if one drive fails, all its data exists, identically, on the other drive.

Prints (and film) are more challenging to store than digital image files because they are physical objects and, most often, unique. A stable environment, especially one with cool temperatures and low humidity, will prolong the life of digital prints as well as traditional photographic materials. Paper must be protected from acidity. Unfortunately, most paper made from wood pulp is left acidic after manufacture; look instead for acid-free inkjet printing paper and mat board (usually made from cotton rag) that are available from specialty retailers. Those same retailers (search for *archival* supplies) can also provide stable, chemically neutral plastic bags, sleeves, and boxes sized for prints, disks, slides, or negatives.

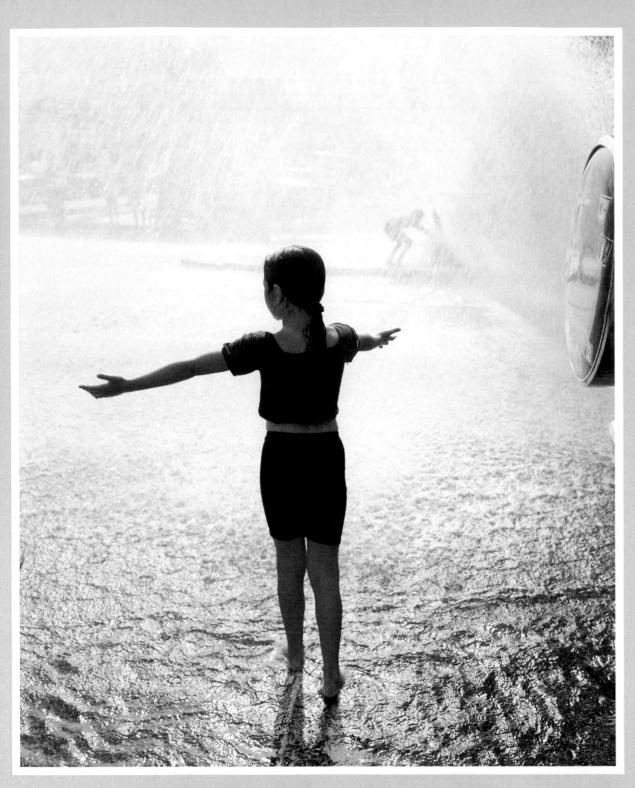

PAUL D'AMATO Isela, Chicago, 1993.

)	Qualities of Light136
•	From direct to diffused136
	Existing Light 138
	Use what's available 138
	The Main Light 140
	The strongest source of light 140
	Fill Light 142
	To lighten shadows142

Simple Portrait Lighting144
Using Artificial Light146 Photolamp or flash146
More about Flash
Using Flash 150

Using Light 78

In this chapter you'll learn...

- the qualities of natural light—the size of the source, its direction, color, and intensity—and the effect that changing these qualities will have on your photographs.
- to duplicate the qualities of natural light with artificial light that you can control.
- to understand the differences between electronic flash and continuous light, and to use a camera-mounted flash unit to make correctly exposed images.

Garry Winogrand. Los Angeles, 1969. Light itself can sometimes be the subject of the picture. Winogrand often photographed complex interactions that we all see every day but seldom notice. Here, in addition to the mix of people on the street, a reflection from a store window makes it appear there are two suns. Winogrand said, "I photograph to see what the photograph will look like." hanges in lighting will change your picture. Outdoors, if clouds darken the sky, or you change position so your subject is lit from behind, or you move from a bright area to the shade, your pictures will change as a result. Light changes indoors, too: your subject may move closer to a sunny window, or you may turn on overhead lights or decide to use a flash to light your photograph.

Light can affect the feeling of the photograph so that a subject appears, for example, brilliant and crisp, hazy and soft, stark or romantic. If you make a point of observing the light on your subject, you will soon learn to predict how it will look in your photographs, and you will find it easier to use existing light or to arrange the lighting yourself to get just the effect you want.

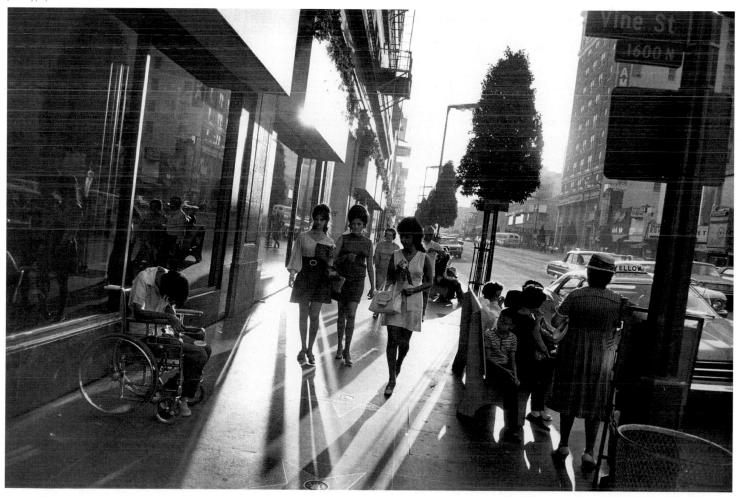

Direct Light

Light can range from direct and contrasty to diffused and soft, whether indoors or out. And whether you control the light on your subject or accept what is there, you should recognize the differences. Here's how to identify these different qualities of light and predict how they will look in your photograph.

Direct light is high in contrast. It creates bright highlights and dark shadows with hard, or sharp, edges. Photographic materials, both digital and film, have limited dynamic range (latitude) and cannot record details in very light and very dark areas at the same time. Directly lit areas may appear brilliant and bold, with shadowed ones almost entirely black. If you are photographing in direct light, you may want to add fill light (pages 142–143) to lighten shadows. Because direct light is often quite bright, you can use a small aperture to give plenty of depth of field, a fast shutter speed to stop motion, or both, if the light is bright enough.

The sun on a clear day is a common source of direct light. Indoors, a flash or photo lamp pointed directly at your subject (that is, not bounced off another surface) also provides direct light.

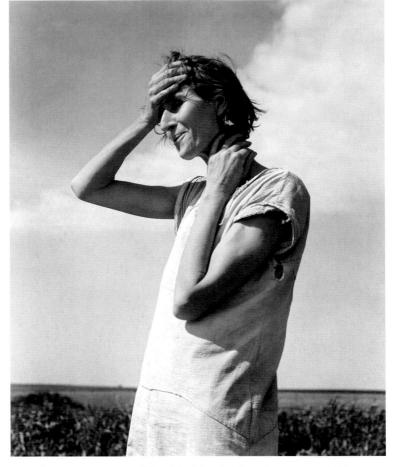

Dorothea Lange. Woman of the High Plains, Childress County, Texas, 1938.

Compare the qualities of light in these pictures and the effect it has on the subjects. Direct light—contrasty, with hard-edged shadows. Directional/diffused light—definite shadows, but softer edged than in direct light. Diffused light—indirect and soft.

Project: THE SAME SUBJECT IN DIFFERENT LIGHT

PROCEDURE Photograph the same person in several different lighting situations. For example, on a sunny day begin by photographing outdoors in the sun. Try not to work at noon when the sun is directly overhead. Light usually appears more interesting in the morning or afternoon when the sun is at an angle to the subject. Make several exposures in each situation.

Work relatively close: head-and-shoulders rather than full-length views. First, have the sun behind your back, so it shines directly into the person's face. Then move your subject so the sun is shining on him or her from the side. Then have the sun behind the person, so he or she is backlit. (Page 72 tells how to meter backlit scenes.)

Make several photographs in diffused natural light, for example, under a tree or in the shade of a building. Make some indoors, with the person illuminated by light coming from a window. As a comparison to sunlight in the morning or afternoon, you could also make some photographs at noon with the subject lit by the sun overhead to see why it is not recommended. Select the best portrait in each type of light.

HOW DID YOU DO? What do you see that is different among the various photographs? Is there more texture visible in some shots? Do the shadows seem too dark in some? (Pages 142-143 tell how to use fill light to make shadows lighter.)

How does the light affect the modeling (the appearance of volume) of the face? Light not only changes the way subjects appear in a photograph, it can change the way we perceive or feel about them. Do some of the portraits appear softer? Harsher? More dramatic? Directional/Diffused Light

Diffused Light

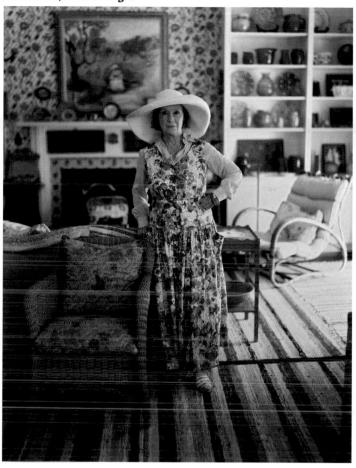

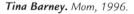

Sage Sohier. Girl Being Prepared for a Horse Show, Sandwich, NH, 2004.

Directional/diffused light is intermediate in contrast. It is partly direct and partly diffused. Shadows are present, but they are softer and not as dark as those cast by direct light.

You will encounter directional/diffused light on a hazy day when the sun's rays are somewhat scattered so light comes from the surrounding sky as well as from the sun. A shaded area, such as under trees or along the shady side of a building, can have directional/diffused light if the light is bouncing onto the scene primarily from one direction. Indoors, a skylight or other large window can give this type of light if the sun is not shining directly on the subject. Light from a flash or photo lamp can also be directional/diffused if it is softened by a translucent diffusing material placed in front of the light or if it is bounced off another surface such as a wall or an umbrella reflector. **Diffused light is low in contrast.** It bathes subjects in light from all sides so that shadows are weak or even absent. Colors are less brilliant than they are in direct light and are likely to be pastel or muted in tone. Because diffused light is likely to be dimmer than direct light, you might not be able to use a small aperture with a fast shutter speed.

A heavily overcast day creates diffused light because the light is cast evenly by the whole dome of the sky rather than, as it is on a sunny day, mostly by the small disk of the sun. Indoors, diffused light can be created with a very broad source of light used close to the subject (such as light bounced into a large umbrella reflector) plus additional fill light. (Page 143 top shows a *soft box*—another broad source—used in a lighting setup.)

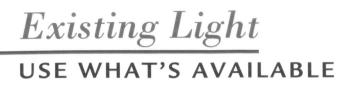

Don't wait for a sunny day to go photographing. You can take pictures even if the light is dim: indoors, in the rain or snow, at dawn or dusk. If you see a scene that appeals to you, you can find a way to photograph it. A high ISO is useful when light is dim. It will help you shoot at a fast enough shutter speed to stop motion or at a small enough aperture to give adequate depth of field. A tripod can steady a camera for long exposures.

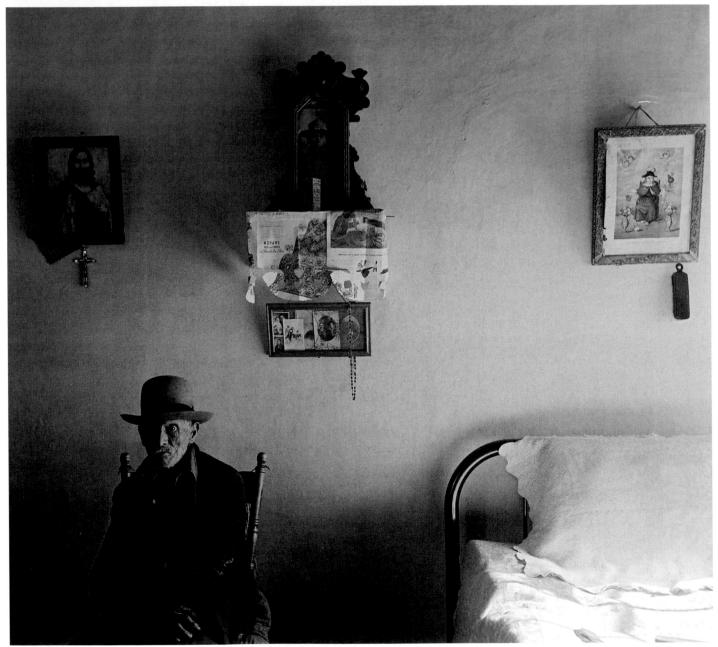

John Collier. Grandfather Romero, 99 years old, Trampas, New Mexico, 1943. Use the light you find if you can; it usually looks the most believable.

Try to make something out of what is already there before thinking of changing anything. The light in this room from one small window is simple and effective. Kenneth Josephson. Chicago, 1961. Available light can also mean available shadow. Often, the play of light and shadow alone can be enough to make a great picture. As subjects, the figures here are not as important as the arrangement of shapes made by bits of sunlight piercing the overhead structure of Chicago's elevated train.

David Alan Harvey. Easter Celebration in the Mixtec Region, Oaxaca, Mexico, 1992. In extremely dim light, start with the highest ISO your camera offers (or an ultrafast film like Fuji Neopan 1600). Only the candles illuminate this scene, which was left reddish by the photographer even though the white balance could be adjusted in post-production. Bracketing is always a good idea in marginal lighting situations. Make several extra shots if you can, increasing the exposure, then decreasing it.

The Main Light The strongest source of light

he most realistic and usually the most pleasing lighting resembles daylight, the light we see most often: one main source of light from above creating a single set of shadows. Lighting seems unrealistic (although there may be times when you will want that) if it comes from below or if it comes from two or more equally strong sources that produce shadows going in different directions.

Shadows define the lighting. Although photographers talk about the quality of light coming from a particular source, it is actually the shadows created by the light that can make an image harsh or soft, menacing or appealing. To a great extent, the shadows determine the solidity or volume that shapes appear to have, the degree to which texture is shown, and sometimes the mood or emotion of the picture.

The main light, the brightest light shining on a subject, creates the strongest shadows. If you are trying to set up a lighting arrangement, look at the subject from camera position. Notice the way the shadows shape or model the subject as you move the main light around or as you change the position of the subject in relation to a fixed main light.

Direct light from a 500-watt incandescent lamp in a bowl-shaped metal reflector was used for these photographs, with no other light sources, producing shadows that are hard edged and dark. Direct sunlight or direct flash will produce similar effects. The light would be softer if it were bounced onto the subject from another surface, such as an umbrella reflector (shown on page 145), or if it were diffused. Fill light (see pages 142–143) would lighten the shadows.

Frontlighting. Here the main light is placed close to the lens, as when a flash unit attached to the camera is pointed directly at the subject. Fewer shadows are visible from camera position with this type of lighting than with others, and, as a result, forms seem flattened and textures less pronounced. Many news photos and snapshots are frontlit because it is simple and quick to shoot with the flash on the camera.

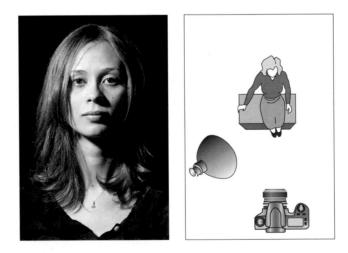

High 45° lighting. If the main light is moved high and to the side of the camera, not precisely at 45° but somewhere in that vicinity, shadows model the face to a rounded shape and emphasize textures more than with front lighting. This is often the main light position used in commercial portrait studios; fill light would then be added to lighten the shadows.

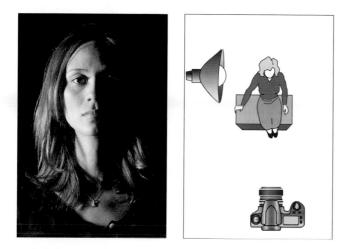

Side lighting. A main light at about a 90° angle to the camera will light the subject brightly on one side and cast chadews acress the other side. When the sun is low on the horizon at sunset or sunrise, it can create side lighting that adds interest to landscapes and other outdoor scenes. Side lighting is sometimes used to dramatize a portrait.

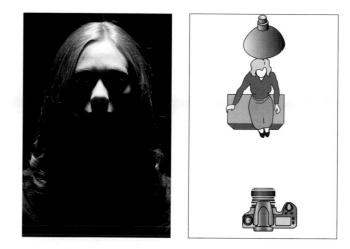

Top lighting. With the light directly overhead, long dark shadows are cast into an cockets and under nose and chin, producing an effect that is seldom appealing for portraits. Unfortunately, top lighting is not uncommon—outdoors at noon when the sun is overhead or indoors when the main light is coming from ceiling fixtures. Fill light added to lighten the shadows can help (see next page).

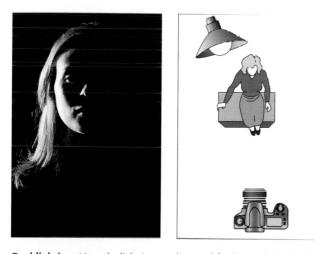

Backlighting. Here the light is moved around farther to the back of the subject than it is for side lighting. If the light was directly behind the subject, the entire face would be in shadow with just the hair outlined by a rim of light. Backlighting, also called edge or rim lighting, is used in multiple-light setups to bring out texture or to separate the subject from the background.

Bottom lighting. Lighting that comes from below looks distinctly odd in a portrait. This is because light on people outdoors or indoors almost never comes from below. This type of light casts unnatural shadows that often create a menacing effect. Some products, however—glassware, for example—are effectively lit from below; such lighting is often seen in advertising photographs.

Fill Light to lighten shadows

Fill light makes shadows less dark by adding light to them. Photographic materials can record detail and texture in either brightly lit areas or deeply shadowed ones but generally not in both at the same time. So if important shadow areas are much darker than lit areas—for example, the shaded side of a person's face in a sunlit portrait—consider whether adding fill light will improve your picture. The fill light should not overpower the main light but simply raise the light level of shadow areas so you can see clear detail in the final image.

When do you need fill light? Negative films are very sensitive to contrast; digital capture is somewhat less so. With either, as little as two stops difference between lit and shaded areas can make shadows very dark. HDR (pages 74–75) can help control excessive contrast but the subject must be absolutely stationary; it can't help when you are photographing people.

In most portraits, a partly shaded subject that has shadows two stops darker than the lit side of the face will be contrasty but will still show full texture and detail everywhere. But when shadows get to be three or more stops darker than lit areas, fill light becomes useful. You can control contrast between highlights and shadows later, in editing, but results are often better if you can lighten shadows by adding fill light, rather than trying to lighten a too-dark shadow later.

Fill light outdoors. It is easier to get a pleasant expression on a person's face in a sunlit outdoor portrait if the subject is lit from the side or from behind and not squinting into the sun. These positions, however, can make the shadowed side of the face too dark. In such cases, you can add fill light to decrease the contrast between the lit and shadowed sides of the face (see right). You can also use fill light outdoors for close-ups of flowers or other relatively small objects in which the shadows would otherwise be too dark.

Fill light indoors. A single photoflood or flash used indoors often produces a very contrasty light in which the shaded side of the face (or any other subject) will be very dark if the lit side is exposed normally. Such light is likely to appear more contrasty than in a similar photograph lit by sunlight because light from the sky acts as fill light outdoors. Notice how dark the shaded areas are in the single-light portraits on pages 140–141. You might want such contrasty lighting for certain photographs, but ordinarily fill light should be added to make the shadows lighter.

Sources of fill light. A reflector, such as a white card or cloth, is a good way to add fill light indoors or out. An aluminized "space blanket" from a camping-supply store is easy to carry and highly reflective. Convenient collapsing "bounce cards" are available from camera retailers that cater to professionals. Holding a reflector at the correct angle, usually on the opposite side of the subject from the main light, will reflect some of the main light into the shadows.

A flash can be used for fill light indoors or outdoors. A unit in which the brightness of the flash can be adjusted is much easier to use than one with a fixed output. Some flash units designed for use with automatic cameras (or built into the camera body) can be set to provide fill flash automatically.

In indoor setups, light from another photoflood can be used for fill light. To keep the fill light from overpowering the main light, the fill can be farther from the subject than the main light, of lesser intensity, bounced, or diffused. See photographs opposite.

Frontlight. The man's face is lit by sunlight shining directly on it. Facing someone into the sun usually causes an awkward squint against the bright light.

Backlight. Here he faces away from the sun and has a more relaxed expression. Increasing the exposure would lighten the shadowed side of his face but make the lit side very light.

Backlight plus fill light. Here he still faces away from the sun, but fill light has been added to lighten the shaded side of the face. A reflection of the bounce card appears in his glasses. Such reflections can be controlled by angling the head slightly.

Using a reflector for fill light. A large white cloth or card can lighten shadows in backlit or sidelit portraits by reflecting onto the shaded side of the subject some of the illumination from the main light. Sometimes nearby objects will act as natural reflectors, such as sand, snow, water, or a light-colored wall. The reflector can be clamped to a stand, held by an assistant, or simply propped up. The closer the reflector is to the subject, the more light it will reflect into the shadows. Be careful to keep it out of the picture.

In the example on the right, the main light is on your left the sitter's right. The light is inside a soft box, used to soften shadow edges. Clamped to a stand on the opposite side of the subject is the reflector, sometimes called a bounce card.

For a portrait, try to angle the reflector to add enough fill light so the shadowed side of the face is one to two stops darker than the sunlit side. Here's how to count the number of stops' difference. Meter only the lit side and note the shutter-speed and aperture settings. Meter only the shadowed side and note the shutter speed and aperture. The number of f-stops (or shutter-speed settings) between the two exposures equals the number of stops' difference.

Using a photoflood for fill light. The photographer placed the main light at about a 45° angle to the left, then positioned a second photoflood on the right side of the camera so it increased the brightness of the shadows. This fill light was placed close to the camera's lens so it did not create secondary shadows that would be visible from camera position. The main light was placed closer to the subject so it would be stronger than the fill light.

Meter the lit side of the scene and the shaded side; then adjust the lights until the shaded side is one to two stops darker than the lit side. To get an accurate reading, you must meter each area separately without including the background or other areas of different hrightness. If you are photographing very small objects, you can use a spot meter or make substitution readings from a photographic gray card positioned first on the lit side, then on the shadowed side.

Using flash for fill light. To lighten the shadows on the subject's face, the photographer attached a flash unit to her camera. If the flash light is too bright, it can overpower the main light and create an unnatural effect. To prevent this, the photographer set the flash for manual operation and draped a handkerchief over the flash head to decrease the intensity of the light. She could also have stepped back from the subject (although this would have changed the framing of the scene), or, with some flash units, decreased the light output of the flash.

The handkerchief also changes the quality of the light. Like a small version of the soft box pictured above, it increases the apparent size of the source and so slightly softens the harshness that usually results from small camera-mounted flash units. Many flash attachments and light modifiers are available separately to further alter the harshness of on-camera flash.

See your owner's manual for instructions on how to set your camera and flash for fill lighting. In general, for a subject that is partly lit and partly shaded, decrease the brightness of the flash on the subject until it is one to two stops less than the basic exposure from the sun.

Simple Portrait Lighting

Many fine portraits have been made using simple lighting setups. You don't need a complicated arrangement of lights to make a good portrait. In fact, the simpler the setup, the more comfortable and relaxed your subject is likely to be. (See pages 166–169 for more about photographing people.)

Outdoors, open shade or an overcast sky surrounds a subject in soft, even lighting (photograph opposite, bottom). In open shade, the person is out of direct sunlight, perhaps under a tree or in the shade of a building. Illumination comes from light reflected from the ground, a nearby wall, or other surfaces. If the sun is hidden by an overcast or cloudy sky, light is scattered over the subject from the entire sky. In sunlight, shadows may appear relatively bluish because they are hidden from the sun and illuminated only with light from the sky. **Indoors, window light** is a convenient source of light during the day (this page, bottom). The closer your subject is to the window, the brighter the light will be. If direct sunlight is shining through the window and falls on the subject, contrast will be very high: lit areas very light, unlit areas very dark. A small window will create harder shadows than a large one. Unless you want extreme contrast, it's best to have the subject also lit by indirect light bouncing off other surfaces. A reflector opposite the window can lighten shadows by adding fill light to the side of the person facing away from the window.

A main light—photoflood or flash—plus reflector fill is a simple setup when available light is inadequate (see opposite top). Bouncing the main light (sometimes called the *key* light) into an umbrella reflector provides a softer light than shining it directly onto the subject.

Amy Stein. Window #2, 2005. Window light can be contrasty unless other windows, as here, a nearby light-colored wall, or a wellplaced reflector, provide fill.

Stein's series Domesticated "explores our paradoxical relationship with the 'wild.'" Like the birds, the woman looks at the world from inside her geometric enclosure. **Sam Comen.** Amy Adams for The New York Times, Los Angeles, 2014. **A main light plus reflector fill** is the simplest setup when you want to arrange the lighting yourself. The main source of light here is from a medium-sized softbox pointed at the subject. A reflector on the other side of the subject bounces some of the light back to lighten the shadows. Comen was given about twenty minutes to shoot the star of Tim Burton's Big Eyes in a hotel's conference room.

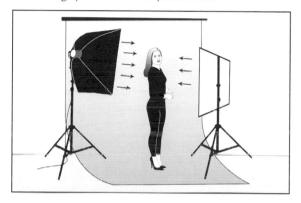

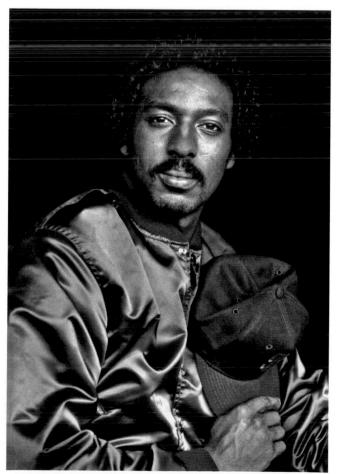

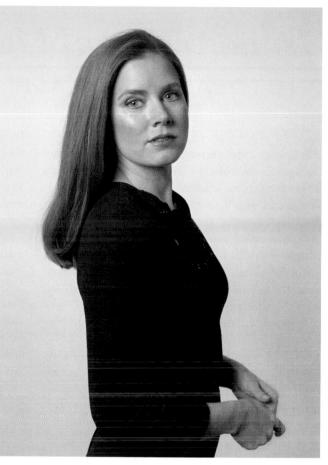

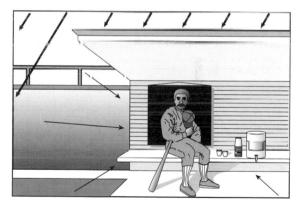

John Weiss. Garry Templeton, San Diego Padres, 1984. In open shade outdoors, a building, tree, or other object blocks the direct rays of the sun. Softer indirect light bounces onto the subject. Here, the ballplayer was shaded by the dugout roof. The photographer hung a black cloth on the dugout wall to provide a plain background.

Using Artificial Light photolamp or flash

Artificial light sources let you bring your own light with you when the sun goes down, when you photograph in a relatively dark room, or when you need just a little more light than is available. Artificial sources are consistent and never go behind a cloud just when you're ready to take a picture. You can manipulate them to produce any effect you want—from light that looks like natural sunlight to underlighting effects that are seldom found in nature. Different sources produce light of different color balances, each requiring a different white balance setting.

Continuously burning (incandescent) lamps such as LED bulbs, tungsten lights, and quartz (or halogen) lamps plug into an electrical outlet. Because they let you see how the light affects the subject, they are excellent for portraits, still lifes, and other stationary subjects that give you time to adjust the light exactly. Determining the exposure is easy: you meter the brightness of the light just as you do outdoors. Professional photographers often refer to continuous sources as *hot lights*.

Electronic flash or *strobe* is the most popular source of portable light. Power can come from either batteries, a rechargeable power pack, or an electrical outlet. Some units are built into cameras, but the more powerful ones, which can light objects at a greater distance, are a separate accessory. Because electronic flash is fast enough to freeze most motion, it is a good choice when you need to light unposed shots or moving subjects.

Flash must be synchronized with the camera's shutter so the flash of light occurs when the shutter is fully open. With most single-lens reflex cameras that have a focal-plane shutter, shutter speeds of $\frac{1}{60}$ sec. or slower will synchronize with electronic flash; some models have shutters that synchronize at higher speeds, up to $\frac{1}{300}$ sec. At shutter speeds faster than that, the camera's shutter curtains are open only part of the way at any time so only part of the sensor would be exposed. The fastest shutter speed during which the curtains open all the way is called the sync speed. Cameras with leaf shutters synchronize with flash at any shutter speed. Some top-of-theline *dedicated* flash units (intended for use with a specific camera model) can operate in *high-speed* sync mode so the camera's focal-plane shutter can be set for any shutter speed. See your owner's manual for details on how to set the camera and connect the flash to it.

Automatic flash units have a sensor that measures the amount of light reflected by the subject during the flash; the unit terminates the flash when the exposure is adequate. Even if you have an automatic unit, sometimes you will want to calculate and set the flash exposure manually, such as when the subject is very close to the flash or very far from it and not within the automatic flash range. Like automatic focus, automatic flash units may give less accurate results when your subject is not centered in the frame. Most dedicated flash models allow the camera, when set for one of its auto-exposure modes, to control the brightness of the flash automatically to add a preset level of fill.

Determining your own exposure with flash is different from doing so with other light sources because the flash of light is too brief to measure with an ordinary light meter. Some professionals use a hand-held light meter that can measure the brief burst of a flash, but you can also accurately determine flash exposure using the histogram display on the back of a digital camera. Use a manual exposure mode and test exposures, varying the aperture, ISO, or flash power setting. Because the farther the subject is from a given flash unit, the dimmer the light that it receives, you can also calculate your flash exposure by knowing—or guessing—the subject's distance (opposite).

Automatic electronic flash is a standard accessory for an automatic exposure camera. The flash has a light-sensitive cell and electronic circuitry that sets the duration of the flash by metering the amount of light reflected by the subject during the exposure. **The inverse square law** is the basis for flash exposure calculations. The farther that light travels, the more the light rays spread out and the dimmer the resulting illumination. The law states that at twice a given distance, an object receives only one-fourth the light (intensity of illumination is inversely proportional to the square of the distance from light to subject). In the illustration here, only one-fourth the amount of light falls on an object at 10 ft. from a light source as on an object at 5 ft. from the source.

To calculate your own flash exposure, you need to know two things: the distance the light travels to

the subject and the guide number (a rating given by the manufacturer for the flash when used with a specific ISO). Divide the distance that the light travels from flash unit to subject into the guide number to give you the lens f-stop you should use. Some flash units have a calculator dial that will do the division for you. Dial in the ISO and the

flash-to-subject distance, and the dial will show the

correct f-stop.

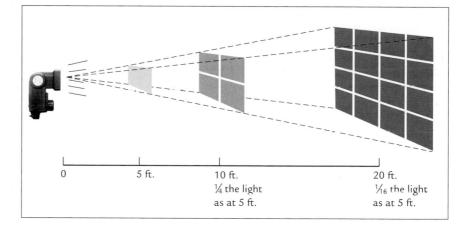

Manually Calculating a Direct Flash Exposure

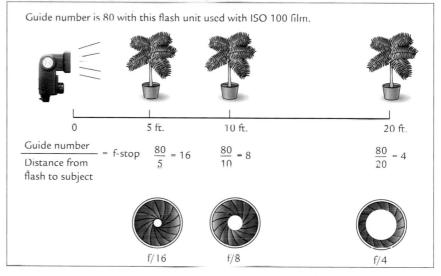

Manually Calculating a Bounce Flash Exposure

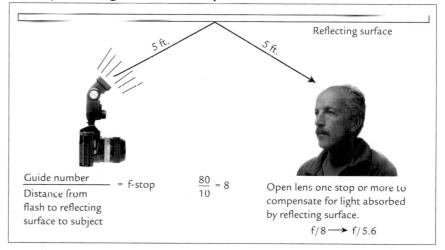

Changing the shutter speed does not affect the exposure from a flash, as long as it is within the acceptable range for synchronization (the sync speed or slower).

You can determine the amount of light falling on the subject by dividing the distance to the subject into the flash unit's output (its *guide number*). Then you set the aperture accordingly (see illustrations above). Some manufacturers overrate guide numbers a bit (in order to make their products sound more powerful than they actually are), so it's a good idea to try out a new flash unit with some test exposures or a professional flash meter before you use it for anything important.

Bounce flash travels an extra distance. If you

are calculating a bounce flash exposure, measure the distance not from flash to subject but from flash to reflecting surface to subject. In addition, open the lens aperture an extra one-half stop or full stop to allow for light absorbed by the reflecting surface. Open even more if the reflecting surface is not white or very light in tone.

Some automatic flash units have a head that can be swiveled up or to the side for bounce flash while the flash sensor remains pointed at the subject. This type of unit can automatically calculate a bounce flash exposure because no matter where the head is pointed, the sensor will read the light reflected from the subject toward the camera. Some cameras can measure flash light through the lens: these also can be used automatically with bounce flash.

More about Flash how to position it

Light gets dimmer the farther it travels. Light from any source—a window, a continuously burning lamp, a flash—follows the same general rule: the light falls off (gets dimmer) the farther the light source is from an object. You can see and measure that effect if, for example, you meter objects that are near a bright lamp compared to those that are farther away. But light from a flash comes and goes so fast that you can't see the effect of the flash on a scene at the time you are taking the picture.

A flash-lit scene may not be evenly illuminated. Because light from a flash gets dimmer the farther it travels, you have to use a smaller lens aperture for subjects close to the flash, a wider aperture for subjects farther away. There are several ways to determine the correct exposure for a subject at a given distance (pages 146–147). But what do you do if different parts of the same scene are at different distances from the flash?

Sometimes you can rearrange the subject, such as the people in a group portrait, so all are more or less at the same distance from the flash; perhaps you can change your own position to have the same effect. You can also modify the flash so it more evenly reaches various parts of the scene, such as by bouncing the light onto the subject or you can use more than one flash unit. If none of these options is possible, you simply have to work with the fact that those parts of the scene that are farther from the flash will be darker than those that are closer. Unless it is extreme, you can effectively compensate for uneven exposure in editing. If you know the light falls off and gets dimmer the farther it travels, you can at least predict how the flash will illuminate a scene.

Flash portraits. In one way, flash is easy to use for portraits: the flash of light is so fast that you don't have to worry about the subject blurring because it moved during the exposure. But the light from the flash is so quick (V_{1000} sec. or shorter) that you can't really see what the subject looks like when lit. However, with some practice you can predict the qualities of light that are typical of different flash positions. Shown on the opposite page are some simple lighting setups for portraiture.

When objects are at different distances from a flash, those that are closer will be lighter than those that are farther away. Notice how dark the back of the room is; even the dog's tail is darker than his head. Try to position the most important parts of a scene (or position the flash) so they are more or less the same distance from the flash.

Notice the dog's unusually bright eyes. In a color photograph they would appear red. Red-eye is a reflection of the eye's retina through its lens and occurs when the flash is mounted too close to the camera's lens. The retina's surface is covered with blood vessels that make the reflected light red. For an example of red-eye in color, see page 218.

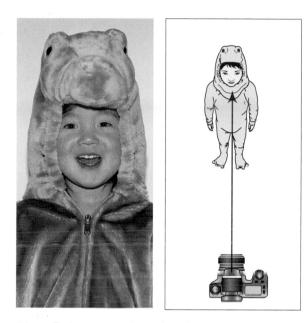

Direct flash on camera is simple and easy to use because the flash is attached to the camera. The light shining straight at the subject from camera position, however, tends to flatten out roundness and gives a rather harsh look.

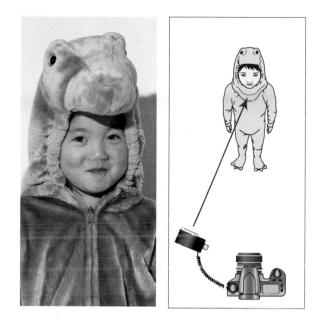

Direct flash off camera—usually raised and to one side gives more roundness and modeling than does flash on camera. A synchronization (or sync) cord lets you move the flash away from the camera. To avoid a shudow on the wall, move the subject away from it or raise the flash moro.

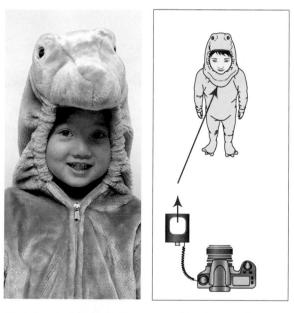

Flash bounced from above onto the subject gives a softer, more natural light than direct flash. Light can also be directed into a large piece of white cardboard or an umbrella reflector and then bounced onto the subject. Bouncing the flash cuts the amount of light that reaches the subject. Some flash units automatically compensate for this, or you can make the exposure adjustment yourself (see page 147).

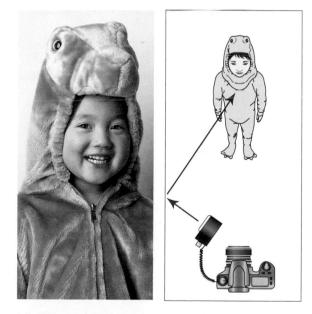

Flash bounced from the side onto the subject gives a soft, flattering light. You can use a light-colored wall, a large piece of white cardboard, or an umbrella reflector. The closer the subject is to the reflector, the more distinct the shadows will be. To avoid a shadow on the back wall, move the subject away from it.

Using Flash

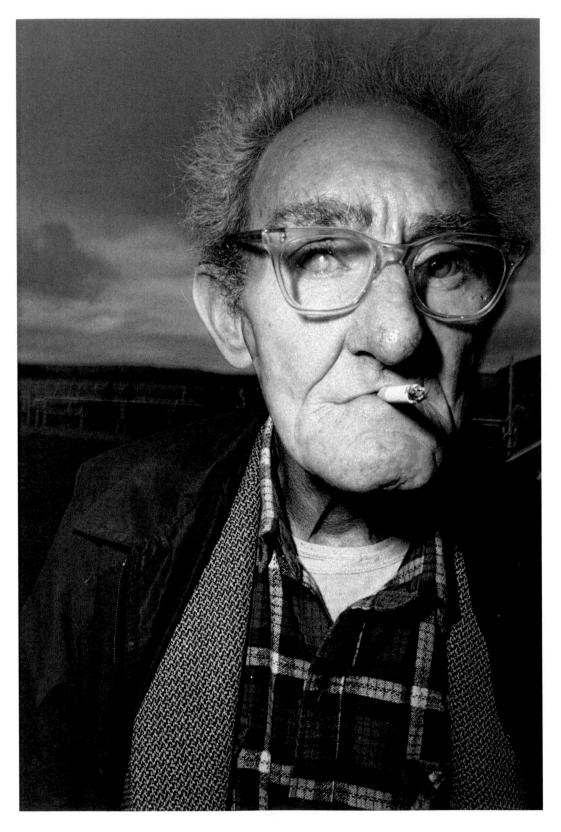

Bruce Gilden. Old Man at a Racetrack, Ireland, 1996. **Flash can be unflattering,** especially direct light from a built-in flash or one attached to the camera. Gilden often shoots with his camera in one hand and the flash in the other, connected by a sync cord. By moving the light source away from the camera he creates shadows that give depth to his subject.

And, because of its very short duration, 1/1000 sec. or less, flash can also capture a momentary expression. Gilden used this image in After the Off, his series on rural racetracks in Ireland.

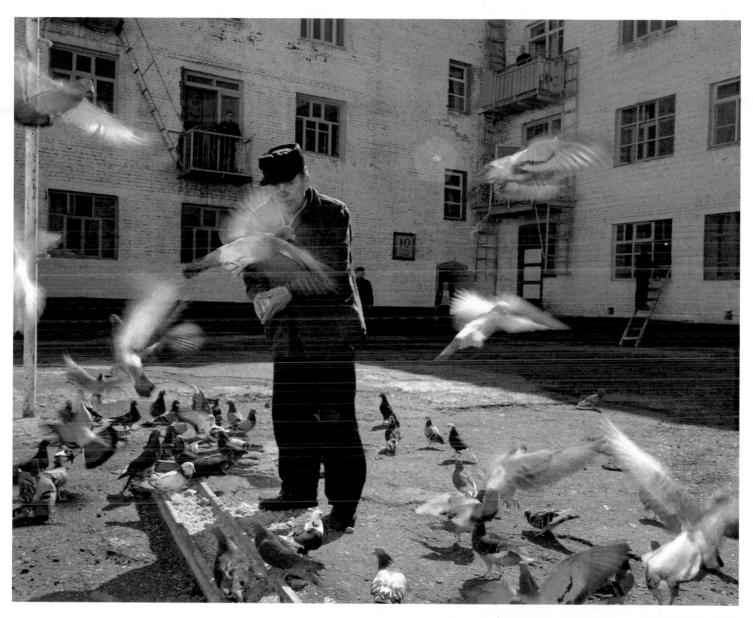

Carl De Keyzer. GI. K. 6. Krasnoyarsk, 2002. **Flash fills the shadows.** Without the flash, shooting into the light like this would put the subject in silhouette; the position of the sun is revealed by the shadows of the man and the building coming toward the photographer. The blur of movement around the birds' wings is the result of movement during the exposure and is noticeable here because the daylight provides more of the overall exposure than the flash.

This photograph is from a self-assigned project investigating Siberian prison camps, former gulags, that was published as the book Zona.

CHAPTER 8 🔓 151

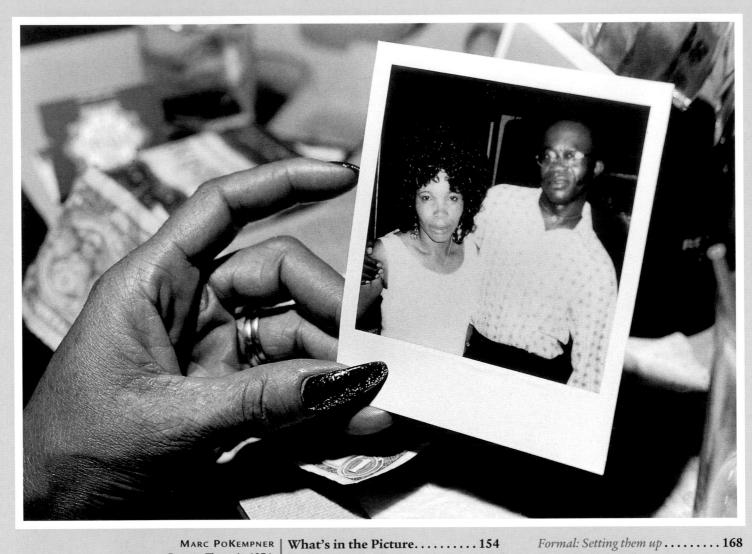

Down at Theresa's, 1974.

What's in the Picture154
The edges or frame154
The background156
Focus
Which parts are sharp 158
Time and Motion in a Photograph160
Depth in a Picture162Three dimensions become two162Chaos into order163
Photographing for Meaning164
Portraits
Informal: Finding them166

Formal: Setting them up 168

Photographing the Landscape 170
Photographing the Cityscape 172
Photographing Inside174
Assembled to be Photographed 176
Responding to Photographs178

Seeing Like a Camera

In this chapter you'll learn...

- to break down your intuitive way of taking a picture into conscious component parts—subject and content, framing and the edge, and the foreground/background relationship.
- to make considered decisions about how your camera settings, location, and subject will affect the meaning of a photograph.
- how to discuss your photographs and those of others in ways that go beyond "I like it" or "It's good."

Pictures translate the world you see. Your photographs leave behind the world outside their edges, and make the parts that are recorded flatter and, usually, much smaller. Black-and-white photographs are even more abstracted than those in color. No photograph is the same thing as what you photographed; it refers somehow to the original scene but has its own life and meaning. The only way to understand and master this translation is to continue the work cycle: make a photograph, look at it, think about it, make another.

Photographs can tell a story, arouse an emotion, or evoke a mood. They can convey a political, sociological, or theological insight, or they can merely be a reminder of an event. The weight and import of your photographs will depend on your own aspirations and the effort you devote to mastering the medium.

Photography is a kind of literature—in two ways First, any time you can spend absorbing the work of recognized masters will reward your own work with insight and inspiration; the Internet is useful but a good library is as important as a good lens. Second, photographs can be assembled like sentences placed consecutively to carry a larger and more complex meaning. For example, the two photographs on pages 172–173 show a romantic and a gritty side of city life, and together say more than either one of them says by itself.

This chapter's illustrations should be a jumping off point, but there is no better way to become a good photographer than to keep making photographs. Every time, before you shoot, ask yourself what you want in the photograph. Once you have taken the photograph as you imagined it, stop for a moment to consider other options. How would it look if you framed the scene vertically instead of horizontally? What if you moved the camera to a very low point of view? What would a slow shutter speed do to motion in the scene? Try some of the variations, even if you are not sure how they will look in a print. In fact, try them especially if you are not sure, because that is the way to learn how the camera will translate the world before it. Photographs affect their viewers, sometimes profoundly. Take them seriously; see and read more about your choices, and how to make them, on the following pages.

Santiago Harker. Norte de Santander, Colombia, 1985. *You have choices.* To begin with, what do you choose to photograph? In a portrait, the whole person, head to toe? Their face? Or just a part of them that reveals something about their life?

Opposite, PoKempner moved in close to concentrate on the hand holding the snapshot. Depth of field is shallow when the camera is close to the subject, so it is important to select and focus on the part of the scene you want to be sharp.

Left, Harker made many choices that were different. He chose full color, natural light, a more distant vantage point, more depth of field, and a vertical format. More importantly, he chose a different balance between form and content (see page 164), choosing to emphasize bold colors and strong graphics over a clear description of an event.

What's in the Picture the edges or frame

One of the first choices to make with a photograph is what to include and what to leave out. The image frame, the rectangle you see when you look through the viewfinder or at the LCD monitor, shows only a section of the much wider scene that is in front of you. The frame crops the scene or, rather, you crop it—when you decide where to point the camera, how close to get to your subject, and from what angle to shoot.

Decide before you shoot whether you want to show the whole scene (or as much of it as you can) or whether you want to move in close (or zoom in with a zoom lens) for a detail. You can focus attention on something by framing it tightly or you can step back and have it be just another element in a larger scene.

Where is your subject positioned in the frame? We naturally look at the middle of things to get the clearest view. Most of us have a similar tendency to place a subject squarely in the middle of the frame, especially when hand holding a camera and framing through a viewfinder. Usually it's better not to center your subject, although there are exceptions to this and to any other rule.

When you look through the viewfinder or at the camera's monitor, imagine you are viewing the final image on display. This will help you frame the subject better. The tendency is to "see" only the main subject and ignore its surroundings. In the final print, however, the surroundings and the framing are immediately noticeable.

You can also change framing later by cropping the edges of a picture when it is printed. Many photographs can be improved by cropping out distracting elements at the edges of the frame. But it is best to frame exactly when you take the picture; the highest quality results from using all the image area you capture. Keep in mind the old saying, "crop with your feet."

How much of the subject should you include? What you put in the picture and what you leave out are among the most important decisions you have to make when photographing. Do you need to move in close to your subject or will a wider view better represent your ideas?

Terry E. Eiler. Old Fiddler's Convention, Gulux, Virginia, 1978. **You can frame the central subject of a picture with other parts of the scene.** Showing the instruments surrounding the fiddler at center, while cropping out most of the other musicians themselves, focuses attention on the fiddler.

Project: THE CUTTING EDGE

PROCEDURE Expose a few dozen digital pictures or a roll of film using the edges of the picture, the frame, in various ways. As you look through the viewfinder, use the frame to surround and shape the image in different ways. Make a viewing aid by cutting a small rectangle in an 8 \times 10-inch piece of black cardboard. It will be easier to move around and look through than a camera and can help you visualize your choices.

Put the main subject off to one side or in one corner of the frame. Can you balance the image so that the scene doesn't feel lopsided?

Put the horizon line at the very top or very bottom of a photograph, or try tilting it intentionally.

Have "nothing" at the center of the frame, like the photograph above. Keep the viewer's interest directed toward the edges.

Make a portrait of someone without his or her head in the picture. Try to have the image express something of the subject's personality. Have someone looking at or reaching for something outside the frame. Have them close to the side of the frame they are looking or reaching toward. Then have them far from that side, at the other side of the frame.

Photograph something in its entirety: a person, a shopfront, an animal, an overstuffed chair—whatever gets your attention. Move in a little closer. How will you use the frame to cut into the object? Do you crop the object evenly all around? More on one side than the other? Move in even closer. Closer. Photojournalist Robert Capa said, "If your pictures aren't good enough, you aren't close enough." Do you agree?

HOW DID YOU DO? What worked best? What wouldn't you ordinarily have done?

What's in the Picture

Seeing the background. When you view a scene, you see most sharply whatever you are looking at directly, and you see less clearly objects in the background or at the periphery of your vision. If you are concentrating on something of interest, you may not even notice other things nearby. But the camera's lens does see them, and it shows unselectively everything within its angle of view. Unwanted or distracting details can be ignored by the eye looking at a scene, but in a picture those details are much more conspicuous. Before shooting, try to imagine how the scene will look if the subject and background are given equal emphasis. To reduce the effect of a distracting background, you can shoot so that the background is out of focus or change your angle of view as shown in the photographs at right. There is no rule that says you shouldn't have a distracting background; sometimes that can be exactly the point, as in the picture opposite. Just be aware of the different way the camera sees.

The relationship of subject to background is called *figure/ground*, or *positive and negative space*, and these terms give you a way to talk about why a picture works or doesn't work. Having a vocabulary for the way pictures are structured (their *formal* qualities) doesn't necessarily make you a better photographer, but does allow you to discuss these issues with others and to analyze what you might be doing subconsciously. See pages 178–179.

Where's the subject? The clutter of objects in the background attracts the eye at least as much as do the man and bird in the foreground. If the picture is about the location, then the

building can make a useful contribution. But if the photograph is supposed to be about the man and his bird, then the busy background seems an unnecessary distraction.

A less-intrusive background resulted when the photographer simply moved to a lower vantage point and changed the angle from

which she shot. The plain sky provides a clear separation between figure and ground, and doesn't distract from the subject.

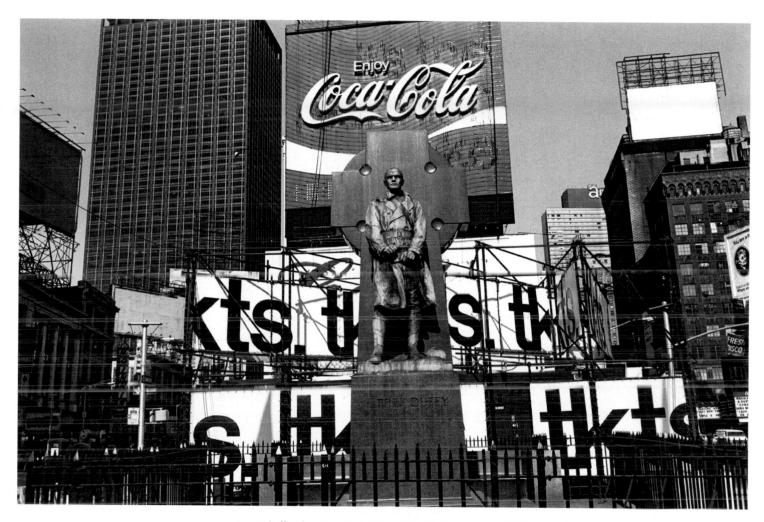

Lee Friedlander. New York City, 1974. Make sure you look at the background of a scene as well as the main subject of interest. If you aren't paying attention, you may lose your subject entirely. Confusion of the background and foreground, however, may itself be the subject. Here, Friedlander uses chiaroscuro, as artists call patterns of light and dark, to suggest the intensity of life—even for a statue—in New York. The picture is visually chaotic and ambiguous, but intentionally so.

Remember that the camera records everything within its angle of view with equal importance, even if you are looking only at one subject. A photograph can render the relation between a foreground object and a background very differently than you perceive it.

Project: USING THE BACKGROUND

PROCEDURE Make photographs in which the background either complements or contrasts with the subject. For example, someone drinking coffee in front of a large ornate espresso maker; an arguing couple in front of a smiling-face poster; a child by a "Library Closed" sign; a shopkeeper standing in front of a store.

Look through the viewfinder (or a viewing aid, like the one

described in the Project box on page 155) as you try different positions from which to photograph.

HOW DID YOU DO? Compare several of your most successful prints. Could the background be seen as clearly as the subject? What did the background contribute?

Focus

WHICH PARTS ARE SHARP

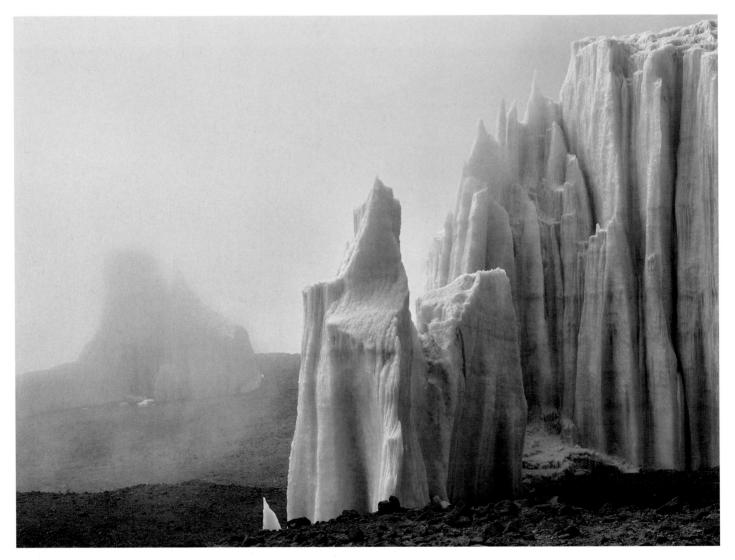

When you see a scene your eyes actually focus on only one distance at a time; objects at all other distances are not as sharp. Your eyes automatically adjust their focus as you look from one object, or part of an object, to another. If you were at the scene shown opposite, bottom, you might look at the wire rack and not notice you were seeing the sailors much less sharply. If you looked at the sailors your eyes would instantly refocus to see them sharply. But in a photograph, differences in the sharpness of objects at different distances are immediately evident because focus relationships are frozen at the time of exposure. Such differences can be distracting or they can add interest to the photograph, depending on how you use them. **Controlling the depth of field.** In some photographs you have little choice about depth of field (the area from near to far within which all objects appear acceptably sharp). For example, in dim light, or with a low ISO, or under other conditions, the depth of field may have to be very shallow in order to get any picture at all. But usually you can control the depth of field to some extent, as shown on pages 44–45. It is not necessarily better to have everything sharp, or the background out of focus, or to follow any other rules, but it is important to remember that in the photograph you will notice what is sharp and what isn't. You get to choose, and it is one of the most important choices you have. Ian van Coller. Eastern Icefield, Mt. Kilimanjaro, Tanzania, 2016. Landscapes are often photographed so that everything is sharp from foreground to background. In this case, land in the distance is rendered sharply even though it is softened by low clouds.

Van Coller endured an arduous five-day trek to reach these remaining icefields at 19,000 feet for his series The Last Glacier, that records parts of the earth's environment threatened by climate change.

Project:

USING DEPTH OF FIELD

PROCEDURE As you look at various subjects, try to anticipate how much depth of field you want, and how you can increase (or decrease) the depth of field to get more (or less) of the photograph to appear sharp. Page 45 shows how to use aperture size, focal length, and/ or distance to do this.

Make several photographs of each scene, using depth of field in different ways. See for example, the landscape on page 47. You might have the entire scene sharp, as shown, or for the same scene, the river in front sharp and the background out of focus. How about just the mountains in the distance in focus? Is there some object you can call attention to using shallow depth of field that might be overlooked with everything in focus?

Keep notes of your aperture size, focal length, distance, and why you chose them, to remind you later what you did.

HOW DID YOU

DO? Compare your results. Were you able to get everything sharp when you wanted it that way? When you wanted something out of focus, was it out of focus enough? Now that you look at the prints, do you see anything you might try next time? **Elliott Erwitt.** Metropolitan Museum of Art, New York City, 1949. **The illusion of depth** is enhanced when the foreground is in sharp focus and the background becomes gradually softer. The gentle transition from near to middle distance to background in this photograph emphasizes its realism.

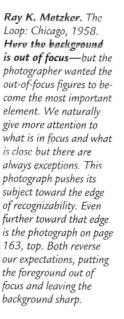

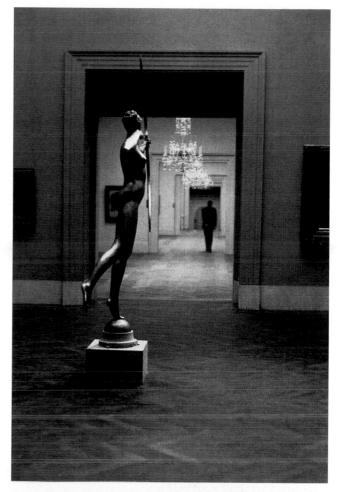

Time and Motion in a Photograph

A photograph is a slice of time. Just as you select the section that you want to photograph out of a larger scene, you can also choose the section of time you want to record. You can think of a photograph as carving through time, taking a wide slice at a slow shutter speed or a narrow slice at a fast shutter speed. In that slice of time, things are moving, and, depending on the shutter speed, direction of the motion, and other factors discussed earlier (pages 18–21), you can show objects frozen in mid-movement, blurred until they are almost unrecognizable, or blurred to any extent in between.

Blur part of a picture for emphasis. If the subject moves a little during the exposure (or if by panning—see page 19—you keep the subject still and move the background) you create visual interest with the comparison. Use a tripod to keep the background very sharp while your subject moves, as was done in the photograph below. Rarely is it effective to have the entire image blurred by motion, the way it would be if you used too slow a shutter speed or didn't hold the camera steadily. But even a photograph that is everywhere out of focus can be a visual treat; it is up to you to make it work.

Mike Mandel. Emptying the Fridge, 1985. Exposure time controls the suggestion of motion. In a reference to motion studies made by efficiency experts Frank and Lillian Gilbreth early in the 20th century, Mandel tied blinking lights to the person's hands and left the camera's shutter open for five minutes. The objects moved to the counter later in the exposure (for less of the total time) appear more translucent.

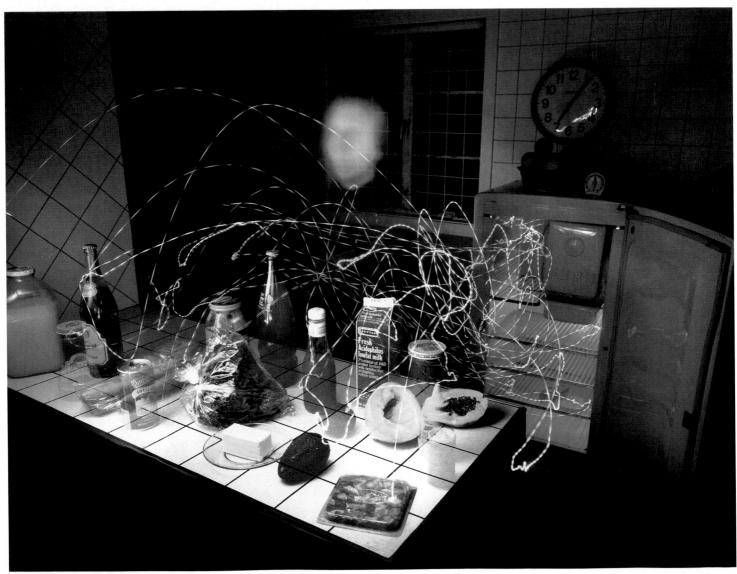

Project:

SHOWING MOTION

YOU WILL NEED A tripod, when you want to keep the camera steady during long exposures.

PROCEDURE Make

a series of photographs that depict motion in different ways. Select a scene that will let you photograph the same action several times, such as people moving on a crowded street, children on swings, or moving water or leaves. Or have someone perform the same action for you several times, such as a skateboarder, a runner, or a dancer.

How can you make a photograph that makes a viewer feel the subject is moving? Try showing the subject sharp. Try showing it blurred. Try panning the camera with the subject, so that the subject appears sharp against a blurred background. Page 19 shows some of the ways you can control the representation of motion.

Try photographing from a different angle, such as very low to the ground. If you move closer to your subject's feet or skateboard, or whatever is moving, you'll get more of a blur than if you stay farther away.

Keep notes of the shutter speed, distance, and relative subject speed so later you can reconstruct what you did.

HOW DID YOU

DO? What worked well? What didn't, but might have worked for another type of subject? Did some exposures produce too much blur? Did the subject disappear entirely in any frame?

Russell Lee. Soda Jerk, Corpus Christi, Texas, 1939. **Time is frozen by u flush.** The rapid motion of the flying ice cream has been halted in midair by the quick burst of light from an on-camera flash. Stopping time this abruptly can be unflattering, for example, by catching faces in between expressions, but it can also produce magical visions the eye could never have seen.

Lou Jones. Boston, 1998. Move the camera along with your subject to keep it in focus. Here, the photographer was positioned on the carnival rido itself so his relatively long shutter speed held nearby passengers in focus but allowed the parts of the scene not moving with him to blur. Panning, or moving the camera during exposure to follow a moving subject, of ten makes your photograph appear this way: a subject in focus against a streaking background.

Depth in a Picture Three dimensions become two

Photographs can seem to change the depth in a scene. When you photograph, you translate the three dimensions of a scene that has real depth into the two dimensions of a visual image. In doing so, you can expand space so objects seem very far apart or you can compress space so objects appear to be flattened and crowded close together. For example, compare these two photographs of buildings in a city. One shows us flat planes that look almost as if they were pasted one on top of the other and the other gives the scene volume, mass, and depth.

Your choices make a difference. The top photograph was made with a long-focal-length lens. Its narrow angle of view and close cropping, combined with the straight-on vantage point, helped the photographer reduce what we can see to a simple—and flattened—geometry. The bottom photo was made with a normal-focal-length lens but from an elevated position. This wider angle of view includes more buildings, and more of the bottom and top of each building. There was probably a limited selection of possible vantage points, but this one was still carefully chosen. Pages 48–49 explain more about how to use your lens and position to control the way a photograph shows depth.

All of your choices affect the viewer's impression of your subject's depth, something the photograph itself—being two dimensional—doesn't have at all. Showing only part of an object or a narrow view of a scene, for example, may contribute to reducing a viewer's impression of volume in a photograph. This may be easy to do by choosing a longer-focal-length lens, but framing, focus, vantage point, and lighting are all important factors as well.

Every time you take a picture, the three dimensions of the real world are translated automatically into the two dimensions of a photograph. But, like taking control of automatic focus and automatic exposure, it is usually best to make your own decisions.

Two perspectives of the city. Buildings (top) seen from the side seem to lie on top of each other. A bird's-eye night view (bottom) gives the buildings volume. All your choices,

Dan McCoy. Midtown Manhattan, 1973.

especially focal length, lighting, vantage point, and focus, can contribute to enhancing or suppressing the sense of a third dimension in your photographs.

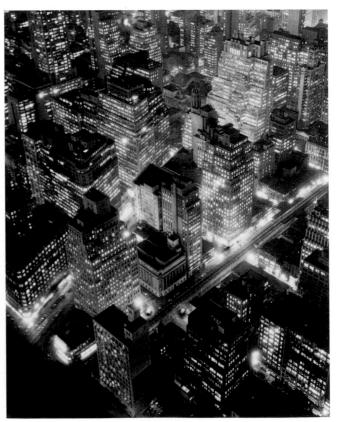

Berenice Abbott. New York at Night, 1934.

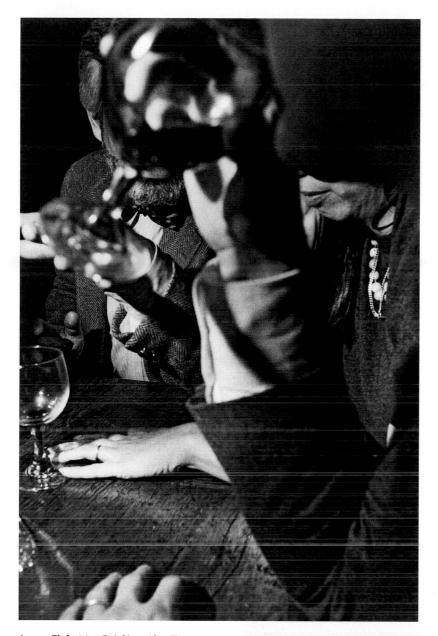

CHAOS INTO ORDER

Your choices of timing, vantage point, focus, and lens are a complex mix. You are *making* photographs, not just taking them, and must keep in mind that viewing them will be a different experience from seeing the world from which they were made. What kind of experience do you want to communicate?

Consider the two photographs on this page. The one below is carefully ordered and organized to create a mood of calm and serenity. We imagine the place—because of the way it is shown to us to have a storybook quality that we can't credit to a simple choice of lens or depth of field. At left is a photograph so chaotic it is difficult at first to sort out. It is jangled and energetic, with no clear subject.

In both cases the photographer has imposed a personal sensibility on what was in front of the lens and so directed our experience in viewing them. The ability to create a unique sensibility, and to do so consistently, is often called *style*. Style takes time to develop, and it hinges on both an understanding of the available tools and a sense of what it is important to use them for.

> **Pete Turner.** Ibiza Woman, 1961. **You can simplify your subject** with choices of where, when, and how to take the picture.

Larry Fink. Man Drinking, Alan Turner Party, 1982. The eye and brain hesitate when an image is too complex to be quickly deciphered. Creating that kind of hesitation is a goal of some photographers (see page 157).

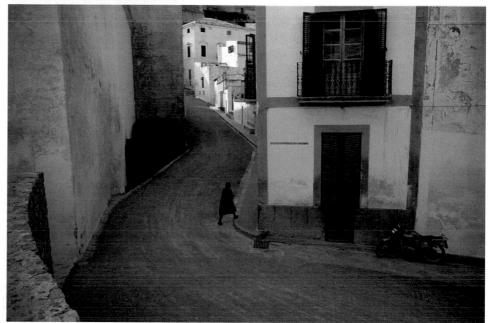

Photographing for Meaning

Good composition and technical quality are not the only goals you could keep in mind as you photograph. For some, it is enough to make a competent, well-designed photograph of the subject of your choosing. In fact, many photographers make a good living doing just that. All photographs have both form—the way a picture looks, including its composition—and content what a picture is about, including its subject. And there is a balance between form and content that the photographer can control. If you'd like an additional challenge, however, consider the way you can use form and content together to create meaning in a photograph.

Meaning can be reinforced, as in the photographs on these two pages, by arranging the way you show your subject. For example, meaning can be created using a metaphor based on appearance, like the supermarket stretching its mouth (opposite) or the muscular lines of Sheeler's Ford factory (right). To expand a picture's possibilities, think not only about what something looks like, but what else it looks like or might mean. Mythology, literature, and religion have invested many subjects with symbolic meaning—a pomegranate in a still life or a rutted path in a landscape—that can add significance. Your pictures can be more than just a record of a subject's existence.

Consider the physical qualities of your photograph. A slightly brown or sepia color of a black-and-white photograph is called *warm tone* because it imparts an emotional warmth to the

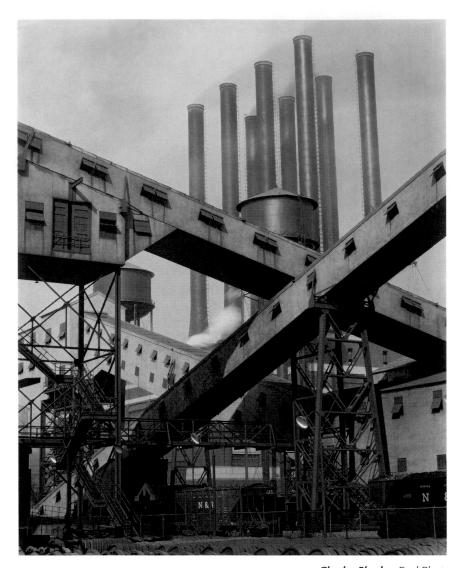

subject of the image. The wide panoramic shape of the landscape below suggests an endless horizon, a topography so vast it can't be contained in an ordinary rectangle. Scale also changes the effectiveness of an image: a tiny print often exudes intimacy; a very large one can project power. A thoughtful presentation of your work will make a big difference in its impact. Charles Sheeler. Ford Plant, River Rouge, Dearborn, Michigan, 1927. Sheeler imagined American factories to be like modern cathedrals, a substitute for religious experience. These powerful shapes reach toward the heavens, but seem to do so in respectful silence.

Warren Padula. Mouth, 1996. **Your subject can be a metaphor** for something else. Here, the dairy aisle in a supermarket becomes an open mouth in an amusing study of consumer culture. Made by using the bottom rack of a supermarket cart as a tripod to hold a home-made pinhole camera—a simple lensless box—it reminds us that the success or fuilure of a photograph is not the result of expensive equipment, but of the efforts and ability of the user. Another example of a photographic metaphor is on page 202, bottom.

Art Sinsabaugh. Midwest Landscape #24, 1961. A photograph's shape can affect its meaning. The extreme panoramic format used for this image was the photographer's response to the relentlessly horizontal and often featureless landscape of the American Midwest.

Portraits INFORMAL: FINDING THEM

A good portrait shows more than merely what someone looks like. It captures an expression, reveals a mood, or tells something about a person. Props, clothing, or a view into the subject's environment are not essential, but they can help show what a person does or what kind of a person he or she is (see photographs at right and on the opposite page).

Put your subject at ease. To do this, you have to be relaxed yourself, or at least look that way. You'll feel better if you are familiar with your equipment and how it works so you don't have to worry about how to set the exposure or make other adjustments.

Don't skimp on shooting when making a portrait. Make sure you aren't imposing on someone's time, then take three, four, or a dozen shots to warm up so your subject can get past the nervousness that many people have at first when being photographed.

Try to use a fast enough shutter speed, ¹/₆₀ sec. or faster, if possible, so you can shoot when your subject looks good, rather than your having to say, "Hold it," which is only likely to produce a wooden expression. Don't automatically ask your subject to smile, either. A quietly pleasant, relaxed expression looks better than a pasted-on big smile.

Lighting. See what it is doing to the subject. Soft, relatively diffused light is the easiest to use; it is kind to most faces and won't change much even if you alter your position.

Side lighting, like in the photographs on these two pages, adds roundness and a threedimensional modeling. The more to the side the main light is, particularly if it is not diffused, the more it emphasizes facial texture, including wrinkles and lines. That's fine for many subjects, but bad, for instance, for your Uncle Pete if he still wants to see himself as the young adult he used to be. Front lighting produces less modeling than does side lighting (see pages 140–141), but it minimizes minor imperfections. Three simple portrait lighting setups are shown on pages 144–145.

Alec Soth. Charles, Vasa, Minnesota, 2002. Leave yourself open to chance meetings. Soth, driving through an unfamiliar neighborhood, noticed a large glass room built on the roof of a house. He introduced himself to the owner, who said the glass room was his "cockpit," a place where he and his daughter built model airplanes.

Project:

A PORTRAIT

PROCEDURE There are at least as many different ways to make a portrait of someone as there are people in the world to photograph. Use at least three dozen exposures to photograph the same person in as many different ways as you can. Twice as many of the same person are even better. It may take a while before both you and your subject feel relaxed and comfortable. Here are some possibilities, but you can think up even more.

As a baseline, consider the conventional head and shoulders graduation-type portrait. Where can you go from there?

. Try different sites and backgrounds, such as in a park, at home, at work. Does the background have to look pleasant? How about in front of a row of beat-up school lockers?

Try different angles: from above or below, as well as from eye level. Try moving in very close, so the camera exaggerates facial features. Does the person always have to be sitting or standing?

If the person feels relaxed enough or can role-play, have him or her express different emotions, such as anger, sadness, silly good humor.

Vary the lighting: front, side, top, bottom, back (see pages 140-141), in direct sun, by a window, in the shade (see pages 136-137).

Do you have to see their face? Can you make a revealing portrait from the back? As a silhouette?

You'll know you have shot enough when both you and your subject are worn out.

HOW DID YOU DO?

Which are your favorite photographs? Why? Which are your subject's favorites? Why? How did the background, props, or other elements contribute to the picture? What would someone who didn't know this person think about them, based simply on seeing the photographs?

Chris Killip. Torso, Pelaw, Gateshead, Tyneside, 1978. A person can be revealed by more than just a face. Killip lived in Newcastle during the 1970s, a period of economic decline and high unemployment in England's industrial north. He was drawn to photograph this man, seated on a wall near Killip's home, by the stained trousers; he didn't notice the poorly repaired coat and mismatched shoelaces until he printed the image.

Years later, when asked to participate in a museum exhibit on portraiture, Killip sent this photograph. The museum sent it back with a note saying it wasn't a portrait. Do you think it is?

167

Portraits FORMAL: SETTING THEM UP

Control more of the situation when you want your portraits to look a certain way. You may want your portrait to look spontaneous, like you just stumbled on your subject, but a photograph can feel casual even if you've made an appointment in advance, asked your subject to wear your choice of clothes, or made them hold a given posture. Like the photographs on pages 166–167 show, there is a power in presenting someone in a believable setting, especially if you want your constructed narrative to have the ring of truth.

Some portraits should look more formal. A political leader or business executive may want a photograph that suggests the traditions of a studio portrait, like the one on this page. A celebrity magazine may want someone photographed in a more expressive way, but one (like on the opposite page) that appears just as deliberate. These styles require an understanding of lighting (see Chapter 8) and are usually made in artificial illumination supplied by the photographer.

A model release protects you if you sell a photograph of someone for commercial use. It is a contract with your subject that gives you the right to sell or publish his or her image. You can find sample releases online with a simple Internet search. The ASMP (American Society of Media Photographers, asmp.org) displays several useful versions online, and offers legal and business information to its members. Remember, even if someone asks you (or pays you) to make their photograph, its ownership, or copyright, remains yours unless you sign it away.

Yousuf Karsh. Sir Winston Churchill, 1941. The photographer was given only two minutes of this world leader's precious time. Lighting was arranged using a stand-in. Churchill arrived with his trademark cigar clenched in his teeth; Karsh instinctively reached out and removed it, capturing the angry and belligerent response that, for him, represented England's wartime defiance.

Arnold Newman. Igor Stravinsky, 1946. **The structure of a photograph can reinforce its meaning.** Newman cropped this portrait to its essentials, departing from the conventional rectangle. Composer Stravinsky is shown with a piano, the image connects him to music. The isolated piano top's shape suggests the quarter note in musical notation. Newman says that the image "echoed my feelings about Stravinsky's music: strong, harsh, but with a stark beauty of its own."

Photographing the Landscape

How do you photograph a place? There are as many different ways to view a scene as there are photographers. Most important for you: what do you want to remember? What is the best part of the place for you? Is it the sweep of the landscape as a whole that is breathtaking or is some particular part of it especially significant? In what way does the place speak to you? **Look at a scene from different angles,** walking around to view it from different positions. Your location can profoundly affect the relation between foreground and background; the closer you are to an object, the more a slight change of position will alter its relationship to the background. Change your point of view and a subject may reveal itself in a new way.

Richard Misrach. Tracks, Black Rock Desert, Nevada, 1989. **A landscape can have an opinion.** Beautiful as they are, the pattern of these tire tracks make us wonder if we are doing

enough to protect the earth from ourselves. Many landscape photographers try to exclude signs of civilization from their images; Misrach has made such encroachments a major theme.

Stuart Rome. Horsetail Falls, Oregon, 1996. **Landscapes are often sharp from foreground to background.** Depth of field increases with smaller apertures, but you must compensate with longer exposures. Here, the longer exposure allowed the motion of the waterfall to blur into a soft, surreal presence—in marked contrast to the hardness and sharpness of the surrounding rock.

Rome photographed from inside a cave to frame the waterfall in rock and show it against a background of forest. Your location can profoundly affect the relation between foreground and background; the closer you are to an object, the more a slight change of position will alter its relationship to the background.

> **Barbara London.** Point Lobos, California, 1972. **A landscape doesn't have to be a wide view.** This photograph of dried mud taken from up close and directly overhead is slightly disorienting. Not only is the subject matter ambiguous, but it isn't clear which way is up. The top of a picture usually identifies the top of a scene because we are used to seeing things—and photographing them—from an upright position. Change your point of view and a subject may reveal itself in a new way.

Photographing the Cityscape

How do you see the city? Is it a place of comfort or of chaos? Is it the people or the buildings that give it character? Whether you live in the city or you are just visiting, use the camera as your excuse to explore it.

Walking gives you time to photograph. Stop if you see something interesting; don't be in such a hurry that you can't pause to think about how best to frame your subject or wait for a moving presence to enter the scene. A passing pedestrian, dog, or city bus in transit may be just the graphic element to make your cityscape distinctive.

Return to a place when the light is best. The sun will illuminate a different side of a building in the morning than it does in the afternoon. Clouds or an overcast sky impart an entirely different emotional tone than a bright, sunny day.

Don't ignore the possibilities of photographing at dawn, dusk, or at night. A tripod will let you make long exposures, but be careful setting one up on a busy sidewalk.

The time of day affects more than just the light, as does the day of the week. Downtown streets look strangely deserted on Sunday mornings; rush hour is a great opportunity to capture human interaction.

Alfred Stieglitz. The Flatiron Building, New York, 1903. Choose your moment carefully. Soft focus and winter weather combine for a peaceful, contemplative scene. Stieglitz asserted this photograph's role as an art object by emphasizing its picturesque qualities and printing it on an elegant, textured paper.

Walker Evans. Graveyard and Steel Mill, Bethlehem, Pennsylvania, 1935. Your vantage point creates relationships. Evans helps us see parallels here between the rhythmic appearance of apartment house windows, the gravestones, and the smokestacks in the background. All these unrelated elements seem purposefully convened before the foreground cross as though for a sermon.

Photographing Inside

Interior spaces always present multiple challenges for the photographer, but overcoming them will be rewarding. Every indoor space has its own character and can imply meaning, much like a landscape. You may want to capture the volume and scale of the space itself, as in the photograph on the opposite page, or you may use it—like below—to highlight your subject the way a stage set features actors. Interiors reflect the lives of people who live or work in them, and even of those who just pass through them. When photographs of people reveal something of the subjects' surroundings they can find resonance with a much wider audience than can a simple head-andshoulders portrait. **Vantage points are limited** indoors. Often there is an inconveniently located wall that prevents you from backing up to fit everything into your picture. It is no wonder that architectural photographers, who are often asked to photograph interiors, carry wide-angle lenses in several focal lengths. Even for the professional who is allowed to move the furniture, finding the right spot for the camera can be a challenge. Don't ignore the possibilities opened up by a vantage point above your head or below your waist.

Shelby Lee Adams. The Napiers' Living Room, 1989. **Bring your own light** if necessary. For his extended series on Appalachian families, Adams carried a set of studio strobes to provide enough light for dark interiors like this one and to let him control the illumination on his subjects for the clarity and depth he wanted.

Pay attention to the light. Most interior spaces are illuminated by several sources; there may be windows on more than one wall, and window light is often supplemented by artificial lighting during the day. Watch for unwanted shadows that may appear more bothersome in a photograph than in the scene itself, and be on the lookout for excessive contrast from strong side or top light. If you are working in color and can't control the lighting, you may see different color casts in different areas. There is less light indoors than you'd find outdoors, almost invariably. Stay aware of depth of field; it is especially important to interior photography because you are often close to your subject. Remember that the closer you are to a subject, the less depth of field you'll get with any given focal length and aperture. If you need to close down the aperture to keep most of the environment in focus, as did the photographers in the examples on these two pages, you may need a tripod, some extra light, or both.

Kate Joyce. Residence, Chicago, 2012. Interior photographs made for a client usually need controlled light to balance what's already there. Five lights were added to this scene, but it still looks natural. Joyce was called in to photograph this converted industrial space in between owners. It is unusual for her to be hired to photograph an unfurnished residence, but she appreciates that "it's pure structure and material, plus one wall clock."

Assembled to be Photographed

You can photograph scenes that could never exist by creating directly from your imagination. There is an idea most of us share that photography has a connection to the truth. Even the most sophisticated and skeptical observers perceive photographs differently than paintings. Even when we know we can't really believe a photograph, we want to. This natural reaction to photographs is a powerful tool in your hands.

There are no rules for personal expression. Journalists must abide by a set of general ethical principles and—usually—a specific set imposed by

an individual publication. If you're not reporting the news, however, you can exert as much control as you'd like over what your photographs look like.

You are already comfortable with certain decisions when you capture an image, choosing subject matter, vantage point, timing, and lighting. You may ask someone to smile for the camera. It's only a short step to hiring, costuming, and posing a model, or creating an entire environment (photograph on opposite page).

The camera sees with one eye. You don't need to be concerned with anything outside its vision.

Lori Nix. Library, 2007. Nix fabricated and assembled every element of this photograph in miniature,

filling the living room of her New York apartment over a period of about seven months. The image is not digitally manipulated. She gets ideas while commuting on the subway and "...postulates what it might be like to live in a city that is post mankind, where man has left his mark by the architecture, but mother nature is taking back these spaces."

Jeff Wall. After Invisible Man by Ralph Ellison, the Prologue, 1999–2001. Wall was inspired by an "accident of reading" to create this environment, based on "the hole in the basement" with "exactly 1,369 lights" in which the narrator of Ellison's novel lives. Wall presents this photograph, a composite of several exposures, as a transparency over eight feet wide that is illuminated from behind so, when exhibited, it becomes itself a light source. Ellison's character says "Without light I am not only invisible but formless as well."

To construct an environment to be photographed, like the ones on these two pages, it helps to lock the camera in place while building the structure, so you can refer to its unique vantage point often during the time it takes to complete. Like a movie set, nothing out of view needs to be finished.

Perspective can be manipulated. We normally get most of our depth perception from stereoscopic vision, each eye sees a slightly different image. But because a photograph is flat, we perceive depth by

using other visual cues—for example, objects at a distance appear smaller. By creating objects smaller than they would be normally or, for example, making a table that is narrower at one end than the other, you can use *forced perspective* to create a false sense of depth. In the world of Hollywood movies, many props and special effects depend on forced perspective.

Look at advertising photographs, as well as films, for ideas. Corporate clients have immense budgets and can materialize almost anything.

Responding to Photographs

"It's good." "It's not so good." What else is there to say when you look at a photograph? What is there to see—and to say—when you respond to work in a photography class or workshop? Looking at other people's pictures helps you improve your own, especially if you take some time to examine an image, instead of merely glancing at it and moving on to the next one. In addition to responding to other people's work, you need to be able to look at and evaluate your own.

The elements of design are a commonly used vocabulary for describing pictures that will be useful for responding to photographs. You might begin with *point*, like the ice-cream scoop on page 161 top, or *line*, like the sides of buildings on page 162 top or the curve of the track on page 161 bottom. *Shape* could describe the shadow in the middle of the image on page 35. Other design elements include *direction* or *movement*, *size* or *scale*, *volume*, *texture*, *color* or *hue*, and *value* or *lightness*. Try finding examples of these in this book—and

look at the other examples in the box below. See if breaking down a picture into formal elements the way it looks, apart from its content or what it describes—makes you more attentive to their presence in your own photographs.

When evaluating your own photographs, ask yourself what you saw when you brought the camera to your eye? How well did what you had in mind translate into a picture? Would you do anything differently next time?

Following are other items to consider when you look at a photograph. You don't have to consider each one every time, but they can give you a place to start.

Type of photograph. Is it a portrait? A landscape? Advertising photograph? News photo? What do you think the photograph was intended to do or to mean? Was it meant to be functional or expressive? Both? A caption or title can provide information, but look at the picture first so the caption does not limit your response.

Suppose the picture is a portrait. Is it one that might have been made at the request of the subject? One made for the personal satisfaction of the photographer? Is the sitter simply a warm body or does he or she contribute some individuality? Does the environment, the setting in which the sitter appears, add anything?

Emphasis. Is your eye drawn to some part of the picture? What leads your eye there? For example, is depth of field shallow, so that only the main subject is sharp and everything else out of focus?

Technical considerations. Do they help or hinder? For example, is contrast harsh and gritty? Is the technique suitable to the subject or not?

Emotional or physical impact. Does the picture make you feel sad, amused, peaceful? Does it make your eyes widen, your muscles tense? What elements might cause these reactions?

What else does the picture tell you besides what is immediately evident? Photographs often have more to say than may appear at first. For example, is a fashion photograph about the design of the clothes, or is it really about the roles of men and women in our culture?

Trust your own responses to a photograph. How do you actually respond to an image and what do you actually notice about it? What do you remember about it the next day?

Visual Elements

Here are some of the terms we can use to describe the visual or graphic elements of a photograph. See the page cited for an illustration of a particular element.

Focus and Depth of Field

Sharp overall (pages 38, 164 bottom), soft focus overall (page 165 top) Selective focus: One part sharp, others not (page 44). See also Shallow depth of field. Shallow depth of field: Little distance between nearest and farthest sharp areas (pages 152, 159 bottom)

Extensive depth of field: Considerable distance between nearest and farthest sharp areas (pages 59, 170)

Motion

Frozen sharp even though subject was moving (pages 35, 36) *Blurred:* Moving camera or subject blurred, part or all of the image (pages 20, 161 bottom)

Light

Front light: Light comes from camera position, shadows not prominent (page 145 bottom) Back light: Light comes toward camera, front of subject is shaded (pages 65, 71) Side light: Light comes from side, shadows cast to side (pages 2, 137 left) Direct light: Hard-edged, often dark shadows (page 136) Directional diffused light: Distinct, but soft-edged shadows (page 144) Diffused light: No, or almost no, shadows (page 137 right) Silhouette: Subject very dark against light background (pages 72 top, 169) Glowing light: Subject glows with its own or reflected light (pages 67, 139 bottom)

Contrast and Tone

Full scale: Black, white, and many tones in between (pages 121, 138)

High contrast: Very dark and very light tones, few gray tones (pages 204 bottom, 205) Low contrast: Mostly gray tones (page 172, 205 top) High key: Mostly light tones (page 24) Low key: Mostly dark tones (page 52)

Texture

Emphasized: Usually results from light striking subject from an angle (pages 138, 150) *Minimized:* Usually results from light coming from camera position or from all sides (page 101, 204 top)

Viewpoint and Framing Eye-level viewpoint (pages 160, 166) High (page 162 bottom), low (page 155), or unusual viewpoint (page 161 bottom) Framing: The way the edges of the photograph meet the shapes in it (page 153)

Perspective

Compressed perspective (telephoto effect): Objects seem crowded together, closer than they really are (pages 36, 162 top)

Expanded perspective (wide-angle "distortion"): Parts of the scene seem stretched or positioned unusually far from each other (pages 52, 39 bottom)

Line

Curved (page 163 bottom) Straight (page 170) Horizontal (page 164-165 bottom) Vertical (page 48 bottom) Diagonal (page 21, top) Position of horizon line (pages 97 bottom, 173)

Balance

An internal, physical response. Does the image feel balanced or does it tilt or feel heavier in one part than another?

179

ESTHER BUBLEY A Picture-Taking Machine in the Lobby at the United Nations Service Center, Washington, DC, 1943. From its start, photography was most popular for its ability to record a person. For most of the 19th century, portraits were made only by professionals or very serious amateurs. George Eastman's 1888 Kodak camera gave the general public a way to memorialize themselves and others nearly any time, but getting the prints meant sending the camera away to have the film inside it processed, and that took time. The photobooth's inventor, a Siberian immigrant named Anatol Josepho, opened the first photobooth on New York City's Broadway in 1925; it made eight portraits on a strip of paper, in about ten minutes, for 25¢. Josepho's Photomaton Studio was a sensation; there, over a quarter-million people slipped behind the curtain of one of its photobooths in the first six months, as many as 7,500 a day.

Daguerreotype
"Designs on silver bright" 182
Calotype
Pictures on paper
Collodion Wet-Plate 185
Sharp and reproducible 185
Gelatin Emulsion/
Roll-Film Base 186
Photography for everyone 186
Color Photography 187
Early Portraits188
Early Travel Photography 190
Early Images of War 191
Time and Motion
in Early Photographs 192
The Photograph
as Document

Photography and Social Change 194
Photojournalism 196
Photography as Art in the 19 th Century200
Pictorial Photography and the Photo-Secession 201
The Direct Image in Art 202
The Quest for a New Vision 203
Photography as Art in the 1950s and 1960s204
Photography as Art in the 1970s and 1980s 206
Color Photography Arrives–Again
Digital Photography 210 Predecessors
Becomes mainstream212

History of Photography

In this chapter you'll learn...

- about the unique era in history into which photography was born.
- the limits that early photographic materials and processes placed on the kinds of photographs that could be made.
- how photography grew as an art form, and overcame opposition from many directions.

Joseph Nicéphore Niépce. View from His Window at Le Gras, Saint-Loup-de-Varennes, France, c. 1826. Niépce produced the world's first photographic image—a view of the courtyard buildings on his estate in about 1826. It was made on a sheet of pewter covered with bitumen of Judea, a kind of asphalt that hardened when exposed to light; he called it a Heliograph. The unexposed, still-soft bitumen was then dissolved, leaving a permanent image. The exposure time was so long (eight hours) that the sun moved across the sky and illuminated both sides of the courtyard.

Photography was one of many inventions in the 19th century the electric light, the safety pin, dynamite, and the automobile are just a few others—and of all of them, photography probably created the most astonishment and delight. Today, most people take photographs for granted, but early viewers were awed and amazed by the objective records the camera made.

Photography took over what previously had been one of the main functions of art—the recording of factual visual information, such as the shape of an object, its size, and its relation to other objects. Instead of having a portrait painted, people had "Sun Drawn Miniatures" made. Instead of forming romantic notions of battles and faraway places from paintings, people began to see firsthand visual reports. And soon photography became an art in its own right.

The camera obscura was the forerunner of the modern camera. It was known that rays of light passing through a pinhole formed an image. The 10th century Arabian scholar Alhazen described the effect and told how to view an eclipse of the sun in a camera obscura (literally, "dark chamber"), a darkened room with a pinhole opening to the outside. By the time of the Renaissance, a lens had been fitted into the hole to improve the image, and the room-sized device had been reduced to the size of a small box that could easily be carried about. The camera obscura became a drawing aid that enabled an artist to trace an image reflected onto a sheet of drawing paper.

What remained to be discovered was a way to fix the camera obscura image permanently. The darkening of certain silver compounds by exposure to light had been observed as early as the 17th century, but the unsolved and difficult problem was how to halt this reaction so that the image would not darken completely.

The first permanent picture was made by Joseph Nicéphore Niépce,

a gentleman inventor living in central France. He first experimented with silver chloride, which he knew darkened on exposure to light, but then he turned to bitumen of Judea, a kind of asphalt that hardened when exposed to light. Niépce dissolved the bitumen in lavender oil, a solvent used in varnishes, then coated a sheet of pewter with the mixture. He placed the sheet in a camera obscura aimed through an open window at his courtyard and exposed it for eight hours. The light forming the image on the plate hardened the bitumen in bright areas and left it soft and soluble in dark areas. Niépce then washed the plate with lavender oil. This removed the still-soft bitumen that had not been struck by light, leaving a permanent image of the scene (left). Niépce named the process heliography (from the Greek *helios*, "sun," and *graphos*, "drawing").

Daguerreotype "Designs on silver bright"

News of Niépce's work came to the attention of another Frenchman, Louis Jacques Mandé Daguerre. Daguerre had been using the camera obscura for sketching and had also become interested in trying to preserve its images. He wrote Niépce suggesting an exchange of information, and by 1829 had become his partner.

The mid-19th century was ripe for an invention such as photography. Interest in this new invention might have spread simply by a growing interest in science, but photography was more. In Western countries, a rising middle class with money to spend wanted pictures, especially family portraits, which, until then, only the rich had been able to afford. In addition, people were interested in faraway places; they traveled to these places when they could and bought travel books and pictures when they could not.

Niépce did not live to see the impact that photography was to have. He died in 1833, several years before Daguerre perfected a process that he considered different enough from Niépce's to be announced to the world as the daguerreotype (right and opposite).

The response to the daguerreotype was sensational. After experimenting for many years, both with Niépce and alone, Daguerre was finally satisfied with his process, and it was announced before the French Academy of Sciences on January 7, 1839. A French newspaper rhapsodized: "What fineness in the strokes! What knowledge of chiaroscuro! What delicacy! What exquisite finish!... How admirably are the foreshortenings given: this is Nature itself!"

Almost immediately after the process was announced, daguerreotype studios were opened to provide "Sun Drawn Miniatures" to a very willing public. By 1853, an estimated three million daguerreotypes per year were being produced in the United States alone—mostly portraits but also scenic views.

Louis Jacques Mandé Daguerre. Boulevard du Temple, Paris, 1839. The busy streets of a Parisian boulevard appear depopulated because of the long exposure this daguerreotype required. Only a person getting a shoeshine near the corner of the sidewalk stood still long enough to be recorded; all the other people, horses, and carriages had blurred so much that no image of them appeared on the plate. The shutter was probably open for several minutes, much less than the eight hours required by Niépce's heliograph, and the results were far superior—rich in detail and tonality. The enthusiastic reception of Daguerre's process extended to poetry: "Light is that silent artist / Which without the aid of man / Designs on silver bright /Daguerre's immortal plan."

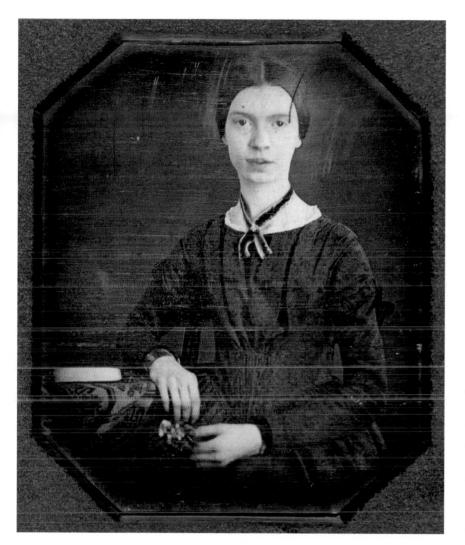

Photographer Unknown. Emily Dickinson at seventeen, c. 1847. Daguerreotype. **The daguerreotype reached the height of its popularity in America.** Millions of Americans, famous and obscure, had their portraits made. Although the exposure time was reduced to less than a minute, it was still long enough to demand a quiet dignity on the part of the subject.

This portrait, taken by an itinerant daguerreotypist, is the only known photograph of the 19th-century poet Emily Dickinson. Just like her poems, it seems direct on the surface but elusive on more intimate levels. Dickinson later described herself as "small, like the wren; and my hair is bold, like the chestnut burr; and my eyes, like the sherry in the glass that the guest leaves."

The daguerreotype was made on a highly polished surface of silver that was plated on a copper sheet. It was sensitized by being placed, silver side down, over a container of iodine crystals inside a box. Rising vapor from the iodine reacted with the silver, producing the light-sensitive compound silver iodide. During exposure in the camera, the plate recorded a latent image: a chemical change had taken place, but no evidence of it was visible. To develop the image the plate was placed, silver side down, in another box containing a dish of heated mercury at the bottom. Vapor from the mercury reacted with the exposed areas of the plate. Wherever light had struck the plate, mercury formed a frostlike amalgam, or alloy, with the silver. This amalgam made up the bright areas of the image. Where no light had struck, no amalgam was formed; the unchanged silver iodide was dissolved in sodium thiosulfate fixer, leaving the bare metal plate, which looked black, to form the dark areas of the picture.

The daguerreotype was very popular in its time, but it was a technological dead end. There were complaints about the difficulty of viewing, for the highly reflective image could be seen clearly only from certain angles. The mercury vapor used in the process was highly poisonous and probably shortened the life of more than one daguerreotypist. But the most serious drawback was that each plate was unique; there was no way of producing copies except by rephotographing the original. The beautiful daguerreotype was rapidly—and easily—eclipsed by a negative–positive process that allowed any number of positive images to be made from a single negative.

Calotype PICTURES ON PAPER

Another photographic process was announced almost at once. On January 25, 1839, less than three weeks after the announcement of Daguerre's process to the French Academy, an English amateur scientist, William Henry Fox Talbot, appeared before the Royal Institution of Great Britain to announce that he too had invented a way to permanently fix the image of the camera obscura.

Talbot made his images on paper. His first experiments had been with negative silhouettes made by placing objects on paper sensitized with silver chloride and exposing them to light. Then he experimented with images formed by a camera obscura, exposing the light-sensitive coating long enough for the image to become visible during the exposure.

In June 1840 Talbot announced a technique that became the basis of modern photography: the sensitized paper was exposed only long

enough to produce a latent image, which then was chemically developed. To make the latent negative image visible, Talbot used silver iodide (the lightsensitive element of the daguerreotype) treated with gallo nitrate of silver. He called his invention a calotype (after the Greek *kalos*, "beautiful," and *typos*, "impression").

Talbot realized the value of photographs on paper rather than on metal: reproducibility. He placed the fully developed paper negative in

contact with another sheet of sensitized paper and exposed both to light, a procedure now known as contact printing. The dark areas of the negative blocked the light from the other sheet of paper, while the clear areas allowed light through. The result was a positive image on paper resembling the tones of the original scene.

Because the print was made through the paper of a negative, the calotype lacked the sharp detail of the daguerreotype. Calotypes are beautiful the fibers in the paper producing a soft, slightly textured image that has been compared to a charcoal drawing. But the process didn't displace the one-of-a-kind daguerreotype until the transparent negative appeared.

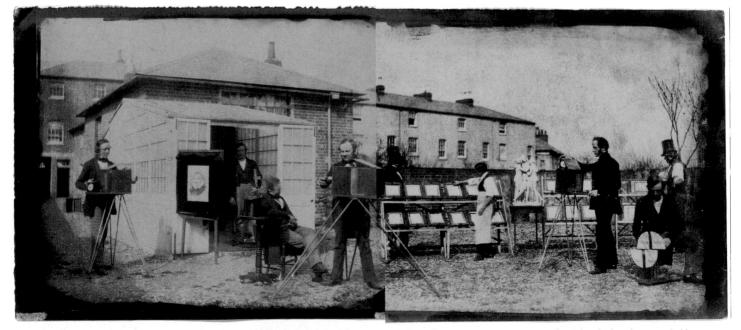

William Henry Fox Talbot. Talbot's Photographic Establishment, 1846. The activities at Talbot's establishment near London are shown in this early calotype taken in two parts and pieced together. At

left, an assistant copies an engraving. In the center, Talbot himself prepares a camera to take a portrait. At right, the man at the racks makes contact prints while another photographs a sculpture of the Three Graces. At far right, the kneeling man holds a target for the maker of this photograph to focus on. Talbot gave assurance that "the plates of the present work are impressed by the agency of light alone." Collodion Wet-Plate SHARP AND REPRODUCIBLE

The collodion wet-plate process combined the best feature of the daguerreotype sharpness—and the best of the calotype reproducibility. And it was more light sensitive than either of them, with exposures as short as five seconds. It combined so many advantages that despite its drawbacks virtually all photographers used it from its introduction in 1851 until the commercial availability of the gelatin dry plate almost three decades later.

For some time, workers had been looking for a substance that would bind light-sensitive salts to a glass plate. Glass was better than paper or metal as a support for silver chloride because it was textureless, transparent, and chemically inert. One binding material was the newly invented collodion (nitrocellulose dissolved in ether and alcohol), which is sticky when wet, but soon dries into a tough, transparent skin.

The disadvantage of collodion was that the plate had to be exposed and processed while

it was still wet. A mixture of collodion and potassium iodide was poured onto the middle of the plate. The photographer held the glass by the edges and tilted it back and forth and from side to side until the surface was evenly covered. The excess collodion was poured back into its container. Then the plate was sensitized by being dipped in a bath of silver nitrate. It was exposed for a latent image while still damp, developed in pyrogallic acid or iron sulfate, fixed, washed, and dried. All this had to be done right where the photograph was taken, which meant that to take a picture the photographer had to lug a complete darkroom along (below).

Collodion could be used to form either a negative or a positive image. Coated on glass, it produced a negative from which a positive could be printed onto albumen-coated paper. If the glass was backed with a dark material like black velvet, paper, or paint, the image was transformed into a positive, an ambrotype, a kind of imitation daguerreotype. Coated on dark enameled metal it also formed a positive image—the durable, cheap tintype popular in America for portraits to be placed in albums, on campaign buttons, and even on tombs.

By the 1860s, the world had millions of photographic images; 25 years earlier there had been none. Photographers were everywhere—taking portraits, going to war, exploring distant places, and bringing home pictures to prove it.

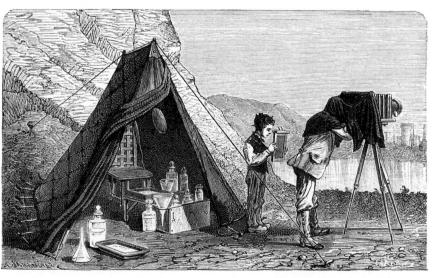

The collodion wet-plate process had many advantages, but convenience was not among them. The glass plates on which the emulsion was spread had to be coated, exposed, and developed before the emulsion dried, which required transporting an entire darkroom to wherever the photograph was to be made.

A Photographer in the Field, c. 1865.

Gelatin Emulsion/Roll-Film Base photography for everyone

Until the 1880s, few photographs were made by the general public. Almost everyone had been photographed at one time or another, certainly everyone had seen photographs, and probably many people had thought of taking pictures themselves. But the technical skill, the massive effort, and the expense and sheer quantity of equipment needed for the collodion wet-plate process restricted photography to professionals and the most dedicated amateurs. Even they complained of the inconvenience of the process and made many attempts to improve it.

By the 1880s, the perfection of two techniques created a fast dry plate and eliminated the need for the fragile glass plate itself. The first development was a new gelatin emulsion in which the light-sensitive silver salts could be suspended. It was based on gelatin—a jellylike substance processed from cattle bones and hides. It retained its speed when dry, unlike collodion, and could be applied on the other invention—film in rolls. Roll film revolutionized photography by making it simple enough for anyone to enjoy.

Much of the credit for popularizing photography goes to George Eastman, who began as a bank clerk in Rochester, New York, and built his Eastman Kodak Company into one of the country's foremost industrial enterprises. Almost from the day Eastman bought his first wet-plate camera in 1877, he searched for a simpler way to take pictures. "It seemed," he said, "that one ought to be able to carry less than a pack-horse load."

Many people had experimented with roll film, but Eastman was the first to market it commercially, with his invention of the equipment to mass-produce film. The result was Eastman's American Film, a roll of paper coated with a thin gelatin emulsion. The emulsion had to be stripped from its paper backing to provide a negative that light could shine through for making prints. Most photographers had trouble with this operation, so the film was usually sent to the company for processing.

Roll film made possible a new kind of camera—inexpensive, light, and simple to operate—that made everyone a potential photographer. Eastman introduced the Kodak camera in 1888. It came loaded with enough film for 100 pictures. When the roll was used up, the owner returned the camera with the exposed film still in it to the Eastman company in Rochester. Soon the developed and printed photographs and the camera, reloaded with film, were sent back to the owner. The Kodak slogan was, "You push the button, we do the rest."

The Kodak camera became an international sensation almost overnight. With the invention of a truly modern roll film (a transparent, flexible plastic, coated with a thin emulsion and sturdy enough to be used without a paper support), a new photographic era had begun. The Eastman Kodak Company knew who would be the main users of its products, and it directed its advertising accordingly: "A collection of these pictures may be made to furnish a pictorial history of life as it is lived by the owner, that will grow more valuable every day that passes." Fredrick Church. George Eastman with a Kodak, 1890. George Eastman, who put the Kodak box camera on the market and thereby put photography into everybody's hands, stands aboard the S.S. Gallia in the act of using his invention. Roll film made the camera small enough to carry easily. Fast gelatin emulsions permitted 1/25-sec. exposures so subjects did not have to strain to hold still.

Color Photography

Daguerre himself knew that only one thing was needed to make his wonderful invention complete-color. After several false starts, one of the first successes was demonstrated in 1861 by the British physicist James Clerk Maxwell. He had three negatives of a tartan ribbon made, each through a different color filter-red, green, and blue. Positive black-and-white transparencies were made of the three negatives and projected through red, green, and blue filters like those on the camera. When the three images were superimposed, they produced an image of the ribbon in its original colors. Maxwell had demonstrated additive color mixing, in which colors are produced by adding together varying amounts of light of the three primary colors, red, green, and blue.

In 1869, an even more significant theory was made public by two Frenchmen, Louis Ducos du Hauron and Charles Cros, working independently of each other. Their process, subtractive color mixing, is the basis of present-day color photography. Colors are created by com-

bining cyan, magenta, and yellow dyes (the complements of red, green, and blue). The dyes subtract colors from the "white" light that contains all colors.

The first commercially successful color was an additive process. In 1907, two French brothers, Antoine and Louis Lumière, marketed their Autochrome process. A glass plate was covered with tiny grains of potato starch dyed red-orange, green, and violet, in a layer only one starch grain thick. Then, a light-sensitive emulsion was added. Light struck the emulsion after passing through the colored grains. The emulsion behind each grain was exposed only by light from the scene that was the same color as that grain. The result after development was a full-color transparency.

Kodachrome, a subtractive process, made color photography practical. It was perfected by Leopold Mannes and Leopold Godowsky, two amateur photographic researchers who eventually joined forces with Eastman Kodak research scientists. Their collaboration led to the introduction in 1935 of Kodachrome, a single sheet of film coated with three layers of emulsion, each sensitive to one primary color (red, green, or blue). A single exposure produced a color image (left).

In the 1940s, Kodak introduced Ektachrome, which allowed photographers and small labs to process slides, and Kodacolor, the first color negative film.

Today it is difficult to imagine photography without color. Amateurs make photographs by the millions each day, and the ubiquitous snapshot is always in color. Commercial and publishing markets use color almost exclusively. Digital cameras always start by capturing a color image; anyone who wants a black-and-white end product must discard the color information. Even photojournalism, documentary, and fineart photography, which had been in black and white for most of their history, are most often now in color.

Alfred T. Palmer. Women War Workers, circa 1942. Kodachrome transparency film was introduced for 16mm movie cameras in 1935, and for the 35mm still photography market in 1936. It was the first accurate, inexpensive, easy-touse, and reliable method for creating color photographs.

Early Portraits

People wanted portraits. Even when exposure times were long and having one's portrait taken meant sitting in bright sunlight for several minutes with eyes watering, trying not to blink or move, people flocked to portrait studios to have their likenesses drawn by "the sacred radiance of the Sun." Images of almost every famous person who had not died before 1839 have come down to us in portraits by photographers such as Nadar and Julia Margaret Cameron (right). Ordinary people were photographed as well-in Plumbe's National Daguerrian Gallery, where hand-tinted "Patent Premium Coloured Likenesses" were made, and in cut-rate shops where double-lens cameras took them "two at a pop." Small portraits called cartes-de-visite were immensely popular in the 1860s (opposite). For pioneers moving West in America, the pictures were a link to the family and friends they had left behind. Two books went West with the pioneers-a Bible and a photograph album.

Photographs had an almost mystical presence. After seeing some daguerreotype portraits, the poet Elizabeth Barrett wrote to a friend in 1843, "Several of these wonderful portraits . . . like engravings-only exquisite and delicate beyond the work of graver-have I seen lately-longing to have such a memorial of every Being dear to me in the world. It is not merely the likeness which is precious in such cases-but the association and the sense of nearness involved in the thing ... the fact of the very shadow of the person lying there fixed for ever! . . . I would rather have such a memorial of one I dearly loved, than the noblest artist's work ever produced. I do not say so in respect (or disrespect) to Art, but for Love's sake. Will you understand?-even if you will not agree?"

Julia Margaret Cameron. Alfred, Lord Tennyson, 1865. Cameron photographed her friends and peers, the wellknown and the well-born, in Victorian England. Tennyson followed William Wordsworth as the Poet Laureate of Great Britain and Ireland from 1850 until his death in 1892.

Photographer Unknown. Woman in Costume.

Photographer Unknown. André Adolphe Disdéri. Cartesde-visite were taken with a camera that exposed only one section of the photographic plate at a time. Thus the customer could strike several different poses for the price of one. At left is shown a print before it is cut into separate pictures. People collected cartes-de-visite in albums, inserting pictures of themselves, friends, relatives, and famous people like Queen Victoria.

One album cover advised: "Yes, this is my Album, but learn ere you look; / that all are expected to add to my book. / You are welcome to quiz it, the penalty is, / that you add your own Portrait for others to quiz."

André Adolphe Disdéri, who popularized these multiple portraits, is shown above on a carte-de-visite. Carte portraits became a fad when Napoleon III stopped on the way to war to pose for cartes-de-visite at Disdéri's studio.

CHAPTER 10 🕺 189

Early Travel Photography

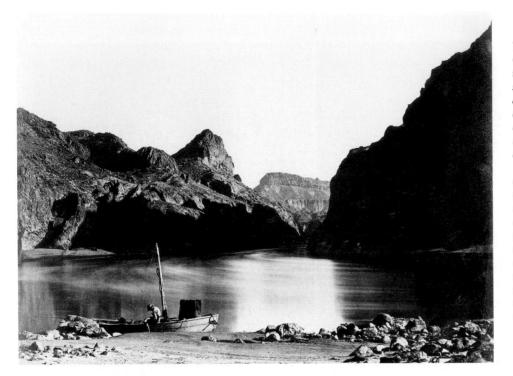

Timothy H. O'Sullivan. Black Canyon, Colorado River, 1871. **Expeditions to photograph distant places were launched as soon as the invention of photography was announced.** In addition to all the materials, chemicals, and knowledge needed to coat, expose, and process their photographs in remote places, expeditionary photographers also had to have considerable fortitude.

Timothy H. O'Sullivan, whose darkroom on a boat appears at left, described an area called the Humboldt Sink: "It was a pretty location to work in, and viewing there was as pleasant work as could be desired; the only drawback was an unlimited number of the most voracious and particularly poisonous mosquitoes that we met with during our entire trip. Add to this...frequent attacks of that most enervating of all fevers, known as the 'mountain ail,' and you will see why we did not work up more of that country."

Early travel photographs met a demand for pictures of faraway places. In the mid-19th century, the world seemed full of unexplored wonders. Steamships and railroads were making it possible for more people to travel, but distant lands still seemed exotic and mysterious and people were hungry for photographs of them. There had always been drawings portraying unfamiliar places, but they were an artist's personal vision. The camera seemed an extension of one's own vision; travel photographs were accepted as real and faithful images.

The Near East was of special interest. Not only was it exotic, but its biblical associations and ancient cultures made it even more fascinating. Within a few months of the 1839 announcement of Daguerre's process, a photographic team was in Egypt. "We keep daguerreotyping away like lions," they reported, "and from Cairo hope to send home an interesting batch." Because there was no way to reproduce the daguerreotypes directly, they were traced and reproduced as copperplate engravings. With the invention of the calotype and later the collodion processes, actual pictures from the Near East were soon available. The most spectacular scenery of the western United States was not much photographed until the late 1860s. Explorers and artists had been in the Rocky Mountain area long before this time, but the tales they told of the region and the sketches they made were often thought to be exaggerations. After the Civil War, when several government expeditions set out to explore and map the West, photographers accompanied them, not always to the delight of the other members of the expeditions. "The camera in its strong box was a heavy load to carry up the rocks," says a description of a Grand Canyon trip in 1871, "but it was nothing to the chemical and plate-holder box, which in turn was featherweight compared to the imitation hand organ which served for a darkroom. This dark box was the special sorrow of the expedition ... "

Civil War photographers Timothy H. O'Sullivan (above and opposite) and Alexander Gardner both went West with governmentsponsored expeditions. William Henry Jackson's photographs of Yellowstone helped convince Congress to set the area aside as a national park, as did the photographs of Yosemite made by Carleton Eugene Watkins.

Early Images of War

Timothy H. O'Sullivan. A Harvest of Death, Gettysburg, July 1863. The first realistic view of war was shown by Civil War photographers such as Brady, Gardner, and O'Sullivan (right). Oliver Wendell Holmes had been on the battlefield at Antietam searching for his wounded son and later saw the photographs Brady made there: "Let him who wishes to know what war is look at this series of illustrations... It was so nearly like visiting the battlefield to look over these views, that all the emotions excited by the actual sight of the stained and sordid scene, strewed with rags and wrecks, came back to us, and we buried them in the recesses of our cabinet as we would have buried the mutilated remains of the dead they too vividly represented."

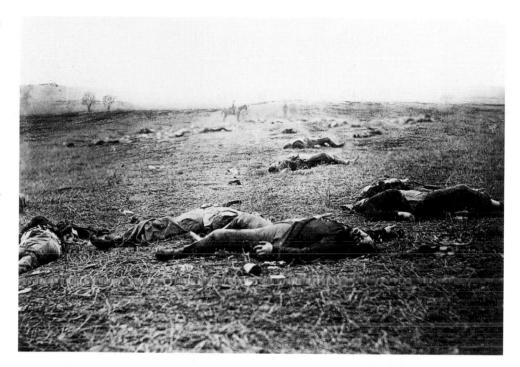

Photographs gave war scenes authority, and made them more immediate for those at home. Until photography's invention, wars seemed remote and rather exciting. People learned of war from delayed news accounts or even later from the tales of returning soldiers or from paintings or poems.

The disastrous British campaigns in the Crimean War of the 1850s were the first conflicts to be extensively photographed. The illfated Charge of the Light Brigade against Russian forces in 1854 was only one of the catastrophes; official bungling, disease, starvation, and exposure took more British lives than did the enemy. However, Roger Fenton, the official photographer (who had been introduced to photography only three years earlier), generally depicted the war with scenic and idealized images. Photographs from the American Civil War were the first to show the reality of war (above). Mathew B. Brady, a successful portrait photographer, conceived the idea of sending teams to photograph the war. No photographs were made during a battle; it was too hazardous. The collodion process required up to several seconds' exposure and the glass plates had to be processed on the spot, which made the photographer's darkroom-wagon a target for enemy gunners.

Although Brady hoped to sell his photographs, they often showed what people wanted only to forget. Brady took only a few, if any, photographs himself, and some of his men (Alexander Gardner and Timothy H. O'Sullivan among them) broke with him and set up their own operation. But Brady's idea and personal investment launched this invaluable documentation of American history.

Time and Motion in Early Photographs

The earliest photographs required very long exposures. Today, photographers using modern cameras consider a one-second exposure relatively long. But photographers using earlier processes had to work with much slower materials, and an exposure of several seconds was considered quite short.

People or objects that moved during the exposure were blurred or, if the exposure was long enough, disappeared completely. Busy streets sometimes looked deserted (page 182) because most people had not stayed still long enough to register an image.

Stereographic photographs were the first to show action as it was taking place, with people in midstride or horses and carts in motion. This was possible because the short-focal-length lens of the stereo camera produced a bright, sharp image at wide apertures and thus could be used with very brief exposure times.

These "instantaneous" photographs revealed aspects of motion that the unaided eye was not able to see. Some of the arrested motions were so different from the conventional artistic representations that the photographs looked wrong. A galloping horse, for example, had often been drawn with all four feet off the ground—the front legs extended forward and hind legs extended back.

Eadweard Muybridge was a pioneer in motion studies. When his photographs of a galloping horse, published in 1878, showed that all four of its feet were off the ground only when they were bunched under the horse's belly, some people thought that Muybridge had altered the photographs. Using the new, fast gelatin-silver emulsion and a specially constructed multi-lens cameras, Muybridge compiled many studies of different animals and humans in action (right, bottom) that were distributed widely.

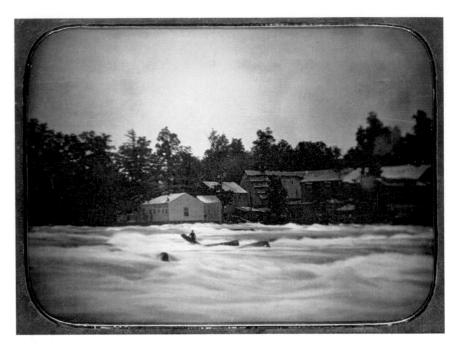

Platt D. Babbitt. Joseph Avery Stranded on Rocks in the Niagara River, 1853. **This is an early example of a news photograph,** unusual because newsworthy events rarely held

still for the long exposures a daguerreotype required. This unlucky man was stranded clinging to a log after a boating accident; his situation held him motionless enough to be recorded.

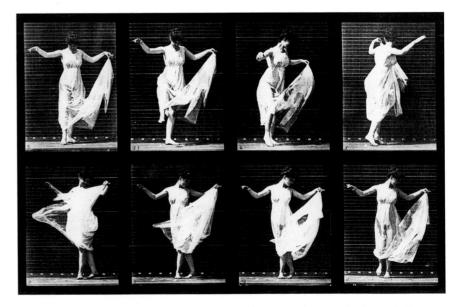

Eadweard Muybridge. Motion Study, c. 1885. Capturing motion became technically possible as the sensitivity of photographic emulsions increased. Muybridge's project Animal Locomotion analyzed the movements

of humans and many animals. Muybridge often used several cameras synchronized to work together so that each stage of a movement could be recorded simultaneously from different angles.

The Photograph as Document

Eugène Atget. Quai d'Anjou, 6am, Paris, 1924. **Eugène Atget artfully revealed the essence of Paris** while seeming merely to document its external appearance. A silent street along the Seine in the early morning, with its graceful trees, moored barges, and soft light speaks of the pervasive charm and architectural harmony of the city.

Karl Blossfeldt. Nigella Damascena Spinnenkopf, c. 1932. Blossfeldt's rigorous plant studies influenced generations of artists. Each specimen in the long series was presented alone against a neutral background so the plant forms could be considered without any hint of the decisions or interpreta-Lions of an artist. Published as a book in 1929, his images were studied by painters, architects, designers, and others who incorporated nature's ideas into their own.

Photographs can be documents on many levels. Most snapshots record a particular scene to help the participants remember it later. A news photograph implies that this is what you would have seen if you had been there yourself, although digital photography continues to chip away at this belief (see page 112). On another level, a photograph can record reality while at the same time recording the photographer's comment on that reality. Lewis W. Hine said of his work: "I wanted to show the things that had to be corrected. I wanted to show the things that had to be appreciated." His statement describes the use of photography as a force for social change and a style that came to be known as documentary (see pages 194-195).

Eugène Atget's work went beyond simple records, although he considered his photographs to be documents. A sign on his door read "Documents pour Artistes." Atget made thousands of photographs in the early 1900s, of the streets, cafée (left, top), shops, monuments, parks, and people of the Paris he loved. His pictures won him little notice during his lifetime; he barely managed to eke out a living by selling prints to artists, architects, and others who wanted visual records of the city. Many photographers can record the external appearance of a place, but Atget conveyed the atmosphere and mood of Paris as well.

Karl Blossfeldt's photographs of plants rejected commentary, as well as sentiment, to be as straightforward and factual as possible (left). He has been associated with the New Objectivity movement (Neue Sachlichkeit), that applied similar goals to a range of media. August Sander attempted to record an entire people the citizens of pre-World War II Germany—in utterly factual portraits meant to show society's classes and not individual character. Later, Bernd and Hilla Becher applied similar formal and procedural rigor to photographing industrial structures, and were teachers to a generation of notable artists whose artistic lineage can be traced directly back to Blossfeldt.

CHAPTER 10 👖 193

Photography and Social Change

Photography soon went from documenting the world to documenting it for a cause. Jacob Riis, a Danish-born newspaper reporter of the late 19th century, was one of the first to use photography for social change. Riis had been writing about the grinding brutality of life in New York City's tenements and slums and began to take pictures (right, top) to show, as he said, what "no mere description could, the misery and vice that he had noticed in his ten years of experience ... and suggest the direction in which good might be done." To take photographs inside the tenements at night, Riis used magnesium powder ignited in an open pan to provide lighting in the dark rooms. The technique was the forerunner of the modern flash.

Lewis W. Hine was a trained sociologist with a passionate social awareness, especially of the abuses of child labor (right, bottom). This evil was widespread in the early 20th century, and Hine documented it to provide evidence for reformers. With sarcastic fury he wrote of "'opportunities' for the child and the family to …relieve the overburdened manufacturer, help him pay his rent, supply his equipment, take care of his rush and slack seasons, and help him to keep down his wage scale."

Jacob Riis. Home of Italian Rag Picker, Jersey Street, 1894. Riis used his camera to expose the slum conditions of New York City. His photographs led to housing regulations that outlawed overcrowded quarters and windowless rooms.

Lewis Hine. Sadie Pfeifer, 48 Inches High, Has Worked Half a Year, Lancaster Cotton Mills, Lancaster, South Carolina, 1908. Lewis Hine documented the abuses of child labor between 1908 and 1921, making 5,000 pictures for the National Child Labor Committee. One foreman casually dismissed accidents, such as children getting caught in the machinery. "Once in a while a finger is mashed or a foot, but it doesn't amount to anything."

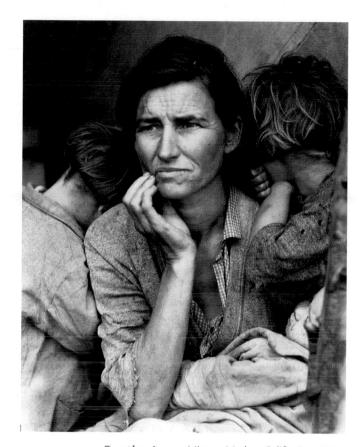

Dorothea Lange. Migrant Mother, California, 1936. **Lange's work reveals her empathy for her subjects.** Sho had a unique ability to photograph people at the moment that their expressions and gestures revealed their lives and feelings. Her photograph of a mother of seven who tried to support her children by picking peas, was one of those that came to symbolize the 1930s Depression.

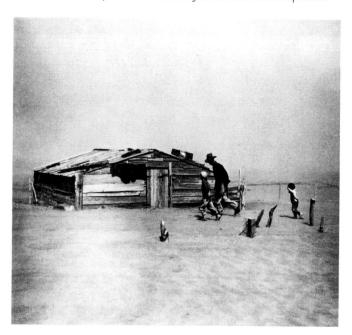

The photographers of the Farm Security Administration recorded the Depression of the 1930s, when the nation's entire economic structure was in deep trouble and farm families were in particular need. Assistant Secretary of Agriculture Rexford G. Tugwell realized that the government's program of aid to farmers was expensive and controversial. To prove both the extent of the problem and the effectiveness of the cure, he appointed Roy Stryker to supervise photographic coverage of the program.

Stryker recruited a remarkable band of talent, including Dorothea Lange (left, top), Walker Evans (page 173), Russell Lee (page 161, top), Marion Post Wolcott, Arthur Rothstein (left, bottom), Gordon Parks, and Ben Shahn. The photographers of the Farm Security Administration produced a monumental collection of images showing the plight of "one third of a nation" during the Depression.

Arthur Rothstein. Dust Storm, Cimarron County, Oklahoma, 1936. Rothstein was the first photographer Roy Stryker hired to document the plight of people during the Depression. During that period, drought turned parts of Oklahoma into a dust bowl. Here, the building and fence posts are almost buried in drifts of sand. Rothstein later wrote that while taking the picture, "I could hardly breathe because dust was everywhere."

Photojournalism

Whatever the news event-from a prizefight to a war-we expect to see pictures of it. Today we take photojournalism for granted, but news and pictures were not always partners. Drawings and cartoons appeared only occasionally in the drab 18th-century press. The 19th century saw the growth of illustrated newspapers such as the Illustrated London News and, in America, Harper's Weekly, and Frank Leslie's Illustrated Newspaper. Because the various tones of gray needed to reproduce a photograph could not be printed simultaneously with ordinary type, photographs had to be converted into drawings and then into woodcuts before they could appear as news pictures. The photograph merely furnished material for the artist.

The halftone process, perfected in the 1880s, permitted photographs and type to be printed together, and photographs became an expected addition to news stories. "These are no fancy sketches," the *Illustrated American* promised, "they are the actual life of the place reproduced upon paper."

The photo essay, a sequence of photographs plus brief textual material, came of age in the 1930s. It was pioneered by Stefan Lorant in European picture magazines and later in America by a score of publications such as *Life* and *Look*. Today, the heyday of the picture magazine has passed, due in part to competition from television. But photographs remain a major source of our information about the world and photo essays have returned on the Internet.

Erich Salomon. Visit of Prime Minister MacDonald to Berlin, 1931. **Not until the 1920s did photographers get a small camera able to take pictures easily in dim light.** Early cameras were relatively bulky, and the slowness of available films meant that using a camera indoors required a blinding burst of flashpowder. The first of the small cameras, the Ermanox, to be followed soon by the Leica, had a lens so fast—f/2—that unobtrusive, candid shooting finally became practical. Cameras began to infiltrate places where they hadn't been before, and the public began to see real people in the news. Erich Salomon was one of the pioneers of this practice, with a special talent for dressing in formal clothes and crashing diplomatic gatherings—sometimes shooting through a hole in his bowler or disguising his camera within a bouquet. He often recorded those in power while they were preoccupied with other matters, such as at this 1931 meeting of German and British statesmen. In tribute to Salomon, the French foreign minister, Aristide Briand, is said to have remarked, "There are just three things necessary for a League of Nations conference: a few foreign secretaries, a table, and a Salomon."

The halftone process converts the continuous shades of gray in a photograph (right) into distinct units of black and white that can be printed with ink on paper (far right).

 FAMILY DINNER the Gariels ext thick heat and potato out from combine part on dirt floor of ber sitchern. The father, mather and her sitchern.

A period where makines the files of levels prove fits as the plan them in a long strand where is the files of levels prove fits as the plan them in a long strand where is part the first of the specific right. then wranged around it. W. Eugene Smith. From Spanish Village, 1951. The photo essay—pictures plus supporting text—was the mainstay of mass-circulation picture magazines such as Life and Look. Above are two pages from "Spanish Village," photo-graphed for Life by W. Eugene Smith, whose picture essays are unsurpassed in their power and photographic beauty.

THE THREAD MAKER

Photojournalism (continued)

Photojournalists were the first to embrace digital photography. The news is now. Photographers on location need to get pictures from the middle of the action to the editors' desks as rapidly as possible. Film requires transportation to a lab, development, drying, and proofing before anyone can tell whether the pictures can be used. The length of a roll limits the number of photographs that can be exposed quickly. And it is easy for information about a picture's content to get separated from the picture itself. The Associated Press (AP) began transmitting conventional photographs digitally before 1980. Their system was used to distribute pictures to editors at different newspapers. In the mid-90s practical digital cameras began to appear in the hands of a very few photographers. The cameras were specially modified 35mm SLRs, the same models many photojournalists were already using, and were very expensive. By 2001 nearly half of all journalists used digital cameras; today virtually all do.

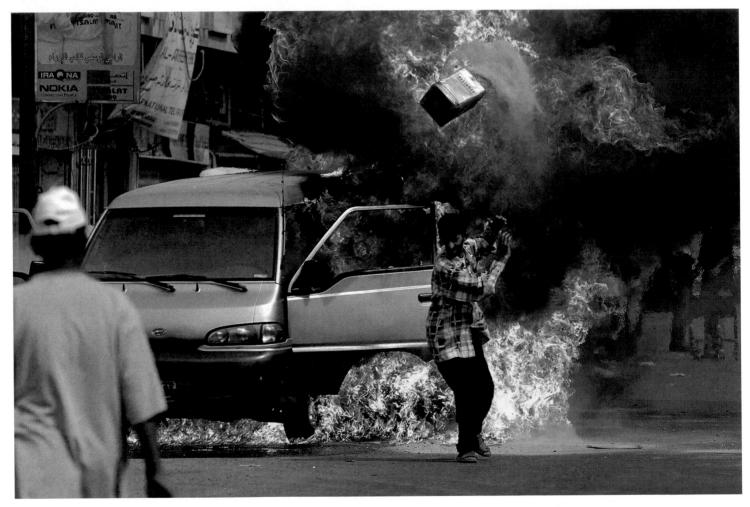

Ashley Gilbertson. Baghdad, Iraq, 2004, Gilbertson has photographed conflict in Iraq since 2002, on assignment for a variety of publications and as a personal project. Here, an Iraqi's attempt to extinguish the fire burning in a van ends spectacularly. Gilbertson's book, Whiskey Tango Foxtrot, records not only the drama of scenes like this, but also the people that are caught up in the conflict. George Packer, writing in The New Yorker, said that war photography can "give back their subjects the humanity that the war is taking away." Alfred Eisenstaedt. Ethiopian Soldier, 1935. War and social injustice are among the staples of news photography. The best of these photographs go beyond the simple recording of an event. They become symbols of the time in which they occurred.

In 1935, when the overwhelming force of a modern, mechanized Italian army invaded an ill-prepared Ethiopia, Eisenstaedt focused on the feet of a barefoot Ethiopian soldier.

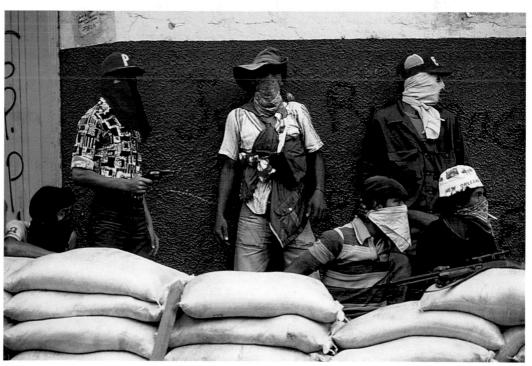

Susan Meiselas. Awaiting Counterattack by the Guard, Matagalpa, Nicaragua, 1978. **During the Sandinista revolt in Nicaragua,** Susan Meiselas photographed these men at a barricade awaiting attack by government troops. She had to decide whether to stay and continue photographing or to leave to make the deadline for publication. "As a documentary photographer, I would have liked to stay, but I had to leave to get the pictures out. It was the first time that I realized what it means to be a photojournalist and deal with a deadline."

Photography as Art in the 19th Century

Was it just a photograph or was it art? Almost from the moment of its birth, photography began staking out claims in areas that had long been reserved for painting. Portraits, still lifes, landscapes, nudes, and even allegories became photographic subject matter.

At the time, the most famous and commercially the most successful of those intending to elevate photography to an art was Henry Peach Robinson. Robinson turned out many illustrative and allegorical composite photographs. These were carefully plotted in advance and combined several negatives to form the final print (right, top). Robinson became the leader of a so-called High Art movement in 19th-century photography, which advocated beauty and artistic effect no matter how it was obtained. Robinson advised: "Any dodge, trick and conjuration of any kind is open to the photographer's use."

By the 1880s, a new movement championed naturalism as artistic photography. Its leader, Peter Henry Emerson, felt that true photographic art was possible only through exploiting the camera's ability to capture reality in a direct way (right, bottom). He scorned the pictorial school and its composite printing, costumed models, painted backdrops, and sentimental views of daily life.

Emerson laid down his own rules for what he called naturalistic photography: simplicity of equipment; no "faking" by means of lighting, posing, costumes, or props; free composition without reliance on classical rules; and no retouching. He also promoted what he believed was a scientific focusing technique that imitated the way the eye perceives a scene: sharply focused on the main subject, with the foreground and especially the background slightly out of focus.

His ideas influenced a new generation of photographers who no longer felt the need to imitate painting but began to explore photography as an art in its own right.

Henry Peach Robinson. Fading Away, 1858. Henry Peach Robinson's High Art photography was inspired by romantic literature. He developed a composite photographic technique that allowed him to produce imaginary scenes. Fading Away (above) was staged by posing models separately and piecing together the images.

Peter Henry Emerson. Gathering Water Lilies, 1885. **Peter Henry Emerson rejected the methods of the High Art photographers.** He insisted that photography should not imitate art but should strive for a naturalistic effect that was not artificially contrived. He illustrated his theories with his own photographs of peasants on the East Anglian marshes in England.

Pictorial Photography and the Photo-Secession

Robert Demachy. Panel, 1898. **Pictorialist photography at the turn of the century** often resembled impressionist paintings, with light and atmosphere more important than sharp details.

Alfred Stieglitz. The Steerage, 1907. **Alfred Stieglitz championed photography as art,** including pictorialist photography. However, his own photographs (except for a brief early period, see page 172) did not include soft focus, handwork, or other alterations of the direct camera image.

Is photography an art? Photographers were still concerned with this question at the turn of the century. Art photographers, or pictorialists, wanted to separate their photographs from those taken for some other purpose—ordinary snapshots, for example. Exhibitions were organized internationally where photographs were judged on their aesthetic merits.

Many pictorialists believed that artistic merit increased if the photograph looked like some other kind of art—charcoal drawing, mezzotint, or anything other than photography. They patterned their work quite frankly on painting, especially the work of the French Impressionists, for whom mood and a sense of atmosphere and light were important. The pictorialists favored mist-covered landscapes and soft cityscapes; light was diffused, line was softened, and details were suppressed (left, top).

In America, Alfred Stieglitz was the leader and catalyst for photography as an art form and his influence is hard to overestimate. He photographed (left, bottom), organized shows, and published influential and avant-garde work by photographers and other artists. In his galleries-the Little Galleries of the Photo-Secession (later known simply by its address, 291), the Intimate Gallery, and An American Place he showed not only what he considered the best photographic works but also, for the first time in the United States, the works of Cézanne, Matisse, Picasso, and other modern artists. In his magazine Camera Work, he published photographic criticism and works whose only requirement was that they be worthy of the word art. Not only did he eventually force museum curators and art critics to grant photography a place beside the other arts, but by example and sheer force of personality he twice set the style for American photography: first toward the early pictorial impressionistic ideal and later toward sharply realistic, "straight" photography.

CHAPTER 10 🕺 201

The Direct Image in Art

Some photographers interested to make art in the early 20th century created unmanipulated images even while pictorialists were making photographs that looked very much like paintings. A movement was forming to return to the direct photographs that characterized so much of 19th-century imagery. In 1917, Stieglitz devoted the last issue of *Camera Work* to Paul Strand, whose photographs he saw as a powerful new approach to photography as an art form. Strand believed that "objectivity is of the very essence of photography... The fullest realization of this is accomplished without tricks of process or manipulation."

Stieglitz's own photographs were direct and unmanipulated. He felt that many of them were visual metaphors, accurate images of objects in front of his camera and at the same time external "equivalents" of his inner feelings. After 1950, Minor White carried on and expanded Stieglitz's concept of the equivalent. For White, the goal of the serious photographer was "to get from the tangible to the intangible" so that a straight photograph also functions as a metaphor for the photographer's or the viewer's state of mind.

Straight photography dominated photography as an art form from the 1930s to the 1970s and is exemplified by Edward Weston. He used the simplest technique and a bare minimum of equipment: generally, an 8×10 view camera with lens stopped down to the smallest aperture for sharpness overall. He contact-printed negatives that were seldom cropped. "My way of working-I start with no preconceived idea-discovery excites me to focus-then rediscovery through the lensfinal form of presentation seen on ground glass, the finished print previsioned complete in every detail of texture, movement, proportion, before exposure-the shutter's release automatically and finally fixes my conception, allowing no after manipulation-the ultimate end, the print, is but a duplication of all that I saw and felt through my camera." Many other photographers, such as Ansel Adams, Paul Caponigro (right), Imogen Cunningham, and Charles Sheeler (page 164) have used the straight approach.

Paul Strand. The White Fence, Port Kent, New York, 1916. **Strand's straight approach to photography as an art form combined an objective view with personal meaning.** "Look at the things around you, the immediate world around you. If you are alive it will mean something to you."

Paul Caponigro. Galaxy Apple, New York City, 1964. **The apple is a symbol** of the biblical story of creation; in this photograph it resonates with the visual metaphor of a universe reflected in its skin. "Photography's potential," Caponigro said, "...is really no different from the same potential in the best poetry where familiar, everyday words, placed within a special context, can soar above the intellect and touch subtle reality in a unique way."

The Quest for a New Vision

György Kepes. Lichtenberg figures, 1951..

László Moholy-Nagy. Jealousy, 1927. Photographers such as László Moholy-Nagy and György Kepes used many techniques in their explorations of real, unreal, and abstract imagery. The photomontage (right) combines pieces of several photographs. Moholy defined photomontage as "a tumultuous collision of whimsical detail from which hidden meanings flash," a definition that fits this ambiguous picture.

György Kepes mined scientific advances for imagery, collaborating with physicist A. R. von Hippel to generate the image above. Lichtenberg figures result from highvoltage static electricity, a principle that led directly to modern xerography.

he beginning of the 20th **century saw great changes in many areas,** including science, technology, mathematics, politics, and also the arts. Movements like Fauvism, Expressionism, Cubism, Dada, and Surrealism were permanently changing the meaning of the word "art." The Futurist art movement proposed "to sweep from the field of art all motifs and subjects that have already been exploited...to destroy the cult of the past...to despise utterly every form of imitation... to extol every form of originality."

At the center of radical art, design, and thinking was the Bauhaus, a school in Berlin to which the Hungarian artist László Moholy-Nagy came in 1922. He attempted to find new ways of seeing the world and experimented with radical uses of photographic materials in an attempt to replace 19th-century pictorialist conventions with a "new vision" compatible with modern life. Moholy explored many ways of expanding photographic vision, through photograms, photomontage (left, bottom), the Sabattier effect (often called solarization), unusual angles, optical distortions, and multiple exposures. He felt that "properly used, they help to create a more complex and imaginary language of photography."

The Bauhaus school closed in 1933, under pressure from the German government, which at the same time made it difficult for foreign citizens like Moholy to work. He moved to London, and then to Chicago, where in 1937 he founded the New Bauhaus school. Moholy brought György Kepes from Europe to head the school's "Light Workshop" area, which included both graphics and photography. Kepes, a prolific artist and writer, later founded the Center for Advanced Visual Studies at MIT, a program that sponsors the arts at the intersection of technology. Over several decades, the CAVS invited dozens of innovative artists to collaborate with scientists working at the cutting edge of their own fields, just as Kepes was doing in his own work (left, top).

203

Photography as Art in the 1950s and 1960s

A tremendous growth took place in the acceptance of photography as an art form, a change that started in the 1950s. Since then, photography became a part of the college and art school curriculum, art museums devoted considerable attention to photography, art galleries opened to sell only photographs, while photography entered other galleries that previously had sold only paintings or other traditional arts, and established magazines such as *Artforum* (page 208) and *Art in America* regularly published photographs and essays about the medium.

American work of the 1950s was often described in terms of regional styles. Chicago was identified with the work of Aaron Siskind (right, bottom) and Harry Callahan (right, top). The West Coast was linked to the so-called straight photographers, such as Ansel Adams (page 47) and Minor White (page 53). New York was a center for social documentation, such as by photographers in the politically active Photo League. Meanwhile, tied to no region, Robert Frank, a Swiss immigrant, was traveling across the United States photographing his own view of life (opposite).

An increasing number of colleges and art schools in the late 1960s offered photography courses, often in their art departments where a cross-fertilization of ideas took place between photographers and artists working in traditional art media. Some painters and other artists used photographs in their work or sometimes switched to photography altogether. Some photographers combined their images with painting, printmaking, or other media. Older photographic processes were revived, such as gum bichromate and platinum printing.

Minor White said that in the 1950s photographers functioning as artists were so few that they used to clump together for warmth. The explosion of photography in academia helped push the medium in many directions, and the long battle over whether photography was an art was finally resolved. The winners were those who said it could be.

Harry Callahan. Eleanor, 1947. Harry Callahan's work was lyrical and personal. He returned again and again to three main themes, the emptiness of city scenes, the rich detail of landscapes, and portraits of his wife, Eleanor. He said, "It takes me a long time to change. I don't think you can just go out and figure out a bunch of visual ideas and photograph. The change happens in living and not through thinking."

Aaron Siskind. Chicago 30, 1949. Aaron Siskind's best-known work consists of surfaces abstracted from their context such as peeled and chipped paint or posters on walls. The subject of the photograph is the shapes, tonality, and other elements that appear in it, not the particular wall itself.

Robert Frank. Bar – New York City, 1955. **Robert Frank's ironic view of America exerted a great influence on both the subject matter and style of photography as an art form.** Like Frank's photographs, the works of Diane Arbus, Lee Friedlander, Garry Winogrand, and others were personal observations of some of the peculiar and occasionally grotesque aspects of American society.

Above, a glimpse inside a New York bar is an unsettling comment on the emptiness of modern society. Jack Kerouac wrote in his introduction to Frank's book The Americans, "After seeing these pictures, you end up finally not knowing any more whether a jukebox is sadder than a coffin."

CHAPTER 10 🕺 205

Photography as Art in the 1970s and 1980s

Photographers continued to explore a variety of subjects and issues. Some remained committed to the straight photography tradition of Edward Weston (page 164) or Ansel Adams (page 47), while others experimented with form to find a new vision. Shaped by repercussions of the Vietnam War and other conflicts, some photographers took the medium in political directions, following the leads of Robert Frank (page 205) or W. Eugene Smith (page 197). Photographers like Lee Friedlander (page 157), Diane Arbus, and Garry Winogrand (page 135) roamed the streets, recording the humor, pathos, and irony of daily life.

Photography found acceptance as a legitimate art form. During the late 1970s and early 1980s, emerging artists using photography like Cindy Sherman (right, top), Robert Mapplethorpe, and Barbara Kruger were exhibited in art galleries, as opposed to photography galleries, and found they could prosper. Photographers like Irving Penn and Richard Avedon (opposite), better known for their commercial work, were given exhibitions of their editorial and personal work in major art museums, evoking controversy in some quarters. Technological advances in color photography, seldom used by art photographers in the past, helped it gain popularity.

Museums hired photographic curators and charged them with building collections and exhibiting photography more regularly. New institutions like the International Center for Photography (1974) and the Center for Creative Photography (1975) were founded. By the early 1980s, photography had become a fixture in museums, academia, and the art world at large.

Photography attracted the attention of respected intellectuals from other fields as well. In *On Photography* (1977), Susan Sontag raised penetrating questions about the medium, its aesthetics, and its ties with the culture at large. Sontag validated photography as a subject worthy of serious analysis. By the early 1980s, photography was not merely accepted, it was hot.

Robert Cumming. Tile/Mirror, Milwaukee, Wisconsin, 1970. **"Photographic conceptualism"** is a label applied to Cumming's early photographic works, like this one, because they broke from the tradition of formal beauty in favor of stressing an idea. Many of his "conceptual" pieces also display a very dry sense of humor.

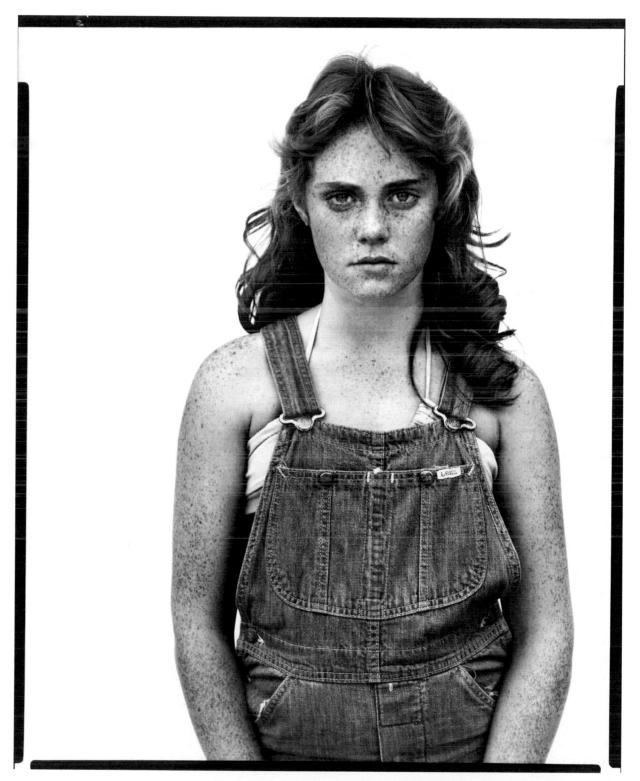

Richard Avedon. Sandra Bennett, twelve year old, Rocky Ford, Colorado, August 23, 1980.

Color Photography Arrives—Again

By 1970, almost everyone's snapshots were in color, but art photographs weren't. The sudden respectability received by serious photography in the late 1960s did not include color. Many of the era's well-known artists had photographed in color—Ansel Adams, Harry Callahan, Helen Levitt, and even Edward Weston among them—but what was seen of theirs was always black and white.

In part, this was due to the expense of printing books and magazines in color. But there were other reasons as well. Serious photographers took pride in their expressive darkroom craft; the tones of a black-and-white print were easily manipulated in the hands of a master. Color photographs either looked accurate or they looked wrong. Also, darkroom color chemicals required more attention, so quality control favored the automated processing machines in high-volume commercial labs. Until the 1970s no photographic artists could make a living just by selling prints, so their darkrooms were usually economical small spaces with simple equipment. There were few options for a modest color darkroom. **Color materials had (and continue to have) permanence issues;** over time, colors fade and change. In museums you can see many pristine examples of black-and-white prints made by the first generation of photographers in the 19th century. Research into the longevity of photographs proved that, with careful processing and storage, silver-based black-and-white prints and negatives can last nearly forever. But the news about color was all bad. It was so bad that until the mid-1970s most museums, because of their obligation to preserve objects in their care, would not collect color photographs at all. Photographers who wanted their prints to outlast them wouldn't take a chance.

Color photography arrived—suddenly, it seemed—in the mid-1970s. Art schools and universities that had only recently introduced photography courses found them increasingly popular. Art departments grew from teaching one or two photo classes to offering a full academic major, which meant expanding their facilities to meet the demand. Color photography classes entered

In 1978 Jan Groover exhibited color photographs at the Sonnabend Gallery in New York. Because Sonnabend was known for exhibiting prominent contemporary painters and sculptors, the appearance of color photographs caused a sensation. Writing about her work almost ten years later in the New York Times, critic Andy Grundberg said, "When one appeared on the cover of Artforum magazine, it was a signal that photography had arrived in the art world—complete with a marketplace to support it."

Artforum. January, 1979.

William Eggleston. Greenwood, Mississippi, 1973. Eggleston had his 35mm color transparencies made into dye transfer prints. Now discontinued, the dye transfer process was labor-intensive and required absolute precision, but the prints are among the most permanent and accurate color photographs ever made. the course catalogs and school labs set up color processing machines. More facilities meant more emerging artists with color portfolios, and more color prints on view.

Newly available research showed that cooler temperatures slowed the deterioration of color photographs. Museums began constructing refrigerated vaults to store the color photographs they could then collect, and some photographers found room in their studios for freezers to keep their color negatives.

For years, Kodak ignored pleas from commercial photographers and artists alike for a more permanent color printing paper, but Fuji listened. They began to market color paper in 1980 and improved its expected lifespan with a new version every few years. Photographers—and collectors began to trust that color photographs wouldn't vanish overnight.

Color photography was validated by museum exhibitions. Stephen Shore was represented by color prints in the enormously influential New Topographics exhibition at the George Eastman House in 1975. Although color photographs had been shown occasionally at New York's Museum of Modern Art since 1937, its 1976 exhibitions of William Eggleston (in May) and Shore (October) were hailed as a watershed in the acceptance of color photographs as fine art.

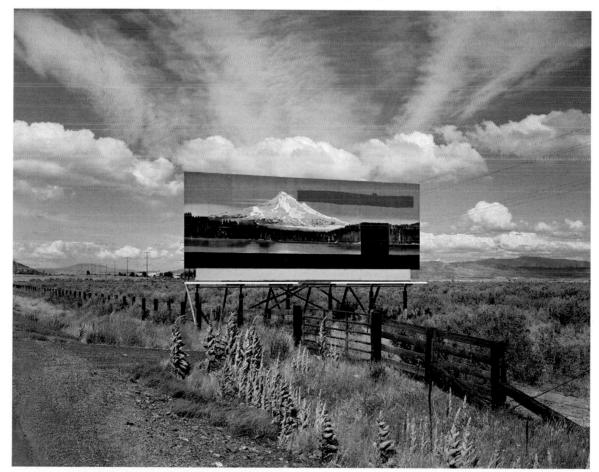

Stephen Shore. South of Klamath Falls, U.S. 97, Oregon, July 21, 1973. **Shore photographed with an 8** \times **10 view camera using color film**. The resulting prints have saturated colors, fine detail, and crystalline clarity but, he says, "...it's that awareness of really looking at the everyday world with clear and focused attention that I'm interested in." "There's something arbitrary about taking a picture. So I can stand at the edge of a highway and take one step forward and it can be a natural landscape untouched by man and I can take one step back and include a guardrail and change the meaning of the picture radically." His not-so-arbitrary decision to step back allowed him to raise questions about the nature of pictures.

CHAPTER 10

209

Digital Photography

PREDECESSORS

oday, it's difficult to think of a sector of our society that isn't affected in some measure by digitized imagery. The print and media industries, the arts, medicine, politics, and sports all use and depend on digital images. Web sites and apps such as Snapchat, Instagram, and Facebook regale us with the latest pictures of friends, pets, kids, and everything else in ways that few people could imagine even a decade ago.

Many of photography's inventors were grounded in the sciences, for example, William Henry Fox Talbot (page 184) and Sir John Herschel in the early 19th century. Talbot, coincidentally, was friends with Charles Babbage, a mathematician whose "difference engine," was the first successful automatic calculator—the direct ancestor of today's computers. In the mid-20th century, scientists and engineers played key roles in developing digital imaging systems. Space navigation and mapping drove the development of, for example, the Hubble telescope and advanced television cameras.

The impulse to manipulate photographs is nearly as old as the medium itself. Long before computers were invented, people wanted to do (and some were doing) one of the things that digital imaging does so well—combining images. Henry Peach Robinson (page 200), Oscar G. Rejlander (right), and others cut, pasted, masked, and rephotographed images to make allegories, illustrate Biblical stories, and create dramatic or simply amusing scenes.

In the early 20th century, artists like Man Ray and László Moholy-Nagy (page 203), Hannah Höch, and John Heartfield created surrealistic and sometimes political—montages.

Instant feedback was an elusive goal for photographers. Until the availability of Edwin Land's first Polaroid camera in 1948, there was no practical way, other than years of experience, to know if a captured image would match the expectations of the photographer. Polaroid's instantprint cameras and film were enormously popular for snapshots, and their professional films were an essential proofing step in studios, but most instant films limited the photographer to producing—like the early daguerreotype—only a small, unique print.

Digital imaging soon reached a popular audience. Sophisticated computer equipment was used to generate new special effects and animation techniques in popular films like Star Wars (1977). Dazzling imagery captivated audiences, including filmmakers and artists who began to glimpse and use the visual possibilities (see pages 212-213). Competition among Kodak, Sony, Fuji, and other corporations led to the introduction of cameras that could capture an image digitally, and show it to the photographer immediately, in the early 1990s. In January, 2008, the Japanese camera manufacturers' trade organization reported film camera sales of less than 0.1% of total cameras sold; after that they stopped including film cameras in their monthly sales reports.

Oscar G. Rejlander. Rejlander Introduces Rejlander the Volunteer, c. 1865. **Rejlander often pieced together negatives to produce composite images.** He enjoyed theatrics and photographed himself and others displaying emotions, made character studies, and created complicated allegorical scenes. In this self portrait, he appears as both the artist and the soldier he is introducing.

Jim Stone. Dawn and Krista at the Lemonade Stand, Syracuse, New York, 1984. To photograph strangers, Stone used a now-discontinued Polaroid instant positive/negative film in his 4 × 5 view camera. It made an instant print that he gave to his subjects to make sure they were comfortable with the image, and a negative he kept to make larger prints. The film pack, a sandwich of black-and-white film and print paper, contained a pod of developing chemicals that would process the materials after exposure—in daylight—in twenty seconds. The frame's distressed edges, visible in the image above, are the result of including a part of the negative that extended beyond the instant print's masked white border.

Digital Photography

BECOMES MAINSTREAM

The 1990 introduction of Adobe Photoshop was a major turning point in the acceptance and use of digital imaging. An early exhibition, *Digital Photography: Captured Images, Volatile Memory, New Montage* (1988) gathered work by artists such as Paul Berger, MANUAL (Suzanne Bloom and Ed Hill), Esther Parada, Martha Rosler (page 76), and others who used digital imaging for a variety of purposes. The flexibility of digital imaging and the integration of applications on the computer led many artists to explore crossmedia and interdisciplinary production using installations, music, and video.

In the 1990s, many traditional photographers, who had long been committed to black and white, began using color, in part because digital technology simplified color management and made the printing process more accessible. In less than a generation, digital technology took over the medium of photography. Anyone who owns a camera, or even just a cell phone, is an image maker. In 2017, Facebook claimed that its members upload 136,000 photos every sixty seconds. By 2014, there were more active cell phones than people in the world, and about 95% of them were camera phones. Virtually everyone in the world is carrying—and using—a camera.

Digital manipulation of images is commonplace, whether in the news, in advertising, or in the simple act of removing unwanted power lines (or unpleasant relatives) from our snapshots. The allure of photography has always in part been about controlling and even altering our experience of reality. We have experienced a revolution whose contours and implications we are just beginning to understand. Martina Lopez. Heirs Come to Pass, 1991. Lopez was a pioneer in the use of digital collage, or compositing, as a fine art medium. This piece references her own family's photographic archive, and she imagines herself as all the female characters, but the figures all came from found photographs. Individual scans were assembled using a very early version of Photoshop, before version 3 (in 1994) introduced Layers and allowed each piece of a composite to be manipulated individually.

Direct high-quality printing from digital files was not widely available at the time. Lopez sent the completed file to a film recorder to create a 4×5 film transparency that she then printed on Cibachrome (now called Ilfochrome) in a color darkroom.

Nancy Burson. Warhead I, 1982. Burson made combination portraits like this one after working with scientists at MIT in the 1970s to develop software to graphically advance a portrait subject's apparent age (it was used to find several missing children).

This digital composite superimposes images of five world leaders, the visual weight of each face represents how many of the world's nuclear warheads they controlled: Ronald Reagan (55%) and Leonid Brezhnev (45%), with Margaret Thatcher, François Mitterand, and Deng Xiaoping (each less than 1%). It was made nearly a decade before photo-quality digital printers appeared; Burson used a film camera to photograph her composites displayed on a CRT monitor, then made exhibition prints in a darkroom.

CHAPTER 10

213

How to Learn More

- Further information on photography is readily available. Many books and magazines extend technical information; others reproduce great examples—both contemporary and historical of practical and artistic photography. The bibliography on page 226 and a local or university library are good places to start.
- Camera store personnel can answer questions about the products they sell. Additionally, the staff in most camera stores are often avid photographers themselves, and they may be eager to discuss photography—especially when the store is not crowded.
- Advanced classes and workshops are offered almost everywhere, from guided photo tours to professional lighting seminars. Ask about them at a camera store, a local community college or university, or search the Internet (see below).
- The Internet can answer almost any question you may have about photography. Like an immense library, the World Wide Web gives you access to information, opinions, and images. On it you can search for prices and order books, supplies, and equipment. And you can show your own photographs to anyone with an Internet connection, worldwide.

Most universities and public libraries have computers that are always online, meaning they are connected to the Internet. Most coffeehouses and many other businesses offer free wireless (*Wi-Fi*) connection to the Internet that you can use if you bring your own laptop computer, tablet, or smartphone.

To connect from your home, you need a computer, tablet, or smartphone and a contract with an *Internet Service Provider* (or ISP). A local computer retail store can help answer questions, and numerous self-help books are available on the topic.

- A Web browser is the software program your computer uses to reach the World Wide Web. Dominating the field are Mozilla Firefox, Apple Safari, Google Chrome, and Microsoft Internet Explorer. They are free (but you need to use one to download another), and most computers are supplied with at least one already installed. Your Web browser lets you type in a location or address, called a *URL* (for Uniform Resource Locator), to reach a specific Web page. Addresses begin with *http:// or www.* Most pages contain links that connect you directly to other related pages simply by clicking on them. Your browser lets you save any URL as a *bookmark* so you can easily return to it.
- Use a search engine to find pages on a specific topic. Most browsers have search engines already stored as bookmarks; three useful ones among many are Google, Bing, and Yahoo. Type keywords to locate your topic, using several to narrow the search. A recent search on the keyword *photography* in English turned up over 1.5 billion sites. Narrowing the search to *photography museum* listed 8 million possibilities. Changing the search to *photography museum* listed 8 million possibilities. Changing the search to *photography museum* listed 8 million possibilities. Changing the search to *photography museum* listed 8 million possibilities of the first one on that list is probably the one you'd want—the home page for the George Eastman Museum.

Online magazines, portal sites, and blogs are very useful for many topics. Anyone can start and maintain a blog (originally *weblog*), a regularly updated Web site. They often include links to other, similarly focused blogs. Over time, some have grown larger, blurring the definition. Some are like public diaries, others consolidate portfolios or technical information, or feature interviews, book reviews, awards, and contests. Try DPReview.com, FlakPhoto.com, FractionMagazine.com, and LensCulture.com to see the range. Also see the list of Web sites featuring the work of photographers represented in this book, on page 220.

Product information is plentiful on the Web. Camera makers feature new products and provide listings of lenses and accessories. Paper manufacturers' sites, like Innova's shown here, have printer profiles you can download, as well as complete product listings.

Museums have sites on the Internet. This one has an online version of a book-length catalog—an exhibition of landscape photography that was held at the Smithsonian American Art Museum. Information about individual artists is often presented along with images.

Photography organizations have galleries and libraries; many publish newsletters and books and—like Light Work, the Syracuse, New York artist's space shown above—sponsor artists with residencies, grants, and in other ways. Find out about their programs from their Web sites.

Troubleshooting

rom time to time, every photographer encounters captured images, scans, or prints that display unexpected problems. This section can help you identify the cause of some common problems—and how to prevent them in the future.

SOLVING CAMERA AND LENS PROBLEMS

IMAGE AREA COMPLETELY BLACK

Cause: The sensor (or film) received no exposure. *Prevention:* Increase exposure by several stops and shoot again. Check that the lens cap is off. With electronic flash, the flash may not have fired.

- **LIGHT STREAKS.** Image area flared or foggy looking overall. If you use film, darkened in a negative, lightened in a print or slide, with film edges unaffected. The image may also show ghosting or geometric spots in the shape of the lens diaphragm.
- *Cause:* The sun, a bright bulb, or other light source was within or close to the image, or bright light struck the lens at an angle.
- **Prevention:** Expect some flare if you can see a light source in your viewfinder. The larger or brighter the light, the more flare you will get; distant or dim lights may not produce any flare at all. To prevent stray light from striking the lens, use the correct size lens shade for your lens focal length (right). Even with a lens shade, make sure the sun is not shining directly on your lens.

PICTURE NOT SHARP. Easier to see in an enlarged print or screen display at 100% magnification.

- *Cause:* Too slow a shutter speed will blur a moving subject or blur the picture overall due to carnera motion. Too wide an aperture will make the scene sharp where you focused it but not in front of or behind that part. An extremely dirty lens can sometimes reduce sharpness overall, especially when combined with lens flare.
- **Prevention:** Use a faster shutter speed or smaller aperture, or support the camera more steadily. Keep fingerprints and dirt off the lens.

- **VIGNETTING.** Image obscured or very dark at the corners.
 - *Cause:* A lens shade, filter, or both projected too far forward of the lens and partially blocked the image from reaching the lens.
 - **Prevention:** Lens shades are shaped to match different focal-length lenses (right). Use the correct shade for your lens; too long a lens shade can cause vignetting, but one that is too shallow will not provide adequate protection from flare. Using more than one filter or a filter plus a lens shade can cause vignetting, especially with a short lens.

Lens shade for long-focal-length lens

For short-focal-length lens

SOLVING CAMERA AND LENS PROBLEMS, continued

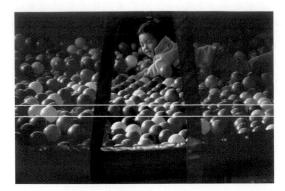

LINES THROUGH IMAGE.

Cause: Nonresponding CCDs. A line on a digital camera photo means a row of CCDs on the sensor is not collecting pixel data. A line on a scan is from a single dead CCD that moves across the image.

Prevention: Fixing the problem may mean replacing the scanner or camera, but such lines are easy to retouch in the image. Photoshop lets you select a single-pixel row or column and adjust it separately (see also Lines Across a Print, page 219).

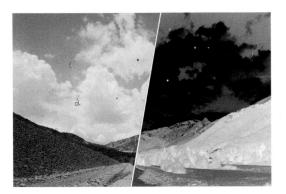

DUST SPECKS. Dark or black specks or marks on a digital image, clear specks on a negative.

- *Cause:* Dust on the sensor or film during exposure. Bits of dust on the light-sensitive surface will keep the light from reaching a small part of it during the exposure.
- **Prevention:** Keep the inside of the camera dust free by carefully blowing or dusting camera surfaces when you change lenses or reload film (see page 29). Clean dust out of the cap that covers the back of your lens before use. Specks can be retouched during image editing to remove them but it is better not to get them.

LIGHTNESS/DARKNESS PROBLEMS

SUBJECT VERY DARK AGAINST LIGHTER BACK-GROUND.

- *Cause:* The meter averaged all the tones in its angle of view, then computed an exposure for a middle-gray tone. The problem is that the average of the overall scene was lighter than a middle tone, so appears too dark.
- **Prevention:** Don't make an overall reading when a subject is against a much lighter background. Instead, move in close to meter just a part of the subject that is middle-toned, then set your shutter speed and aperture accordingly (see pages 70–72).

SUBJECT VERY LIGHT AGAINST DARKER BACK-GROUND.

Cause: If the subject is too light, your meter was overly influenced by a dark background and overexposed the image.

Prevention: Don't make an overall reading when a subject is against a much darker background. Instead, move in close to meter just a part of the subject that is middle-toned, then set your shutter speed and aperture accordingly (see pages 70-72).

SHARPNESS PROBLEMS

FLASH PROBLEMS, continued

NOT ENOUGH (or the wrong part) OF THE SCENE IS IN FOCUS.

- **Cause:** 1. Not enough depth of field. Too wide an aperture will result in shallow depth of field, making the scene sharp where you focused the camera, but not in front of or behind that part of the scene. 2. Shutter speed was too slow, subject or camera moved during exposure. 3. Camera wasn't focused on the main subject.
- **Prevention:** 1. Choose a smaller aperture. 2. Choose a faster shutter speed or set the camera on a tripod. 3. Choose manual focus, or make sure you know how your autofocus lens selects a focus distance (see page 43).

ALL OR PART OF SCAN OUT OF FOCUS.

- *Cause:* If the entire image is out of focus, the scanner vibrated during the exposure or, with film, the original is held too far from the scanner's plane of focus. If part of the scan is out of focus, the scanner may have been bumped during the scan. The film may be buckling or moving during the scan, or may not be held flat enough.
- **Prevention:** Make sure the scanner sits on a solid surface and is not vibrated by nearby equipment. A glass holder or covering sheet will keep the film flat, but may introduce Newton's rings, undesired rainbow-colored patterns. Special anti Newton glass is available.

FLASH PROBLEMS

PART OF SCENE EXPOSED CORRECTLY, PART TOO LIGHT OR TOO DARK.

- **Cause:** Objects in the scene were at different distances from the flash, so were exposed to different amounts of light.
- **Prevention:** Try to group important parts of the scene at about the same distance from the flash (see page 148).

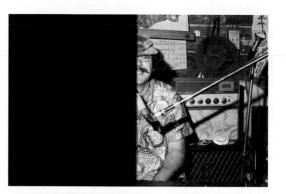

ONLY PART OF SCENE EXPOSED.

- *Cause:* Shooting at too fast a shutter speed with a camera that has a focal plane shutter, such as a single-lens reflex camera. The flash fired when the shutter was not fully open.
- **Prevention:** Check manufacturer's instructions for the correct shutter speed to synchronize with flash, and set the shutter-speed dial accordingly. For most cameras, 1/60 sec. is safe; faster speeds are usable with some cameras. The flash shutter speed may appear on your camera's shutter-speed dial in a different color from the other shutter speeds, or it may be marked with an X.

SUBJECT APPEARS TOO DARK OR TOO LIGHT. Manual flash settings are more likely to cause problems than automatic operation, which reads the illumination from the flash through the lens. More about flash operation on pages 146–147.

- **Cause:** Too dark—the scene was underexposed, not enough light reached the film or sensor. Too light—too much light reached the film or sensor. Setting exposure for flash manually, an occasional too dark or light frame probably results from setting the lens aperture incorrectly or making an exposure before the flash is fully charged.
- **Prevention:** In manual operation, increase the exposure about a stop for scenes shot outdoors at night or in a large room like a gymnasium; the relatively dark surroundings absorb light that would otherwise bounce back to add to the exposure. With a non built-in flash, if your pictures are frequently too dark, try setting the flash unit to half the ISO you are using.

Close down the aperture about a stop when shooting in small, light-colored rooms to compensate for excess light bouncing back from walls and ceiling. With a non built-in flash, if your pictures are usually overexposed and too light, try setting the flash unit to twice the ISO you are using.

SOLVING FLASH PROBLEMS, continued

Flash pointed straight at reflective surface

Same scene shot

UNWANTED REFLECTION.

Cause: Light bouncing back from reflective surfaces such as glass, mirror, or shiny walls.

Prevention: Position the camera at an angle to highly reflective surfaces or aim the flash at the subject from off camera.

RED EYE. A person's or animal's eyes appear red or amber in a color picture, very light in a black-and-white picture (see page 148).

Cause: Light reflecting from the blood-rich retina inside the eye. *Prevention:* Move the flash away from the lens or have the subject look slightly to one side of the camera. Turning the subject's head slightly can also prevent bright reflections from eyeglasses. Some cameras have a red-eye reduction mode: the flash lights up briefly before the main exposure so that the subject's iris contracts, reducing the amount of visible red.

SOLVING COLOR PROBLEMS

GREENISH LOOK TO SCENE OVERALL.

Cause: Scene shot in fluorescent light, which emits disproportionate amounts of greenish light. See also Unexpected color cast, below.Prevention: With film, try an FL filter on the lens. Set the white balance of a digital camera to fluorescent (see pages 6 and 58).

BLUISH OR REDDISH LOOK TO SCENE OVERALL.

Cause: Color film or a digital camera's white balance setting not matched to the type of lighting on the scene. Daylight film shot in incandescent light will give a reddish look.

Prevention: For a more realistic color balance, set the white balance of a digital camera to the type of lighting used (see pages 6 and 58). Use a #80A filter for a scene lit by incandescent (about 3200K) light bulbs. Use daylight-balanced film in daylight or with flash.

UNEXPECTED COLOR CAST.

- **Cause:** Light reflected from a nearby colored object can give a color cast to the scene. The shade of a tree can add an unexpected look to skin tones because the light was filtered through colored leaves; here, orange fall leaves. Similarly, light bouncing off a strongly colored wall can tint the scene the color of the wall. The effect is most noticeable on skin tones or neutral tones like white or gray.
- **Prevention:** Try to recognize and, if you wish, avoid the situation. In some cases, the color balance of selected areas can be adjusted separately during image editing.

SOLVING OTHER DIGITAL PROBLEMS

PIXELATION. Edges look stair-stepped. Details are indistinct.

Cause: Image resolution too low for the intended use.

Prevention: 72 dpi is ideal for display on a monitor, but printing from an inkjet or dye-sublimation printer requires 180–360 dpi. If you scanned the image, rescan it at a higher dpi setting.

If the image came from a digital camera, try Photoshop Image>Image Size to resample the image at a higher dpi. Next time you photograph, use a higher resolution.

SOFT IMAGE. Details in the image are not sharp.

Cause: Possibly poor focus or camera movement (see Picture not sharp, page 215). Extreme file compression (JPEG, page 81) is shown in the example above.

With a digital camera, quality level is too low. At low-quality settings (also called *basic* or *good*), the camera compresses the image file. When the image is reopened and uncompressed, details can be lost. The visible results may be negligible when prints are very small, but will be noticeable if they are enlarged.

Prevention: Try to anticipate the final size and reproduction method for your images. Pictures to be used only on the Web can be shot at low quality. Use the camera's highest quality setting if you might ever want to make 8×10 -inch or larger prints.

All digitally captured pictures need some sharpening (page 104). If you are just starting out, you may not be used to just how unsharp your unsharpened photographs will appear.

DIGITAL NOISE. Colored specks in dark areas.

- *Cause:* Often occurs in shadow areas, in photos taken at night, or in low light with a long exposure.
- **Prevention:** Try shooting at a lower ISO; instead of ISO 800 or 1600, try ISO 100 or 200. Try Photoshop Filter>Noise>Despeckle. This reduces the noise, although it softens the image somewhat.

BANDING. Unexpected bands in areas with no detail.

- **Cause:** With a digital camera, scene may have been shot at too high an ISO setting. Some fine patterns, like a window screen, may create a pattern (called *moiré*) when overlaid with the pixel grid.
- **Prevention:** Try shooting the scene with a lower ISO. You might need to use a tripod and a slower shutter speed or add light from a flash or other light source.

OVERSHARPENING. Details too crisp and contrasty that may show digital noise; colored fringes along edges.

Cause: Oversharpening the print while scanning or while working on the image in an image-editing program (see page 104).

Prevention: Rescan the print, transparency, or negative without sharpening it. With a digital camera image, return to the original digital file, if it has not been sharpened. When you resharpen the image, do so while viewing at 100% magnification.

LINES ACROSS A PRINT.

Cause: Misaligned or clogged print heads.

Prevention: Use the printer's software utility to check for a problem. The utility will also align heads, print a test pattern, and run cleaning cycles.

Photographers' Web Sites

eb pages are today's galleries; many photographers use them to show a broader sampling of their work than they could in a gallery exhibit or a monographic book. Compared to those venues, a Web site is also available to be seen almost anywhere at any time and can always be updated to include new work. Use the links below to find out more about the photographers whose work appears in this book.

Adams, Ansel Adams, Shelby Lee Avedon, Richard Barney, Tina Bateman, Edward Brooks, Drex Burson, Nancy Carey, Alison Cartier-Bresson, Henri Chin, Christine Comen, Sam D'Amato, Paul De Keyzer, Carl Divola, John Dujardin, Filip Eggleston, William Ekberg, Adam Erwitt, Elliott Fink, Larry Fontcuberta, Joan Frank, Robert Galvan, Laurisa Gilbertson, Ashley Gilden, Bruce González, Dionisio Gossage, John Gould, Meggan Harker, Santiago Harvey, David Alan Hatakeyama, Naoya Hocks, Teun Iooss, Walter Johnson, Keith Jones, Lou Jones, Peggy Ann Joyce, Kate Karsh, Yousuf Killip, Chris

anseladams.com shelby-lee-adams.blogspot.com richardavedon.com tinabarney.com xmission.com/~capteddy drexbrooks.com nancyburson.com alisoncarey.com magnumphotos.com christinechin.net samcomen.com pauldamato.com carldekeyzer.com divola.com filipdujardin.be egglestontrust.com adamekberg.com elliotterwitt.com billcharles.com fontcuberta.com pacemacgill.com laurisagalvan.com ashleygilbertson.com magnumphotos.com dionisiogonzalez.es loosestrifebooks.com meggangould.net santiagoharker.com magnumphotos.com takaishiigallery.com teunhocks.nl walteriooss.com keithjohnsonphotographs.com fotojones.com pinhole.us kate-joyce.com karsh.org chriskillip.com

Klett, Mark Koo, Bohnchang Kost, Julieanne Koudelka, Josef Leibovitz, Annie Leventi, David Liebling, Jerome Lopez, Martina Mandel, Mike Manzano, Javier McFarland, Lawrence Meiselas, Susan Miralle, Donald Misrach, Richard Moholy-Nagy, László Oberschneider, Christoph oberschneider.com Owyoung, Todd Padula, Warren Parr, Martin Pinkhassov, Gueorgui PoKempner, Marc Richfield, Robert Richter, Christian Robinson, Geoffrey Robledo, Maria Rosler, Martha Rowin, Stanley Schäfer, Michael Scherer, Jim Sherman, Cindy Shore, Stephen Siskind, Aaron Smith, W. Eugene Sohier, Sage Soth, Alec Stein, Amy Sternfeld, Joel Stone, Jim

markklettphotography.com bckoo.com ikost.com magnumphotos.com contactpressimages.com davidleventi.com jeromeliebling.com martinalopezphoto.com thecorner.net javiermanzano.com lawrencemcfarland.com susanmeiselas.com donaldmiralle.com fraenkelgallery.com moholy-nagy.org toddowyoung.com wpadula.com martinparr.com magnumphotos.com pokempner.net robert-richfield.com richterchristian.com geoffrobinsonphotography.co.uk judycasey.com martharosler.net stanstudio.com mschaefer-studio.de jimscherer.com metropicturesgallery.com stephenshore.net aaronsiskind.org magnumphotos.com sagesohier.com alecsoth.com amysteinphoto.com joelsternfeld.com jimstone.com

Brian Ulrich. Untitled (Thrift 0509), 2005. **Obsolescence comes quickly in the digital world,** as you can see in this photograph from Ulrich's series on thrift stores. We know through

Strembicki, Stan Tarnowski, Tom Taylor, David Turner, Pete Ulrich, Brian Umbrico, Penelope van Coller, Ian strembicki.com ttarnowski.net dtaylorphoto.com peteturner.com notifbutwhen.com penelopeumbrico.net ianvancoller.com/ Vanderwarker, Peter Webb, Alex Weems, Carrie Mae Weifenbach, Terri Whaley, Jo Willis, Deborah xRez Studio advertising that the equipment and software for making photographs are constantly evolving, but so are the pictures we can view online. Use the list on these two pages to check in on your favorites.

vanderwarker.com magnumphotos.com carriemaeweems.net stephendaitergallery.com jowhaley.com debwillisphoto.com xrez.com

Glossary

- Aberration Optical defect in a lens (sometimes unavoidable) causing distortion or loss of sharpness in the final image.
- Adapter ring A ring used to attach one camera item to another; for example, to attach a lens to a camera in reverse position in order to increase image sharpness when focusing very close to the subject.
- Additive color The three primary colors (red, green, and blue) that can be mixed as light to match any other color. See Subtractive color. Ambient light See Available light.

- Angle of view The amount of a scene that can be recorded by a particular lens from a given position; determined by the focal length of the lens.
- Aperture The lens opening formed by the iris diaphragm inside the lens. The size is variable and adjusted by the aperture control.
- Aperture control The ring on the camera lens (a push button on some models) that, when turned, adjusts the size of the opening in the iris diaphragm and changes the amount of light that reaches the film.
- Aperture-priority mode An automatic exposure system in which the photographer sets the aperture (f-stop) and the camera selects a shutter speed for normal exposure.
- Application See Software.
- Archiving Copying and storing digital files in a way that protects against loss.
- ASA A film speed rating similar to an ISO rating.
- Aspect ratio The ratio of width to height, a measure of the shape of a rectangle. A camera that uses a sensor with 11/2 times the pixels measured horizontally as vertically has a 3:2 aspect ratio.
- Automatic exposure A mode of camera operation in which the camera automatically adjusts either the aperture, the shutter speed, or both for normal exposure.
- Automatic flash An electronic flash unit that uses its light-sensitive cell or the camera's to determine the duration of the flash for normal exposure by measuring the light reflected back from the subject.
- Available light The light that already exists (as opposed to being added by the photographer) where a photograph is to be made.
- Averaging meter An exposure meter with a wide angle of view. The indicated exposure is based on an average of all the light values in the scene.
- B See Bulb.
- Backup An exact duplicate of a digital file or set of files, made as protection against loss.
- Bellows An accordion-like section inserted between the lens and the camera body. In close-up photography, the bellows allows closer-thannormal focusing, resulting in a larger image.
- Binary number A number consisting only of one or more 1s and 0s.
- Bit The smallest unit of information usable by a computer, indicated by a 1 or a 0, describing one of two conditions: on or off.
- Bit depth The number of bits used to represent each pixel in an image, determining the number

of possible divisions or steps of color and tone between black and white.

- Bleed mount To mount a print so there is no border between the edges of the print and the edges of the mounting surface.
- **Body** The light-tight box that contains the camera mechanisms and protects the sensor or film from light until you are ready to make an exposure.
- Bounce light Indirect light produced by pointing the light source at a ceiling or other surface to reflect the light back toward the subject. Softer and less harsh than direct light.
- Bracketing Taking several photographs of the same scene at different exposure settings, some greater than and some less than the setting indicated by the meter, to ensure at least one wellexposed frame.
- Built-in meter An exposure meter in the camera that takes a light reading (usually through the camera lens) and relays exposure information to the electronic controls in an automatic camera or to the photographer if the camera is being operated manually.
- Bulb A shutter-speed setting (marked B) at which the shutter stays open as long as the shutter release is held down.
- Burn in To darken a specific area of an image in a darkroom, by giving it additional printing exposure. Hence the name of Photoshop's Burn tool.
- Byte A unit of digital data. A number represented by 8 bits. Used to measure size or capacity of a computer file or device. See also Kilobyte, Megabyte, Gigabyte.
- Cable release An encased wire that attaches at one end to the shutter release on the camera and has a plunger on the other end that the photographer depresses to activate the shutter. Used to avoid camera movement or to activate the shutter from a distance.
- Calibrate To adjust a device, for example, a computer monitor, to match a predefined standard.
- Camera Raw One of several proprietary file formats that preserve all the data from a digital camera picture with no after-capture interpretation.
- CCD Charge-coupled device. One of two types of light-sensing devices (the other is CMOS) placed in a grid to make the sensor in a digital camera. Also used in scanners.
- CC filter (for color conversion or color correction). A transparent filter placed in front of the camera's lens to alter the color of the light, usually to adjust white balance.
- Center-weighted meter A through-the-lens exposure meter that measures light values from the entire scene but gives greater emphasis to those in the center of the image area.
- Close-up A larger-than-normal image obtained by using a lens closer than normal to the subject.
- Close-up lens A lens attached to the front of an ordinary lens to allow focusing at a shorter distance in order to increase image size.

- CMOS Complementary metal oxide semiconductor. One of two types of light-sensing devices (the other is CCD) placed in a grid to make the sensor in a digital camera.
- CMYK The basic set of four colors used in most printing presses and desktop printers: cyan, magenta, yellow, and black. Also the color mode usually used in the professional graphic arts and printing industry. The other common color mode is RGB (red, green, blue). Files can be stored and edited in either mode and converted between them. See Subtractive color.
- **Color balance** 1. The proportion of different colors in a white light source. 2. A film's response to the colors in a scene. Color films are balanced for use with specific light sources. 3. The reproduction of colors in a photograph. See White balance.
- **Color management** A means of coordinating the color output of various devices so the colors you see on a monitor, for example, will be the ones that will appear when you print the image.
- Color space 1. A system for defining specific colors, for example, RGB or CMYK. 2. A predefined gamut, for example, sRGB, Adobe RGB (1998), or ProPhoto.
- Color temperature Description of the color of a light source. Measured in degrees Kelvin (K).
- Composite An image made from parts of two or more other images.
- **Compound lens** A lens made of several elements.
- Compression A means of reducing the size of a digital image file in order to reduce storage requirements or transmission time across a network. "Lossy" techniques permanently eliminate some information to obtain highly compressed, very small files. Lossless techniques compress images without losing any information in the file. See JPEG.
- Contrast The difference between the light and dark parts of a scene or photograph.
- Contrasty Having greater-than-normal differences between light and dark areas. The opposite of flat.
- Crop To trim the edges of an image, often to improve the composition. Cropping can be done by moving the camera position while viewing a scene, during image editing, or by trimming the finished print.
- Darkroom A room where analog (film-based) photographs are developed and printed.
- Depth of field The distance between the nearest and farthest points that appear in acceptably sharp focus in a photograph. Depth of field varies with lens aperture, focal length, and camerato-subject distance.
- Diaphragm (iris diaphragm) The mechanism controlling the size of the lens opening, therefore the amount of light that reaches the sensor. It consists of overlapping metal leaves inside the lens that form a circular opening of variable sizes. (You can see it as you look into the front of the lens.) The size of the opening is referred to as the f-stop or aperture.

- Diffused light Light that has been scattered by reflection or by passing through a translucent material. An even, often shadowless, light.
- Digital camera A camera that records an image directly in digital form, instead of on conventional silver film.
- **Digital imaging** A means by which a photograph is recorded as a digital image that can be read and manipulated by a computer and, subsequently, reformed as a visible image.
- Diopter Unit of measurement that indicates the magnifying power of a close-up lens.
- Direct light Light shining directly on the subject and producing strong highlights and deep shadows.
- Directional/diffused light Light that is partly direct and partly scattered. Softer and less harsh than direct light.
- **Dodge** To lighten an area of a darkroom-made print by shading it during part of the printing exposure. Hence the name of Photoshop's Dodge tool.
- **Dpi** Dots per inch; a measure of the resolution of a photomechanical halftone or the resolution capacity of a digital printer. Frequently (but inaccurately) used for the final resolution of an image, actually ppi. See Ppi.
- Dry mount To attach a print to another surface, usually a heavier mat board, by placing a sheet of adhesive dry-mount tissue between the print and the mounting surface. Generally, this sandwich is placed in a heated mounting press to malt the adhesive in the tissue. Some tissues are pressure sensitive and do not need to be heated.
- **DSLR** or **D-SLR** Digital single-lens reflex. See Single-lens reflex.
- Electronic flash (strobe) A camera accessory that provides a brief but powerful flash of light. A battery-powered unit requires occasional recharging or battery replacement but, unlike a flashbulb, can be used repeatedly.
- **Environmental portrait** A photograph in which the subject's surroundings are important to the portrait.
- Exif Exchangeable image file format. Information about the camera, lens, and exposure that is automatically stored with each file by the camera. See Metadata.
- **Exposure** 1. The act of allowing light to strike a light-sensitive surface. 2. The amount of light reaching that surface, controlled by the combination of aperture and shutter speed.
- Exposure meter (light meter) An instrument that measures the amount of light and provides aperture and shutter-speed combinations for correct exposure. Exposure meters may be built into the camera or they may be separate instruments.
- **Exposure mode** The type of camera operation (such as manual, shutter-priority, aperture-priority) that determines which controls you set and which ones the camera sets automatically. Some cameras operate in only one mode. Others may be used in a variety of modes.
- **Extension tubes** Metal rings attached between the camera lens and the body to allow closerthan-normal focusing in order to increase the image size.
- Fast 1. Describes a sensor when it is set to a high ISO. 2. Describes a lens that opens to a very wide aperture. 3. Describes a short shutter speed. The opposite of slow.

- File A quantity of data storage on a computer. Each photograph is saved as a single file.
- File format One of several standard ways a photograph can be encoded digitally. See JPEG, TIFF, and Camera Raw.
- Fill light A light source or reflector used to lighten shadow areas so that contrast is decreased.
- Film A roll or sheet of a flexible material coated on one side with a light-sensitive material and used in the camera to record an image.
- Filter 1. An editing command that performs a specific adjustment to a file, like sharpening. 2. In an image database, a search tool for finding a specific image or group of images, for example, to find all pictures taken at f/16.
- Fisheye lens An extreme wide-angle lens covering a 180° angle of view. Straight lines appear curved at the edge of the photograph, and the image itself may be circular.
- Flare Nonimage-forming light that reaches the image sensor, resulting in a loss of contrast. Caused by stray light reflecting between the surfaces of the lens or inside the camera.
- Flash 1. A short burst of light emitted by an electronic flash unit or strobe to illuminate the scene being photographed. 2. The equipment used to produce this light.
- Flat Having less than normal differences between light and dark areas. The opposite of contrasty.
- **Focal length** The distance from an internal part of a lens (the rear nodal plane) to the image plane when the lens is focused on infinity. The focal length is usually expressed in millimeters (mm) and determines the angle of view (how much of the scene can be included in the picture) and the size of objects in the image. A 100mm lens, for example, has a narrower angle of view and magnifies objects more than a lens of shorter focal length.
- **Focal plane** The surface inside the camera on which the lens forms a sharp image.
- Focal-plane shutter A camera mechanism that admits light to expose an image by opening a slit just in front of the focal plane.
- Focus 1. The point at which the rays of light coming through the lens converge to form a sharp image. The picture is "in focus" or sharpest when this point coincides with the focal plane. 2. To change the lens-to-sensor (or lens-to-film) distance (or the camera-tosubject distance) until the image is sharp.
- **Focusing ring** The band on the camera lens that, when turned, moves the lens in relation to the focal plane, focusing the camera for specific distances.
- Focusing screen See Viewing screen.
- Frame 1. A single exposure or image. 2. The edges of an image.
- **F-stop (f-number)** A numerical designation (f/2, f/2.8, etc.) indicating the size of the aperture (lens opening).
- Gamma The rate of brightness change, a measure of visual contrast. The line in a graphic display of the tones of an image (like Photoshop's Curves dialog box) has a higher gamma when it has a steeper slope.
- **Gamut** The range of colors that can be seen or that a particular device can capture or reproduce. For example, the range of colors that a digital camera can record.

- Ghosting 1. A kind of flare caused by reflections between lens surfaces. It appears as bright spots the same shape as the aperture (lens opening).2. A combined blurred and sharp image that occurs when flash is used with bright existing light. The flash creates a sharp image; the existing light adds a blurred image if the subject is moving.
- Gigabyte Approximately one billion bytes or one thousand megabytes (actually 1,073,741,824).
 A measure of computer file size or device storage capacity. Abbreviated G or GB.
- **Glossy** Describes a printing paper with a great deal of surface sheen. The opposite of matte.
- **Gray card** A card that reflects a known percentage of light falling on it. Often has a gray side reflecting 18 percent and a white side reflecting 90 percent of the light. Used to take accurate exposure meter readings (meters base their exposures on a gray tone of 18 percent reflectance). Some gray cards are also color-neutral, to be used for setting color balance.
- Guide number A number rating for a flash unit that can be used to calculate the correct aperture for a particular ISO speed and flash-tosubject distance.
- Hand-held meter An exposure meter that is separate from the camera.
- Hand hold To support the camera with your hands rather than with a tripod or other fixed support.
- Hardware The processor, monitor, printer, and other physical devices that make up a computer system. See Software.
- HDR High Dynamic Range; an image with a span of brightness values greater than the range that can be captured in a single exposure. Several bracketed exposures can be merged into one HDR image
- **Highlight** A very light area in a scene or image. Also called a high value.
- **Histogram** A graph that shows the distribution of tones or colors in a digital image.
- **Hot shoe** A clip on the top of the camera that attaches a flash unit and provides an electrical link to synchronize the flash with the camera shutter, eliminating the need for a sync cord.
- Hyperfocal distance The distance to the nearest object in focus when the lens is focused on infinity. Setting the lens to focus on this distance instead of on infinity will keep the farthest objects in focus as well as extend the depth of field to include objects closer to the camera.
- Incident-light meter A hand-held exposure meter that measures the amount of light falling on the subject. See also Reflected-light meter.
- **Infinity** Designated ∞. The farthest distance marked on the focusing ring of the lens, generally about 50 feet. When the camera is focused on infinity, all objects at that distance or farther away will be sharp.
- **Infrared** Wavelengths of electromagnetic radiation, like light but slightly longer than those in the visible spectrum. Photographs can be made from reflected infrared radiation with special equipment or film.
- **Inkjet** A digital printer that sprays microscopic droplets of ink onto a receptive surface (see Media) to create the appearance of a continuous-tone photograph.

- Interchangeable lens A lens that can be removed from the camera and replaced by another lens.
- Interpolation Estimating the data between two known points. Used to create a finer grid of pixels than what was captured
- **IPTC** International Press Telecommunications Council. A form of metadata that can be added to an image file after capture.

Iris diaphragm See Diaphragm.

- **ISO** A numerical rating that indicates the sensitivity (speed) of a sensor or film. The rating doubles each time the sensitivity doubles.
- JPEG A "lossy" format for saving digital photographs (see File) that compresses data to preserve space in the computer's memory. See Compression.
- Key light See Main light.
- **Kilobyte** Approximately one thousand bytes (actually 1,024). A measure of computer file size or device storage capacity. Abbreviated K or KB.
- Latitude The amount of over- or underexposure possible without a significant change in the quality of the image.
- **LCD** Liquid Crystal Display. The kind of thin, flat visual display screen often used for on-camera monitors and data displays, as well as computer monitors and televisions.
- **Leaf shutter** A camera mechanism that admits light to expose film by opening and shutting a circle of overlapping metal leaves.
- LED See Light-emitting diode.
- Lens One or more pieces of optical glass used to gather and focus light rays to form an image.
- Lens cleaning fluid A liquid made for cleaning lenses.
- **Lens coating** A thin, transparent coating on the surface of the lens that reduces light reflections.
- Lens element A single piece of optical glass that acts as a lens or as part of a lens.
- **Lens hood (lens shade)** A shield that fits around the lens to prevent unwanted light from entering the lens and causing flare.
- Lens tissue A soft, lint-free tissue made specifically for cleaning camera lenses. Not the same as eyeglass cleaning tissue.
- Light-emitting diode (LED) A display in the viewfinder of some cameras that gives you information about aperture and shutter-speed settings or other exposure data.
- Light meter See Exposure meter.
- **Long-focal-length lens** A lens that provides a narrow angle of view of a scene, including less of a scene than a lens of normal focal length and therefore magnifying objects in the image. Often called telephoto lens.
- **Luminance** A relative measure of brightness, reflectance, or value, independent of color (hue) and saturation.
- **Macro lens** A lens specifically designed for closeup photography and capable of good optical performance when used very close to a subject.
- Macro-photography Production of images on the sensor or film that are life size or larger.
- Macro-zoom lens A lens that has close-focusing capability plus variable focal length.
- Magnification The size of an object as it appears in an image. Magnification of an image taken by a camera is determined by the lens focal length. A long-focal-length lens makes an object appear larger (provides greater magnification) than a short-focal-length lens.

- Main light The primary source of illumination, casting the dominant shadows. Sometimes called key light.
- **Manual exposure** A nonautomatic mode of camera operation in which the photographer sets both the aperture and the shutter speed.
- **Manual flash** A nonautomatic mode of flash operation in which the photographer controls the exposure by adjusting the size of the camera's lens aperture.
- Mat A cardboard rectangle with an opening cut in it that is placed over a print to frame it. Also called an overmat.
- Mat cutter A short knife blade (usually replaceable) set in a large, easy-to-hold handle. Used for cutting cardboard mounts for prints.
- Matte Describes a printing paper with a relatively dull, nonreflective surface. The opposite of glossy.
- Media A loose term for the various papers, inks, and other materials used in a digital printer, or for the various cards, tapes, disks, and other items used for storing digital data.
- Megabyte Approximately one million bytes (actually 1,048,576). A measure of computer file size. Abbreviated M or MB.
- Memory card An in-camera, removable, and reusable storage device that records and saves images captured by the camera until you transfer the files to a computer or other storage device and erase (reformat) it.
- Menu A list of choices, like commands or adjustments, that is displayed by an application or operating system on a computer screen.
- Metadata Information about information. In digital photography, the camera, exposure, and subject data stored in the image file.
- Meter 1. See Exposure meter. 2. To take a light reading with an exposure meter.
- **Middle gray** A standard, average gray tone of 18 percent reflectance. See Gray card.
- **Midtone** An area of medium brightness, neither a very dark shadow nor a very bright highlight.
- Mirror A polished, metallic reflector set inside an SLR camera body at a 45° angle to the lens to reflect the image up onto the focusing screen. When a picture is taken, the mirror moves out of the way so that light can reach the sensor.

Negative 1. An image with colors or dark and light tones that are the opposite of those in the original scene. 2. Film that was exposed in the camera and processed to form a negative image.

- **Neutral-density filter** A piece of dark glass or plastic placed in front of the camera lens to decrease the intensity of light entering the lens. It affects exposure but not color.
- Noise Pixels of random colors and brightnesses, most often appearing in the dark areas of a digital image.
- Normal-focal-length lens (standard lens) A lens that provides about the same angle of view of a scene as the human eye.
- **Open up** To increase the size of the lens aperture. The opposite of stop down.
- **Operating system** or Disk Operating System (DOS). Management software, usually supplied with the computer, that starts when you boot up (turn on the power to) the computer and performs such operations as reading from and writing to hard drives, and opening and managing application software. Common operating systems are Mac OS X, Windows 8, and Unix.

- **Optical storage** A data storage medium, such as a CD, DVD, or BD, that uses light (usually a laser) to read and write information.
- **Overexpose** To make an exposure with too much light, making a picture that is too light.

Overmat See Mat.

- Palette A data box that appears on a computer's monitor. Palettes displayed by image-editing software offer tool options, provide information, and so on.
- Pan To move the camera during the exposure in the same direction as a moving subject. The effect is that the subject stays relatively sharp and the background becomes blurred.
- **Parallax** The difference in point of view that occurs when the lens (or other device) through which the eye views a scene is separate from the lens that exposes the film.
- **Pentaprism** A five-sided optical device used in the eye-level viewfinder of a single-lens-reflex camera to correct the image from the focusing screen so that it appears right side up and correct left to right.
- **Perspective** The optical illusion in a two-dimensional image of a three-dimensional space suggested primarily by converging lines and the decrease in size of objects farther from the camera
- **Photoflood** A tungsten lamp designed especially for use in photographic studios. It emits light at 3400 K color temperature.
- Photo-micrography Photographing through a microscope.
- **Photomontage** A composite image made by assembling parts of two or more photographs.
- Pinhole A small clear spot on a negative usually caused by dust on the film during exposure or development.
- Pixel Short for picture element. The smallest unit, usually square, of a digital image that can be displayed or changed.
- **Plane of critical focus** The part of a scene that is most sharply focused.
- Plug-in An add-on software module for a program or application that extends its capabilities. Some applications (such as Photoshop) are made so that *third-party* developers can produce and market plug-ins.
- **Polarizing screen (polarizing filter)** A filter placed in front of the camera lens to reduce reflections from nonmetallic surfaces like glass or water, or to darken the sky.
- **Positive** An image with colors or light and dark tones that are similar to those in the original scene. See Negative.
- Ppi Pixels per inch, a measure of the resolution of an image that has a physical size, like one that has been printed or is displayed on a monitor.
- **Primary colors** A set of basic colors that can be mixed to match any other color.
- **Print** 1. A two-dimensional image, usually on an opaque surface like paper, made from a captured, scanned, or drawn image file. 2. To produce such an image.
- **Profile** The data for a digital device, such as a printer or monitor, that describes its gamut, or range of colors. Used to match the gamut from one device to another. See Color management, Gamut.
- **Programmed automatic** A mode of automatic exposure in which the camera sets both the shutter speed and the aperture for a normal exposure.

- **Proof** A test print made for the purpose of evaluating density, contrast, color balance, subject composition, and the like.
- Quartz lamp An incandescent lamp that has high intensity, small size, long life, and constant color temperature.
- **Raw file** A digital camera file or scan that contains picture information exactly as it is acquired. Most raw file formats used in cameras are proprietary, or specific to the camera manufacturer, and must be interpreted before editing. See Camera Raw.
- **Reflected-light meter** An exposure meter (hand held or built into the camera) that reads the amount of light reflected from the subject. See also Incident-light meter.
- **Reflector** Any surface—a ceiling, a card, an umbrella, for example—used to bounce light onto a subject.
- **Reflex camera** A camera with a built-in mirror that reflects the scene being photographed onto a ground-glass viewing screen. See Single-lens reflex.
- **Resampling** Changing a file to create the same image with more or fewer pixels to achieve a different resolution. Called upsampling for more pixels, downsampling for fewer.
- Resin coated paper Printing paper with a waterresistant coating that absorbs less moisture than a fiber-base paper. Abbreviated RC paper.
- **Resolution** 1. The total number of pixels in a camera sensor, for example, a 2000 × 3000 pixel grid has a resolution of 6 megapixels. 2. The number of pixels per unit length, generally a measure of maximum image quality. See Ppi.
- **Retouch** To remove small imperfections in an image caused by dust specks or flaws in the process. Also, to remove perceived imperfections or flaws in the subject.
- RCB A color mode that uses the additive primary colors (red, green, and blue) to match any other color. See CMYK.
- Scanner A device that optically reads a conventional negative, slide, or print, converting it to digital form for use in digital imaging.
- Sharp Describes an image or part of an image that shows crisp, precise texture and detail. The opposite of blurred or soft.
- **Sharpening** A software manipulation of an image that increases contrast in areas of tone transition and creates the visual sensation of a more sharply focused image.
- **Shoe** A clip on a camera for attaching a flash unit. See also Hot shoe.
- Short-focal-length lens (wide-angle lens) A lens that provides a wide angle-of-view of a scene, including more of the subject area than a lens of normal focal length.
- Shutter A device in the camera that opens and closes to expose the sensor or film to light for a measured length of time.
- **Shutter-priority mode** An automatic exposure system in which the photographer sets the shutter speed and the camera selects the aperture (fstop) for normal exposure.
- Shutter release The mechanism, usually a button on the top of the camera, that activates the shutter to expose the sensor or film.
- Shutter-speed control The camera control that selects the length of time the sensor or film is exposed to light.

- **Sidecar file** A file with the same name as a Camera Raw file (but having the extension .xmp) that contains added metadata. Created by programs that cannot write new information to a proprietary raw file.
- Silhouette A dark shape with little or no detail appearing against a light background.
- Single-lens reflex (SLR) A type of camera with one lens that is used both for viewing and for taking the picture. A mirror inside the camera reflects the image up into the viewfinder. When the picture is taken, this mirror moves out of the way, allowing the light entering the lens to travel directly to the sensor or film.
- Slide A transparency made in the size of 35mm film. See Transparency.
- Slow See Fast.
- SLR See Single-lens reflex.
- **Soft** 1. Describes an image that is blurred or out of focus. The opposite of sharp. 2. Describes a scene or print of low contrast. The opposite of hard or high contrast.
- **Software** A computer program designed to perform a specific purpose or task, for example, image editing or word processing (application software) or an operating system.
- **Spectrum** The range of radiant energy from extremely short wavelengths to extremely long ones. The visible spectrum includes only the wavelengths to which the human eye is sensitive.
- **Speed** 1. The relative ability of a lens to transmit light. Measured by the largest aperture at which the lens can be used. A fast lens has a larger maximum aperture and can transmit more light than a slow one. 2. The relative sensitivity to light of a sensor or film. See ISO.
- **Spot meter** An exposure meter with a narrow angle of view, used to measure the amount of light from a small portion of the scene being photographed.
- Stop 1. An aperture setting that indicates the size of the lens opening. 2. A change in exposure by a factor of 2. Changing the aperture from one setting to the next doubles or halves the amount of light reaching the sensor or film. Changing the shutter speed from one setting to the next does the same thing. Either changes the exposure one stop.
- Stop down To decrease the size of the lens aperture. The opposite of open up.
- Strobe See Flectronic flash.
- Substitution reading An exposure meter reading taken from something other than the subject, such as a gray card or the photographer's hand.
- Subtractive color A set of primary colors (cyan, magenta, and yellow) that can be mixed as pigments to match any other color. The CMYK color mode adds black (K) to compensate for imperfections in manufacturing the other three colors. See Additive color.
- Sync (or synchronization) cord A wire that links a flash unit to a camera's shutter-release mechanism.
- Synchronize To cause a flash unit to fire while the camera shutter is open.
- **Tacking iron** A small, electrically heated tool used to melt the adhesive in dry-mount tissue, attaching it partially to the back of the print and to the mounting surface. This keeps the print in place during the mounting procedure.
- **Telephoto effect** A change in perspective caused by using a long-focal-length lens very far from all parts of a scene. Objects appear closer together than they really are.

Telephoto lens See Long-focal-length lens.

- **Terabyte** Approximately one trillion bytes (actually 1,099,511,627,776). Approximately one thousand Gigabytes. A measure of computer file size or device storage capacity. Abbreviated T or TB.
- **Through-the-lens meter (TTL meter)** An exposure meter built into the camera that takes light readings through the lens.
- **TIFF** An open-source (not proprietary) format for saving digital photographs (see File format) that is readable by most graphic software running on most computers.
- **Transparency (slide)** A positive image on clear film viewed by passing light through from behind with a projector or light box.
- Tripod A three-legged support for the camera.
- TTL Abbreviation for through the lens, as in through-the-lens viewing or metering.
- Umbrella reflector An apparatus constructed like a parasol with a reflective surface on the inside. Used to bounce diffused light onto a subject.
- **Underexpose** To make an exposure with too little light, making a picture that is too dark.
- View camera A camera in which the taking lens forms an image directly on a ground-glass viewing screen. A film holder or digital adapter is inserted in front of the viewing screen before exposure. The front and back of the camera can be set at various angles to change the plane of focus and the perspective.
- Viewfinder eyepicce An opening in the camera through which the photographer can see the scene to be photographed.
- Viewing screen The surface on which the image in the camera appears for viewing. This image appears upside down and reversed left to right unless the camera contains a pentaprism to correct it.
- Vignette To shade the edges of an image so they are underexposed. A lens hood that is too long for the lens will cut into the angle of view and cause vignetting.
- Visible spectrum See Spectrum.
- White balance 1. The color balance of a white light source. 2. A setting or adjustment on a camera or in an image editor that adjusts the overall image colors for the light source in which it was captured.
- Wide-angle distortion An unusual perspective caused by using a wide-angle (short-focallength) lens very close to a subject. Objects appear stretched out or farther apart than they really are.
- Wide-angle lens See Short-focal-length lens.
- **Workflow** A repeatable series of steps leading to a desired result or product. A digital photography workflow includes, at minimum, the steps between image capture and output.
- **Zone focusing** Presetting the focus to photograph action so that the entire area in which the action may take place will be sharp.
- **Zoom lens** A lens with several moving elements that can be used to produce a continuous range of focal lengths.

Bibliography

A vast number of books on photography are available, whether your interest is in its technique or its history, its use for art or for commerce. Look for them online, or in your local library, bookstore, or camera store.

If you want a broader selection of books than you can find locally, try Photo-Eye, 376 Garcia Street, Santa Fe, NM 87501 (505-988-5152). This photoonly bookstore has an immense selection of new and used photo books sold by mail and through its online bookstore, *photoeye.com*. Other online photobook specialists are *vincentborrelli.com* and *dashwoodbooks.com*.

Light Impressions, 2340 Brighton Henrietta Town Line Road, Rochester, NY 14623 (800-975-6429) is an excellent source of photographic storage, preservation, and display materials. Catalogs are free. You can buy online or request a printed catalog at *lightimpressionsdirect.com*.

Technical References

Ang, Tom. *Digital Photographer's Handbook*. 6th ed. New York: DK Publishing, 2016.

Ashe, Tom P. Color Management & Quality Output: Working with Color from Camera to Display to Print. Boston, MA: Focal Press, 2014.

Evening, Martin. *The Adobe Photoshop Lightroom CC/ Lightroom 6 Book.* Berkeley, CA: Adobe Press, 2015. A complete guide to the Adobe workflow application. ——. *Adobe Photoshop CC for Photographers: 2016 Edition.* Boston, MA: Focal Press, 2016.

Faulkner, Andrew and Conrad Chavez. *Adobe Photoshop CC Classroom in a Book*. Berkeley, CA: Adobe Press, 2017. Includes access to the interactive Web edition. A good way to learn the basics of the most popular image-editing software.

Hirsch, Robert. *Light and Lens: Photography in the Digital Age.* 2nd ed. Boston, MA: Focal Press, 2012. Profusely illustrated, detailed compendium of processes and techniques.

Jones, Lou, Bob Keenan, and Steve Ostrowski. Speedlights & Speedlites: Creative Flash Photography at Lightspeed. 2nd ed. Boston, MA: Focal Press, 2013. Use small, inexpensive, portable flash units to achieve professional results.

Kobré, Kenneth. *Photojournalism: The Professionals' Approach.* 7th ed. Boston, MA: Focal Press, 2016. Complete coverage of equipment, techniques, and approaches used by photojournalists.

Krogh, Peter. *The DAM Book: Digital Asset Management for Photographers*. 2nd ed. Cambridge: O'Reilly Media, 2009. How to organize, keep, archive, and find digital photographs.

London, Barbara, John Upton, Jim Stone. *Photography.* 12th ed. Hoboken, NJ: Pearson Education, 2016. Complete information about both film-based and digital photography, widely used as a text. Very comprehensive. Long, Ben. Complete Digital Photography. 8th ed. Independence, KY: Course Technology, 2014. Extensive information, clearly written. ——. Getting Started with Camera Raw: How to Make Better Pictures Using Photoshop and Photoshop Elements. 2nd ed. Berkeley: Peachpit Press, 2009.

McKenzie, Joy, and Daniel Overturf. *Artificial Lighting for Photography*. Clifton Park, NY: Delmar Cengage Learning, 2009. Clear explanation of lighting techniques with visual examples.

Sascha, Erni. Capture One Pro 10: Mastering Raw Development, Image Processing, and Asset Management. San Rafael, CA: Rocky Nook, 2017. A complete guide to the Phase One workflow application.

Rodney, Andrew. *Color Management for Photographers: Hands on Techniques for Photoshop Users*. Boston, MA: Focal Press, 2005.

Russotti, Patricia, and Richard Anderson. *Digital Photography Best Practices and Workflow Handbook*. Boston, MA: Focal Press, 2009.

Wilhelm, Henry. *The Permanence and Care of Color Photographs: Traditional and Digital Color Prints, Color Negatives, Slides, and Motion Pictures.* A comprehensive conservation guide. The entire book may be downloaded free at wilhelm-research.com/book_toc.html

Business Practices

American Society of Media Photographers. *ASMP Professional Business Practices in Photography.* 7th ed. New York: Allworth Press, 2008.

Bostic, Mary Burzlaff. 2018 Photographer's Market: How and Where to Sell Your Photography. 41st ed. New York: North Light Books, 2017.

Crawford, Tad. *Business and Legal Forms for Photographers.* 4th ed. New York: Allworth Press, 2009.

DuBoff, Leonard D. *The Law (in Plain English) for Photographers*. 3rd ed. New York: Allworth Press, 2010.

Himes, Darius D., and Mary Virginia Swanson. *Publish Your Photography Book.* Revised, updated ed. New York: Princeton Architectural Press, 2014.

Kieffer, John. *The Photographer's Assistant: Learn the Inside Secrets of Professional Photography and Get Paid for It.* New York: Allworth Press, 2001.

Oberrecht, Kenn. *How to Start a Home-Based Photography Business.* 6th ed. Old Saybrook, CT: Globe Pequot Press, 2010.

Swanson, Mary Virginia. *Finding Your Audience: An Introduction to Marketing Your Photographs*. mvswanson.com: Self-published, 2017. How to market yourself as a photographer in the Internet age.

Essays, Collections, and Histories

Adams, Robert. *Beauty in Photography: Essays in Defense of Traditional Values*. New York: Aperture, 2005. New edition of 1981 edition.

Barrett, Terry. *Criticizing Photographs: An Introduction to Understanding Images.* 5th ed. New York: McGraw-Hill, 2011. Widely used as a text to help develop techniques for discussing photographs.

Barthes, Roland. *Camera Lucida*. New York: Hill and Wang, Reprint edition, 2010.

Benson, Richard. *The Printed Picture*. New York: Museum of Modern Art, 2008. Eloquent descriptions of the way meaning is affected by printing technologies.

Berger, John. *Ways of Seeing*. New York: Penguin Modern Classics, Reprint, 2009.

Burgin, Victor. *Thinking Photography*. London: Macmillan, 1982 and 1990.

Coleman, A. D. *The Digital Evolution: Photography in the Electronic Age*. Portland, OR: Nazraeli, 1998.

Cotton, Charlotte. *The Photograph as Contemporary Art.* 3rd ed. New York: Thames & Hudson, 2014.

Frizot, Michael, ed. A New History of Photography. Köln, Germany: Könemann, 1999. Massive, beautifully produced, thorough, and relatively inexpensive.

Grundberg, Andy. *Crisis of the Real: Writings on Photography Since 1974.* 2nd ed. New York: Aperture, Reissue 2010. Readable, stimulating essays on contemporary issues in photography.

Gustavson, Todd. *Camera: A History of Photography* from Daguerreotype to Digital. New York: Sterling Signature, 2012. From the Curator of Technology at the George Eastman House.

Heiferman, Marvin, ed. *Photography Changes Everything*. New York: Aperture, 2012.

Hirsch, Robert J. Seizing the Light: A Social & Aesthetic History of Photography. 3rd ed. Boston, MA: Focal Press, 2017. Thorough (608 pages) and contemporary survey of the medium's history.

Morris, Errol. Believing is Seeing: Observations on the Mysteries of Photography. New York: Penguin Press, 2011. Essays on the nature of truth in photography.

Papageorge, Tod. Core Curriculum: Writings on Photography. New York: Aperture, 2011.

Rosenblum, Naomi. *A World History of Photography.* 4th ed. New York: Abbeville, 2008. Comprehensive and profusely illustrated.

Shore, Stephen. *The Nature of Photographs: A Primer.* 2nd ed. London: Phaidon Press, 2010.

Sontag, Susan. *On Photography*. New York: Farrar, Straus and Giroux, 1977.

Szarkowski, John. *The Photographer's Eye*. New York: Museum of Modern Art, 2007. Landmark exhibition catalog with essays from the medium's most influential curator.

Wells, Liz. *Photography: A Critical Introduction.* 5th ed. New York: Routledge, 2015.

Print and Online Magazines

Aint Bad Magazine, P.O. Box 8444, Savannah, GA 31412. Since 2011, producing monthly online portfolios, an irregular print magazine, and mono-graphic books. (*aint-bad.com*)

American Photo, 2 Park Ave., New York, NY 10016. Online only. Photography in all forms, including the fashionable and the famous. (*americanphotomag.com*)

Aperture, 20 East 23rd Street, New York, NY 10011. A superbly printed magazine dealing with photography as an art form. Published at irregular intervals. (*aperture.org*)

Black & White, PO Box 1529, Ross, CA 94957. Bimonthly print magazine that includes portfolios and contests. (bandwmag.com)

Digital Photo, Madavor Media, Madavor Media, 25 Braintree Hill Office Park, Suite 404, Braintree, MA 02184. Online and quarterly print magazine "for passionate photographers." (dpmag.com) —____. Digital Photo Pro. Includes business news, articles, and other content aimed at professional photographers. (digitalphotopro.com)

Fraction Magazine, publishes monthly portfolios and book reviews online, and prints books, all by living photographers worldwide. (fractionmagazine.com)

LensWork, 1004 Commercial, Anacortes, WA 98221. High-quality, bimonthly black-and-white print and online publication about photographs, not cameras, with articles and interviews. *(lenswork.com)*

Photo District News, 770 Broadway, New York, NY 10003. Unrected toward professionals in photography. (pdnonline.com)

——. pdn.edu, an online and print periodical for student photographers; the printed magazine is distributed directly to schools. *(digitalmag.pdnedu.com)*

Photographer's Forum, 813 Reddick Street, Santa Barbara, CA 93103. Geared toward students and those seeking photographic careers. (pfmagazine.com)

The Photo Review, 340 East Maple Avenue, Suite 200, Langhorne, PA 19047. Fine-art photography exhibition and book reviews with portfolios, online. (photoreview.org)

Popular Photography, 2 Park Ave., New York, NY 10016. Online magazine for hobbyists that mixes information about equipment with portfolios and how-to articles. (*popphoto.com*)

Professional Photographer, 229 Peachtree St NE, Suite 2200, International Tower, Atlanta, GA 30303. Monthly print and online magazine for commercial and industrial photographers. *(ppmag.com)*

Rangefinder, P.O. Box 3601 Northbrook, IL 60065. For professionals in the fields of wedding and portrait photography. Print magazine free to US addresses. (*rangefinderonline.com*)

Shutterbug, TEN, 831 S. Douglas St., El Segundo, CA 90245. Monthly print magazine, mostly products reviews and how-to articles. (*shutterbug.com*)

Photographic Organizations

Most of these nonprofit membership organizations publish magazines and newsletters and have informative Web sites. If you live near one, you may also wish to join for their sponsored workshops, lectures, or exhibitions.

American Society of Media Photographers, 150 North Second Street, Philadelphia, PA 19106. Publishes *ASMP Bulletin*, a guide for the working professional (distributed only to ASMP members. (*asmp.wrg*)

Center for Photography at Woodstock, 59 Tinker Street, Woodstock, NY 12498. Publishes *Photography Quarterly*, currently on hiatus. (cpw.org)

CENTER, P.O. Box 2483, Santa Fe, NM 87504. Organizes portfolio-review events (*Review Santa Fe*) and sponsors juried awards for photographers. (*visitcenter org*)

CEPA Gallery, 617 Main Street, Buffalo, NY 14202. Exhibitions, lectures, and an artist project program. (cepagallery.org)

George Eastman Museum. 900 East Avenue. Rochester, NY 14607. A museum of photography and cameras, as well as the restored mansion and gardens of Kodak's founder. Publishes a newsletter and occasional exhibition catalogs. (*eastman.org*)

Houston Center for Photography, 1441 West Alabama, Houston, TX 77006. Publishes *Spot* magazine, twice a year. (*hcponline.org*)

The Light Factory, 1817 Central Avenue, Suite C200, Charlotte, NC 28205. A museum of photography and film, offers classes. *(lightfactory.org)*

Light Work, 316 Waverly Avenue, Syracuse, NY 13244. A community-access lab, several galleries, and an artist's residency program, publishes *Contact Sheet* and exhibition catalogs. *(lightwork.org)*

National Press Photographers Association, 120 Hooper Street, Athens, GA 30602. An organization of working and student photojournalists; publishes the monthly *News Photographer. (nppa.org)*

Photographic Resource Center, 411A Highland Ave. #317, Somerville, MA 02144. A gallery, library, lecture series, and portfolio reviews. Publishes *Loupe* occasionally. *(bu.edu/prc)*

San Francisco Camerawork, 1011 Market Street, San Francisco, CA 94103. Publishes Camerawork: A Journal of Photographic Arts. (sfcamerawork.org)

Society for Photographic Education, 2530 Superior Avenue, #403, Cleveland, OH 44114. An organization centered around the teaching and practice of photography as a fine art. Publishes *Exposure*. *(spenational.org)*

Visual Studies Workshop, 31 Prince Street, Rochester, NY 14607. Incorporates a degree-granting school with workshops, gallery, and artist's book studio. Publishes *Afterimage. (vsw.org)* **Space constrains this list** of organizations and periodicals to those in the United States. Many other countries have organizations and publications devoted to photography, which can be found online, through a public library, or by contacting the nonprofits listed here.

Online Video Tutorials and More

tv.adobe.com Adobe Web site with free tutorials for each of their applications.

phaseone.com Follow Products>Software to find a link to Capture One Pro tutorials.

dpreview.com Tests and reviews of digital cameras, lenses, printers, and software, plus forums, photo sharing, and contests.

jkost.com Adobe Photoshop "Evangelist" Julieanne Kost provides free hints and tutorials on Photoshop and Lightroom.

lynda.com Software training site, some content is free, some by subscription.

photo.net Online peer-to-peer forums, photo sharing, and critiques.

strobist.com All about location lighting with porta ble equipment, with tips for inexpensive solutions.

visitcenter.org See entry under Photographic Organizations, left; their Web site has a Resources page with links to other useful sites.

Photo Credits

p. ii Teun Hocks, Courtesy of the artist and Torch Gallery, Amsterdam, NL; p. 2 Annie Leibovitz/ContactPress Images; pp. 9 (bottom right), 73, 159 (bottom) © RKM Archive; p. 10 (top) Panasonic Corporation of North America; p. 10 (bottom left) Pentax Imaging Company; pp. 10 (right), 11 (right), 12 (bottom right), 59 (top right), 62 (top right), 84 (bottom) Courtesy of MAC Group; p. 12 (top) FUJIFILM North America Corporation, 2017; p. 12 (center) Courtesy of Panasonic North America; p. 13 (top) Used by permission of Sony Electronics Inc. All Rights Reserved; pp. 14 (bottom), 85 (bottom left), 146 Courtesy of Nikon Inc., Melville, New York; pp. 14 (top), 112 (top) Courtesy of Canon USA; p. 21 (top) Josef Koudelka, Magnum Photos; p. 21 (bottom) Courtesy of Naoya Hatakeyama and Taka Ishii Gallery, Tokyo; p. 24 Joel Sternfeld, Courtesy of the artist and Luhring Augustine, New York; p. 30 Geoffrey Robinson/Alamy Stock Photo; pp. 33, 118 Courtesy xRez Studios, Inc.; p. 35 Henri Cartier-Bresson, Magnum Photos; p. 36 Ed Jones/Getty Images; p. 37 Andreas Feininger/ Getty Images; p. 38 © David Leventi/Courtesy Rick Wester Fine Art; p. 41 (bottom) Donald Miralle/Getty Images; p. 46 Christoph Oberschneider/Alamy Stock Photo; p. 47 (top) National Archives and Records Administration, Records of the National Park Service; p. 52 Javier Manzano/AFP/Getty Images; p. 53 Reproduced with permission of the Minor White Archive. Princeton University Art Museum. © Trustees of Princeton University; p. 59 Gueorgui Pinkhassov, Magnum Photos; p. 65 Library of Congress LC-DIG-fsa-8d24901; p. 71 Courtesy of the Liebling Family Trust; pp. 86, 89 (top), 116 Courtesy of Epson America, Inc.; p. 89 (bottom right) Hasselblad Bron, Inc.; p. 112 (bottom) Library of Congress LC-DIG-cwpbh-03225; p. 114 Teun Hocks, Courtesy of the artist and P·P·O·W Gallery, New York; p. 115 (left) © The Museum of Modern Art/Licensed by SCALA/Art Resource, NY; p. 131 Alex Webb, Magnum Photos: p. 135 © The Estate of Garry Winogrand, Courtesy Fraenkel Gallery, San Francisco; p. 136 Library of Congress LC-DIG-fsa-8b32434; p. 137 (left) Courtesy Janet Borden, Inc.; p. 137 (right) Courtesy Foley Gallery, New York; p. 138 Library of Congress; p. 139 (bottom) David Alan Harvey, Magnum Photos; p. 150 Bruce Gilden, Magnum Photos; p. 151 Carl De Keyzer, Magnum Photos; p. 155 Library of Congress, American Folklife Center; p. 157 © Lee Friedlander, Courtesy Fraenkel Gallery, San Francisco; p. 159 (top) Elliott Erwitt, Magnum Photos; p. 159 (bottom) Courtesy Laurence Miller Gallery; p. 161 (top) Library of Congress LC-DIG-fsa-8b37302; p. 162 (bottom) Courtesy of Minneapolis Institute of Arts, Gift of the William R. Hibbs Family; p. 164 (top) © The Lane Collection. Photograph Museum of Fine Arts, Boston; pp. 164-5 (bottom) Hallmark Photographic Collection, Hallmark Cards, Inc., Kansas City, MO © 2013 Katherine Anne Sinsabaugh and Elisabeth Sinsabaugh de la Cova; p. 166 Alec Soth, Magnum Photos; p. 168 © Yousuf Karsh, Courtesy Julie Grahame; p. 169 Arnold Newman/Getty Images; p. 170 © Richard Misrach, Courtesy Fraenkel Gallery, San Francisco; pp. 173 Library of Congress LC-USF342-001167-A; p. 171 Jeff Wall, Transparency in lightbox 174.0 x 250.5 cm, Courtesy of the artist; p. 180 Library of Congress LC-USW36-950; pp.181, 185, 188, 200 (bottom) Harry Ransom Humanities Research Center, The University of Texas at Austin; p. 182 Bayerisches Nationalmuseum München; p. 183 Courtesy Amherst College Archives and Special Collections; p. 184 Metropolitan Museum of Art. Gilman Collection, Gift of The Howard Gilman Foundation, 2005; p. 186 Courtesy of George Eastman House, International Museum of Photography and Film; p. 187 Library of Congress LC-USW36-950; p. 188 Metropolitan Museum of Art. Harris Brisbane Dick Fund, 1941; p. 190 Library of Congress LC-DIG-ppmsca-10017; p. 191 Library of Congress LC-DIG-ppmsca-12557; p. 192 (top) Library of Congress LC-USZC4-477; p. 192 (bottom) Library of Congress LC-USZ62-103037; p. 193 (top) Metropolitan Museum of Art. Gilman Collection, Purchase, William Talbott Hillman Foundation Gift, 2005; p. 193 (bottom) Metropolitan Museum of Art. Warner Communications Purchase Fund, 1978; p. 194 (top) Museum of the City of New York; p. 194 (bottom) Library of Congress LC-DIG-nclc-01455; p. 195 (top) Library of Congress LC-DIG-fsa-8b29516; p. 195 (bottom) Library of Congress LC-USZ62-11491; p. 196 (top) Metropolitan Museum of Art. Ford Motor Company Collection, Gift of Ford Motor Company and John C. Waddell, 1987; p. 197 W. Eugene Smith/Getty Images; p. 198 Ashley Gilbertson/ VII Photo Agency; p. 199 (top) Alfred Eisenstaedt/Getty Images; p. 199 (bottom) Susan Meiselas, Magnum Photos; p. 200 (bottom) Metropolitan Museum of Art. Gilman Collection, Purchase, Mrs. Walter Annenberg and The Annenberg Foundation Gift, 2005; p. 201 (top) Metropolitan Museum of Art. Alfred Stieglitz Collection, 1933; p. 201 (bottom), 202 (top) Courtesy Andrew Smith Gallery, Santa Fe, NM; p.203 (top) Courtesy of the Kepes Estate; p. 203 (bottom) Courtesy of Hattula Moholy-Nagy; p. 204 (top) © The Estate of Harry Callahan, Courtesy of Pace/MacGill Gallery; p. 204 (bottom) Courtesy the Aaron Siskind Foundation; p. 205 © Robert Frank, from The Americans, courtesy Pace/MacGill Gallery, New York; p. 206 (top) Courtesy of Cindy Sherman and Metro Pictures Gallery, New York; p. 207 © 1980 The Richard Avedon Foundation; p. 208 (right) © Artforum, January 1979 [cover]; p. 208 (bottom) © Eggleston Artistic Trust. Courtesy Cheim & Read, New York; p. 210 Science & Society Picture Library; p. 214 (bottom left) Innova Art Ltd.; p. 214 (bottom center) Smithsonian American Art Museum; p. 214 (bottom right) Light Work, Syracuse, New York.

James Henkel. Volume 1-7, 2004.

Index

Abbott, Berenice, 162 aberrations, 31 acid-free inkjet printing paper, 133 Adams, Ansel, 47, 202, 204, 206, 208 Adams, Shelby Lee, 174 additive primaries, 56, 83 Adobe see also Bridge software; Lightroom software; Photoshop software Bridge, 85 DNG converter, 88 RGB (1998), 82, 118 Adobe Camera Raw (ACR), 85 American Society of Media Photographers (ASMP), 168 angle of view, 32, 33, 156, 162, 170 aperture bracketing and, 74 control, 15 creative use of, 24-25 depth of field and, 23, 44 exposure and, 53, 62, 64 f-stops, 23 high contrast and, 73 and light, 22 maximum, 31 ring/button, 17 settings, 23 shutter speed and, 26-27 Aperture software, 118 editing and, 108 aperture-control ring, 31 aperture-priority mode, 16, 69 Apple, 78 application file, 92 appropriation of copyrighted material, 113 Arbus, Diane, 205, 206 archival mounting materials, 120, 121 archiving, 86, 133 art, photography as, 200-207 Artforum magazine, 208 artificial lighting, 146-147 Associated Press (AP), 198 Atget, Eugène, 193 autochrome process, 187 autofocus, 14, 40, 43 automatic electronic flash, 146 automatic focus, 43 Avedon, Richard, 206, 207 averaging meter, 63 Avery, Joseph, 192 Babbage, Charles, 210 Babbitt, Platt D., 192

Babbitt, Platt D., 192 background, 156–157 backlight button, 66 backlighting, 72, 141, 142 backup strategy, 86, 130, 133 balance, 179 banner mode, 119 Barney, Tina, 137 Barrett, Elizabeth, 188 batteries, 28 Bauhaus, 203 Bayer array, 85 Bayer filter mosaic, 85 Becher, Bernd, 193 Becher, Hilla, 193

bellows, 50 Berger, Paul, 212 bit, 80 bit depth, 80, 81, 89 black and white images, 108 black points, 94, 97 bleed mounting, 126-127 Bloom, Suzanne, 212 Blossfeldt, Karl, 193 Blu-ray (BD) disks, 78, 130, 133 blurring, 19 camera motion and, 28 vs. depth of field, 26-27 for emphasis, 160 shutter speed and, 15, 19 bottom lighting, 141 bounce flash, 147, 149 bracketing, 64-65 Brady, Mathew B., 112, 191 Brezhnev, Leonid, 213 Briand, Aristide, 196 Bridge software, 85, 88, 132 brightness, of papers, 117 Bubley, Esther, 180 built-in meters, 63, 69 burning, 98 Burson, Nancy, 213 bytes, 80 cable connections, 17, 88 cable release, 28 Callahan, Harry, 204, 208 calotypes, 184 camera(s) see also digital cameras aperture, 4, 15, 22-27 (see also aperture) automatic exposure, 65-67 with automatic features, 3 battery power, 28 camera controls, 14-17 clean lens surface, 29 exposures, 6-8 (see also exposure) features, 17 film in, 4 focusing of, 6 (see also focusing) functions, 4 getting started with, 4-9 hand holding, 28 lens of, 4, 28–29 (*see also* lens(es)) and memory cards, 4, 29 protection, 28, 29 sensor, 4, 29 (see also sensors) shutter of, 4 shutter speed, 18-21, 26-27 tripod and cable release, 28 types of, 10-13 viewfinder, 4 camera obscura, 181 Camera Raw files, 58, 70, 81, 86, 130 black and white images, 108 sharpening and, 104 working with, 85, 133 Camera Work (magazine), 201, 202 Cameron, Julia Margaret, 188 Caponigro, Paul, 202 Capture One Pro, 132 capturing an image, 78, 83, 86 Carey, Alison, 34 cartes-de-visite, 188, 189

Cartier-Bresson, Henri, 35 cartridges, ink, 117 cataloging applications, 132 CCD. 54 CDs, 133 cell phone cameras, 13 Center for Advanced Visual Studies (CAVS), 203 Center for Creative Photography, 206 center-weighted meter, 63 CF (Compact Flash) card, 88 channels, 83, 94, 97, 108 chaos and order in photography, 163 chiaroscuro, 157 Chicago style, 204 Chin, Christine, 60 chrome filter, 109 Church, Fredrick, 186 cityscape photography, 172-173 clipping, 61, 73 close-ups, 50 Cloud storage, 78 CMOS, 54 CMYK mode, 56, 82, 83, 87 cold-mount tissues, 122 Collier, John, 138 collodion wet-plate process, 185 color additive process, 56 balance, 57-59 characteristics, 57 conversion filter, 58 digital, 82-84 as element of design, 178 management, 84 modes, 56, 82 photography, 187, 208-209 subtractive process, 56 wheel, 56 Color Rendering Index (CRI), 59 color temperature, 58, 59 ColorChecker Passport, 59 colorimeter, 84 Comen, Sam, 145 command dial, 17 compact cameras, 5, 12 compositing, 106-107 compound lens, 31 compressed perspective, 48 computer, 8, 78 conservation board, 121 continuous-tone photograph, 54 contrast, 57, 73-75, 96, 136, 179 control dial, 14 controls, camera, 14-17 copyright laws, 113 Corel AfterShot Pro, 87 corrupted storage devices, 130 cover sheet, 122 craquelure filter, 109 crop factor, 32 cropping, 110, 154 Cros, Charles, 187 Cumming, Robert, 206 Cunningham, Imogen, 202 Curves, 96-97, 100, 110

Daguerre, Louis Jacques Mandé, 182 daguerreotype, 182-183 damaged photographs, repairing of, 102 D'Amato, Paul, 134 dark noise, 75 data file, 92 data panels, 14, 17 De Keyzer, Carl, 151 Delano, Jack, 65 Demachy, Robert, 201 demosaicing, 85 depth, in photographs, 48-49, 162-163 depth of field, 179 and aperture, 23 vs. blurring, 26-27 close-ups and, 50 focusing and, 42, 46, 47 previewing, 46-47 tables, 47 depth-of-field scale, 31 derivative files, 86, 130 design, elements of, 178 desktop inkjet printer, 116 dialog boxes, 78 diaphragm, 17 diffused light, 68, 137, 166 digital cameras, 12-13, 77, 78 color temperature and, 58 histograms and, 61 internal data block of, 131 ISO setting, 66 light-sensitivity of, 53 noise, 75 panoramic mode in, 119 sales of, 210 digital color systems, 56 digital photography, 198, 210-213 Digital Photography exhibition, 212 digital single-lens reflex (DSLR) cameras, 10, 12, 17, 29, 40, 75 digital workplace see workplace, digital digital zoom, 40 direct flash, 149 direct image, in art, 202 direct light, 136, 140 directional/diffused light, 137 direction/movement, as element of design, 178 Disdéri, André Adolphe, 189 display, printing and, 114-127 distance marker, 31 distance scale, 31 distortion, wide-angle, 39 Divola, John, 20 .dng (Digital Negative) files, 81, 88 documentary style, 193 documents, photographs as, 193 dodging, 98 dots per inch (dpi), 116 downloading images, 8, 86, 88 downsampling, 55 drivers, printers and, 116 drives, 130 dry mounting, 121, 124-125 Dujardin, Filip, 90 dust, 29, 89, 102 DVDs, 78, 130, 133 dye-based inks, 117 dye-sublimation printers, 116

dynamic range, 73, 89 high dynamic range (HDR), 74-75 Eastman, George, 186 Eastman Kodak Company, 186 edges, 154-155 editing, 86, 90-113 back up/saving files, 92 black and white images, 108 compositing in, 106-107 Curves in, 96-97 equipment, 78 ethics, 112–113 filters, 109 getting started, 92-93 histograms use during, 60 image adjustment, 94-99 Layers in, 100-101 Levels in, 94-95 nondestructive, 87 resolution and, 55 retouching in, 102-103 selections in, 98-99 sharpening in, 104–105 workflow, 110–111 Eggleston, William, 208, 209 Eiler, Terry E., 155 Eisenstaedt, Alfred, 199 Ekberg, Adam, 67 Ektachrome, 187 electronic flash, 146 electronic viewfinder (EVF), 13 Elements (Photoshop), 78 Ellison, Ralph, 177 Emerson, Peter Henry, 200 equipment digital, 78 for mounting, 122 Erwitt, Elliott, 159 ethics, 112-113 Ethridge, Roe, 178 Evans, Walker, 173, 195 exhibitions, 115, 206, 209, 212 see also galleries, photographs in Exif (Exchangeable image file format), 131 expanded perspective, 48 exposure, 52-75 of an average scene, 68-69 automatic, 6, 7, 16 automatic exposure camera, overriding, 66-67 backlighting and, 72 close-ups and, 50 color photography, 56-57 compensation dial, 66 for contrasty scenes, 70 filters and, 51 focusing and setting, 6 high dynamic range and, 74-75 of high-contrast scene, 72, 73 histograms, 60-61 images, 8 latitude, 54 of lighter/darker scenes, 70-71 lock, 66 manual, 16, 64-65 meters, 61-65 pixels and resolution, 55 programmed (fully automatic), 16 readout, 7 sensors and pixels, 54 white balance and, 57-59 external hard drives, 78, 130 eyedroppers, 94, 97

fair use, 113 Farm Security Administration photographers, 195 fast shutter speed, 27

fault-tolerant systems, 133 Feininger, Andreas, 37 Fenton, Roger, 191 fiber-based papers, 117, 124 figure/ground relationship, 156 files derivative, 86, 130 flattening, 100 formats, 81 raw (see Camera Raw files) renaming, 88 saving, 130 sizes, 80 fill light, 142-143, 151 film, 4, 133, 186, 187 film cameras, 10–11 film scanners, 89 filter size, 31 filters, 51, 85, 100, 104, 109 Fink, Larry, 163 fisheye lenses, 40, 41 flash as artificial light, 146-147 automatic, 146 bounce, 147, 149 direct, 140, 147, 149 electronic, 146 fill light and, 142-143, 151 motion and, 161 portrait lighting and, 144, 148 positioning, 148-149 flatbed scanners, 89 focal length, 15, 18, 31-39 depth and, 162 depth of field and, 42, 44-45 long, 36-37 normal, 34-35 short, 38-39 focal-plane shutter, 18 focus peaking, 13 focusing, 15 automatic, 6, 43 depth of field and, 42, 158, 159, 179 manual, 6 ring, 14, 17 scanners and, 89 zone, 46 tocusing ring, 31 Fontcuberta, Joan, 113 forced perspective, 177 framing, 120, 154-155, 179 Frank, Robert, 204-206 Friedlander, Lee, 157, 205, 206 Frith, Francis, 106 frontlighting, 140, 142, 166 f-stops, 23, 26, 64 Fuji, 209 full frame, 13 full-frame sensors, 32 galleries, photographs in, 201, 204, 206, 208 Galvan, Laurisa, 50 gamma, calibrating, 84 gamuts, 82 Gardner, Alexander, 190, 191 gelatin emulsion, 186 gelatin-silver emulsion, 192 gigabyte, 80

Gilbertson, Ashley, 198

Godowsky, Leopold, 187 González, Dionisio, 111 Gossage, John, 121

grayscale, 56, 82, 83, 108

Gilden, Bruce, 150

Gould, Meggan, 77

Grayscale Mix, 108

gray card, 58, 73

glass filter, 109

glazing, 120

halftone process, 196 halogen lamps, 146 hand-held meters, 62, 64, 69, 72 hard disk, 78 hard drives, 78, 130, 133 hardware resolution, 89 Harker, Santiago, 153 Harvey, David Alan, 139 Hatakeyama, Naoya, 21 Hauron, Louis Ducos du, 187 Heartfield, John, 210 heliography, 181 Herschel, Sir John, 210 High Art photography, 200 high dynamic range (HDR), 74-75, 142 high lighting, 140 high-key lighting, 70 High-Pass filter, 104 high-speed sync, 146 Hill, Ed, 212 Hine, Lewis W., 193, 194 hinges, 127 histograms, 7, 60-61, 68, 95 history of photography, 180-213 art, photography as, 200–207 calotypes, 184 collodion wet-plate process, 185 color photography and, 187, 208-209 daguerreotype, 182-183 digital photography, 210-213 early portraits and, 188–189 early travel photographs, 190 early war images, 191 gelatin emulsion/roll-film base and, 186 photograph as document in, 193 photojournalism, 196-199 social change and, 194-195 time and motion, 192 Hoch, Hannah, 210 Hocks, Teun, 114 Holmes, Oliver Wendell, 191 hot lights, 146 hot shoe, 17 hue, 57, 178 icons, 92 illumination see also lighting compositing and, 106 illustrated newspapers, 196 image database, 132 image quality, 6 image-editing software, 78, 83, 89, 92 importing image, 86, 88-89 incandescent lamps, 146 incident-light meters, 63, 69 indirect light, 144, 145 Info palette, 92 Infrared black and white, 108 infrared blocking filters, effectiveness of, 108 ingesting image, 86 inkjet printers, 116, 117, 119 inks, for printing, 117 input values, 96 interchangeable lens, 14, 32 International Center for Photography, 206 Internet, 78, 153 interpolated resolution, 89 inverse square law, 147 inverting, 98

Groover, Jan, 208

ground-glass screen, 6

Grundberg, Andy, 208 guide number, 147

process, 204

gum bichromate and platinum printing

Iooss, Walter, 48 IPTC (International Press Telecommunications Council) fields, 131 ISO, 4, 64, 66, 75, 138, 139, 158 isostacy, 107 isostatic equilibrium, 107

Jackson, William Henry, 190 Jones, Ed, 36 Jones, Lou, 72, 161 Jones, Peggy Ann, 116 Josephson, Kenneth, 139 Joyce, Kate, 175 .jpeg (JPEG) files, 81, 85, 88, 104, 108 Jude, Ron, 115 Karsh, Yousuf, 168 Kepes, György, 203 Kerouac, Jack, 205 key light, 144 Killip, Chris, 167 kilobyte, 80 Klett, Mark, 101 Kodachrome, 187 Kodacolor, 187 Kodak box camera, 186 Koo, Bohnchang, 61 Kost, Julieanne, 107 Koudelka, Josef, 21 Kruger, Barbara, 206 landscape photography, 51, 170-171 Lange, Dorothea, 136, 195 Lasso tool, 98, 99 latitude, 54 Layers, 100-101 Layers palette, 92 LCD monitor, 8, 13, 154 leaf shutter, 19 Lee, Russell, 161, 195 Leibovitz, Annie, 2 lens(es), 4, 12, 17, 30–51 *see also* depth of field; focal length; focusing attachments for, 50-51 barrel, 31 basic difference between, 32-33 cleaning, 25 compound, 31 elements, 17 fisheye, 40 focal length, 31-33 function of, 31 interchangeable lens, 14, 32 Macro, 40 range of f-stops, 23 speed, 31 telephoto, 36-37 wide-angle, 38-39 zoom, 40 lens focal length, 15 lens-to-subject distance, 44, 49 Levels, 94-95, 100, 110 Leventi, David, 38 Levitt, Helen, 208 Liebling, Jerome, 71 light, 52-75, 179 aperture and, 22 and exposure (see exposure) shutter speed and, 18 sources, 57, 58 lighting, 134-151 artificial, 146-147 close-ups and, 50 existing, 138-139 fill light, 142-143 flash (see flash) indoor, 142, 144, 174-175 outdoor, 142, 144 portrait, 144-145

lighting, (Continued) qualities of, 136-137 source of, 140-141 lightness/luminance, 57 Lightroom software, 78, 87, 88, 91, 118, 132 color and, 85 editing and, 108 line, as visual element, 178, 179 live view, 12 loading, 98 local contrast, 57 London, Barbara, 171 Long Exposure Noise Reduction, 75 Lopez, Martina, 212 Lorant, Stefan, 196 low light exposures, 67 low-key lighting, 70 Lumière, Antoine, 187 Lumière, Louis, 187 luminance, 82, 83, 85 macro lens, 40, 50 macro-photography, 50 magazines, 196 Magic Wand, 99 main lighting, 140 Mandel, Mike, 160 Mannes, Leopold, 187 MANUAL, 212 manual exposure, 16, 64-65 manual focusing, 6 manual mode, 66 Manzano, Javier, 52 Mapplethorpe, Robert, 206 Marquee Tool, 99 masks, 83 mat board, 122 mat cutter, 122 matting a print, 121 maximum aperture, 31 Maxwell, James Clerk, 187 McCoy, Dan, 162 McFarland, Lawrence, 97 medium-fast shutter speed, 27 medium-format digital SLR cameras, 12 medium-wide aperture, 27 megabyte, 80 Meiselas, Susan, 199 memory card reader, 78, 88 memory cards, 4-6, 8, 17, 29, 88, 130 menus, 78, 92, 93 metadata, 131 metal ruler, 122 metamerism, 117 metering cell, 17 meters, 61-65 manual exposures and, 64-65 weighting of, 63 Metzker, Ray K., 73, 159 microSD, 88 middle gray, 62, 70, 73, 96, 97 Miralle, Donald, 41 mirror (camera), 17 mirroring, 133 mirrorless cameras, 12-13 Misrach, Richard, 170 Mitterand, François, 213 35mm equivalent focal lengths, 32, 33 mode dial, 17 model release, 168 modem, 78 modes, color, 56 Moholy-Nagy, László, 203, 210 monitor profile, 82 monitors, 78, 84, 87, 92, 118 Monochrome Mixer, 108 motion, 18-19, 160-161, 179, 192 mount board, 122, 124-127 mounting a print, 122-127

mounting press, 122 multiscanning, 89 multi-segment meter, 63 museum board, 121 museums, photography and, 206, 208, 209 Muybridge, Eadweard, 192 Nadar (photographer), 188 National Daguerrian Gallery, 188 naturalism, 200 naturalistic photography, 200 neutral-density (ND) filters, 51 New Objectivity movement, 193 New York, social documentation and, 204 Newman, Arnold, 169 news photography, 199 newspapers, photography in, 196 Niépce, Joseph Nicéphore, 181 Nix, Lori, 176 noise, 54 digital, 75 normal exposed picture, 61 Oberschneider, Christoph, 46 object distance, 42 OEM (Original Equipment Manufacturer) brand, of papers and inks, 117 On Photography (Sontag), 206 open shade, lighting and, 144 optical brightening agents (OBAs), 117 optical disk storage, 130, 133 optical resolution, 89 optical storage medium, 78 options menu, 5, 6 organizing and storing, 128-133 organizing of files, 86 O'Sullivan, Timothy H., 190, 191 output, 78, 86, 104 profile, 82 values, 96 overall (global) contrast, 57 overexposed picture, 6, 61, 73 overmatting, 121, 126-127 Padula, Warren, 165 palettes, 92, 93 Palmer, Alfred T., 187 panning, 19, 161 panoramic cameras, 11 panoramic photographs, 119, 164, 165 papers, for printing, 117, 133 Parada, Esther, 212 parallax error, 10 Parks, Gordon, 195 patch tool, 102 Pen Tool, 99 Penn, Irving, 206 pentaprism, 17 perspective, 179 Peterson, Rolf, 115 Phase One Capture One Pro, 87 photo corners, 127 photo essays, 196, 197 Photo League, 204 Photo Merge software, 74 photodiodes, 54, 85 photoflood light, 142-144 photograms, 203 photographic conceptualism, 206 photographic laser printers, 116 photography assembled to, 176-177 background in, 156-157 cityscapes in, 172-173 depth in, 162-163 depth of field in, 158, 159 edges/frames in, 154-155

focus in, 158-159 history of, 180-213 indoors, 174-175 landscapes in, 170-171 meaning and, 164-165 portraits and, 166-169 responding to, 178-179 time and motion in, 160-161 photojournalism, 196-199 photolamp, 146-147 photo-micrography, 50 photomontage, 203 photo-quality desktop printers, 116 photo-secession, 201 Photoshop software, 78, 86, 87, 89, 100, 118, 119, 132 see also Bridge software; Lightroom software Adobe Camera Raw and, 85 color and, 83, 85 editing and, 92, 98, 100, 102, 108, 110, 111 Elements, 78 filter menu, 109 introduction of, 212 Merge to HDR Pro feature, 74 photosites, 54, 75, 85 pictorial photography, 201 pictorialist photography, 201 picture magazines, 196, 197 pigment inks, 117 Pinkhassov, Gueorgui, 59 pixels, 54, 55, 80, 83, 85, 116 see also value of pixels pixels per inch (ppi), 116 plug-ins, 93 Plumbe's National Daguerrian Gallery, 188 pocket drives, 130 point, as element of design, 178 PoKempner, Marc, 44, 152, 153 polarizing filters, 51 Polaroid camera, 210 Polaroid instant positive/negative film, 211 portable hard drives, 8, 130 portraits, 213 early, 188-189 formal, 168-169 informal, 166-167 lighting for, 144-145, 166 medium-long lens for, 37 post-processing process, 86 power brick, 130 prime lens, 32 printers, 56, 78, 116, 119 printing and display, 114-127 framing in, 120 matting in, 121 mounting and, 122-127 panoramic photographs and, 119 papers and inks in, 117 printers and drivers in, 116 soft proofing in, 118 prints, storing, 133 profiles, 82, 84, 118 programmed (fully automatic) exposure, 16 ProPhoto RGB, 82 .psd files, 81 public domain, 113 puck (spectrophotometer/colorimeter), 84 quartz lamps, 146 Quick Mask, 99 RAID (redundant array of inexpensive disks), 133

RAM (memory), 78

rangefinder cameras, 10–11 raster image processors (RIPs), 116 raw-format workflow programs, 92 Ray, Man, 210 Reagan, Ronald, 213 reflected-light meters, 62, 63, 68, 69, 72 reflection-control glass, 120 reflections, polarization and, 51 reflectors, 143 Rejlander, Oscar G., 210 release paper, 122 resampling process, 55 resin-coated (RC) papers, 117, 124 resizing, 110 resolution, 13, 55, 89, 116 retouching, 102-103, 110 RGB mode, 56, 83 Richter, Christian, 75 Riis, Jacob, 194 RIPs (raster image processors), 116 Robinson, Henry Peach, 200, 210 Robledo, Maria, 57 roll-film base, 186 Rome, Stuart, 171 Rosler, Martha, 76, 212 Rothstein, Arthur, 195 Rowin, Stanley, 41 royalties, 113 Sabattier effect, 203 Salomon, Erich, 196 Sander, August, 193 saturation, 57 saving, digitally edited photo, 91 scanners/scanning, 78, 86, 89 Schäfer, Michael, 103 Scherer, Jim, 105 SD (Secure Digital) card, 88 selections, in digital editing, 98-99 sensors, 4, 17, 18, 22, 32, 45 cleaning, 29 color and, 85 digital, 53 exposure and, 54 infrared blocking filter of, 108 limit, 74 size, 13 shadows HDR and, 74 lighting and, 140, 142-143, 151 Shahn, Ben, 195 shape, as element of design, 178 sharpening, 89, 104-105, 110 Sheeler, Charles, 164 Sherman, Cindy, 206 Shore, Stephen, 209 shutter release, 17 release button, 14 shutter speed and aperture, 26-27 bracketing and, 64-65 control, 15 creative use of, 20-21 exposure and, 53, 54, 62, 64 flash and, 146 and light, 18 and motion, 18 portraits and, 166 settings, 18 shutter-priority mode, 7, 16, 69 side lighting, 141, 166 silhouettes, 72 SilverFast, 89 single-lens reflex (SLR) cameras, 10, 12 see also digital single-lens reflex (DSLR) cameras Sinsabaugh, Art, 165

Siskind, Aaron, 204

size/scale, as element of design, 178 slide show displays, 132 sliders, 94 slow shutter speed, 27 SLR cameras, 75 small aperture, 27 smart filters, 100 Smith, W. Eugene, 197, 206 social change, photography and, 194–195 soft proofing, 110, 118 software see also Adobe; Bridge software; Lightroom software; Photoshop software image-editing, 78, 86, 92 organizing and storing, 132 programs, for editing photographs, 77 scanning, 89 Sohier, Sage, 137 solarization, 203 solid state drives (SSD), 78 Sontag, Susan, 206 Soth, Alec, 166 space positive and negative, 156 working, 82 spectrophotometers, 84 spot meter, 63 Stained Glass filter, 109 stamp filter, 109 Stein, Amy, 144 stereocameras, 11 stereographic photographs, 192 Sternfeld, Joel, 24 Stieglitz, Alfred, 172, 201, 202 stitching, 119 Stone, Jim, 211

storage see organizing and storing straight photography, 201, 202 Strand, Paul, 202 Strembicki, Stan, 128, 129 strobe flash, 146 Stryker, Roy, 195 style(s), 163, 204, 205 subcompact digital cameras, 12 subjects, photographic exposing main, 73 of portraits, 166 substitution reading, 72, 73 subtractive primaries, 56, 83 Sun Drawn Miniatures, 181, 182 sun, lighting and, 136, 144 sync speed, 146

tacking iron, 122 tagging, 131, 133 Talbot, William Henry Fox, 184, 210 tape, 122 Tarnowski, Tom, 95 Taylor, David, 80 telephoto lens, 36-37 temperature color temperature, 58, 59 mounting press and, 124 terabyte, 80 texture, 178, 179 Thatcher, Margaret, 213 3-D cameras, 11 through-the-lens (TTL) meter, 62 thumbnails, 92 .tif (TIFF) files, 81, 85, 89, 104, 108 time and motion, in photography, 160–161, 192 time of day, light and, 172 tones, 70, 81, 179 Curves and, 96

dynamic range and, 73 histograms, 60 Levels and, 94 warm, 164 tool options bar, 93 toolbox, 93 too lighting, 141 transmission equipment, 78 transparencies, scanning, 89 travel photographs, 190 tripods, 8, 28, 161 Tugwell, Rexford G., 195 Turner, Pete, 163 twin-lens reflex (TLR) cameras, 11

underexposed pictures, 61, 70, 73 underwater cameras, 11 Unsharp Mask filter, 104 unsharp masking (USM), 104 upsampling, 55

value of pixels, 54, 60, 82, 85 value/lightness, as element of design, 178 values, input and output, 96 Vanderwarker, Peter, 100 view cameras, 11 viewfinder, 4, 7, 15–17, 22, 154 viewing screen, 17 viewpoint, 179 visual elements, 179 volume, as element of design, 178 VueScan, 89

Wall, Jeff, 177 war photographs, 191 warm tone, 164 watercolor filter, 109 Watkins, Carleton Eugene, 190 Web site, 78, 113, 210 sRGB printing for, 82 Webb, Alex, 131 Weems, Carrie Mae, 79 Weifenbach, Terri, 25 Weiss, John, 145 West Coast style, 204 Weston, Edward, 202, 206, 208 Whaley, Jo, 123 white balance, 6, 57–59, 85 White, Minor, 53, 202, 204 white points, 84, 94, 97 wide aperture, 27 wide-angle lenses, 174 wide-format inkjet printer, 116 Willis, Deborah, 68 window light, 144 Winogrand, Garry, 135, 205, 206 Wolcott, Marion Post, 195 word commands, 92 workflow applications, 78, 85, 87, 111, 132 editing, 110-111 programs, 83, 87, 92, 98, 102 for raw files, archiving, 133 setting up, 86 workplace, digital, 76-89 Camera Raw files, working with, 85 digital color and, 82-84 equipment and materials for, 78-79 pictures as files in, 80-81 workflow (see workflow) Wu, Jingbo, 108

Xiaoping, Deng, 213 xRez Studios, Inc., 119

zone focusing, 46 zoom lens, 32, 40, 154